FÉLICIEN DAVID

1810–1876

Arts and Ideas

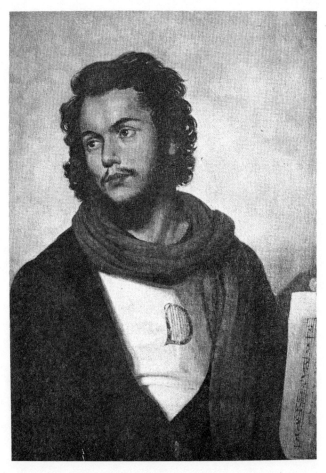

Frontispiece. Félicien David in Saint-Simonian garb, by Raymond Bonheur. Musée Municipal de Saint-Germain en Laye.

FÉLICIEN DAVID
1810–1876
A Composer and a Cause

DOROTHY VEINUS HAGAN

SYRACUSE UNIVERSITY PRESS 1985

Library of Congress Cataloging in Publication Data

Hagan, Dorothy Veinus, 1910–1980.
 Félicien David, 1810–1876.

 (Arts and ideas)
 Bibliography: p.
 Includes index.
 1. David, Félicien, 1810–1876. 2. Composers—France
—Biography. I. Title. II. Series.
ML410.D24H3 1985 780'.29'4 [B] 84-20213
ISBN 0-8156-2321-6

Manufactured in the United States of America

For Charlie

Foreword

*T*HIS VOLUME is the first of a projected "Arts and Ideas" series de-
voted to studies of the arts in their broader humanistic context. Our
first study considers the case of a composer caught up in the social aspira-
tions of liberated, post-revolutionary France at the confluence of two ex-
citing historical movements—romanticism and socialism. This and the
volumes to follow proceed from the assumption that artists working
within a specific period share a world of ideas with other members of their
society. Since their works are sponsored by and addressed to their fellow
citizens, the tastes of their time, the social and aesthetic conventions, and
the vocabularies of their period are inevitably reflected in their output.
For, no matter how thick the walls of their ivory towers may be, artists do
not work in a vacuum. Buildings are of necessity commissioned and con-
structed for specific purposes. Up until recent times paintings and sculp-
tures were ordered by patrons who had special settings and purposes in
mind. Books and music also normally were and continue to be written for
particular audiences and occasions. All reflect to greater or lesser degree
the convictions and conflicts, the energies and ambitions of an era.

Any work of art is demonstrably at the same time an organized
whole and a historical fact. In the first instance, the process of analysis can
be illuminating as the work is dissected into its component parts for pur-
poses of formal study. It goes without saying that specialized, narrowly
disciplinary studies predominate in the recent and current annals of schol-
arly publication. Regrettably uncommon, however, is the ultimately in-
dispensable, broad cultural study which heeds the specialist's discoveries
but casts its nets far more widely to catch the just perspective of the art,
the creator, and the controlling milieu. The musical art of Félicien David,

vii

as a case in point, can hardly be fully appreciated without observing its crucial relationship to social, political, and philosophical issues of his time. The goal of this new series of studies in cultural history is to deepen understanding of the arts in their relation to each other and to the societies and times in which they played a significant part.

Dorothy Veinus Hagan's *Félicien David* is the first modern study to examine in detail the life and work of a musician wholly identified throughout his life with the Saint-Simonian messianic religion. This once-popular Christian technocracy was founded by Henri, Compte de Saint-Simon, who has been dubbed "France's last *gentilhomme* and first socialist." In the 1830s and 1840s the movement attracted a wide circle of businessmen, engineers, politicians, managerial types, welfare-state advocates, writers, musicians, and intellectuals. While Berlioz and Liszt were drawn to the ideals of the movement, only David adhered to it formally as a convert. Barthélemy-Prosper Enfantin, Saint-Simon's successor, regarded himself as the father figure of the movement, and Félicien David enjoyed favorite-son status. To David was entrusted the task of creating a music that would act as a powerful instrument in effecting a moral regeneration of mankind along Saint-Simonian lines. David's works were planned to aid in the propagation of the religious, social, and political ideals of the cult.

David's gifts as a musician were ideal for the task. He wrote an appealing, sensuously colorful music. He was adept at expressing the exotic and the picturesque to the current taste. In fact, David was the first noteworthy French composer to tour the Near East, physically as well as in musical replay, and apparently the first to invest musico-exotic symbols with social correlatives. The ode-symphony, his principal genre-adjustment to the symphonic repertory, was a programmatic form invented to advance the brave new world of his Saint-Simonian co-religionists. The first of these—*The Desert*—received instant acclaim, as did several of his Saint-Simonian operas. Berlioz continually reviewed his work with respect if not always with complete approval. A religiously inspired composer, then, is the focus of this historical study of the merging of romanticism with religious socialism in nineteenth-century France. The relationship of art and ideology is a subject much theorized about. This book deals in detail with a primary historical case.

Dorothy Veinus Hagan (b. New York City, 1910; d. Houston, Texas, 1980), author of the present study, was active lifelong as a scholar,

teacher, concert performer, and critic. She earned her Baccalaureate at
Hunter College, her Master's degree at Cornell University, and her Doc-
torate at the University of Illinois. She was a woman of wide learning who
drew easily upon diverse fields: music, literature, visual arts, social doc-
trine, economics, and political history. From 1968 to 1976 Dr. Hagan
taught music at the University of St. Thomas, Houston. Earlier her pro-
fessional experience had ranged from serving as dance accompanist at
Smith College and editing *The Musical Mercury* to directing musical the-
ater in Dallas. But her interest in David and his epoch began early and was
long enduring, and she devoted every available spare moment to the re-
search and study of his life and works. Owing to Dr. Hagan's untimely
death, projected chapters on David's songs, chamber, and orchestral mu-
sic remained unwritten. Discussion of the early piano pieces of the 1830s,
however, was completed. They are germane to the composer's later devel-
opment and warrant inclusion here along with more extended treatment
of the large-scale oratorios, concert, and stage works on which David's
reputation rests. All translations from French sources are her own.

The author particularly wished to acknowledge the utmost courtesy with
which the staffs of the music division of the Bibliothèque Nationale and
the Bibliothèque de l'Arsenal in Paris made available to her the collections
of David material. She was also indebted to the American Council of
Learned Societies for a grant that enabled her to attend and contribute to
the commemoration of David's centenary at his birthplace in the summer
of 1976. She was grateful to Professor Ralph Locke of the Eastman School
of Music of the University of Rochester, whom she called her "companion
in the research of Saint-Simonian lore," for generously sharing the fruits of
his archival research. Her thanks also went out to her brother, Professor
Abraham Veinus of Syracuse University, "for his unfailing encouragement
and patient reading of the manuscript," and to her faithful friend and col-
league at the University of St. Thomas, Professor Mary Schoettle, for
longstanding assistance and support. To her husband Charles Hagan, pro-
fessor emeritus of political science, University of Illinois (Urbana) and
University of Houston, she attributed "some of the more sensible of my
generalizations based on a large body of material rich in mystical appeal
but correspondingly opaque in terms of both political and musical ges-
tures."

Because Dorothy Hagan did not live to complete her work, this
project became, of necessity, a collaborative effort. Professor Michael

Miller of the History Department, Syracuse University, wrote the first
chapter that places the Saint-Simonians in cultural-historical context.
Professor George Nugent of the Fine Arts Department, Syracuse Univer-
sity, undertook general editorial work, the choice of musical examples,
some textual revision, and the checking of documentation. Mr. George
Catalano of the School of Music, Syracuse University, prepared the musi-
cal examples. Professor Clyde Young of Onondaga Community College
assumed the burden of typing the manuscript and preparing the index.
Heartfelt thanks must also go to Dr. Hagan's husband and family for
their support in bringing this project to fruition. As General Editor of
this new series, I have kept my finger on the pulse at all stages of the
process, and Professor Veinus and I collaborated on the final chapter.

For all of us whose lives were enriched by knowing the author,
bringing her work to publication has been a labor of love in tribute to a
very special person who left a generous token of her spirit in these pages.

William Fleming

Syracuse, New York
Summer 1984

Contents

LIST OF ILLUSTRATIONS

LIST OF MUSICAL EXAMPLES

FÉLICIEN DAVID

1810–1876

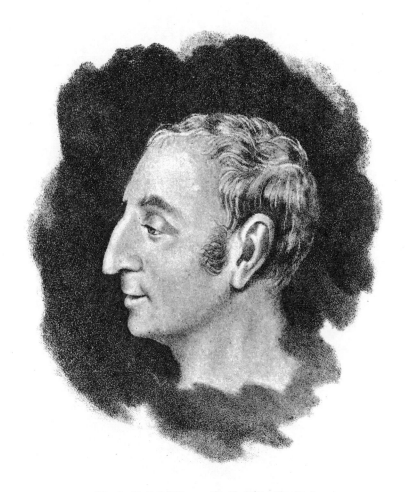

SAINT-SIMON
Fondateur
de la Religion Nouvelle

Figure 1. Claude-Henri de Rouvroy, Count of Saint-Simon, 1760–1825. After Engelmann. Paris: Bibliothèque Nationale. From Henry-René D'Allemagne, *Les Saint-Simoniens, 1827–1837*. Paris, Librairie Gründ, 1930.

1

France in Social Upheaval

𝒯HE COMPOSER Félicien David was born and bred in an atmosphere of revolutionary ferment and fervor. The French Revolution of 1789 had unleashed a host of political, social, economic, and aesthetic forces that propelled themselves well into the nineteenth century. The Paris of the 1820s and 1830s abounded with prophets and poets, messiahs and social saviors, reformers and dreamers, all attempting to direct and consolidate the intellectual and emotional energies of this turbulent period. Of the many movements that arose in these critical times, it was Saint-Simonian socialism that completely captured the mind and imagination of this young composer and shaped his musical thought.

The Saint-Simonians were among the true believers in the ideals of liberty and fraternity. It is against this background of a perception of crisis and a heady confidence in the freedom of individuals to reorder their environment that the movement is to be understood. They derived their name from their self-anointed role as the disciples of one Claude-Henri de Rouvroy, Count of Saint-Simon (1760–1825), a man part sage, part crackpot (Figure 1). Throughout his life, he wrote a great deal about the ills of his times and how they could be corrected. From their master the faithful received the vision of a world plunged into crisis, beset by antagonisms, excessive individualism, and waste. They received as well his model solution: technocracy infused with the spirit of brotherly love.

Saint-Simon had written that a society organized for maximum productivity would end conflict and despair—first because the extraordinary powers of industrialism, if properly harnessed, placed freedom from want at last within grasp; second because the pursuit of this goal demanded a social principle grounded in mutualism.

The state, said Saint-Simon, was to be replaced by a tripartite elite. First would come the intellectuals and scientists who would discover laws useful to mankind and evaluate the projects of others. Here also were the artists, or "men of imagination," who would initiate projects and provide society with moral direction. Their arts, particularly music, would inspire humanity for the great tasks ahead, harmonize diversity, and reinforce the ethic of brotherly love. Next, the businessmen and industrialists would administer and execute the great productive projects that would bring plenty for all. Then, all others would be assigned productive functions that best suited their natural talents.

This system would assure individual fulfillment, but there was nothing individualistic about it. From liberals Saint-Simon borrowed the idea of each according to his merit, but he then wedded this to prevailing conservative theories of the day that society should be hierarchical and or-ganic, a world of harmonious functions, not conflict. It was essential that society abandon its defense of traditions and privileges and be directed to-ward collective and productive ends. Like Karl Marx, Saint-Simon stood on the threshold of industrial change and looked out with awe, and like Marx he was convinced that industrial capitalism would never replace the domination of men over men with the domination of men over things. Technocracy, with a human face, was the Saint-Simonian answer.

The movement that gathered around Saint-Simon in his last years and then grew after his death (although never to sizeable proportions) be-lieved it had a message to spread to the world and set about doing so in public lectures and newspapers. Its motto proclaimed that all social insti-tutions must have as their purpose the amelioration of the moral, physi-cal, and intellectual lot of the poorest and most numerous class; all privi-leges of birth, without exception, were to be abolished; to each according to his capacity, to each capacity according to its works—fundamental Saint-Simonian doctrine.

But the master had also possessed a religious, deeply emotional, and questionably sane strain, and by the 1830s when the impressionable Féli-cien David was to join the movement, this side was coming to be domi-nant. It did so largely under the bizarre influence of Barthélemy-Prosper Enfantin (1796–1864), a man of considerable charismatic powers who es-tablished himself as Le Père, the high priest of a Saint-Simonian religion. Some could not abide his innovations and obsessions and broke with the group. Others were ecstatic in their adoration of Le Père and followed him willingly nearly over the deep end. Under Enfantin's tutelage Saint-Simonism was transformed into a cult worship of love: love of mankind, love of each other, a mystical, deeply felt emotional and pseudo-religious

belief in the power of love to create a perfect world. Beneath, the basic technocratic urge never disappeared altogether. But it was submerged under a consecration of their movement to the spirit of love and fraternity and the obsession with endowing this devotion with the trappings of religion.

In their retreat at Ménilmontant on the outskirts of Paris, the Saint-Simonians lived the life of apostles, preparing themselves physically and spiritually to carry their gospel to humanity. Art, which had always loomed large in the Saint-Simonian vision as an emotive force of social cohesion, was now given an exalted, nearly priestly function. Music in particular was integrated into the rituals that now occupied a good part of their day. The disciples chanted, sang hymns, and dressed themselves in costumes that could only be laced from behind to affirm their commitment to their need for each other (see Figure 3). On Sundays they went on public display, hoping by their example to win over the world. They succeeded in drawing great crowds—up to ten thousand a day—but many came to gawk, lured on by rumors of Saint-Simonian free love. There is no evidence that Saint-Simonians made love more than the rest of French society, and at Ménilmontant they were directed to abstain altogether. But with the focus on love and emotions had come another of Enfantin's obsessions—the need for female liberation and the moral legitimacy of ephemeral sexual relationships. When asked what the new moral law would be, Enfantin said that he himself could not give it, that it would be handed down by a female messiah who would soon take her place alongside him as high priestess of their religion.

This was the signal for some to leave. Others swallowed it whole, accepting chastity as their lot while awaiting the coming of the *Femme-Messie*. In the summer of 1832 the Saint-Simonians were finally brought to trial by a government that was looking for any excuse and found Enfantin most accommodating. The trial was a farce, Enfantin expounding on the hypocrisy of bourgeois marriages (one of the counts against them was outraging public morality) while seeking to mesmerize the jury with his magnetic gaze. He was found guilty and, along with Michel Chevalier, sentenced to jail for a year.

It is difficult today to look back upon the Saint-Simonians without cracking a smile. But it would be a mistake to assume that one was dealing with lunatics or that Saint-Simonism was an early experiment in the theater of the absurd. Those who were drawn to the movement were earnest, sensitive, often highly talented young men, many coming from the École Polytechnique, the elite engineering school of France then and now. Many were to go on to distinguished careers. If they surrendered to their

emotions then it must be remembered they were living in the romantic era when cultivation of feelings and passions was given free license. Indeed, emotion was deemed a higher realm of human experience than reason or cold logic. The tremendous enthusiasm that drove them to believe they were creating a religion was not unlike the "exalted, religious, almost messianic" tone, as William Sewell has reminded us, with which the workers were coming to invest the word *association*.[1] In this sense the Saint-Simonians were very much the children of their times, just as they were when they believed they could reorder the world with a critique of the present and a plan for the future. Indeed, the first half of the century was to sow a whole crop of these system builders, equally smug in their knowledge, equally given to emotional transports and messianic pretensions, equally tending to degenerate from social critique into sectarian practice.

One thinks immediately of Charles Fourier (1772–1837), another prophet to come forth during the early years of the century. Fourier too had an all-encompassing system for human liberation and happiness, although his looked more backwards than forwards, to a return to the land in communal cooperatives where work was made pleasurable and fruitful and where restraints on human expression—in all forms—were eliminated. Like the Saint-Simonians, Fourier's critique was one that extended well beyond the specific social problems of the day, but one as well that felt that the economic changes of the century and the laissez-faire principles that underlay them were deepening a crisis in human affairs. He too was given to messianic raptures and a certainty that change could be sweeping and immediate, if one could only count on understanding and support. In his wilder moments he could make Saint-Simon and Enfantin appear the most reasonable men in the world. His following, too, descended into sectarianism, until Victor Considérant rescued the movement and placed it on a more practical track.

Even more striking is the case of Étienne Cabet (1788–1856) and his Icarian movement. Cabet today is far less known than Saint-Simon or Fourier, but in the 1840s he was the one early socialist with a truly sizeable following, especially among artisans. In 1840 Cabet published his *Voyage to Icaria*, a utopian vision of a future communistic world. The dream took hold, largely because Cabet was well versed in politics and adept as an organizer. Yet by the late 1840s the Icarians too were coming to assume a sectarian, religious, and millennarian character.[2] Even when founders and followers remained level headed, there was still the tendency toward grand system-building, the sense of a crisis that required resolving, the confidence that sweeping changes could be implemented,

the faith in the principle of association, the belief that nothing was fixed. No one was more pragmatic than Louis Blanc (1811–82), whose *Organization of Work* (1839) nevertheless argued that producers' cooperatives financed by the state would drive capitalism out of the marketplace. Blanc also was a product of his times, one more testimony to the intellectual and social matrix out of which Saint-Simonism arose.

How important were these movements and their promoters? Their very number and variety could have a diffuse effect, and some gathered precious little in the way of a following. Yet they were the issue of a romantic era that believed in the power of ideas and ideals to shape reality and this made the system builders a force as well as a symptom. Together they contributed to the hopes of the 1840s that alternative worlds could still be constructed, and to the shift in radical thought from the political to the social. The influence of workers grew in proportion to their political sense. Cabet's *Voyage to Icaria* went through five editions before the Revolution of 1848, and the readership of his newspaper has been estimated at about forty thousand.[3] "The Organization of Work," taken from the title of Louis Blanc's book, became one of the great catchwords among artisans in the 1840s, expressing their priorities should revolutionary times come once again. When the revolutionary wave did at last break, workers measured their successes and frustrations against the uncertain influence of Blanc's ideas in the provisional government.

Historians differ over the conclusion of the French Revolution. Some hold it was in 1792–93 with the establishment of the first French Republic and the trial and execution of King Louis XVI. Others that it came with the collapse of the Directory and rise of Napoleon in 1799. Still others felt it ended with the downfall of Napoleon in 1815. In the first half of the new century, however, it was widely felt that the Revolution was still an on-going process. Politically its goals had not been reached. It dismantled the ancien régime but failed to determine what was to replace it. Looking back from the nineteenth century, the Ultra-Royalists would have preferred to turn the clock as far back as possible. The Republicans insisted that the most radical phase represented the true Revolution. There were those who supported the Constitutional Monarchy of 1789–91 but who identified the Republic with terror, dictatorship, and excess and shrank from this with revulsion—the Liberals. And there were those who wished to preserve the gains of the Revolution, but who also sought order and believed the solution lay therefore in revolutionary authoritarianism—the Bonapartists. It was the competition between these political legacies that was to account for so much of the political instability of the nineteenth century: a Bourbon restoration overturned by a revo-

lution in July 1830; a constitutional monarchy overturned by a revolution in February 1848; a Second Republic overturned by a Bonapartist coup in late 1851; a Bonapartist Second Empire overturned by defeat in war in 1870, followed by civil war and then the establishment of a Third Republic that was to give France her longest post-revolutionary period of political continuity.

It was especially during the middle years of this period, from the late 1820s to the disillusionments of 1848, that the sense of ferment was greatest. Conservatives or Ultra-Royalists were already sensing that the lid would blow once again. Liberals were confident that this would be *their* century, but the price of success was once again a revolution from below as in 1830. Their continuation in power would require repression, by force of law or by sheer force alone. 1830 was a disappointment to Republicans who knew that the people in the streets had not fought for a mere modification in the monarchy. But it was a tremendous stimulus as well. Down to 1830 republicanism had suffered from its identification with the reign of terror. It represented the Red Scare of its day. But the three-day revolution of July 1830 signalled a return to a radical tradition of change, most of all a return of the people of Paris to the political scene. After 1830 republicanism was to grow, fired by social discontents and the political rigidity of the July Monarchy, as well as by the boredom of a romantic generation who believed extraordinary men could only sense themselves extraordinary in extraordinary times, and that the regime's commitment to bourgeois values did not meet this test. Republicans had never accepted the 1815 settlement as a final one. After 1830 they were confident that the revolutionary momentum was underway once again. With the most radical political vision of their day, and one gathering force in the 1830s and 1840s, they too added to the feeling that the future of France remained up for grabs.

The ferment, the mood that things were not fixed, derived from more than politics. Economically, and consequently socially, France was a nation in transition. To speak of an industrial revolution in the first half of the century would perhaps go too far. Only England was well on her way to becoming an industrialized state, and by mid-century, as David Landes reminds us, the continent was still a generation behind.[4] Not until the 1840s did France enter the take-off stage. True industrialization would come only with the building of a national rail network, initiated under the July Monarchy but completed during the Second Empire. Yet changes were occurring, more and more spindles in Alsace and the North, more steam engines in use, new processes and technology in textiles and metallurgy. More important were changes in the organization of work that had

a profound impact on the lives of French workers. These changes occurred not in the new industries associated with industrialization, but in traditional trades like tailoring, shoemaking, and cabinetmaking where work had remained artisanal, and where the majority of French production still was situated. Nor were the changes necessarily related to the introduction of machines. Innovative businessmen found that by simplifying the work process, intensifying the division of labor that went into a product and thereby farming out more and more work to semiskilled labor, they could lower costs and speed up production, which in turn lowered costs still further. The result was a shift from custom-made goods to ready-made articles, but this was exactly what a new retail market was encouraging. By the 1840s *magasins de nouveautés*, precursors of the department stores that would come several decades later, were sprouting all over Paris. Predicated on the basic marketing innovation that higher turnover of low-cost goods that could be sold quickly and efficiently would bring a higher volume of profits, the *magasins de nouveautés* found in ready-wear the perfect article for their needs. From both ends of the entrepreneurial spectrum then, manufacturing and retailing, pressure was building on the old artisanal trades.

For many the impact was pernicious and seen as catastrophic. The threat was not proletarianization, in the sense of replacement by machines and the transfer of work to vast, impersonal factories. But division of labor meant speed-up of the work process, a lowering of wages, and often an exploitative combination of the two through the use of sweatshops and piece-work pay rates. Work of this sort had always been around, but in the past it had been kept on the periphery of the artisanal community. There had been a distinction between the "honorable" and "dishonorable" trades, the latter name deriving not only from the conditions of work, but the inferior craftsmanship it offered as well. Now the "dishonorable" trade was threatening to engulf the "honorable." Artisans who in the past had controlled the conditions of their work, had set and maintained the standards of production, and had commanded relatively high wages all because they were craftsmen in possession of a skill whose supply was limited, now found that they could control precious little as the skill itself was no longer in demand. Which was felt more keenly, the decline in the material conditions of their lives produced by a degradation of skills? Or the psychological effects of a loss of their identity as craftsmen and of their control over the product of their work? The latter Marx called alienation, which was equally a result of the degradation of skills. The issue inspires continuing historical debate. What is certain is that artisans felt they were living in a time of crisis.

Artisans felt their community was breaking up. But because they possessed this sense of community, shared common neighborhoods, mixed together in cafés, possessed a sense of something vital to defend, backed by tradition, possessed as well rudimentary forms of mutual assistance—their mutual-aid societies for burials or injuries—they also possessed the means to organize a defense. In the early 1830s France was racked by strikes (although illegal) and outright insurrections. Stirred by the uprising of 1830, angered by the refusal of the July Monarchy to address the social questions, resentful of a regime whose definition of liberty included no restraints on the entrepreneurial competition and innovation they blamed for their plight, the artisans resorted to action, even violence. A noteworthy example comes from Lyons in the clash between silk workers (*canuts*) and silk merchants who were driving down wages and intruding their authority deeper into the workplace. In late 1831 the *canuts* rose in rebellion under a slogan—"Live Working or Die Fighting"—that captured the intensity of the issues at stake. Several hundred did die fighting. So did several hundred more when the *canuts* rose once again in 1834.

After this the government felt compelled to introduce more repressive laws against workers' organizations, which cooled things until a new wave of strikes erupted in 1840. The government intervened largely because it feared that workers' discontents were being exploited by the dread political enemy, the Republicans. This was not altogether incorrect. The 1830s and 1840s witnessed a major shift in the nature of European radicalism. Down to this time, to be radical meant to be Republican. But by the 1830s Republicans were turning to artisans as a new base of support. Republicans now spoke of social questions, issued social critiques, adopted social programs to respond to the grievances of workers. Radicalism began to assume a social as well as a political cast. But there were also fundamental differences between the two camps that were never resolved until the crunch came with the February Revolution of 1848.

For Republicans, the priority remained a political revolution and the establishment of a Second Republic which would also be socially concerned. For many workers, Republicanism was a way station along the road to social and economic transformation, a political opportunity to redress social wrongs. How deep was the difference became clear in June 1848, when workers rose against a Republic that was clearly not going to give them all that they sought, and that suppressed their rebellion with a ferocious bloodletting. By the end of the century, Republicanism openly accepted a position of social conservatism—"The [Third] Republic will be conservative or it will not be at all," declared one of its founders, Adolphe Thiers—while radicalism of a truly revolutionary character became monopolized by the socialists and some anarchists.

But all this lay ahead, and in the 1830s and 1840s, when Republicans were still revolutionary and speaking their language, artisans found in Republicanism a message of hope. Republicanism was an argument that liberal economics as well as politics might someday be swept away. It was a confirmation that one lived in an era of flux rather than settlement, and that workers might still shape the future as they pleased. This desire to retain control over their destiny also turned them elsewhere, to a new definition of what could be accomplished through resources of their own. There was much talk, and some putting into practice, of producers' cooperatives, where both decisions about labor and the fruits of labor would be retained in the hands of labor. Others went further, speaking of a brotherhood of labor that would form the basis of a worker-controlled state. In each case they gave expression to their vision through the magic word "association." "Association" stood not only for what workers could accomplish through joining together, but also for the very goal that was sought—an abandonment of liberal individualism and a return to community control over work. Here again one is struck by that great mood of openendedness, that belief or frenzied will to believe that options had not been foreclosed, that the path of industrialization had not been clearly cut, that alternatives were possible, that as E. P. Thompson saw in regard to Owenism, "the structure of industrial capitalism had only been partly built, and the roof not yet set upon the structure. Owenism was only one of the gigantic, but ephemeral, impulses which caught the enthusiasm of the masses, presenting the vision of a quite different structure which might be built in a matter of years or months if only people were united and determined enough."[5] The future remained open, to be shaped by those who had a program, and the dedication to see their vision home. Or so it was thought.

Socialism, however, did not come to France in 1848. The dreams of the workers were smashed on the barricades of their June Days' revolt and then laid to rest with the Bonapartist coup. Indeed when the revolutionary waters retreated from Europe the mood had turned from a blind faith in enthusiasm and ideals to a concentration on power and organization. These were the forces that had triumphed in 1848, politically, socially, and nationally. The lesson was not lost on the socialists, who were to gravitate to more "scientific" camps. Marx, in his early writings, had shared the romantic and visionary inclinations of the others. But by 1848 he was clearly spelling out the difference between his theory of history grounded in class struggle and political organization with the systems of his predecessors whom he now labelled Utopian. In their systems, Marx argued, "historical action is to yield to their personal inventive action, historically created conditions of emancipation to fantastic ones, and the gradual

spontaneous class organization of the proletariat to an organization of society especially contrived by these inventors."[6] The Utopians—and the name has stuck ever since—believed they could stand outside all power relationships, political, social, and economic, simply set their plans in motion, and wait for socialism to sweep over the world. This to Marx was what made them so condemnable: their complete obliviousness to the dynamics of change. "Hence they reject all political, and especially all revolutionary, action; they wish to attain their ends by peaceful means and endeavor, by small experiments, necessarily doomed to failure, and by the force of example, to pave the way for the new social Gospel." The result was "fantastic pictures of future society," "castles in the air," "proposals . . . of a purely Utopian character." After 1848 Marx and Marxism would still have many battles to fight, but these would be more with libertarians than Utopians of the old model, and by the end of the century Marxist theory would be dominant.

And what of the Saint-Simonians? In a way the movement was already dying by the early 1830s. Enfantin and the trial pretty well saw to that. Earlier the Saint-Simonians had been much talked about. Their lectures in the Rue Taitbout were well attended. But conversions, as Charléty tells us, were rare, fragile, and often for peculiar reasons.[7] Nor was Saint-Simonian doctrine—hierarchical, authoritarian, looking forward to industrialization—of a sort to attract artisans embittered by a loss of control in the workplace and looking backwards to an idealized, pre-industrial age. The questions that Marx was to raise about the Utopians were already becoming apparent in 1830, when the Saint-Simonians revealed themselves devoid of a theory of action or organization in a moment of political change. Individual Saint-Simonians threw themselves into the battles of the July Revolution. The movement, pacifist and caught unawares, remained on the sidelines. Then came the descent into weirdness. After the trial those whose faith remained unshaken embarked for what was then called the Orient, today the Near East, in search of La Mère or the Female Messiah. They did not find her and were probably fortunate not to have been stoned to death. Joined by Enfantin who was back on the technocratic track, they talked of building a canal through Egypt (among Saint-Simon's earliest projects had been an interoceanic canal across Central America), settled for building a dam, and failed to do that. Returning to France, Enfantin continued his grandiose schemes. A bid to become economic guru of Europe never materialized, but rebounding to reality Enfantin worked to create the Paris-Lyon-Mediterranean rail system. The man did possess considerable talents. Later Ferdinand de Lesseps would borrow heavily (some would say stole) from Enfantin's Suez Canal plans.

But while the Fourierists and Icarians grew, the Saint-Simonians splintered and then disintegrated as a movement. In 1848 they were mere spectators. In 1852 Enfantin welcomed the return to Bonapartism, believing an authoritarian system alone was capable of realizing the Saint-Simonian vision.[8]

So Saint-Simonism was a failure, certainly on the ambitious and enthusiastic terms it had set for itself in the late 1820s. Yet there are those who would argue that the movement did not fail altogether, that it succeeded in launching a Saint-Simonian strain into French thinking and planning. Saint-Simonism, the argument goes, took root among certain elite groups, especially the corps of the École Polytechnique, eventually finding fruition in the economic policies of the Fourth and Fifth Republics. Such a perspective is provocative, even enchanting, but it seems to have little to do with history. The more direct impact of two world wars, a defeat in the second and an occupation that required planning to keep the economy alive and to serve German policies, along with comparable developments elsewhere, would seem to have played a greater role in French economic policy since 1945 than some mystical ideal handed down from one generation of engineers to another. Others have looked for more direct influence, finding it in the economic policies of Napoleon III who has frequently been labelled a Saint-Simon on horseback. It is true that the Second Empire was one of the great boom periods in French economic growth and that Louis Napoleon encouraged this, even believed the state should play an initiating role. Yet it is questionable whether Louis ever read the Saint-Simonians or believed he was carrying our their designs. What did influence him was his reading of the Napoleonic legend that argued a Bonaparte must work for the welfare of the nation. By the mid-nineteenth century this could only be interpreted as fostering industrial expansion. Also at this time, it was clear that a Bonaparte was only going to hold onto power if he oversaw an era of prosperity.

Still, these debates are largely irrelevant. The Saint-Simonians have fascinated historians not because of a supposed influence throughout modern French history but because they were there, a part of their times; because they expressed moods and discontents and aspirations that found equivalent, if different, expression among many Frenchmen and women in the first half of their century; because they were precursors of a socialist movement that *has* largely shaped the modern world; and because, quite simply, their story is fascinating in its own right. There is something of the marvelous, even the incredible, in the Saint-Simonian adventure that will always draw an audience, just as the Saint-Simonians never failed to attract attention to themselves in their own day. Perhaps this is what con-

tinues to fascinate us, not only the remarkable tale in itself, but that so many remarkable or talented individuals played a role in it. There were promising engineers and theorists like Michel Chevalier who went on to become one of the leading economists of France. There were brilliant businessmen like the Pereire Brothers, early Saint-Simonians who later built railroads all over the continent and pioneered in banking until they clashed with the Rothschilds for supremacy and lost. And there were also rising artists, including musicians like Berlioz and Liszt, who flirted with the apostles before, in the end, however, resisting their charms. One, admittedly less great but nevertheless celebrated in his century, and who gave himself completely to the movement, never wavering in his faith, was Félicien David. It is this story of a composer under the Saint-Simonian spell that the following pages will set forth.

2

The Saint-Simonians

*A*CCORDING TO GOETHE, the special task of biography is "to exhibit the man in relation to the features of his time; and to show to what extent they have opposed or favoured his progress; what view of mankind and the world he has formed from them, and how far he himself, if an artist, poet, or author, may externally reflect them."[1] That will be the intent here—first by viewing our subject in the mainstream of the intellectual and social currents that shaped his life and mind, then by a close look at his music.

The middle decades of nineteenth-century Paris, with their explosions of intellectual energy, saw the rise and fall of many musical reputations. One of these was that of Félicien-César David (1810–76), the centennial of whose death was duly celebrated in the summer of 1976 at his birthplace, the small town of Cadenet in the Vaucluse. His fame rests principally on his ode-symphonies and operas, and he was one of only five native composers to achieve new productions at the Paris Opéra during the days of the Second Empire of Napoleon III. His works also embrace most of the musical fields practiced in his time—oratorios, chamber music, piano pieces, and songs. Now they all lie respectfully interred in various French libraries awaiting rediscovery by enterprising musicians. Similarly forgotten are the socio-political movements of David's time which had great impact on his life and work.

David was the first French musician of stature to tour the Near East and to recapture the experience in his music, investing musico-exotic symbols with social parallels. He identified himself throughout his life with Saint-Simonism, a messianic cult built on technocratic doctrines developed by Henri, Comte de Saint-Simon. In his youthful years Saint-

13

Simon had crossed the Atlantic to volunteer in the American War of Independence and serve in several campaigns. Afterward he participated in the French Revolution, and then became a philosopher, social activist, and political reformer. His last book *Le nouveau christianisme* (1825) became the foundation stone of the movement that bears his name. As his theories shaped up, the main tenets of the movement were to be the promotion and application of science to improve the human condition; the creation of a new leadership based on intellectual power and creativity; the emancipation of women; the equitable distribution of wealth according to each individual's contribution to society; and the propagation of a new religion founded on the here and now rather than on the hereafter.

After Saint-Simon's death in 1825, Barthélemy-Prosper Enfantin became the charismatic leader and father figure of the movement. Subsequently he was always known to his followers as Le Père (see Figure 2). Under his aegis, the new religion claimed over 40,000 adherents by the middle of 1831. Félicien David joined the cause officially in 1832 at a time of climax in its ecstatic ideology. Saint-Simonism's special aura bestowed on David's career an incandescence consistent with a world view predicated on the fulfillment of all human hopes and capacities, the artistic above all, as a religious duty. The moral tenor of the new gospel in heres in the very titles of Paris' first socialist newspapers—*Le Producteur* (1825–26), *L'Organisateur* (1829–31), and *Le Globe* (1830–32). For seven years they besieged city and country with pronouncements on the productive forces that determined social organizations and the global creative spirit on which they were to depend.

Several of Enfantin's disciples are still remembered in accounts of France's early socialist movements. Enfantin himself occupies very little space in the annals of social economics, although in his own right he was a managerial type of considerable accomplishment.[2] Over time, the most striking of his many faces, that of the mystic, has eclipsed the others and set up his image for caricature. Yet it is this image that again comes to the fore in an attempt to redress the obscurity into which Félicien David has fallen.[3] David was the musician-disciple whom Le Père called "le plus mon enfant" (most like a son). Their histories are inextricably linked. Enfantin's person and his religious teachings were the great inspiration of David's life and art.

Enfantin claimed credit for locating God in a new place—a socioeconomic sphere supplied with moral absolutes that people could use here on earth. Like Dostoyevsky's Grand Inquisitor, he assumed that people would be glad to accept his answers and be saved from the agonies of free decisions and free markets.[4] With bold simplicity he assumed Saint-Si-

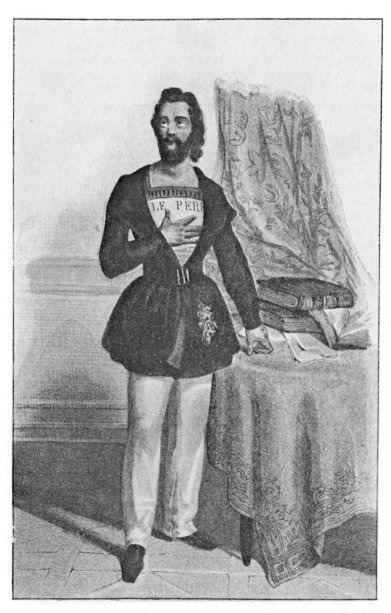

Figure 2. Barthélemy-Prosper Enfantin. From Henry-René D'Alle-
magne, *Les Saint-Simoniens, 1827–1837*. Paris, Librairie Gründ,
1930.

mon's solution to the terrible social problems of his time: government by an elite of intellectuals drawn from the ranks of scientists, industrialists, and artists. He regarded what they termed the rationalization of industry not only as a pressing need, but as a center of manipulations bringing together his own inspirations, those of the engineer-economist, and those of the self-proclaimed father of his flock.

The Saint-Simonians under Enfantin were not democratic. Enfantin favored a planned economy, but he was prepared to out-balance individual freedom and equality with a hierarchy of capacity based on the slogan "to each according to his capacity; to each capacity according to his works."[5] Accordingly, the hierarchy thus formed became the projected basis of government by a scientific and educational elite. Saint-Simon had recognized the difficulties inherent in this designation of high priests of science, art, and ideas. It is not given to everyone to grasp scientific truth intellectually. Consequently, the path between priest and populace, now that science was to replace established religion, required repaving. The ability of religion to unite people in the pursuit of the social good had in some way to be retained. Throughout his life Enfantin pondered an ethics according to which an industrial system could be made to operate by moral principle. Like Saint-Simon, he was convinced that deep inhibitions of a moral or religious nature could hold people back from the exercise of pure selfishness. At the same time, the very rationality of the industrial system envisioned by the Saint-Simonians endangered the effectiveness of the emotional factors which they held forth as primary enforcing pressures in the texture of social behavior. Consequently, while the educated elite could absorb knowledge on scientific principle, knowledge had to be imparted to the masses with the aid of ritual, cult, and quasi-mystical thought control.

A first principle, that of brotherly love, was reinforced by a law of association derived by Saint-Simon from Newton's law of gravitation. This law, in the guise of the so-called "passional" attraction which the Saint-Simonians shared with the romantic social philosopher Charles Fourier, Enfantin had the honor of testing in his own life-style. He was the Mesmer of social romanticism, father of a new religion whereby perception of things gained by a combination of rational and sentimental processes found expression in social institutions characterized by common belief. The aim was to join religion and politics to effect a society organized as a church, the convenient model being the Catholic church itself. The new church was then viewed as a progressive fulfillment of the idea of Christian brotherhood.

On the downward see-saw from metaphysics, Enfantin's practical

projections always returned to a kind of super-national school of administration like the French polytechnical academy (he was a graduate engineer of the Polytechnique), which still fills key civil service positions in industry, politics, diplomacy, banking and finance, international organizations, and the arts. Toward mid-century he began to see himself as the moving spirit of such a government, but his hopes for an influential administrative appointment were always frustrated. Yet he remained a presence on the French scene. He had the ability to assert himself by his will power, by his handsome person, and by the peculiar force of the rhetoric with which he sanctified money, banking, credit, railway systems, canals, and, as will be seen, musical compositions. His prophetic powers, as he saw them, were those of the Saint-Simonian model "at once a rational scientist, a practical industrial activist, a man of feeling and moral drives, a creature of emotion."[6]

In the interest of his ideology, Enfantin's charismatic personality made him one of the greatest propaganda wizards of modern times. With an intuition of music's effect on the human being no less remarkable than Saint Augustine's, Enfantin proceeded to point his propaganda arm for the arts toward the celebrities of the Parisian musical world, many of whom had already been seized by a crisis of conscience. Saint-Simonian rhetoric held a strong attraction for many young intellectuals of the day, including the composers Hector Berlioz (1803–69) and Franz Liszt (1811–86) and the writer Heinrich Heine (1797–1856). The spectacularly widened prospect of the artist's high place in the social hierarchy, his prophetic role, his assignment to bring the entire social order under judgment, the necessity, in the course of an expression of society in its progressive march, to achieve a new technique—all this should have captivated the most thoughtful among the musicians, and it did—to a degree.

After the first rapture Berlioz seems to have been put off by the new religion that smacked of authoritarianism, discipline, and paternalistic rule. Liszt was also initially attracted by the notion of a Promethean priesthood of artists transmitting the divine fire to an eager humanity. He is known to have played at several of the Saint-Simonian meetings, one of which numbered General Lafayette in the congregation. According to a contemporary source, Liszt would take his seat at the piano and abandon himself to his fantasy.[7] But he never became a formal member, and soon his restless idealistic energies were diverted elsewhere. The musician who did assume the role of the Father's devoted and dependent son, and that of the *charmant compositeur moraliste* of the Saint-Simonian cult, was a twenty-two-year-old naif from Cadenet named Félicien David.

The notion of socially conscious music was not born with the Saint-

Simonians, but it did assume with them a particular and insistent focus in a didactic mission for social change. Insofar as they attempted an aesthetic, it was less a science of the beautiful than a series of deductions following on their politics and their philosophy of history. The Saint-Simonians based themselves on a theory of historical periodicity, announced in the opening chapter of the *Doctrine de Saint-Simon*,[8] which distinguished between two societal types, organic and critical. The critical society, such as the one in which Saint-Simon found himself, was a conflict-ridden, aggressive, egotistical society of conquest. Conversely, the organic society (e.g., ancient Greece, medieval Europe) called on men to join in a common productive undertaking bolstered by love and obligation. "Love one another" stands at the head of Saint-Simon's *Système Industriel*. In a period propelled by a great religious idea, great art could not but follow. Conversely, since literature and the arts were timebound, a disorderly society propagated disorder in its passions, its society, and its art. In short, the Saint-Simonians hoped to initiate a new art inculcating ideals "from which the life of society seemed [then] so strangely to be heading away."[9]

When Saint-Simonian ideology was eventually applied to all phases of social life, Saint-Simon's original idea—that the artist as producer would occupy a secondary place in the hierarchy—was altered to insure him a position of primary influence in the moral and religious work of conversion. The relevant ideas are to be found in an official proclamation delivered by fiery Émile Barrault (1799–1869), former professor of rhetoric turned Enfantin's official orator-in-chief. Their far-flung repercussions on musical criticism in the middle third of the century can hardly be overestimated, not only in *Le Globe*, but also in the journals of literature and politics, and in the new musical weeklies.[10] Henri Blaze de Bury (1813–88), diplomat, poet, and music critic for the *Revue des deux mondes*, argued along the lines of critical-historical analysis in attacking Berlioz's "egotism." Berlioz dazzled his readers in the *Journal des débats* with his view of David's Desert Symphony, projecting Saint-Simon's notion of progress. The critic Paul Scudo (1806–64), in the *RDM*, blamed David's deficiencies on the Saint-Simonian mirage. And there is no mystery about the Saint-Simonian echoes in the musical commentaries of Heine, George Sand, Liszt, Joseph d'Ortigue, and others. Reviews which began with reference to contemporary social ills intensified as the revolutionary year of 1848 loomed, then passed and left even worse maladies in its wake.

Barrault's address *Aux artistes* of 1830 effectively revives the ideas of Jean-Jacques Rousseau's *Discours sur les sciences et les arts* (1750) to reverse the weight of history in order to bring man back into harmony with the inner springs of his nature. Voltaire, had he had the opportunity, would

have included Barrault among those enthusiasts of good faith, Christ at their head, with a weakness for publicity. Rousseau, Barrault, and Enfantin, all three, had the ability to awaken in their readers a kind of feeling which George Eliot once described, speaking of Rousseau, as "an electric thrill" through the intellectual and moral frame quite apart from views on life, religion, and government which might be "miserably erroneous."[11]

Foremost is the attack on the Enlightenment, its artificial forms and contrived language. Is it not strange, asks Barrault, that in the eighteenth century pure form should have taken precedence over the power of profound moral expression?[12] And is it not because of a want of proportion between society and the individual that meaningless display has afflicted the performing arts?[13]

Look to the hymn. In its sublime brevity, it is the résumé of a whole organic epoch. The epic, in its imposing unity and proportions, is its vast reflection.[14] Homer is to be extolled as a vast popularizer; Raphael, for his faithful rendering of the *feelings* of Catholicism. Pindar, rather than Horace, is to be praised for achieving in the ode "un caractère sociale."[15] The drift of Barrault's bird's-eye view is, of course, a manipulation of the literary and aesthetic heritage in order to be able to approve those artists of the past who exhibited responsibility to society, who were not lonely virtuosi but teachers committed to cognitive and moral functions. We may deduce, from David's models, that the musical heritage yielded similar choices.

When Rousseau is mentioned, he receives maximum emphasis. With his religious ideas, his sentimental concept of General Will, his myths and idyllic imagination, he was a genuine Saint-Simonian ancestor, valued for his shrewd estimate of his own period. Observing the coincidence of classical perfection and the moral and political decadence of his time, Rousseau pronounced anathema on both. In his "Lettre sur les spectacles," he found the simple civic festivals of Geneva the most touching of public pleasures—the most elevating, the most worthy of humanity. Was it for this, asks Barrault, that the "loving and affectionate" Rousseau was banished from his critical epoch, while Voltaire "gamboled" in the midst of its disorders?[16] Among the Romantics, only Mme. de Staël had known how to rehabilitate love and enthusiasm. No wonder. She was a woman![17] "Rehabilitate" is the key word. Like the Saint-Simonians, Germaine de Staël (1766–1817) responded to the emotional climate of Rousseau's ideas rather than to the ideas themselves. Love and enthusiasm, reveries in the arms of nature which "spoke to the soul," confidence in the fundamental worthiness of man—all answered to her romantic nature.

It is not to museums, continues our Saint-Simonian orator, that the

public should go in search of lively and salutary emotional experience. The most popular, hence the most powerful, artist of his time is the musician. He owes his ethical force not to the invention of harmony, of which the ancients knew nothing, but to music's very nature. In a time when exterior symbols for the sentimental needs of the human being were perishing, this vague, mysterious, and universally responsive language was the only viable language between men.[18]

It is, perhaps, to the musician in particular that Barrault dedicated his famous allegory on the artist's rise to the top of the social hierarchy. The artist is not an inferior being secondary to scientists and producers.

> No, in our eyes the artist is not . . . like an insect in the hand of a child, held back with a string that limits his flight. The artist is not the feeble bird who repeats in his cage the melodies that his master teaches him. But in his free flight he soars above the earth and, close to the sky, it is from there that he makes his voice heard, inspired and often prophetic. He redescends, not with thunder and lightning, but with a flame pure, pacific, sacred, capable of setting all hearts on fire. In a word, the artist alone, by the power of that sympathy which enables him to embrace both God and society, is fit to direct humanity.[19]

Once that "fallen angel," the artist, is cleansed of his "vague and confused" ideas (those, presumably, of Aristotle, Boileau, and Schlegel who are set aside at the beginning of the essay) he is free to embrace Saint-Simon. His new preoccupations are enumerated: "complete emancipation of women, the freeing of the laboring classes, disinherited by fortune, the amelioration of their lot, and the development of human activity in the triple direction of science, art, and industry under the invocation of a God aggrandized by the progress of humanity."[20]

In a second "sermon," music "with its special sonorous delights," becomes the art par excellence of the new prophecy. Here Barrault goes so far as to suggest that flexible, sensitive instrumental scoring (which David was to achieve) is the important source not only of music's "delights" but of the power of music to advance Saint-Simonian pantheism. He even names desert and ocean (David's future symphonic subjects) as viable regions awaiting a composer's descriptive pen.[21]

It can come as no surprise that in reversing an earlier philosophy of industrialism—man's conquest of nature—the Saint-Simonians should arrive at some kind of pantheism. This, as with all of Enfantin's forays into the inexpressible, required a way of stating his feeling for the contin-

uous flow of matter and spirit, the religious vehicle for a new balancing of nature and man. His rhetoric is often correspondingly opaque, but there is no doubt that he possessed a symbolic imagination. He acted on an intuition of the essential capacity of religious symbolism to induce people to play a wide range of social roles. Predictably, he ended by defining his pantheism as a "living politics."[22] Enclosed in this politics was a three-pronged ideological eroticism comprising a heightened feminism, a redemptive rehabilitation of the flesh, and a matricentric fantasy. These drives sustained a continuing search for La Mère, the mother on whose coming the final organization of the society of the future waited, and they reecho insistently through David's librettos.

Enfantin's Dionysian matriarchalism recalls J. J. Bachofen, whose *Das Mütterrecht*, when it appeared in 1861, was also widely caricatured. It has been noticed that Bachofen grew up so devoted to his mother that he did not marry until the age of fifty.[23] Enfantin did not marry at all, although he accumulated considerable notoriety on the score of the mistresses with whom he associated, not always successively. Enfantin's son Arthur, born out of wedlock; Félicien David, the favorite son; and others who survived the ill-fated utopian experiments, all received elaborate instruction on the happy and useful life under the banner of La Mère, whose image Enfantin projected as a symbol of an unconditional love embracing not only one's own children but all children and all human beings. This lofty philosophy transcended mere personal love and required that the faithful accept celibacy.

It is of interest to note that modern social psychologists have pointed to a sympathy between matricentric tendencies and socialist ideas, not only in the psychic basis of the Marxist social program but also in that of Max Weber, the great apostle of self-denial and social responsibility. A comparison suggests itself also with D. H. Lawrence who, like the Saint-Simonians, sought a work place remote from European civilization where woman as deepest source could act on men and make them good.[24] To make man good was, for Enfantin, to make him productive, so that the search for La Mère corresponds with a universal productive capacity of the economy.

Enfantin grappled with these ideas until the end. Their final summation is in two essays published in 1858 and 1861, respectively: "La science de l'homme" and "La vie eternelle." Typically, orderly method disappears under the pressure of powerful inspiration, and these religious pieces are, like his letters, heterogeneous, spur-of-the-moment notes which may be regarded as recollected monologues directed at his charges Charles Duveyrier[25] and Félicien David. Boxes in the Bibliothèque Na-

tionale are stuffed with his epistolary outpourings of love and ecstatic pantheism. Exactly here may be located Le Père's power over the community he called his *Famille*. Some of them died with paraphrases of "La vie eternelle" on their lips. When, on the point of death, David is said to have cried, "Enfantin summons me," he was not preparing his soul for its rise to a Christian heaven. All such events in his operas should be interpreted as allegories of the rich terrestrial experience that flows naturally and ethically between human beings. Enfantin had said, "I am in you, you are in me," an experience of virtue to be regenerated eternally in the world. His preoccupation with "moi" and "non moi" relates to the social evaluations which man would learn to make in the new world of Saint-Simon. "I walk toward God as I nourish myself from all of you who are not myself. Likewise, you walk toward God in nourishing yourselves from me. For we are in God, and our common life is in God."[26] Stripped of its metaphors, the message would seem to be that, since one is never separate from one's milieu, only to the extent that the individual is in collective life and plays his role according to capacity, is he in God, and God in him. This march toward God is the subject, in one way or another, of David's choruses. They are all hymns according to Barrault's definition, including those written for Enfantin's "Church," for larger concert works, and for various operatic situations.

The dead, seen in the light of *la vie immortelle*—eternal survival in the living collective, had no need of burial rites. Enfantin and several of his adepts called for civil obsequies, invoking Enfantin's wonderful phrase "Les morts n'ont d'autre tomb que le vivant (The dead have no other tomb than the living)." It remains a question whether Enfantin's mystique benefitted the urgencies of French social life, but unquestionably it inspired a remarkable song, David's "Le jour des morts," to Alphonse Lamartine's Enfantinean words:

> A wind from the tomb also blows away the living.
> They fall then by the thousand,
> just an an eagle drops his old feathers in flight,
> only to grow new plumage at winter's approach.[27]

Buried in this overview of a spirit gone with its age is a sense, as in Barrault's long passage on Rousseau, of the need to develop in the artist the rich, harmonious personality which would enable his works to militate against a dissociated contemporary life—a widespread and extremely influential view at that time.[28] The notion that art, understood in the sa-

cred sense, was to "accompany, anticipate, and incite mankind ceaselessly in its march to a more and more beautiful destiny, sometimes with harmonious music, at others with a rough and strict voice,"[29] was important enough to prompt from David an acknowledgment of instruction received. In a letter to Le Père from Lyons in 1833, written en route to the Near East, we see him promising to write rough music for the workers and sweet songs for La Femme.[30] Rough songs are, however, scarce in David's output. This came partly from temperamental lassitude and a personal preference for the musical environment of bland surfaces. Partly it may also have been a conscious adjustment to later Saint-Simonian theory, according to which the workers were no longer, if they ever had been, an active force. Instead they were subsumed within a poor and numerous class greatly in need of amelioration and always including women. Succor was to come from above, from a benevolent, pacific, instructing middle class.

A small association of intellectuals remained together under the banner of Saint-Simonism until well beyond the middle of the century, but theirs were the fraternal and humanitarian-philanthropic ties that still bound them to Enfantin's secular church. In David's case this lifelong relationship put him fully at the service of Enfantin's plans as if in an actual Saint-Simonian state. Enfantin conferred upon himself the power, through his understanding of the general good, to direct the individual's work into productive channels. "You are harmony itself," he told David in a long letter designed not only to instruct but to increase David's productivity by offering security in the psychological sense. For insecurity is one of the persistent ills of the dissociated system. Enfantin became for David a savior. His early letters testify to the state of emotional anxiety with which he came to the Saint-Simonians. The stability offered by them as part of their ethic was for him a personal life-line up from the depths of an unrelieved obscurity and abandonment. Enfantin made no secret of the sign of God on his forehead. As he himself said with customary lack of modesty, "a smile from your father shall exercise on you the same power that there is in all the joys of humanity taken together."[31] Since the musician was known, on the best of aesthetic authority, to command ready access to man's responsive emotional nature, it followed that the composer himself was constantly to be stimulated to the necessary pitch of religious feeling. This was the challenging task that Enfantin assigned to his youthful musical conscript. A critical look at David's works will show how well he rose to the occasion.

3

From the Provinces to Paris

*F*ÉLICIEN DAVID was born on 13 April 1810 at Cadenet in the Vaucluse. His middle name, César, like others in the region that echo in the classical genealogy (Auguste, Brutus), has the ring of Roman ancestors among the colonizing legionaries in the Provence of 2,000 years ago. The family has been traced to Aix-en-Provence in the early seventeenth century.[1] Félicien's father, Charles Nicolas David, was the son of a goldsmith. He married Marie Anne Françoise Arquier, twenty years his junior and herself the daughter of an agent of the Corporation of Goldsmiths of Aix. Although Félicien showed no interest in taking up his father's profession, he enjoyed from earliest childhood singing to his father's violin accompaniments. His brother Charles, with whom he was to share lodgings when they both went to seek their fortunes in Paris, did engage in a profession related to his father's, that of painting miniatures. The Calvet museum in Avignon has several examples of his work.[2]

Charles David had amassed a considerable fortune at San Domingos in Guinea which he had to abandon while escaping from a disruptive revolt of the blacks in that region. He reestablished himself in Marseilles, then at Cadenet, where his young wife died soon after giving birth to Félicien. Charles himself died in 1815, leaving four small children of whom Félicien was the youngest. At seven and a half years of age Félicien's clear, penetrating voice and exceptional intonation caught the attention of a neighbor, a former oboe player in the Paris Opéra, and relatives in Aix were persuaded to enter him as a choirboy at the cathedral of Saint-Sauveur. There, like the Baroque master André Campra before him, he learned reading, writing, a little Latin, and solfège. According to his early biographers, David's sight-singing was phenomenal.[3] In seven years

of study, he read all the available scores of Haydn, Mozart, and Cherubini. As his biographer Alexis Azevedo tells us, David pursued a method of self-instruction reminiscent of the young Mozart.[4] He learned his own part by heart, and then listened attentively one by one to the others, writing everything down later and paraphrasing what he could not remember exactly. He did not learn to sight-read at the piano until much later in Paris, although he had little access to the expensive scores he needed. His piano music and accompaniments, while they indicate an ear attentive to the singing tone of the instrument, seldom invite comparison with the new virtuoso claims being staked out in the musical capital. His forte was improvisation.

By the time David's voice changed, he had already taught himself to play the violin well enough to be able to compose a respectable string quartet and, when he entered the Jesuit college at Aix, to serve as first violinist in its orchestra.[5] He obtained his certificate in rhetoric in four years — just in time, as it happened, for in 1828 all the establishments of the Society of Jesus were closed by government order. At eighteen David could probably sing Gregorian chant in whatever way was acceptable to provincial French churches at the time. Knowledge of plainsong was then at a low level; indeed, it was not even taught. Where organs existed in the provinces there was nobody to play them, certainly not with what an old-fashioned musician would consider the necessary erudition. A contemporary pamphlet published at Aix cites among the vanished skills that of improvising preludes "beginning in one key and ending in a distant one; improvising from a bass in parts; and composing fugues using different effects of register."[6]

At the Jesuit college, nobody supervised David's musical endeavors. He adapted liturgical words to operatic music for local use, and no more was required. But the Jesuits did have a library where he could go on studying the religious works of Haydn, Mozart, and Cherubini, which he adored and memorized. The reverend fathers did not permit copying, and all of David's biographers testify to his remarkable memory for scores.

On the strength of having held first chair in his school orchestra, he was able to gain the post of assistant conductor for the vaudevilles of the Aix theater. His singers had little notion of rhythm, intonation, or "habitable" keys, according to Azevedo, and this career yielded in short order to a trial law-clerkship which had even fewer advantages. At this juncture, one of David's former teachers, the saintly M. Sylvestre, was offered the preceptorship at Saint-Sauveur in Aix, and he proposed his pupil for the post instead. David later returned the favor when he departed for Paris.

The years 1828–30 at Saint-Sauveur were happy ones for the young composer. The six motets which he wrote for performance there are respectable pieces. The last, "O Salutaris Hostia," the only one without organ accompaniment, provided the point of departure for his mature men's choruses, so much admired later on in Paris. After hearing the young composer's work, an uncle was persuaded to offer the monthly 50 francs that were to sustain David in Paris for a time. Meanwhile, David's friend Sylvain Saint-Étienne had been urging him to write nocturnes for amateurs in Aix. "Night's mantle enfolds the countryside" is a sample text. It was but a short step from this to the Paris of nocturnes and romances, the stuff of all salon music of the day. Barcarolle, boléro, tarantelle, valse, mélodie, duo—these were to form the backbone of his operatic numbers.

It was no small thing to leave the provinces for Paris in the spring of 1830. In a matter of months, an old fear of the Catholic philosopher Joseph de Maistre (1753–1821) was to be fulfilled: "All Europe is gripped by revolution, the force of which we have seen only the fearful beginnings."[7] A Saint-Simonian sketch of musical Paris in this critical period would have shown Luigi Cherubini and Daniel-François Auber in command at the important institutions. The public was flocking to performances at the opera of Auber's *La Muette de Portici, Dieu et la Bayadère*, and *Fra Diavolo*; at the concert halls for Berlioz' *Symphonie Fantastique*, as well as a few favorite works of Haydn, Mozart, Beethoven, Weber, Méhul and Rossini; and at the theater for Victor Hugo's *Cromwell* and *Hernani*. In society gossip of the day, the fluctuating fortunes of Rossini and Meyerbeer were of the most absorbing interest.

Enter Félicien David, aged twenty, armed with an introduction to the king's Superintendent of Music. He obtained an interview with the formidable Cherubini, who first reduced him to tears, and then put him to lessons with a conservatory underling.[8] David gravitated toward the composer-theorist Napoléon-Henri Reber (1807–80), who must have had a taste for the simplicity of the old *opéra-comique* as well as for the modern orchestration of Berlioz and Meyerbeer.[9] Having outgrown the usual age for beginning piano lessons, David practiced that instrument by himself and studied organ regularly with François Benoist, a formidable improviser himself. With Reber he undertook private harmony lessons, following the advanced system of Beethoven's friend Antonin Reicha. On the evidence of the elegant instrumental counter melodies in his operatic songs, David's counterpoint lessons with François-Joseph Fétis (1784–1871) may have been an important gain from this single year at the conservatory. But he seems to have remembered the course only as "the making of fugues, perforce."

His earliest impressions of "this lovely city" and the effect of its musical scene on his own aspirations may be gleaned from the first letters to his close friend in Aix, Sylvain Saint-Étienne.[10] Public concerts were impossibly expensive. He had not heard Paganini, but he was more than repaid by the superb concerts at the conservatory. With the very first letter came an all-important statement of faith.

> Ah, my friend, you have no idea of the beauty, the ideal beauty, especially when they play Beethoven. No more sublime composition exists than the Choral Symphony. It is a poem which sings of the grandeur and goodness of eternity. Indeed, the most beautiful music has always been inspired by this sublime aim. One of my friends took me to the opera the other evening to hear Weber's *Euryanthe*. It is a beautiful work, very new; but it should be heard, and more than once: the choruses especially are remarkable.[11]

The friend is the painter Pol Justus, and the message indicates that a fateful step had already been taken toward the Saint-Simonian composite of the good and the beautiful, with its ethical implications of a higher pleasure deriving from the joining of aesthetic enjoyment and ultimate human concern. The transmission of Saint-Simonian feeling is noticeably more important at this time than an account of the impression on David's sensitive ear and musical understanding of what had occurred in Beethoven's Ninth Symphony. As a symbol of the "grandeur and goodness of eternity," this response to the symphony recalls a remark of the Russian anarchist Bakunin a quarter of a century later to the effect that everything will pass, and the world will perish, but the Ninth Symphony will remain. The appeal of this music to the socialist mind continues in the present century. For example, the contemporary philosopher Theodor Adorno's reverence for Beethoven is also "a good deal clearer than the grounds on which it rests." A common judgment, however, exists in that the Saint-Simonians discerned, as Adorno did in the present century, "an ultimate social morality" in aesthetic quality.[12]

David's single-sentence presentation of the nature of *Euryanthe* is especially interesting because half of it, concerning the chorus, bears on a genuine feeling of Weber's that David was to share, the feeling for nature and country folk. The other half, that the work was very new, goes without saying, for Weber exacted a promise from his librettist that it should by all means be so.[13] David is identifying with a brilliant romantic, but the intense and lasting attraction is to Weber's mood pictures and visual

effects, not to the musical style as such. David was to share with all of his contemporaries a fondness for harmonies of the diminished seventh. But there are few instances in his work of a technique of chromatic harmony such as Weber displayed in *Euryanthe*.

Meanwhile, David's earthly misery "strikes the imagination dead." Although he was beginning to design an *opéra-comique*, he had not a *sou*, since payments from the uncle had ceased.[14] Although his health had generally been good, the miserable winters and the infections of a poor-man's Paris would soon take their toll. He was lucky enough to find a few pupils for solfège, harmony, and piano, and with one of these young ladies he fell in love. Azevedo describes him at this time as "dreamy, wondering, timid, and more than a little confused." He had more than a little to worry about. One letter to Saint-Étienne describes his intense relief over exemption from the seven-year draft. He arranged a celebratory concert at his lodgings on the Rue Mazarin. His friend Justus sang and was acknowledged a genius in music as well as painting. In connection with the draft, another significant note indicates that his attraction to Saint-Simonian ideas was already strong early in 1831. At mid-April he was telling his lifelong friend Saint-Étienne that not only would military service have amounted to "a veritable burial" so far as his career was concerned, but it would have been a moral outrage. To God he owed his "good fortune."[15] Now he could take some giant steps forward. He spoke also of completing one act of an opera. The music is now lost, but some of it may have been reused in the later *Fermier de Franconville*, which exudes nostalgia for the native countryside and its church—"Oh! how happy then were our hearts! Voices praising God in church, birds singing in the springtime, knowing true bliss, always loving, always beholding the birth of spring, and joined together always."[16] Typically, the farmer from Franconville carries his Rousseauesque simplicity to the big city in search of his heart's desire, only to discover that the ideally pure love perishes in the crowd, and he returns to his solitary garden where "nothing can trouble his voice."

Coincidentally, the young composer speaks of having written a few reveries for piano which have been received well by his friends. The lovely pieces called "Reveries" in the *Brises d'Orient* published later on may have had their origin here. David's diffidence at this time is such that although he was dreaming of London and Rome, he did not apply for the Prix de Rome. He feared an almost certain failure on account of the machinations of the controlling musical clique, and he feared even more the blow to his fragile self-esteem. An added worry was the falling off of pupils. He pressed his friend to contact his sister and brother-in-law in Peyrolles-en-Provence on the matter of a family inheritance.

Unless my luck improves, I shall be naked as a rat at the morgue. For some reason my mind has been rather sterile lately, perhaps because of my dogged practicing of the piano. I'm working at some piano pieces. They are not sonatas: the term is too old. You understand I am a romantic. That's what everybody tells me, even my teachers. Just between us, it's true. I've little patience with theory. I'd love to be romantic like Beethoven and Weber, that is to say, new, original like them. There is my romanticism. I hope this will not detract from my severe principles. You would be amazed to see my chin dark with a black beard. It is the secret sign of the romantics, or rather of those who intend to be so. [17]

David began to frequent the Saint-Simonian lectures in the Rue Monsigny. He discovered that he belonged to a class unable to actualize their mental and moral potentialities in the world as it was, but he hoped for help of a practical nature from introductions to artists influential at the Institut de France—Ingres and Pradier no less. Pradier, the famous sculptor, promised to present him to Auber—and David hoped the latter would give him advice on instrumentation. Should I please him, adds David naively, he could send me far, for, as you know, he is "in vogue."

Nevertheless, it is clear that deep as he was in fugues for Fétis, "perforce," and in currying favor with establishment figures, he was also beginning to absorb the high-flying phrases of social romanticism. "I am not romantic like Rossini and Auber," he told his friend. "God preserve me from this music frequently denuded of harmony and artistry."[18] Daniel-François Auber (1782–1871), whose protégé he was to become much later, was, like his partner, the poet and librettist Eugène Scribe (1791–1861), anything but a voyager in the romantic heights of an ideal world. In *Le Globe* of the 1830s which a young man like David would not be reading, Auber appeared much as he did later in Heinrich Heine's more graphic portrayals in *Lutèce*:

They [Auber and Scribe] have the most refined possible ideas about topical matters. They know how to amuse us agreeably and sometimes even to enchant and dazzle us with the luminous facets of their wit. Both of them possess a certain talent for knitting, by means of which they connect together the tiniest bagatelles. They are the unscrupulous hucksters of art. With a smile they erase from our memory the nightmares of the past, the stories of ghosts that oppress the heart, and with their coquettish caresses they remove from our brows, as if with a light brush of peacock feathers, all buzzing thoughts of the future. [19]

Thus, in August 1831, David spoke of having seen Auber's *Le Philtre* (The Love Potion), which he judged "a feeble work with a few pretty passages outweighed by sloth for the rest. Nobody [here] wants music that you have to hear more than once to understand. Beethoven, Weber, Cherubini are ovelooked in Paris: there is room only for current favorites. Weber's *Euryanthe* is even more beautiful than *Freischütz*. But, on the contrary, what a furor over the Italians!"[20]

4

Music as Social Message

\mathcal{I}T HAS BEEN CLAIMED that Félicien David's entire musical impulse proceeded from religious feeling, and to this the composer owed "the elevation of his style, the poetry of his inspirations, the mysterious profundity of his charming melodies. If the wind of the utopias had not moved the dreamer, he would have continued Palestrina."[1] This somewhat overgenerous statement reflects the respect with which David's professional critics approached his work. The die had been cast shortly after his twenty-first birthday. He joined Enfantin's movement at its height. The interlaced aims of his life and art — fidelity to the Saint-Simonian religion and allegiance to its pantheistic aspirations — were enunciated and espoused. The cult had found the "natural" musical romantic it was looking for.

Enfantin's propaganda plans rested on a hierarchal order corresponding to the groups that were to be proselytized: first the intellectuals, then the women and people. The program was to provide elegant dinners for the cultural elite; sociable suppers after the public lectures; and Sunday gatherings at Enfantin's country estate at Ménilmontant, and so on to Rousseauesque merrymaking in the boulevards.

Meetings in the Salle Taitbout were attended by many of Paris' leading intellectuals, most of them drawn to Saint-Simonian ideas without being moved to membership in the "temple." Discussions focussed on liberal institutions, constitutional government, inheritance, financial inequities, and technology. Social questions about the place of women, marriage and divorce, education, and the New Christianity were also raised. Vital portions of the final version of the doctrine of the founder, Count Claude de Saint-Simon, were studied and interpreted.

Receptions followed in the Rue Monsigny. An enthusiastic account of one of them, held in the winter of 1830–31, recognizes our "charmant compositeur" among the celebrities. Also in attendance are Émile Souvestre, the romantic moralist, and Raymond Bonheur, father of the celebrated artist Rosa. Sainte-Beuve never missed a Thursday. Franz Liszt abandons himself to fantasy at the piano. Berlioz listens, and the opera star Adolphe Nourrit is surrounded by admiring ladies. Conversation flows. After a formal dinner there is waltzing. The impression is of an elegant diplomatic assembly floating on a cloud of expansive fraternity. Young Louis Blanc, future revolutionary socialist, finds the germ of his slogans here—fraternity, the idea of association, the natural, just order.

> Everything contributed toward making the active Saint-Simonian propaganda irresistible. The family established in the Rue Monsigny was like a noisy home which had the double virtue of radiance and attraction. The doctrine was developed there to sounds of festivity and under the inspiring eyes of women. Abandoning their occupations, their dreams of fortune, their childhood affections, engineers, artists, doctors, lawyers, poets flocked with their most precious possessions and generous hopes. Some brought their books, others their furniture and funds. Meals were communal. They were trying on the cult of fraternity.[2]

And Suzanne Voilquin, who was to carry her double role of Saint-Simonian Florence Nightingale and apostle of the moral rights of women to Egypt, later recorded her own excitement as she hurled herself "into this social renovation with the security and joy of a convalescent who, throughout a beautiful spring day, sings with the thousand voices of nature: hosanna! glory unto God!"[3] In the days of the retreat, she was to report that, very often on returning from a visit to Le Père, a group of the faithful would have a frugal dinner together, then spend the evening dancing to a couple of violins played by ladies. Real family parties she called them. Then they "roamed the boulevards . . . singing together the beautiful songs of Ménilmontant."[4]

Intricate, authoritative explorations of the social and economic foundations of the politics and the political theology of the doctrine were the primary concern of Enfantin and his high priests. Inevitably, however, there were ideological conflicts and crises behind the scenes among the elders. The gifted young acolytes were welcomed on clouds of romantic optimism, far from the poverty and the desperate efforts at self-help that had

been damaging their health and spirits. David's case was perhaps the most dramatic of all, especially with respect to the doctrinal hierarchy of capacity that was being finalized at the time of his identification with the movement. His yearning for a harmony of practicality and beauty was uniquely satisfied in the unification of music with the daily politics of the new religion. Class distinctions among the Saint-Simonians existed only in terms of the "capacities," and Enfantin had himself endowed that of the artist with aristocratic preeminence. For David, the distressed and perplexed provincial orphan, the basic explanation sufficed. His new society was committed to situating each person according to his true capacity. As a result of this situation, certain services were expected of the chosen individual. Elements of the faith furnished moral directives to the participating members of the social structure. The religious doctrines were both protective and stimulating to individual activity. To the banker who approached him, Enfantin spoke of the moral power of money to regenerate the world and unite Occident and Orient in a saintly communion. The musician, destined by the very nature of his activity for accomplishments no less extraordinary, received a place among those "at the head of society." This was obviously preferable to an anonymous place in Fétis' counterpoint class at the Conservatory.

Many of Enfantin's adepts recoiled from the absolute rule implied in his "consultations," but David fell easily into the arms of his new confessor and judge. To him he entrusted his misery, his identity crisis, and his sexual fantasies. Enfantin was a singularly handsome young man (see Figure 2). Unlike Saint-Simon, with his Roman nose, pointed chin, and Mephistophelean ears, his physiognomy was not easily subject to caricature. His portraits disclose a benign expression, a florid complexion, and hair waving fashionably from a medium forehead. Only his piercing blue eyes account for the magnetic look with which he attempted (unsuccessfully) to shame the prosecutor of the famous trial in August 1832. His conversations must have moved, like his writing, in crescendos and ellipses of excitement. Above all, as Erik Erikson has remarked of the young Mahatma Gandhi, he was a magnetic leader to his followers at a particular stage of their personal lives. Followers in such a time, place, and circumstance, according to Erikson, are characterized by the fact of having found the unique man among their contemporaries at a crucial moment in their lives as well as in history—and of having been selected by him.[5]

The French government had tolerated the exceptional activity in the Rue Monsigny for three years, but suddenly, in January 1832, the meeting place was closed. Le Globe was suspended for lack of funds, and the

movement went into what has been described as its last agony. Unaccus-
tomed as Enfantin was to operating, like the Buddha, under a simple bul-
bul tree, his plans continued to enclose high ceremony, resplendent cos-
tumes, and ritual music. A small band of forty, including our composer,
regrouped in what amounted to a religious investiture. They retired to the
large property at Ménilmontant that Enfantin had inherited when his
mother died of cholera. The plan was to lead a communal, celibate, mo-
nastic existence as the nucleus of a universal family preparing to undertake
an apostolate to the world. On Sundays they conducted public ceremonies
according to Félicien David's order of the day. In a setting reminiscent of
the radiant city palaces of the forest utopias, these observances, held out-
doors in a long avenue lined with linden trees, attracted enormous
crowds.[6] Many came as to a Sunday circus, but Suzanne Voilquin recol-
lected the opening of the "temple" at Ménilmontant on the first of July
1832 with a special ear for "the music of our songs, composed by young
David," which the crowd acknowledged as the work of "a great artist, a
master of his art."[7] David's comrades, like their mentors, did not express
themselves modestly. But if he did not rise like a fiery phoenix from a year
at the conservatory to world renown, he did show in his first *Hymn to
Saint-Simon,* written as a member of the Saint-Simonian family and signed
"apostle," how far above the level of school exercises his faith and act of
participation had carried him. The small score with piano accompaniment
(25 pages) has the diversity of a genuine oratorio form as well as the tone
of sentimental dignity that was to characterize David's choruses through-
out his career. Harmonic procedures which pay homage to the romantic
composers he admired and a careful declamation of Raymond Bonheur's
rhetorical obeissances to the spirit of the master's "living law" (*loi vivante*)
also point to a presentation style higher than that of the redundant refrains
in which he was to set his more popular hymns for the retreat.[8]

The habit designed by Bonheur evoked the splendors of a past em-
bellished by the romantic imagination. It had a Turkish look, like the col-
orful dress of the Bensalemitans in the *New Atlantis*. Maxime du Camp de-
scribed it in his *Souvenirs*: "The trousers were white, the waistcoat red, and
the tunic blue-violet. White is the color of love, red that of work, blue-
violet that of faith. The name of each member was inscribed on his chest.
On Enfantin's chest was written 'the father,' on Duveyrier's 'Charles, poet
of God.'"[9]

Enfantin had orders for everything, and for the above his order read,
"all will wear their name across the chest, a sign of personal distinction, a
pledge of conduct, and a guarantee of morality." The waistcoat, buttoned

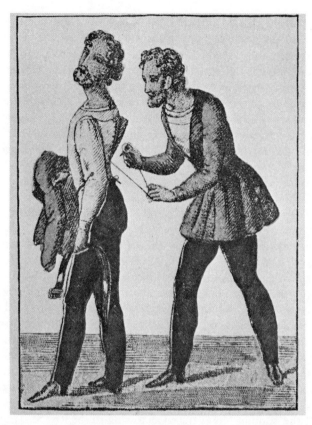

Figure 3. "La toilette du Saint-Simonien." From Henry-René
D'Allemagne, *Les Saint-Simoniens, 1827–1837.* Paris, Librairie
Gründ, 1930.

in the back, was always to be donned with the assistance of a brother, as a
symbol of fraternity (see Figure 3). In Bonheur's portrait of David in
Saint-Simonian costume, there is on the chest only a *D* with vertical lines
indicating the strings of the symbolic lyre he carries in the portrait (see
Frontispiece).

For David, Ménilmontant was the most important experience of his
life. If it was no small thing to jump from the provinces to the excited,
idealistic atmosphere of 1830s Paris; still more, then, to invent the litur-
gical style of a new religion and to become the Saint Ambrose, Saint

Gregory, Palestrina and Luther of the Saint-Simonian chorale (Azevedo) were experiences passionate and romantic in the extreme. His knack of writing simply and clearly, his unbounded loyalty and patience, made him an ideal ally for Enfantin and his proselytizing poets. While they carried their overcharged imaginations elsewhere, he turned his hand to the strict moralizing purpose. He invited ditties in familiar eight-line stanzas with refrain which he set syllabically—Calvinistically, one might say. They avoid taxing the untutored singer. Many of them are written in four parts, note against note, with piano accompaniment. The highest voice sings a tune simple enough to be remembered on one hearing. The brief, plain phrases neatly enclose the sense and fall quickly to the tonic. Azevedo's mixed metaphor (Saint Ambrose to Luther) was to ring through accounts of David's career until as late as the memoir appended to Blaze de Bury's appreciation of a revival of *Pearl of Brazil* in 1883.[10] And it was said there and elsewhere that with the assistance of his coreligionist Tajan-Rogé, David was able to teach the liturgy to his ensemble of fraternal mathematicians, engineers, and economists, none of whom had ever learned to read music. One of these, the engineer Auguste Chevalier, left behind at the time of exodus a notation on his functions at Ménilmontant. From it we learn that the fine, worthy Rogé heard him singing David's *Greeting to the Father* by ear while working in the garden and assured him that he could become a good choir singer. He taught him enough in a half hour to insure eligibility for the part. "If I can thus contribute to social regeneration and make you happy," says the good adept, "I accept with pleasure." He also learns to play fanfares on the trumpet in a month's time. "If the wand of Moses traced a crossing to the Red Sea, my trumpet has dulled the point of the sword, and women have passed by smiling." What is the utility of this kind of education, he asks and answers unerringly, "sympathy for the workers which will ameliorate their lot." Sadly he reflects on the loneliness of life on the outside. Most of all he regrets the necessity to leave off the long hair, the beard, and the Saint-Simonian cap for the hat of the employable engineer. Alas, "a Saint-Simonian without beard, hair, tunic, and white vest opening in the back is a [pitiful] sight."[11]

Meanwhile, David at his piano, seized on his mission with all the ardor of a starved soul. He improvised music endlessly to spur the brothers to their tasks, to rest them, to comfort them in sickness, and to accompany their lessons. The titles of his hymns refer to the routines to which they attach themselves. For example, the "Address to the Public" in the first collection of pieces published by David (1833) acknowledges authorship of the words by the stoneworker Bergier as a token of regard for the

class "most laborious and pacific." The words offer homage as well to women, who with the laboring people are the slaves of existing society ("Women, Arise!").

The experiences of daily life at Ménilmontant were David's principal inspiration. The inauguration of the temple, the death of a comrade, the sermons (Barrault's harangues, in particular) invoked musical preludes, thematic choruses and instrumental pieces. David was the composer and conductor of everything. His music even aided in the dramatization of an astronomy lesson ("Dance of the Stars") conducted by the able mathematician Charles Lambert, the Saint-Simonian who later founded a polytechnical school in Cairo. In this instance David invited himself into the lesson, well instructed as he was by this time in the educational task. Far from embarrassment at the childishness of the acting out, David's scientists and professors were persuaded to derive enormous satisfaction from the exercise. [12]

It is not for nothing that David came to feel that the experiences of the temple and his employment in the proceedings of the cult had given him the presentiment of a new music. [13] The knowledge presaged an enduring trust that David was carefully to explain to his correspondent in Aix on the return from the enchanted voyage to the East.

> You have no idea of the new life that Saint-Simonism has given me . . . of the spaciousness of this religion, of the new and grandiose inspirations to be drawn from it by the artist. I have never doubted the future of my religion. The ways may change, and the times, but these do nothing to diminish my faith. Perhaps you thought that this title of Saint-Simonian would be damaging. In that case [know that] I still carry the sign. You will see me with the beard and the long hair. Otherwise I dress *en bourgeois*, but I shall never hide my opinions if I am asked. [14]

Enfantin took great pride in this achievement of the movement, in taking those who came to it—the insecure, the lonely, the personalities susceptible to authoritarian discipline—and giving them a kind of family within which they could remake themselves, replacing the rootlessness of the past with the camaraderie and the apocalyptic hope of a new existence. It gave them a genuine identity as Frenchmen and human beings that transcended old bonds, understandings, and personal ties, and it put in their place an ideal of human brotherhood which endangered and, in fact, precluded such attachments.

Piteous declarations issued from the ranks on the score of the celi-

bacy which Enfantin imposed on everybody but himself. The love for La Mère who was to share the Saint-Simonian godhead and absorb the erotic energies of the apostles was the worst of the trials which David confessed to his Saint-Simonian father. At the height of his temptations and confusions before departure to the Orient, a heartfelt cry went out to Enfantin in prison. Not surprisingly, it is accompanied by a report of acute colic.

> I am overcome with burning desire. I thirst for love. When shall I be allowed to quench it? She whom I left behind in Paris was not worthy of an apostle. I shall not drink from her cup. Oh! how I need to draw from you patience and calm. How often have you been the pacifier of the grave riots that arose in me. I've thought of you and only you, and consciousness returned.[15]

Finally, memories of the useful occupations and sublimations of Ménilmontant settle his mind, and he assures his mentor that

> At the same time that I give to the workers rough and spirited songs, I shall sing something sweet, full of desire and longing for the woman. Through music she will know your devotion, your love. I will tell her that you call her, you wait for her, that she must hurry, for you suffer, Father, and the more you love, the more you suffer![16]

Since the trail of the Mother is to occupy us through most of David's oratorios, operas and odes, it is worth pointing out that the peculiar relations of love that Enfantin inflicted on David were accepted by a considerable number of the brilliant but disturbed young people who joined the inner circle in the early years. One of these was Henri Fournel, Saint-Simonian high priest of technology, who gave up the management of the great Creusot works to respond to Enfantin's cajolery. His wife, Cécile, while tormented by her ardent love for her husband, nevertheless separated from him because of the obligation to celibacy. Referring to the elusive Mother, she wrote as follows: "I am chagrined not to know where to find this woman whom he lacks and whom we all lack, for if I knew where she is, I would go in search of her, barefoot if necessary, as far as China, in order to stop all this suffering and to see the birth of this Eve so beautiful who is promised to us."[17]

Frank Manuel has come as close as an explorer in Saint-Simonian lore can to an insight into what was, apparently, experimentation on Enfantin's part with techniques for the cure of souls.[18] On the one hand he

hoped to develop character through a strong attachment of love to his own person. On the other, and through his person, he seemed to be offering to both men and women the love—physical and spiritual—of a second mother, a moral mother. To his own mother he wrote:

> Now the mother of whom I speak is not the mother by birth but a mother by adoption, a mother who through moral direction has the power of giving birth not once but forever, for her words and her caresses give life. This mother can love and allow herself to be loved without fear, because her love saves the child who suffers and calms the one who is distraught.[19]

Manuel has suggested that Saint-Simonian emphasis on the smallest social unit helped to develop sympathies and love for larger groups, thus isolating further the dread anarchic individualism of contemporary society. Gradually the theoretical Mother merged with the dream of the railroads, which Enfantin came close to realizing in his lifetime. To paraphrase the caustic Heinrich Heine, Enfantin hoped that the female Messiah would make her blessed entrance not on an ass, as before, but in a steam locomotive. More than most, Heine had luxuriated in the Saint-Simonian notion of an artistic priesthood, but in time, he, like other members of the free-thinking intelligentsia who had begun by admiring Enfantin, ended by abandoning this high priest of an operatic, not to say ambiguous, industrial pantheism.

In reading accounts which preceded the closing of Ménilmontant and the imprisonment of Le Père (among the cited felonies were offenses against public morals), one is struck by his persistent effort to fix the jury with his attractive eye. His lack of success was complete, for he could not enforce in the bourgeois world what he managed in the world of his own creation. The typical juror was the bourgeois of Stendhal's *Lucien Leuwen*, the banker whose son threatens to run off and become a Saint-Simonian if his wishes are not acceded to.[20] Inevitably, gaining a few disturbed youngsters went along with losing some of his best activists. Michel Chevalier, who shared a seven-and-a-half month prison term with Enfantin, returned to Second Empire society as its official economist and prominent senator. Nevertheless, he remained a sterling example of Enfantin's New Man, the self-active, interpersonally related human being with perfectly regulated capacity for work and human brotherhood.

More susceptible to the affective components of the Saint-Simonian scheme, young Félicien David kept his place in Enfantin's opaque fantasy world. Entirely comfortable with its erotic-therapeutic symbolism, he

moved securely into his next assignment, the giving of himself to others according to his capacity, with no greater reward than praise or blame from his Father. Paris having denied Enfantin's group a new home, David and his "brothers" set out to plant their ideals elsewhere. In Egypt, Suzanne Voilquin was to have charge of exciting women to demand moral equality, an education extensive enough to free their aptitudes, and "a retribution sufficient to maintain the dignity of their independence." David's liberating goal was, judging from his future actions, by means of his improvisations, to attract attention to his group in the most agreeable way. In the religious sense this was an assignment directed toward liberating the human being by rejoicing him, and this was, fortuitously, the message of the choral movement of Beethoven's Ninth Symphony.[21]

5

Exotic Voyage

\mathcal{C} NOUGH OF GREECE and Rome: Th'exhausted store of either nation now can charm no more." So wrote the laureate William Whitehead in his prologue to Arthur Murphy's *The Orphan of China* (1759).[1] The ubiquities of neoclassicism had already begun to pall, and the early romantics were casting about for new worlds to conquer. With colonial expansion, the regular voyages of the East India companies, and the China trade, eighteenth-century Europeans were increasingly aware of the Far East. Chinoiserie in various shapes and forms had become high fashion. In England, Chinese Chippendale furniture flourished; and in 1815 the architect John Nash designed the Brighton Pavilion, an oriental extravaganza, as a pleasure palace for the Prince Regent.

Interest in the Near East awakened with Napoleon's 1798 campaigns in Egypt and Palestine. Accompanying him were a phalanx of scientists, writers, artists, and archeologists. They returned with statuary, sculptural fragments, sketches of the pyramids, drawings of the desert, tall tales and descriptions, all of which opened up a new and exciting world to the European public. Hitherto only classical scholars who had read Herodotus and Strabo, and a few intrepid travelers had any real knowledge of ancient Egypt. New books and journal articles began to flow from the printing presses. Readers were transported backward in time to a world that had been ancient even in the days of the foundation of the Roman Empire.

Now the public could read Baron Denon's first-hand descriptions in *Voyage in Lower and Upper Egypt*, illustrated with his beautiful drawings and watercolors. Edme Jomard's twenty-four volume *Description of Egypt* was issued in installments between 1809 and 1813. Through parts re-

43

leased in the popular press, the Parisian public became aware of things never seen before. The discovery of the Rosetta stone and subsequent deciphering of the mysterious hieroglyphics further whetted the popular appetite. In 1826 Chateaubriand came out with a widely read *Itinerary from Paris to Jerusalem*, containing chapters on Constantinople and Alexandria. Victor Hugo's collection of poems *Les Orientales* appeared three years later. Delacroix's on-location sketches and his painting *Algerian Women in Their Harem* were exhibited in 1834. And some years later Ingres's great female fleshscape, *Turkish Bath*, begun in 1852, added still more fuel to the imaginative fires.

Near Eastern themes began to permeate all aspects of modish life. There were wall papers with Egyptian motifs, chairs with arms in the shape of sphinxes, and ladies of fashion received their guests while wearing varicolored turbans and flowing exotic robes, languishing like odalisques on Turkish divans. There were operas set in Cairo, Baghdad, even China. Vienna, being the closest capital city to the Near East, had actually been threatened with Turkish conquest. After things settled down, Janizaries acquired a reputation for their dashing demeanor and feats of derring-do. Mozart and Beethoven inserted movements *alla turca* in several large-scale works. Mozart set his opera *Die Entführung* in a seraglio, and Rossini, for his part, brought forth both *The Italian in Algiers* (1813) and *The Turk in Italy* (1814). However, beyond a few rhythmic and melodic conventions, plots, scenery, and costumes, such works presented no authentic oriental material and no specific local-color connotations. By David's time the moment was ripe for materials closer to the source— music that brought more vivid images of Egypt, Palestine and the Sahara into the drawing rooms and theaters of Paris. Thanks to a specific mission of his coreligionists, he was to experience for himself the strange wonders of the East.

The occasion was provided when the zealot Émile Barrault organized an expedition to Egypt in search of the female messiah. His group of twenty-four Saint-Simonians made up four divisions. The largest convened in Lyons, another in the Midi, a third continued the mission exclusively among the proletariat in Paris. The fourth, Barrault's "Company of Women" destined for Constantinople, set sail from Marseilles in March 1833. It was the day of the equinox, which Barrault pronounced a sign of the equality of day and night, just as it was a symbol of the equality of men and women. The small band, destined to become smaller still, included Félicien David, his friend Pol Justus, the engineer, Félix Tourneux the sculptor, Alric the writer, Granal, and the physician Cognat. It was not until October that Enfantin, on release from prison, was able to travel

to Alexandria for a reunion with all those who had been called to the East. Among the most dedicated were Dominique Tajan-Rogé, former choir director at Ménilmontant; Suzanne Voilquin, who wished to study the role of women in Egyptian society and to offer moral instruction to Egyptian children; and the former Parisian proselytizer Reboul.

According to the many Enfantin messages that followed them, they were to salute the tomb of Byron on the way to Rome, Constantinople, and Jerusalem. They began their exhortations and requests for aid in Lyons, of all French cities the most prone to enthusiastic idealism. Here an admirer presented David with a portable piano of five and a half octaves, specially constructed to resist the effects of high temperatures and the jarring effects of transit. Protected with a seaworthy case, it followed David everywhere. On land it went, together with David, by donkey.

The Catholic city of Avignon, less prone to enthusiasm than Lyons, detained the group only briefly. Marseilles offered a tumultuous welcome, and on 22 March 1833, the advance group were ready to sail for Constantinople, the hoped-for city of light. Clorinde, Tajan-Rogé's beautiful wife, who rivalled Barrault in intense expression of her dedication to the Saint-Simonian religion and its recognition of female equality, gave her name to the brig. A very young Giuseppe Garibaldi happened to be its second mate.[2]

Constantinople proved to be the first of their disasters. The sultan took fright with one look at them, and after four days in jail, they were put to sea with a small supply of olives and onions. Without surprise they faced the trial by ordeal they had been led to expect in an Orient of joy and suffering. David commemorated the beauty of Smyrna in a limpid piano piece, originally improvised on the balcony of the lodgings that he shared with Barrault, Alric, and Granal during the three months spent in that enchanting city. David's famous melancholy and picturesque style was born and flowered here in the improvisations later to be gathered together for the collection he called *Breezes from the East* (*Brises d'Orient*). To the natives, the formulas of David's Western vocabulary were irrestible exoticisms. But in Paris, where Hugo's *Orientales* had caused a great flapping of romantic wings, David's imitations of Near Eastern singing and playing went unnoticed.

At the moment of leaving Smyrna, Barrault sent back another *Appeal to Artists*. It arrived in France just as Rogé and his Parisian contingent, discouraged by their inability to command funds for teachers, instruments, and meeting places, proceeded to Lyons. Rogé and David had been maintaining sharply differentiated Saint-Simonian assignments. Rogé's orders were to organize and stimulate the faithful to make appro-

priate music. (The people, Michelet once said, will write their own books.) David, as official composer, served the wider aims of the new religion. According to the reassurance that has become commonplace in communist countries—that an appetite for fine arts is inherent in human nature—he was to find his place in a cultural vanguard dedicated to an aesthetic fulfillment of humanity no less lofty than that proposed by Plato and Aristotle. David, moreover, held his high position of composer-prophet of the new morality by appointment from Enfantin himself, the man whom no less a personage than Heinrich Heine was to designate "the most considerable thinker of our time."

Rogé seems very early to have singled out his own capacity for organization. With the Saint-Simonians, his task was to round up the populace (an entity addressed always as "women and people"), and to bombard it with propaganda festivals and spectacles. He came to the movement more hesitantly than David, but once transformed in religion, he applied an experience gained earlier in various orchestras, notably as a founding member of Habeneck's *Societé des Concerts du Conservatoire*.[3] A little further down in the utilitarian hierarchy, a third figure comes to light. Known as Jules Vinçard, by trade an optician and by Saint-Simonian calling a working-class musician, he, with several others, wrote ditties for the popular singing planned in the weeks before the demise of Ménilmontant. It was a remarkably successful propaganda effort. Paris literally rang with Saint-Simonian jingles. One of the exploits was to distribute a chorus in the parterre and galleries of a popular vaudeville theatre like the *Panorama dramatique* where, at each interlude, the lead man would intone a song answered enthusiastically by the mob to wild applause.[4]

Thus, while David improvised under a mosquito netting on his balcony in Smyrna, bombarded with flowers by his appreciative audience below, Rogé introduced the proletariat of Paris to the doctrine with singing and band playing. Rogé succeeded in assembling twenty-four players at one point. None had notable proficiency, and the results would have daunted a lesser spirit. The ensemble included three clarinets, three keyed trumpets, two piston trumpets, four ordinary trumpets, a piccolo, four horns, three trombones, and a drum, not to mention a chorus of sixty, twenty-three of them women.[5] Three festivals took place in various Parisian music halls and they were said to have made a great impression. However, the corps of musicians that was to have accompanied the advance guard to Egypt (in Saint-Simonian language "an industrial battalion marching joyously under the inspiration of a vigorous and spirited music") never got off the ground.[6] A march, "á l'Orient," by David's friend Henri Reber, which had been designed to accompany this gallant battalion, was

presented to Le Père, and the piece finally had a performance by a large or-
chestra at the Salle Molière to the acclamations of the entire audience.[7]

Reboul, whose memoir will occupy us below, finally led a second
group of eight out of Marseilles. Rogé, the level-headed organizer, was
forced to remain behind to take care of delayed passports and funds. Later,
he was able to rejoin Barrault's group in Egypt. Meanwhile, Barrault, Da-
vid, and Granal continued on to Jaffa. Here legend has it that David ef-
fected with his music the cure of a child sick with fever. Jerusalem was the
next goal, and Ramla presented itself as a convenient stopping place.
They were fortunate enough to be received well at first by the Franciscan
fathers in their twelfth-century Spanish Hospice.[8] But soon the good fa-
thers, like the sultan in Constantinople, took fright and banished their
visitors to the outdoors for their bread and water. Bad enough was the sus-
picion that they might be Jews; even worse was the feeling that their odd
costumes and behavior suggested out-and-out heretics. It should be re-
membered that Enfantin's missives from prison followed his children with
detailed instructions on propaganda, songs, costume, and strict adherence
to discipline in every circumstance. As he wrote:

> Sing often David's three songs. Put new words to them according to
> circumstance. This will be easy for our poet. Avoid dining alone.
> Sing before and after each meal. Drink to the glory of the Father and
> the coming of the Mother. Dinner is an excellent means of commun-
> ion with the workers. Repeat to all and make them repeat the Saint-
> Simonian Credo.[9]

Whether workers or fathers, all were subjected to Barrault's constant and
curious monologue. Only Enfantin, when he finally appeared on the
scene, had the effect of silencing him briefly. And what were the Francis-
cans to make of a message reconciling faith and technology, Orient and
Occident, spirit and the flesh, and solemn marriages between other cate-
gories hitherto embattled and antagonistic like science and industry, and
theory and practice? What, indeed, were they to make of that vividly por-
trayed horizon, that peaceful future in universal association, when liber-
ated womanhood would appear to them, meditating in some remote
harem on her apostolate? Even in Paris, the capital of social romanticism,
this Saint-Simonian symbol of the sacerdotal couple, one member of
which was to be sought at the ends of the earth, drew ridicule. In a favor-
ite newspaper caricature, La Mère was depicted as a monkey in a bonnet
clutching an alarmed Enfantin with the caption "the liberated woman has

Figure 4. "La Femme-Libre. Elle est trouvée!" From the satirical journal, *La Charge*; in Henry-René D'Allemagne, *Les Saint-Simoniens, 1827–1837*. Paris, Librairie Gründ, 1930.

been found!" (Figure 4). She was, of course, not to be found, although she was awaited in a good deal of bad poetry and prose.[10] Finally she was enshrined in the music of Félicien David, where in various guises she was to sing according to prescription something soft, full of desire and longing.

Barrault demanded complete acceptance of the prophecy, which accounted for the departure of all but two proselytes from the first group. There can be no question that, to an extent unprecedented in French music, a composer had been caught up in a phenomenon already well known in the literary currents of the nineteenth century—an orientalism new in that it also related to questions posed by the socialists. In David's case the prophecy, unconditionally accepted as required, merged with an ecstatic response to the beauty of the desert terrain. With Barrault at his side, he was subjected in advance to a barrage of verbal impressions typical of his leader's published documents. On the one hand, he was directed to hear the shuddering harmonies of the plains; on the other hand, the agitations of the simoun, the marvelous warbling of night birds in the depths of the groves, the strident cries of the hyena, the roar of the wild beasts in the desert. As usual, this intense atmosphere floated above the more realistic problems of daily life.

His prison term over, Enfantin hastened to join his wanderers in Alexandria in order to consider at close range problems which long-distance messages had failed to solve. Barrault arrived for the second time in that city, together with David, Granal, and Alric, who had been sightseeing on his own in Cyprus. According to Reboul's narrative, the group now numbered fourteen.[11] They had almost no means of support; famine seemed likely, and everything pointed to an individual dispersal—and soon. "Le Père received us at table," wrote Reboul, "and we celebrated his arrival and deliverance from prison with a musical soirée, to which he permitted us to invite a few friends from the city."[12]

Enfantin was grave and reserved. He had been informed on the resolution to disband; on Barrault's abdication of authority over the "company of women"; on the need for each to assume responsibility for his own actions according to the extent of his aptitudes. But their obedience to Enfantin's slightest wish was to continue as an expression of devotion which was the natural consequence of his superior kindness and wisdom. Hence, nothing had changed. If discipline had been relaxed, the charisma of the leader, the power from which all the goodness was supposed to come, continued unabated. Still, a few sensible comments on human fallibility do emerge in Reboul's memoir. If their goal was the happiness of oriental peoples, one had to consider that the constituent elements of the happi-

ness of one people have often enough no affinity at all with those of other people. In short, without knowing a society well enough to share its conscience, Reboul wonders "how does one dare address oneself to its emotions without the risk of bringing trouble while wishing to bring peace?"[13]

Clearly, Reboul, the former businessman turned adverturer-philosopher, stood at some distance from Barrault's messianic fantasies. Like those more realistic industrial types, Michel Chevalier and Henri Fournel, he saw the oriental-erotic fantasy as an imaginative spur to the transmission of the rational content of Enfantin's plans, so plainly based on the assumption that the Orient was predestined for great industrial-humanitarian undertakings. Barrault's original group, those in whom he had at first been able to encourage blind confidence that a paradise of universal satisfaction awaited the faithful, had already dispersed. Some, like Gustave d'Eichthal, surrendered to pressure from their families to return to normal life at home. The threat of cholera drove others in different directions. Reboul's comments may have originated in a sorting out, on Enfantin's part, of the deeper factors contributing to their internal and external failures. At the highest level of meaning, fraternity, like happiness, is a Utopian ideal. Activating it within an unfamiliar part of the world was bound to threaten existing values of intimacy. Moreover, oriental societies infused with centuries-old concepts of revealed truth were unlikely to respond quickly to new ideas. Nor was economic growth, the essential pragmatic panacea urged by the Saint-Simonians, likely to move communities preoccupied with eternity. The conclusion is inescapable that the Saint-Simonians were not wrong in assuming that the ecstatic atmosphere in which the little band had been living, the atmosphere which David communicated successfully through his improvised open-air music, would create an opening wedge to a ragged people accustomed to voicing their personal prayers in a melange of street sound with occasional shouts in unison: Allah is great! Allah is life! This perception was to govern both the form and content of David's Desert Symphony, more than a decade in the future. For the present, Reboul verbalized it in his memoir:

> [What of] the masses on whom habit exerts such a powerful influence, and for whom edifying examples practiced incessantly over long periods of time are the only lessons understood? In order to act on a society in a salutary manner, one must love and be loved in return. It takes time to feel, to take part in the nature of their affections, to enter into all the details of their public and private existence. Time, unremitting zeal, and naturalization are indispensable

to such projects, as is nourishing in oneself a calm and patient courage fed by an ardent desire for amelioration, but adaptable to the organizing tendencies of the people among whom one lives.[14]

The last sentence bares the essential problem—the bridge from evangelism to direct dealing in matters of communal modernization. To build the bridge would take—after love—time, patience, and understanding.

The next foray, which Reboul went so far as to call an "incursion" into Cairo, was accomplished in November. Spirits raised, costumes still intact, David was among those who left for Egypt. On board ship they lived like Arab fellahs, "with all the happy privileges of poverty," including the comforting effects of David's hymns.[15] Sung at daybreak and sundown, like muezzin's prayers, they made the arduous journey from the Bosphorus to Egypt bearable. These gay, harmonious and poetic religious songs,[16] so different from the "monotonous and dour Christian prayer that the harsh voices of the crew delivered with impassive faces,"[17] were, like their costumes, "poetic reminders" (official *Le Globe* language) of one's superiority to those Europeans, "captive in their close-fitting dress, who were still encased in the leveling symbols of a false equality."[18]

Reboul records the excitement of the approach to Cairo, as first the incredible pyramids came into view, and then the shining minarets and pretty masts waving in the Nile breezes, all of which David later remembered in his *Christopher Columbus* music. A reunion with friends takes place in a large Arab café at the waterfront.[19] There was native music to be heard in such places, and it could not have escaped David's attentive ear. The contemporary testimony of Alexandre Christianowitsch that Turkish influence had long since obliterated the dreamy melody that was to his mind the principal charm of traditional Arabian music may be exaggerated.[20] Thirty years earlier David must have been listening to a mixture of the classical and popular music that can still be heard there in the cafés, flowering with throat trills and scales, played and sung in unison or heterophonically, sometimes dreamy, sometimes nasal and monotonous. Drawings supplied by Christianowitsch of instruments in use are, according to Professor Malm, still played in areas of Islamic influence.[21] Christianowitsch groups the bowed and plucked Kemangeh (Iranian kemanja) or spiked fiddle; the rebab (rabab) or short-necked lute; the Turkish Quanon (kanun) or zither with 72 strings plucked by small picks attached to the index fingers; the bendeyr (bendair) or tambourine which, together with the drumming derbouka (darabukka), David imitated in his dance music; the gunibry (genibri), another Near Eastern popular two-stringed lute, flutes identified as djouwak and gsbah (gasba) with five or six finger-

holes, played slanted slightly sideways and capable of the short, breathy melodies that David also imitated, as well as a square-shaped tambourine called deff (duff) and the tobilets (paired drums) and the dznoutsch (finger cymbals). A variety of such instruments in combinations applied to unison melodies are still to be heard in the cafés and they may have suggested the characteristic traceries of David's later orchestrations, notably that of *Christopher Columbus*. The doubling of melodies at the fourth, fifth, or octave, along with pedal points became characteristic of David's style.

It was with great relief that Reboul's party settled down in Cairo. Europeans there seemed simpler, more given to plain dealing, more accessible, less constrained by the hierarchy of social condition which the Saint-Simonians condemned. A person neither rich nor well known to the milieu he wished to enter—the predicament of the Saint-Simonian in Alexandria—had no means of gainful employment there. The stranded newcomers eventually found jobs as language teachers, doctors, engineers, architects, bookkeepers, artists and musicians. French and German teachers had been engaged since 1825 in teaching at the newly established music schools, and there were army and navy bands formed on European models. [22]

On the other hand, this was not the Orient that Enfantin thought he heard from his faraway prison, an Orient crying for reform. [23] It was not crying out for a radical change in social relations, much less for the moral equality of women. Félicien David was among the first to find out. The young music professor thought best to turn down the viceroy's offer of employment in his harem, since the proposed method of instruction involved transmission at second hand through a number of eunuchs. [24] He was undoubtedly much happier listening to the popular songs and dances in the cafés, possibly one source for the tunes in the Egyptian pieces in his *Breezes From the East*.

Voilquin, taking her appointment to study the women of the country literally, not only obtained entry to the harems, but she began her operation by organizing the household of an elderly resident French doctor sympathetic to Saint-Simonian ideas. Reciprocally, she served as moral tutor to the children, and they made an amusing game of teaching her the Arab language. She was admitted also to the music lessons taught by two sheiks. Pupil and professor shared a rug on the ground; the pupil sang and accompanied herself on "a sort of guitar called the *gusla*, placed flat on her knees. This song was sweet and melancholy; I understood none of the words . . . yet I was moved, for it spoke of intimate sorrows, of a distant land, and heartbreak." [25] If these experiences were communicated to David, they may account for Zora's charming waltz, with guitar accompani-

ment by Naouna in *The Pearl of Brazil*. Indeed, they may also account for the tone of Lalla-Roukh's future lamentations.

In his personal life, David was never happier than at Cairo. Voilquin reports that she found him, "our sweet nightingale of Ménilmontant," living with his companions Lamy and Marechal "amicably like brothers." A comely young black woman served her master affectionately, and he, on his side, "was far from treating her as a slave."[26] Reboul, for his part, assessed the situation more primly: "They have a harem there, so I abstain from entering."

The strange beauty of the city gave them all enormous pleasure. For David it must have activated memories of the brilliant sun and the soft night air of his native Provence. He would retain nostalgic impressions, so faithfully recorded by Voilquin,[27] of the narrow streets where the beaten earth suited the feet of the camels and barefoot Arabs so well, and of the overhanging upper stories of the houses shading the lanes and offering a cool respite. David, like Voilquin, later noted the tableau of female costume so bizarre and unexpected that it astonished and charmed at once. To this impression he was to couple a rare remark about language and music among these diverse populations. "Their language, now rude and gutteral, now soft and harmonious, and their simple and original songs of which I have carried away a great number . . . [and] arranged for the piano and for military music . . . I propose to bring them out all at the same time."[28]

Voilquin speaks of a request from the Pasha for a royal birthday cantata to be improvised by her friends. In the end, the celebration did not take place, for cholera descended on the joyous city. In the normal course of events the outcome of such an epidemic would have horrified the Saint-Simonians, unaccustomed to the spectacle of hired public mourners.

> Already on every side could be heard the loud wailing of the public mourners. This funeral industry is quite odd to observe. The artists of the genre take turns. To their high-pitched cries they add the most pathetic demonstrations. Seated around the corpse, they cover their heads with ashes, tear at their clothes, dramatizing the colloquies that they address to the dead, ending in a simulation of the most dishevelled despair.[29]

Like George Sand, the Saint-Simonians preached that illness, whether mental or physical, had social causes; that death was to be observed not with frenetic public lamentation but with the thought that cholera, afflicting as it did many more poor people than rich, would dis-

appear once the living law ruled the earth. The death of the individual had for its monument the virtuous society of the future. Its music was also in the future, in the dreamy lullaby of the bereaved Indian mother in Part IV (*The New World*) of David's *Christopher Columbus*. Voilquin herself, working as a nurse during the epidemic in Cairo, recovered from an attack of the disease, a cure she did not hesitate to attribute to Enfantin's "prayer of the heart." At all times, such prayers were coupled, for good measure, with utilitarian advice responding to the social cause; for example, Egypt could not become prosperous until her chiefs understood that peace and productivity alone make a people great and homogeneous no matter how diverse they may be ethnically or economically. David's "Stroll by the Nile" was possibly in memory of just such a promenade as Voilquin describes, taken on the arm of Le Père in Cairo during which, like Socrates, he encouraged questions and tendered answers.

> Thank you, my good daughter for listening; but your arrival coincides with two big facts, the apparition of the plague and the cessation of that work in which we had hoped to employ all the lively forces of our diverse natures.
>
> Father, do you mean that we must pitch our tent elsewhere, on the banks of the Red Sea, perhaps the dam?
>
> You touch there on an immense question, much more grave seen at close range than imagined or studied from afar. But let us not become fatalistic. God will explain himself in what comes to pass.[30]

The immense question was, of course, the Suez Canal. On his boat in Alexandria harbor, Enfantin had encouraged his company of women in their symbolic adventure, but his own preoccupation was the account brought to him by the ambassadors he had instructed to interview the viceroy on the subject of the canal. As he listened to David's improvisations on the piano, he made up his mind to intervene personally in the matter, and he undertook the trip to Cairo. Enfantin was to pursue his dream at Suez and in Syria until 1836. By that time, enough doors had closed on him to indicate that the moment to return to France had come. His compulsion to fertilize his excellent ideas with the fevered address of a Messiah did nothing but harm to his plans and to the fine work of his engineers. In spite of his intervention at this time, work on the Suez Canal was not to begin for another thirty years. Enfantin can, however, be credited with a preparatory role. When de Lesseps finally received the contract, he made little mention of the Saint-Simonians, their dreams, or their pioneering engineering work. As man and Saint-Simonian, Enfantin

proved capable of putting the task before personal rewards. The takeover mattered only insofar as it meant achieving the canal project as promptly as possible.

Similarly, the defection of Michel Chevalier was to be the worst of his disappointments, but he was able to persuade himself that the rupture was a step necessary to a rapprochement with the French government. Indeed, Chevalier carried his Saint-Simonian social ideology with him when he became successively legal counsel to the state, a senator, professor at the Collège de France, and member of the Academy. So far as the oriental venture was concerned, Enfantin and his disciples could point to significant projects accomplished. They had built military orchestras, a polytechnical school, an agricultural institute and hospitals. They had influenced veterinary medicine and the moral education of the young; and above all they had championed the idea of the Suez Canal as a means of linking the Occidental and Oriental worlds.

David was among the first to leave Cairo on the long and trying journey home, which started in February 1835. Enfantin extended his own stay in order to concentrate on the main goal, the vital medium for a productivity that would take care of all humanity. Evidently David was considered to be responsible now for his own acts in the world at large. He was to continue in his own way to preach peace, love, and concord through music and musical activities in Paris, as the capital of the world.

After forty days overland and by sea and a period of quarantine in Livorno, Italy, he started for Marseilles. The letter written on board ship on May 11th to his old friend Saint-Étienne in Aix-en-Provence begins bravely, "I return to France to sing of the east."[31] He is awaited in Paris by the poet Charles Duveyrier, his former companion and music director at Ménilmontant. Together, David and Duveyrier must have been instructed to do something new.[32] The account stops there. We know that Duveyrier was already gaining popularity in music hall and light-opera circles. David's struggle was just beginning. He made it quite clear to his friend in Aix that extending his stay in Egypt would only have inhibited his professional career. For all its beauties, Egypt was in a state of infancy with respect to art. As for the Khedive Mohammed Ali, he was too busy with material interests to think of such things. A lucrative post had been offered, but it was not worth David's time. One is reminded of Ingres's response to an early effort to interest him and his students in the Saint-Simonian mission to Egypt. What use, he is reported to have replied, there is no Rubens there.

Although he escaped contagion, the plague precipitated David's departure. One of his friends had died of the cholera, and since some of Da-

vid's effects were housed in his quarters, they had to be abandoned. His beloved piano, which had received "all the emotions of my travels," also remained behind. In late June David was in Marseilles, recuperating and acquiring a new wardrobe. He was to reenter Paris in middle-class garb.

The sojourn in Marseilles is not without interest in other respects. David's indoctrination had not been interrupted. He comments on a performance of Bellini's *Norma*. The music is very feeble, he says. It is still in Rossinian style or, when liberated, frightfully boring. Long before he left Paris, David had had every opportunity to read in *Le Globe* such reviews as the following of Rossini's *Tancredi*:

> This week Warsaw fell. Parliament sank deeper into its lethargy. The people in the streets grew paler with hunger as they grew more excited with noble sympathies. Civil war menaces in the public square, and armed men kill defenseless people. But here at the Italian opera, they sing and they weep tenderly for the sorrows of Tancredi. When it's over, one hurries into one's carriage, stumbling over the dead, the wounded and the starving. And yet, even the critic cannot help enjoying Rossini's youthful, egotistical preoccupations, poisoned as they are by memories of a multitude of human beings who have no bread. Evidently one's enjoyment is individual, but one's regrets are for society.[33]

Bellini's *bel canto* efflorations, so much admired in the twentieth century, and forged, by the composer's own account, according to an ideal of passionate expression, were seen by the Saint-Simonians as mere difficulties, playthings to be overcome; the real truth had yet to be discovered. Félicien David had arrived in France to sing of the East. Meanwhile, he waited patiently in Marseilles. There he had a perceptive ear for his "travel impressions of a new kind, derived at the source." He worked with his friend from Lyons, Theodore de Seynes, on a song entitled *Stroll by the Nile*. "The refrain of the boatmen is a very pretty Arab song. I believe that it will have a great success because it has an original conception." De Seynes had been inspired by David's oriental narratives. He understood that the orient "out there" was quite different than that which "they were fashioning here."[34]

6

Breezes from the East

O N HIS RETURN from the Near East in 1835 Félicien David faced anew the problem of establishing a foothold in French musical life, not helped in the task by a characteristic personal reticence. Count Gobineau's forecast for returning adventurers applied aptly to his situation: "When you come back, you will most likely be given a job in what, in modern phraseology, is imposingly described as 'practical life,' by which is signified the manifold commonplaces, follies and meannesses of our present-day existence."[1]

David's letters from Paris to Aix paint a picture of the artist as a young man of his time, an innocent dreamer, different from his neighbors on the Ile Saint-Louis only in that he believed fervently in the Saint-Simonian vision that Enfantin had planted in his mind.

During the winter of 1836 he visited several salons. Predictably, he found the atmosphere "bien égoïste." The challenge of the marketplace is problematical in any age, but David realized that presenting his new *Mélodies Orientales* to Louis Philippe's Paris posed particular problems. It was the better part of wisdom to admit that this society was not likely to offer him the exalted position which the Saint-Simonians had envisaged. His unusually pliant and dependent nature, coupled with favorite-son status where Enfantin was concerned, had done little to prepare him for Count Gobineau's "follies and meannesses." He was temperamentally unfit for a successful Paris career, and ill luck dogged his footsteps from the first. That he felt himself too idealistic for his public goes without saying. Only his brothers in the movement still represented love and security. With their help, he engraved his piano pieces at his own expense. A fire destroyed the plates and what remained of his edition. It was not until

1845, following on a more successful foray into musical exoticism, that he obtained a second French printing and a German one by Schott of Mainz. The first scheme projected seven parts. The reissue, entitled *Brises d'Orient* (Breezes from the East), had only six of these and the seventh book became *Les Minarets*—three oriental fantasies for the piano. The following, excerpted from the publisher's prospectus, is worth citing for the light that it sheds on the state of mid-19th century musical orientalism.

> The people, half barbaric, who swarm in the Levant, have no other music than their national tunes sung at the unison. They have no conception of *Harmony*. The title *Mélodies* pays homage to their primitive and unknown authors and [is] a means of modestly hiding from the public the labor of *Harmony* that it has been necessary to add in order to render this uncultivated music agreeable to our European ears.[2]

This national outcry, as Brancour reads it,[3] was David's acknowledged inspiration; for, as he had said previously, the real Orient was quite different from that which they were imagining in Paris at second hand. With a taste and balance which became a conspicuous mark of his style, the pieces with Egyptian titles and references do with discreet harmonies invoke antiphonal Arab unisons, drones, and the repetitious rhythms of tambourines and pot drum. Clearly, David hoped that his process would neither violate the original nor disturb the conventions of European perspective. In fact, it was bound to do both.

But the residue of oriental reflections still arrests our attention, as it did that of Georges Favre when he grouped David with the virtuoso composers Chrétien Urhan and Charles-Valentin Alkan as the pioneers of the "unexplored limits of Romanticism."[4] Perhaps David was unwise to advertise the exoticism of his melodies to a newly liberated bourgeois public for whom the piano and its preferred repertory had become full partner in social prestige with that other flourishing industry, the grand opera. Indeed, operatic "gems" were the basis for medleys, galops, polkas and fantasies without end. David offered no gems. He did try to shape forms and proportions of his salon pieces after the idealists whose traces appear throughout the collection: Beethoven, Weber, Schubert, Mendelssohn, Schumann and Chopin. Had David been living in Germany, he might well have been among the lesser young composers rated by Schumann as worthwhile because of their attention to the expressive as well as to the technical possibilities of the piano. The belief that the romantic artist was a progressive who set out to enrich the existing tradition would certainly

have qualified the young French composer as a romantic by Schumann's definition.[5]

Most of David's pieces were first improvised on the console piano of his itinerant desert days. The eventual printed versions would seem to have been intended for the new Érard instrument described by one reviewer as "the most beautiful piano formula in existence: a low register like the contrabass, a middle like the violoncello and a top like wind instruments. It can vie with the orchestra, yet it has an easy, even touch and is used by Hummel, Moscheles, Pixis, Bertini, Liszt, Thalberg, etc."[6] David was not unprepared to accept some of the contemporary fashions of piano music—ballroom and ballet dances, drawing room fantasies, fleeting "musical moments"—but he rigorously excluded the ubiquitous transcriptions and potpourris being manufactured and put before teachers and pupils by the Thalbergs and Herzes of their generation.

The opening piece, *Une promenade sur le Nil* (Stroll Along the Nile), composed in Cairo, directly introduces the promised exotic style. A banal ascending chromatic flourish labelled *Départ* rushes upward over a static announcement of the tarabouka beat. The material of the first part, labelled "the oarsmen," is set out in D major in three equal statements, call and response fashion, with supporting harmony cadencing on open fifths (see Musical Example No. 1). The first section ends on a more insistent version of the tarabouka beat, introducing appropriate change of key. The attractive Arab air moves in basic harmonies over drumming in fifths and octaves.[7] After modest modulation, both the solo drumming and a shortened version of the oarsmen material return, this time in E minor. A curtailed statement of the Arab air (E major) follows, with a coda echoing away over the receding drum. The illusion of distance is suggested by a relaxation of the beat from ♩ ♫ ♩ ♫♫♩ to ♩♫♫ ♫♩ | ♩ 𝄾 | ♩ 𝄾. The sum total of David's exotic stock-in-trade is contained here in microcosm. It lacks only the orchestra with which he hoped some day to impress his brothers. Lacking also is an element in the local expression of such a scene rarely admitted by this gentle composer. With or without orchestra, with or without voices, a temperamental constraint excludes from David's music the raucous animation easily conveyed by Suzanne Voilquin in a verbal description of such a water festival on the Nile.

> Each of these barques has its instrumentalist who, his tarabouk (small conical drum) under the arm, sings while accompanying himself with this instrument. Noise serves them in lieu of harmony. But, as each artist pays no attention whatever to what his neighbor is

Musical Example No. 1. "Une promenade sur le Nil" (*Brises d'Orient*, Book I).

doing, the result is a remarkable confusion of songs in a frightful ca-
cophony from which the Arabs derive unrestrained pleasure. [Fi-
nally] a large number of them on shore throw themselves in the
water and swim with the agility of fish, uttering great cries of joy
around the barques, an appropriate ending to this strange concert.[8]

Smyrna, second of the *Breezes*, captures in two pages the very per-
fume of that charming city. Its graceful manner harks back to Beethoven's
short piano piece *Für Elise*. Indeed, transitions between parts are frankly
Beethovenian in rhythm, harmony and dynamics.

The *Danse orientale* composed in Cairo juxtaposes ideas in separate
oriental (minor tonality) and occidental (major) frames, the first portray-
ing an elegant, voluptuous Egyptian dance, the *almée* and its sensual mim-
ing; the second, a parody of European country-dance style. The *Fantasia
Harabi*, although its tune may well be Egyptian, more immediately sug-
gests an elaborate Schubertian Ländler-waltz with contrasting sections and
choices of harmony. In the brief, binary-form *Prayer*, composed in
Alexandria and dedicated to B[arrault?], David quotes Schubert's *Lorelei*
melody quite explicitly, then digresses into Schumannesque turns of
phrase.

The *Egyptian Girl*, composed in Cairo and dedicated to C[ognat?],
the doctor in the Cairo group, is in its first part a slow waltz in $3/8$ meter.
Substantial length and brilliant piano writing suggest the model of a We-
ber concert waltz, especially in the endings of both parts. An *Air Arabe*,
played staccato at the beginning, preserves the native convoluted motion
within the narrow ambitus of a perfect fifth. As usual, pedal fifths figure
prominently in the accompaniment, but the first section ends rather unex-
pectedly with a quotation from the first bars of Schumann's *Papillons*.
What then follows could be taken for the simple, robust dance of any
people—the type Mozart called contredanse: a rustic waltz with oom-
pah-pah accompaniment.

As the collection progresses, David seems to be feeling out his audi-
ence. Not only was Paris music-mad, but pianists comprised one of the
most numerous classes of society, as a Saint-Simonian-minded critic
observed in *La France musicale*. The brilliant German virtuoso Sigismund
Thalberg (1812–71) conquered Paris in 1836. He, like David and
Chopin, was a quiet, modest young man, but the public demanded a dis-
play of fantastic technique already in the possession of a new breed of pre-
cocious Liszts with whom the self-taught David could hardly compete.
Musical salons of the '30s and '40s rattled with such cascading arpeggios,

chromatic scales, interlocking octaves, and assorted double-notes as to make virtuosi of the Revolution and the Empire tremble.

> [Thalberg] can sustain tone in such a way as almost to change the nature of the instrument. A Saint-Simonian critic would say that Thalberg organizes the piano. With one hand he often plays two to three accompanying parts, each with distinct character and followed in all its developments, the ear never losing the principal melody under the elegant enveloping decoration. And this melody has a power that seems in its fullness to belong to wind instruments. His left hand is as formidable as his right. It sings and accompanies at once. . . . As Rossini said of one of [Thalberg's] performances of a grand fantasy, "Is there no way of arranging that for two hands?"[9]

Earlier players such as Steinbelt, Dussek and Clementi, opines this critic, had inferior pianos, but they knew how to impassion the public with effects short of contortion. Thalberg answered to both the old demands and the new. Gifted with a prodigious memory, he was capable of playing all five acts of Meyerbeer's *Robert le diable*, recitative and all, complete with all possible pianistic sleight-of-hand, while at the same time maintaining a charming simplicity in his bearing. Neither a Liszt nor a Thalberg, fish nor fowl, Félicien David was completely ignored by the virtuosity-crazed public.

With the piano piece called "Harem," David marks the beginning of his long struggle to consolidate a crossover from his elite cult-audience into the marketplace. With a smaller, more refined stock-in-trade, he parrots some of the devices Beethoven used in his *Fantasy*, Opus 77. Composed in Constantinople, "Harem" is not so much insistently oriental as it is an attempt to organize a fantasy around allusions to Arab melodic and rhythmic material. A spirited introduction and two lyrical themes (minor tonality) allude to sensual *almée* dancing. A brief *allegretto* passage in 6/8 meter maintains the tonic-dominant harmony which preceded but reduces the rhythm to a tonic drum beat (the turn of melody here suggests Mendelssohn). The purpose, as in the twelfth variation (in major) of Beethoven's *Thirty-two Variations in C minor*, is to effect a shift to the major, but here a few of the introductory measures from the first section move *furioso*, in double chromatic octaves, down to a sustained dominant-seventh chord of C minor. The final page seems to cast a wistful glance toward the opening of Beethoven's final piano Sonata, Opus 111 in C minor.

The second section builds on material from the first, cast now in C major, enriched with various virtuoso flurries. But by the end the home

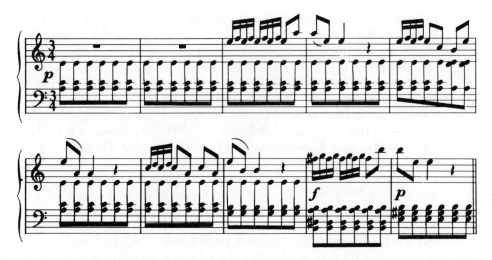

Musical Example No. 2. "L'Almée" (*Brises d'Orient*, Book V).

key is regained. David is known to have been working hard at improving his piano playing, and this ambitious piece carries more than one sign of the presence of Beethoven's more expansive later works on his rack, side by side with examples of the pianistic language of the more recent masters.

Filles d'Egypte (Egyptian Maids), probably the most oriental-sounding piece in the collection, offers many of the attractive accentual patterns that would become common in the exotic ballets of his contemporaries. Another, *A une Smyrniote*, on the other hand, captures the graceful movement of Smyrna's beautiful girls without recourse to oriental allusions. It has the style, in fact, of a conventional drawing-room piece. The songful *Rêverie* confines its orientalism to a few shakes of the tambourine; its overall effect, however, is unabashedly Schubertian, almost to the point of parody.

In *L'Almée* of Book V (see Musical Example No. 2), the apprentice composer is seen to be practicing his pattern with ease and conviction. The piece is a prototype of the Parisian exotic ballet. Despite an initial obscurity, it must have supplied a model to innumerable composers of opera, mid-century and later. Berlioz, for his only concession to popular operatic taste—the "Danse des almées" in *Les Troyens*, may well have been among them. David's dance is all the more delightful for purporting to originate in his Egyptian experience. As in ballet, the introduction spells

a typical entrance in short steps with turns on points. A descending scale leading to the cadential bow is pointedly occidental, and the expected turn to major introduces a *cantabile* section redolent of Schubert, Mendelssohn and Schumann. Young David had found his place intuitively in romantic piano music by observing the increased possibilities offered by the new keyboard instrument for legato phrasing and delicate shading. As usual, static oriental material (minor tonalities) alternates with shifting major tonalities. "*A Plaint*," dedicated to "C***" (Cognat?) is a slow French waltz, suitably lamenting at the outset, but soon shifting to the lighter music-hall style.

In the present space there is no need to identify every type represented in the "Breezes." Suffice it to say that oriental patterns mingle with slow French waltzes and passages in the lighter music-hall style. The well-versed pianist will also find readily identifiable reminiscences throughout this set. For example, Mendelssohn's *Songs Without Words* leave their imprint on both the *Reverie* (Bk. VI) and *Une larme de douleur* (A tear of sadness). And the Schubert of the *Moments musicaux* is captured in *Un moment de bonheur* ("A moment's happiness"). The cultivation of pastiche was assuredly not limited to David or his time. Debussy's elegantly turned out, short, easy pieces come to mind—echoes, to some extent, of Massenet, Borodin, Delibes, and Chabrier.[10] The difference lies in David's underlying ideological motivation: the intentionally simple-minded projection of a Saint-Simonian personality offering a musico-political solution (*Harmony* "modestly hiding") to the technical problem of unifying Eastern and Western musics, one a traditional art transmitted orally, the other an artistic product buttressed by the extraordinary development of a musical instrument brilliantly exploited in the new romantic music of Chopin, Liszt, and Schumann.

David's stated aim, to sing of the Orient in France, must have been dictated by one or another of his brothers. Our account of selections from his *Breezes from the East*, tells what one composer did in 1835 in Paris to attract attention to himself and to his group. First, he had to make a living, and his early customers may well have been beginners like the young neighbors who, Heinrich Heine said, had two left hands. The pieces had not only to be easy to play, "charming, graceful and melancholy" in spirit,[11] but they also had to be expressed in a natural musical language suited to the Saint-Simonian message. Although the loose binary and ternary constructions of David's *Breezes from the East* may now seem remarkably naive for their era, their referential capacity is nonetheless striking.[12] The "message" had yet to be received and recognized through musical routes, but as a basic element of Saint-Simonian propa-

ganda, it already had widespread notoriety throughout Europe. It concerned the moral foundations of industrial and developing societies worldwide. In place of international antagonism there was to be harmonious technological interdependence. In place of revolution the new world would have organization, productivity, and a commitment to a moral-social consensus.

7

The Desert Symphony

*T*HE YEAR OF *Le Désert*, 1844, found the Saint-Simonians diminished in numbers but still staunch in their utilitarian purpose. Le Père was at hand, both in person and through his subaltern prophets and volunteers, to persuade David that a proper laurel wreath would eventually be placed on his brow by La Mère.[1] Saint-Simonism was not dead. Music was still, according to the legend, the most humane of the arts, the most popular, the most capable of exalting genuine moral qualities, and David was its prophet. The Saint-Simonians, however, were now no more interested in art purely for art's sake than they ever had been. Nor had they reason to question Barrault's assurance of long ago that reconciling differences among Aristotle, Boileau and Schlegel was a waste of time. They had taken vows to proselytize communal action in the world with new ideas enlivened by myth and ritual. This program was designed to counteract the older myths of unavailing black-robed Christianity, with its ascetic morality and idea of hell. Religion was to be transposed into the more emotionally expressive pantheism already vibrating in the pages of *L'Esprit du Temps*.[2] The idea of an East-West reconciliation of peoples according to a shared *morale* and art of life had already taken Enfantin's groups to the shores of the Bosporus, the place above all others where sustaining old myths had become empty forms under the weight of oppression.[3]

From prison in Paris, Enfantin had pursued his children from behind with a magic carpet of allegories providing a mythical underlay for his Mediterranean system. Once he was free to join them, they would together repair the misery of plundered populations with public works and promises of general happiness. Immense dams would transform deserts

into arable terrain and centuries-long social chaos into potential new economies.

His followers' accomplishment had been remarkable, but the main chance, the Suez Canal, eluded them. Poor and depressed, the musical prophet Félicien David came back to Paris from his dream world only to give piano lessons, write short pieces, and pray to his complex God for a larger assignment. When that came, it was the first large-scale composition to challenge, albeit obliquely, the attitude of his own critical society (captive to its own miseries) toward its Eastern neighbors. In the attempt, he seems to have set a new course for French musical orientalism, a course boldly focussed on vivid musical impressions purposefully organized, not merely as a decorative backdrop for a factitious operatic plot, but invested with admiration for the natural beauty of the Near Eastern terrain, the natural beauty of its people, and above all for its patient reenactment of a ritualized religious life.

It was in the spring of 1844 that the poet Auguste Colin, former champion of the women's movement, appeared at David's door. Under his arm was a substantial poem based on elements of their mutual moral-exotic experience. By this time, to both of them the promised land must have appeared to be more and more distant. They sat now, as the poet Gérard de Nerval had done on returning from his own trip to the East, with whirling dervishes in his mind's eye, a drab Paris apartment in the foreground, the "imagination knocking against the window panes like an imprisoned insect."[4] But the charm of oriental cities held fast, cities built on the shores of sparkling seas, teeming with beautiful people performing traditional rites under the Eastern skies so pure, to quote Gérard's words, that they brought "the heavens close to men."

There was, however, another aspect to the picture. Gérard had seen it, and the Saint-Simonians knew it. The dramatist Théophile Gautier (1811–72), for instance, had been well advised to put Cairo in a ballet before he saw it, so Gérard told him. Once seen, the vision turned dusty and dreary in the face of poverty, lethargy, and decay.[5] Enfantin's mission had proposed the remedy: industrial progress without destruction of cultural values. David's new work was to enhance the most important of these values, the Arab feeling of communal participation and direct accessibility to Allah. The world was expected to listen attentively to this new song of peace and to seize its moral.

And how significant was this Colin? Voilquin remembered him as a man of distinguished intellect in whom the desert heat had aggravated a tendency to monomania. He fancied that his family wanted him back so badly that they had arranged to introduce aphrodisiacs into his food: he

might then do something reprehensible to result in his expulsion from Egypt. Apart from this mania, he seemed to her entirely sensible. In the end, he was one of the last to leave the sinking Saint-Simonian ship, and Voilquin tells us that later on in Paris Colin proceeded to write some highly regarded articles.[6] She was both right and wrong. Colin did fashion a fitting libretto for David, and he was gifted. He was also disoriented, like many of his contemporaries, and he was capable, as we shall see, of causing trouble.

There is every sign that Enfantin stood behind the collaborators. It may even be that it was he who encouraged David's preoccupation with Beethoven in the direction of the Ode-Symphony, the name by which the Ninth Symphony is still known in France. This takes nothing away from the result: an original French design for a work intended to project an organic society located in a part of the world generally taken to be barbaric. As Théophile Gautier remarked: "What do apothecaries, lawyers, and undertakers know of a society so noble, so ideal? If it is barbaric, so much the worse for civilization."[7] The first performance of Le Désert took place at the Paris Conservatory in an all-David concert on 8 December 1844. The work was an instant success, and arrangements were made immediately for a second concert. This time, according to Gautier, the house was packed. Had a single ticket remained, it would have fetched fifty louis at the very least. Conspicuous persons of every description swelled a crowd which included the Duchess of Aumale, who had never before been seen in a concert hall, a number of English ladies with monstrous coiffures who had been persuaded that an exotic carnival was about to be unveiled. Enfantin's church had lost the better part of its congregation, but the advertising apparatus was left intact. Gautier and the other critics in town were recipients of copious information from the source.[8]

The audience included other curiosities: the god-like Le Père himself, with a large entourage in the loges, and a few Arab chiefs in the balcony trying to maneuver enormous lorgnettes presented to them by the French government, "the better, no doubt, to give them a high idea of European industry."[9]

And those valiant mediocrities, David's fellow composers, were also there—drudges "in a sonorous algebra, deafened by an indecisive philosophy of their society's choosing." Finally, there was David himself. Long since raised up by his movement to a condition of "new class intellectual" fit to change the planet, he still wandered around with the box office in mind. Pockets empty, he repaired to the first tenors, where Gautier caught him in a rare portrait. "This is a young man of olive complexion, coal black sparkling eyes, abundant curly hair—you might take him for

an Arab who never won a prize or made a trip to Rome at the expense of the French government."[10]

We arrive, as Gautier says, at the music, a belated response to Enfantin's order from prison to David in Lyons on the eve of the Adventure.

> You must tell me if, in this world where I have thrown you, there comes to your heart new gusts of harmonies, if the voice of the people is appealing to your conscience with its thousand harsh voices of labor and misery, if the hammers, the saws, the noise of the wheels and the whistling of steam send new chords to your ear: If this variety of objects, forms, divers sounds thrown pell-mell around you— so to speak, in disorder and in a confused anarchy—does not inspire in you a divine musical anarchy which our apostle's voice traverses and calms.[11]

The effect of this directive was lasting. It gave the musician-apostle his ground rules. To paint scenes and people as they group and regroup in daily life is not directly music's task. Rather, music has been given the means of ordering an anarchic sound-continuum analogous to the true objects in nature. Hence, a craftsmanslike, clear, unified, orderly music was uniquely capable of carrying an appeal to conscience that was the connecting trait of all Saint-Simonian striving toward a superior truth beyond the reach of ordinary language and events.[12]

The Desert opens with a majestic introduction in the strings sustained under a pedal of thirty-odd measures' duration. For Gautier, it activated the picture of an ocean of sand and an idea of pantheism undoubtedly interpreted from a Saint-Simonian source. Pantheism, with its immense meaning and resonant harmonies, was eminently suited to music, "that multiple and complex art which can make instruments speak together, each contributing a note to the general idea," each note, like each grain of sand, carrying the voice of the poet. Nowadays, adds Gautier, musicians are not preoccupied with the music of the spheres, with a description of "how stars dance or comets vocalize." Did David cull these Platonic ideas in the Orient, the cradle and the tomb of all learning? Had he become a Moslem? On the contrary, if he had a god, it was Pan, the Pan to whom Victor Hugo had addressed the hymn which closes his *Feuilles d'Automne* (Autumn Leaves). "All religions are symbols, more or less obscure, of this luminous God whom Goethe admired!" The last of the interpolated spoken voices of the introduction—Gautier takes the composition to be in the style of the old melodramas—is then admired particularly for adding to the solemnity of the occasion through a percep-

tion of the relation of silence to sound so special to music: "Unutterable harmonies from everlasting silence/Each grain of sand given its own voice/The concert hovers in undulating space/I feel it, I see it!"[13]

In David's "oriental" context, the musical idea is suitably unfocussed in terms of Western tonality and imbued with a sense of mystery by the sustained pedal point in the middle strings. A phrase of empty octaves in the lower strings falls alternately to A and A flat. Horn solos float above in short, pseudo-oriental motives circling segments of a possible F minor scale, the wavering A-flat assuming increasing importance until finally, on the faraway romantic horn, it recedes for homage to Allah delivered in a clear C major. The male chorus is set in the manner of David's Ménil-montant days, but the instrumental accompaniment is enriched with chromatics, major-minor contrasts, and Beethovenian tremolos for the enumeration of Allah's oracular gifts.

The caravan appears in a march movement which Gautier relates to the slow movement of Beethoven's Seventh Symphony. The wonders of the Beethoven symphonies were then being construed in so many ways having to do with political aspiration, humanitarian hope, and cosmic emotion that they also came easily to hand for Saint-Simonian propaganda. The finale of the Ninth Symphony, joyous and heroic, might just as well have served the comparison, for hardly anybody worried that the awesome figure of Beethoven might dwarf the accomplishment of our interesting but less impressive composer.

Gautier's gifts were those of the descriptive and pictorial poet, and he was easily diverted by the "desert tempest," in his opinion the best orchestral storm in the literature. Whatever Gautier and others meant by this extreme statement, we may note that the pleas to Allah for protection against the elements which endure over the orchestra—an effective unifying device—certainly add distinction to a movement which is otherwise exactly what the audience expected of a picturesque composition: a certain amount of lively motion, fortissimo, with chromatic scales and blustering tremolos. When calm returns, more or less after the manner of Beethoven's *Pastoral* Symphony, the caravan resumes its march toward the purified air of mysterious horizons, as the words declare.

"Hymn to Night," which opens Part II, brought down the house and launched the demand for encores that persisted throughout the evening. "La Nuit" represents the moral-exotic-erotic manner which David adopted for his definition of local color. In its way, it projects a magical sense of difference and mystery. While authenticity as such concerned the general public very little, a public for the Orient of Hugo and the painters Delacroix and Alexandre Decamps already existed among artist friends.

When Gautier wrote that France was sick with exoticism, it was to note that the moral content of the strain going back to Montaigne, Diderot, Rousseau, Mme. de Staël and Chateaubriand (a content, we may note, that the Saint-Simonians were attempting to restore) had been lost somewhere along the path of fashion. The perception of a qualitative difference in David's exoticism was beyond the fashion-conscious Parisian audience, agog at the spectacle of burnooses sweeping up and down the grand staircase. For no deeper reason than this, remarked Gautier, all of Paris took it into its head to enter the Salle Ventadour on the same evening.

Nevertheless, the music worked its magic for everybody. It did so again for the first time in a new century when "La Nuit" was performed in the mild evening air of Cadenet on 5 July 1976, on the occasion of a centenary David concert sponsored by the mayor.

What was the new exotic technique to which Heine and the Saint-Simonians alluded occasionally, a technique expected to arise naturally from the bedrock new morale? David searched a decade for a technique to go along with this theory. In "La Nuit" it comes easily, naturally and gracefully. By augmenting the fourth of his E-flat scale and initiating the piece on the dominant, the image of the fiancée's veil glides into relief before the composer settles into the tonic of his key. The inevitable *tarabouka* taps mysteriously beneath the sparsely harmonized texture while the melody falls, rises, and cadences in typical scalar rise and languid descent with roulades—David's pervasive Arab imitation—as it enters and reenters the accompaniment. The swaying middle voice in the muted strings promises from the beginning a more explicit setting of the line "to the sounds of the tarabouk, the dance undulates like the smoke of the chybouk," a montage from David's earlier camel song and his *Chybouk*.

The piece is captivating in itself. At the same time, it is a revival in music, a decade after the fact, of David's declared intention in a letter to Le Père to celebrate *La Femme,* to sing "something soft, full of desire and longing. Through music she will show your devotion, your love. I shall tell her that you call her, you wait for her, that she must hurry, for you suffer, Father, and the more you suffer, the more do you love."[14]

Accordingly, the woman of David's night piece is not merely the *almée* or the Bedouin fiancée. The heightened feminism attributed by Iggers to the late Saint-Simonian doctrine absorbed the woman, traditionally exploited like the worker, into the overall symbolism of an oncoming, loving, pacific and productive society.[15] In "La Nuit," the music throws back to the peaceable Bedouin and the calming smoke of the *chybouk*. Even the excitable *almée* is persuaded to undulate with them. David's specialty has become a music of Saint-Simonian dream mirrors, to borrow from the

Manuels' speculation on the paradox of their persistent utilization by French pragmatists. It has indeed been the case, they say, that dreamers are also supreme realists.[16]

David's exotic style grows more confident as his Part II progresses into a specifically labelled Arab fantasy. According to messages received, the critics, including Berlioz, reported that the fantasy was built on an authentic Syrian motive, its "Danse des Almées" on an Egyptian tune. Taking this as given, and with David's relativistic method in mind, we approach anew the essential problem that David's critics evaded. On their own knowledge they had no means of assessing David's exotic invention. They took from Saint-Simonian-supplied notes information which supported their own interests. Gautier continued to luxuriate in music of the spheres, light years away from the scene at the Conservatory, but absolutely constant in viewing our timid young composer as an embodiment and guardian of the arts and sciences of ancient Greece.

The critics responded with uniform delight to David's use of the orchestra, with its mélange of pseudo-oriental percussion—triangle, cymbals, tambour-de-basque[17] and drums—that contributed to the work's peculiar character, bizarre charm and surprising color.[18] Maurice Bourges, joint editor of the *Revue et gazette musicale de Paris* who was among the emerging composers influenced by David's exotic instrumentation (his opera *Sultana* was produced at the Opéra-Comique in 1846), spoke admiringly not only of the "melodic rhythms" which David distributed "with exquisite taste among the divers sections of the orchestra," but of the charming use of the oboe, "an instrument [of the shawm family] familiar to the orientals."[19] This critic indicated that he heard something new here in the relationship of color and line. If hindsight suggests that David took a good look at the Pastoral Symphony and found ways not only to imitate nature but also to imitate Beethoven, this takes nothing away from his success.

Berlioz, no slouch at score analysis, evidently found David's inventions charming, primitive, self-explanatory, and proceeded to other considerations. The "Arab Fantasy" introduces an exceptional exotic style. Rhythmic-melodic forms circle within an authentic Arabic tonal mode (half tones between 2-3 and 6-7 in a G scale). The raised seventh degree is pointedly avoided, and the tonic is approached from above. At first the accompaniment is limited to tonic and lower dominant octaves, but "Western" triads enter the middle ground gradually as the harmonic rhythm accelerates and the drumming is marked for accent on the half measure. The fantasy is a prelude to the dance, which acquires ornamental grace-notes and modulates conventionally to the minor tonality at its close; the dance

also takes its own distinctive meter and rhythm. If the movement's program is based on an actual performance David may have witnessed, it can only be inferred from the music, for the mood and technique here are quite different from the "Almée" of Book V of *Breezes from the East*.[20] Played from a balcony in Smyrna to charm passers-by, the piano piece invoked recognizable Arab patterns before each intervention of bland music from a Parisian parlor no Arab had ever seen. In that situation, it was meant to draw attention to David himself and, in the long run, to his group and its purposes.

The desert *almée* is another matter. It is a brilliant concert piece intended to beguile an elite audience at the Paris Conservatory. As such it offers an interruption to the prevailingly idyllic portrayal of Enfantin's "Eden of the World." David wanted contrast at this point in his symphony, and, if Enfantin or Duveyrier were consultants on the spot, they must have supported an exotic musical vocabulary to stir the listeners' interest. This would help to further the dream, even if it recalled little that Enfantin had set down in his more explicit political writings. In them Egypt lay prostrate, undeveloped, unproductive, miserable.[21] The Egyptian dancing girl was among the wretched folk who managed, like the fellahs, to preserve their gaiety, sweetness, and steadfast faith. Only a direct verbal description could have restored this woman's dignity by means of a psychological analysis of the dance which disclosed her problem. Suzanne Voilquin had taken as her task to educate and liberate such women from bondage to the cruel sensuality of their profession.

Eugène Fromentin (1820–76), France's talented painter-novelist, sent back from the Sahara letters to a friend on the customs of the country. Among the first of these is a magnificent rendering of the *almée's* predicament worth quoting. Fromentin's caravan stops near Boghari, and in the cool of the evening the locals send for dancers and musicians. You know, he writes, that "this town serves as a trade center for the nomads. It is populated with pretty women of easy virtue. Orientals have charming names to disguise their real business. For better or worse, let's call them dancers." And he continues:

> Five or six musicians armed with drums and flutes, and veiled women escorted by a great number of Arabs who invited themselves to the divertissement finally appeared at the fires, forming a large circle. The ball commenced with the deafening sound of unseen flutes and drums, the latter showing in the most visible spot in the circle, like great golden disks which seemed to shake and resound of themselves.

The dancer began to move with slow undulations of the body, or convulsive stamping of the feet. Presently her head turns, as if in a mysterious swoon, her beautiful hands extended as if in solemn entreaty.

At first, the dancer shows her pale face shyly, hidden by thick plaits of hair braided with wool. She turns around, hesitates under the gaze of men. But, obeying the increasing measure, she becomes more agitated, her step more animated, her gesture bold. Then begins, between her and the invisible lover who speaks to her in the voice of the flutes, a most pathetic action. She gives her hand, less to plead for herself than to reach out, while with the other hand she gestures as an enchantress. One senses that the more she defends herself the more she entices. This whole pantomime is very long and lasts till the music, at least as worn out as the dancer, has had enough.[22]

Given the absence of verbal instruction in David's dance, it is surprising how much of the appropriate action he manages to suggest. The first third of his dance, to an evocative melody in the oboe, maintains a regular four-bar phraseology. In the second third, the dancer's crisis, as described by Fromentin, is mirrored in rapid modulation which drives the characteristic melodic motive through several minor keys. In the last section, the melody eventually collapses over a swaying pedal. Orchestra and dancer wear each other out, and a short, loud transition moves into the energetic "Freedom in the Desert."

This devotional chorus delivers a sermon on the scourge of modern cities: "Dwell in your tombs of stone, pale inhabitants of cities. The desert is our country. We are free, proud and strong." It goes without saying that liberty in the liberal formal sense is not in question here. In the Saint-Simonian view, liberty has to do with the unifying creed which inspires a collective experience. This passion in the desert calls up an assortment of Saint-Simonian images—the generous calm of the splendid natural environment, the sun and space, the bright mirage, the passing cloud so dear to Saint-Simonian allegory—against the restless, dynamic city where one sees neither sky nor the majestic beauty of the land, where existence is withered by tedium and remorse.

Push the clock forward by a century and a half, and we have a latter-day environmental parable. Push it back but very little and we have Shelley's "Revolt of Islam." Through Shelley's poem, the sensitive reader can virtually feel the tremulous air of the desert, but the deeper impression is instructional. One can construe such representations as a sort of moral ex-

oticism, a timely protest by means of which the symbolic vitality of a distant locale is opposed to the inadequate present place.

David brought moral exoticism to his "Liberté" not by means of direct imitation, to use Berlioz's handy term, but with the simple expedient of a military march and a syllabic choral setting, each line separated from the next by a repetitive instrumental interlude, as in the Islamic unison choruses and orchestras. It was widely held in the 1840s, and essential to Saint-Simonian purpose, that music, as in the Greek world before the Sophists, cohered in a harmonious artistic and social existence. The Saint-Simonians habitually borrowed from ancient vocabularies for such ideas, bending them at need to the proselytizing spirit of their technocratic prophecies. In the case of music, aesthetic elements had to be manipulated to suit. David had come a long way from the polemicism of his early Women-People choruses and his frankly adulatory tributes to Le Père, but here he was seeking the marketplace, and simplicity remained a prime tool. He used it well, and he won instant popularity. Highly perceptive was a critique from Germany that, while talk of genius might be exaggerated, David was still to be credited with significant talent and the gift for producing strong effect with simple means.[23]

Indeed, David seems to have found a musical equivalent for the avidly read popular fiction of the time, for which Émile Souvestre supplied the appropriate requirements in this preface from 1836: "An easy flow of language careless of the affectations of the art, but seizing by instinct the aspects of a drama—at once declamatory and rapid, emphatic and naive: a child who had in himself the inclinations of that other sublimely ignorant child one calls the public."[24]

"Freedom in the Desert" closes with a familiar Davidian exotic referent: the tarabouka drum echoing away as the caravan marches toward distant encampment. The same idea had distanced the oarsmen in the "Stroll Along the Nile." The second referent, from the same source, is the Arab melody, now called "Evening Reverie," which the singer elaborates with oriental graces. Two thoughts furnish the text. "My languid eyelids surrendering to sweet slumber, my voice already dying away, my dearly beloved awakens with transports of love," is overtly sexual; but underneath it rings Enfantin's enthusiastic preaching of man's need to liberate the feelings to the point of learning how to accept moral-social goals as objects of intense love and desire. Such expressions of feeling were actually urged on the artists in preparation for the new age.

The second verse is marked to include ad-libitum women's voices at the important words "Progress without noise, shining moon! To heaven I do not wish to follow you. Here, as my voice sings, my dearly beloved

awakens." It is now the moon's turn to implement Saint-Simonian allegory. Impressive in its "soundless passage," it activates ideas of social change without revolutionary turmoil. The human being aspires to a heaven not in the sky but one on earth moved by loving impulses of the highest order. This is no ordinary serenade but an awakening to that seductive junction of the spirit and the flesh where Saint-Simonism located the redemptive force of the new morality. To emphasize the foregoing, the music repeats in choral unison, this time for men's voices, accompanied in octaves at the bottom of the orchestra while the middle texture moves in banal "angelic" arpeggios into a final hushed recollection of the introductory invocation to Allah.

Part III of the symphony features a desert sunrise, an interpretation of a muezzin's call to prayer, and a triumphant reiteration of the processing caravan regrouped for the final approach to the tomb of the saints. The public, unworried by aesthetic argument, demonstrated unrestrained enthusiasm for David's command of orchestral color. The sector of the intelligentsia with advance information were also prepared for no ordinary sunrise, but rather the dream of a Mohammedan paradise and the dawn of a new society.

David's natural inclination toward the pleasant sound picture, generally fortified with Saint-Simonian scripture ("Withdraw furious north wind! Come gentle southern winds!"), always met with success, especially when his beloved models, Beethoven and Weber, came to his aid. For a tremolo in muted strings over a wind ostinato, critics did not fail to find precedents in such works as Berlioz's *Romeo and Juliet*, but the ultimate model may well have been the rondo before the finale of Weber's *Oberon*. There, as in David's sunrise, a persistent figure works its way through the sections of the orchestra and down in octaves to the bass strings. This and the ubiquitous tremolo which sustains the happy emotions of Weber's characters are for David just as serviceable for an introductory recitation, a bit of typical socialistic rhetoric. *Oberon* was David's primer, and *The Desert* served as his exercise book for the orchestration of his second symphonic ode.

It remains to follow the composer from the painting of dawn to the tour de force of the morning "Chant du Muezzin." Of the "Five Pillars" or basic Islamic religious observances, the pilgrimage to Mecca had served admirably for the overall design of the Ode Symphony. The most important detail was unquestionably the Muezzin's call, not only a pillar of prayer, but an indispensable ritual signal. It served to confirm the Saint-Simonian idea of a society as a political unit within which ritual behavior had desirable consequences on moral actions.

No Arab would understand the Moslem morning prayer sounding from the minaret primarily as music. What the picturesque Arabs in the audience at the Salle Ventadour heard must have retained a modicum of its original activating power, for it was noticed that they moved their lips in some accustomed prayerful response. For them, the *adhan* as a fact of life, undisturbed for a thousand years, would always be there. For the European audience, on the other hand, it was a new and dazzling happening. And the composer had his own guideposts for a modern rendering of the ancient rite. Foremost was the need to re-order (clean up, as De Maistre said of ancient truths).[25] This new order Enfantin had explained to his musician-apostle with high-flown exhortation. Just as the anarchical variety of forms in nature required the apostle to create a new order favorable to progress, so the apostle of Art-God was required to create a new order stabilizing the existing divine musical anarchy with the calm of his apostolic voice. The prospectus of the *Breezes from the East* had stated a practicable means of transmitting Arabic musical material in ways striking and appealing to a Parisian public. The Muezzin's call fits into the scheme (see Musical Example No. 3).

We do not know whether muezzin calls were among the large quantity of simple and original songs that David told his friend Saint-Étienne he had been noting down for future setting.[26] The Israeli musicologist Peter Gradenwitz has suggested that the experience of hearing the call from a window of the old Crusader monastery as Ramla early in the trek eastward prompted this important moment in *The Desert*.[27] Even from the less romantic atmosphere of Constantinople later on, other versions may have lodged in David's retentive memory. To this day, the traveller still feels their awesome effect. And Fromentin, after hearing his first muezzin in the Sahara, remembered it together with the aspect of a "sky without clouds above a desert without shadows."

> A muezzin whom one did not see began to chant the evening prayer, repeating it four times at the four points of the horizon, and in a mode so passionate, with such accents that everything seemed to hush in order to hear it.[28]

David's version of the call makes three repetitions in regular eight-measure units, finally cadencing with a fine oriental downward flourish. A normal Western-style coda ensues, strings amplified with winds, and the vocal line transferred to unison bassoon and cello. The setting contrives to imitate Eastern models which a European audience would hear in such a context as a sort of accompanied recitative.

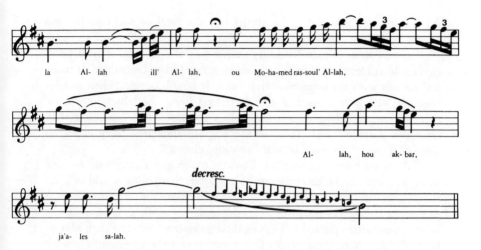

la Al- lah ill' Al- lah, ou Mo-ha-med ras-soul' Al-lah,

Al- lah, hou ak- bar,

decresc.

ja'a- les sa-lah.

Musical Example No. 3. "Chant du Muezzin" (*Le Désert*, Part III), voice part only.

At the same time, it can be demonstrated that David's conception respects important features of Islamic melody: repetition of motive and rhythm, formulas limited to a few notes and linked to reciting tones, the typical conjunct scalar rise and ornamental fall answered by groupings containing disjunct fourths. Even the chordal interpolations ride over a procession of empty octaves in the bass strings, allowable as Eastern consonances and in themselves suggestive of plaintive Eastern melody. The ornamental cadence at the end simulates the Arabian gloss. Chromatic tones are notated but, from all accounts, David's exceptional tenor had mastered the nasal way of singing together with the softly wavering tones which could only have been conveyed orally.

Among the orientalists, Salvador-Daniel was later to articulate the view that modal melody required modal harmony for a suitable accompaniment. Farmer, who followed Salvador into the twentieth century, considered David Frenchified to a fault.[29] As might be expected, David's first-night critics divided in mysterious ways. With no first-hand knowledge, their judgments moved easily between extreme poles. On the one hand, it was asserted that David had nothing in his favor but absolute authenticity; on the other, that he had everything in his favor for viewing the exact quotation not as a measure of what we now call ethnological astuteness, but as an absence of the more valuable capacity for originality.

As Gradenwitz has said, "the air [if not the fact] of authenticity was clearly sensed by the early audiences."[30]

A sure sense of pictorial unity shared with the painters of his generation enabled David to close his canvas of general ideas embedded in magical sounds with his original march tune. It booms out and then recedes together with a repetition of the declaimed lines "ineffables accords de l'éternel silence/ Chaque grain de sable a sa voix. . . ." No larger than Gautier's grain of sand, the poet's voice had spoken—every grain, as Tennyson was to say even better, "an awful charm."

A satisfactory account of David's overnight change of fortune brought about by the great success of his Desert Symphony would in itself fill a book. Judicial incidents, as a reporter for the *Revue et gazette musicale de Paris* called the lawsuits that ensued, would fill another. A mountain of excited journalism proved to be even more exploitive. No less than Meyerbeer's *Robert le diable,* David's *Le Désert* was taken to be an exemplary work of its time. Modernism inhered in the very subtitle ode symphony, neither oratorio nor symphony but partaking of both and geared to a new synergetic order of religious sentiment, the Saint-Simonian religion of humanity. In addition, the virtue of the moment, described by Heinrich Heine as romantic spirit tempered with classical simplicity, was universally attributed to the composer.

La France Musicale entertained its readers throughout the year 1845 with regular praise of David and accounts of his progress. This had not a little to do with the fact that the composer, in his naiveté, had sold the rights to his music, past, present and future, to the journal's editors, the brothers Escudier of the Parisian publishing house that bore their name.[31] Elsewhere a rain of critical notices accomplished instantly for the movement what Enfantin, socialism's first advertising agent, had failed to do in a decade's effort.

Le Désert is "a masterpiece in the true sense of the word," wrote the provincial critic J. Maurel. "It bears no resemblance to any other music but partakes of the virtues of all musics." Maurel described David's melodic gift as

> natural and lively like the Italian, but not common. It is dreamy and sad like the German, but not boring. It is just and expressive like the French, but never cold. His phraseology is new and inspired, but at the same time severe and classical. It is effective, but with the simplest means. Make no mistake. These are the true marks of genius.[32]

In the preceding decade, Jean-François Gail (1795–1845), writing critically of the French musical theater, had expressed hopes for such genius to surface in the indigenous opéra-comique.[33] Significantly, the opera was to be David's future professional haven.

Another theory being revived at the time—the classical concept of art as the imitation of nature—took on new intimations of truth. The Encyclopedist definition into which Berlioz had breathed new life maintained itself well in the musical criticism of the 1840s. By means of it, the critic Maurel was able to assert that David had rarified natural data in his storms and sunrises. Just as Berlioz had relied on Lacépède for his theory of analogy, Maurel acknowledged Rousseau for a more pointed connection between art and morality. We are speaking here of the real truth, "about an awakening of the heart to a conviction of the truth, not about realism."

In Paris, Berlioz noted that the whole audience rose to greet the torrents of harmony of David's dawn,

> unmindful of the systematic anathema of the adversaries of imitative harmony. . . . If David had chosen to counterfeit the roaring of lions and cries of jackals, he would have won ridicule. . . . But Beethoven's *Storm* and David's *Simoun* and *Dawn* . . . are the results of the purest and highest musical art, and they are admired in spite of all the theories in the world because they are moving and beautiful, and because they represent faithfully . . . what the subject dictates up to the point permitted by the art.[34]

There is nothing profane about this pantheism, concluded Maurel, bringing the discussion back to the moral social context. Digesting in his own way the Saint-Simonian information received, Berlioz made his choice among the same phrases that attracted Gautier. "[David's] orchestral blast is striking without ceasing to be harmonious. A thousand sounds crowd together to form a single sound, just as the grains of sand raised by the *Simoun* unite to form a burning cloud."[35]

The composer had not neglected to set his own stage. "Having begun my career with a social aim, I have always suffered from its discontinuance. The moment has again come."[36] And Enfantin informed one of the brothers who had remained in Egypt,

> In listening to this admirable music *that is entirely ours,* how much I wish that you could see this charming little man directing his orchestra with authority, dignity, and an apostolic saintliness. His time

has come. He feels it. He fairly oozes mission. He knows perfectly
well what he is launching into the world. Beneath his modest mien
is the saintly pride of the apostle.[37]

"His day has come," echoed Berlioz in his generous review, which
opens with an accolade he had already paid, almost word for word, to
Spontini.

If music were not abandoned to public charity, there would be some-
where in Europe a theater, a lyric pantheon, dedicated exclusively to
the performance of musical masterworks performed at long intervals
with a care and a pomp worthy of them and listened to by a sensitive
and intelligent audience. . . . If we were an artistic people and if
such a pantheon existed in Paris, we should have seen it lit to its pin-
nacle last Sunday, for a great composer has just appeared. . . . His
name is Félicien David, and the masterpiece is called *The Desert,*
ode-symphony.[38]

Following the leader, Maurice Bourges was able to cry, "Make
room, gentlemen: a great composer is born to us!"[39] After which it was
no great step to Sylvain Saint-Étienne's clarion call in *La France musicale:*
"Mark what I tell you today: there is only one great artist in Paris at pres-
ent who will one day be ranked on the level of Mozart, Beethoven, Méhul
and Weber, and that artist is Félicien David."[40]
Amid the din, Berlioz paused to design a context for estimating the
young composer's brush with modern musical problems. It is of interest
that Saint-Simonian ideas which were widely current furnished his argu-
ment. Then as now networks of affinity and alliance proliferated among
French intellectuals, and Saint-Simonism served as an umbrella for the
most outspoken of them. Berlioz is explicit on two points. He salutes a
work which deals musically with local color—a local color, moreover,
charged with moral and emotional intensities. And he subscribes to the
Saint-Simonian idea of progress, with its conviction that art, science and
morals were advancing hand in hand toward the transformation of old
forms and the leap to new ones worthy of the beauty and nobility of man's
terrestrial life. The first pronouncement comes immediately after the pan-
theon proposal. Citing David, he declares:

He embraced Saint-Simonian doctrines with ardor and followed his
coreligionists and friends to the Orient . . . to Egypt, Syria, Pales-

tine . . . to the foot of the pyramids . . . and the rivers of Jordan. He heard the great voice of the desert and the splendid concert of the starry nights on the banks of the Bosporus. It is in view of these immense solitudes, of the great stars of these skies, of the antique forests of these mountains, to the confidences of silence and liberty that his heart and mind expanded, elevated, refreshed, enlightened and strengthened.[41]

Then the second pronouncement: "He had long since learned the elements of his art at the Conservatory . . . He thought that all things progress, that everything is modified, transformed, enriched . . . not just in industry, science, language but in music, too, essentially the freest of all. . . . He wished to be an inventor, and he was."[42] Berlioz then reviews the organizing principles and their justifications in the plan of the work: the verses declaimed over orchestral pedalpoints; the immobile string sound, the voices grouped for strong sonority, all in the service of an expansiveness of language and spirit and a trajectory of action quite different from that of the classical symphony. Symphonic form, that of Haydn and Mozart in particular, then enters the argument. Berlioz's conservative opponents were inclined to instruct their readers with histories of the symphony up to and including modern alternatives, the "classical" symphonies of Onslow and Reber on the one hand; on the other, Berlioz the lion, out on a limb.[43] The polemics of Berlioz's review of *The Desert* have to be taken as the outburst of an innovator at bay. He complains that the symphonic plan as traced over and over by Haydn and Mozart is completely predictable, repetitive and formula-bound. And so, the four movements of a symphony are

no more than a chain of pretty phrases, little melodic coquetries, piquant and witty orchestral games having for their aim only to divert the ear. . . . Never can one note the slightest tendency toward that order of ideas called poetic. . . . Imagination consisted in substituting a *fa* for a *mi* in certain chords, in modulating in a certain way, in placing a horn where one had heard a viola, in embroidering a song agreeably. The note was the aim, not the means. Expressive feeling slumbered except when they wrote to a text. Symphonies followed each other and resembled each other. . . . The instrumental body never varied from the usual complement of strings, one or two flutes, two oboes, rarely two clarinets, two horns, two bassoons, very rarely two trumpets, and a drum. It never occurred to Haydn, Mozart or to their innumerable followers to add to or replace these by others or to

make new combinations. One may say without exaggeration that the
90 [sic] symphonies written by Haydn and Mozart are 90 variations
on the same theme for the same instruments.[44]

Berlioz's romance with the modern orchestra had been confirmed in
the previous year with the publication of his *Traité d'instrumentation*. There
an article of faith dedicates the orchestra to the expansion of man's soul in
its communication with nature.[45] His *Desert* review focusses on the future
of the modern symphony in terms of Beethoven's composite innovations.
The scherzo of his First Symphony is cited in connection with David's
Symphony in E-flat, played in the first half of the 1844 concert. Berlioz
sees Beethoven's influence in David's ability to develop fresh and distin-
guished ideas, with an exquisite choice of timbres, and great skill in the
management of the violins. Beethoven's strong innovations pointed to the
possibility of unlimited advance, especially on the side of representa-
tional, descriptive and program music which was assumed to be music's
prerogative. In a time when industry, science and language were being
modified, transformed and enriched, music, the most liberal art of all,
should also be the most inventive.

This accords well with the Saint-Simonian view that the informing
ideas and feelings of a work of art disappear with time. The forms that re-
main are mere shells. They cannot be re-used and re-applied as if they
were scientific theorems. The ideas and feelings of the immediate present
are the vital ones. Given their surpassing ability to convey these ideas and
feelings, artists cannot afford to shirk their responsibilities. Accordingly,
Enfantin failed to understand why the Pasha balked at destroying a pyra-
mid to make room for a projected dam on the Nile. "Our dam is a pro-
gressive and poetic idea," he told the Pasha, "and for its sake it is fitting
to destroy a monument that time has been unreasonably slow in dis-
carding. Progress is time given new life, movement, purpose, and, above
all, utility."[46]

Berlioz's comprehensive review leaves no doubt that he thought he
had found an ally in his battle for the acceptance of a new style. From it
stem the summary statements in history books which still connect David
and Berlioz. The implication that orientalism as such was a mutual point
of interest is, however, not substantiated to any great extent in the article.
The point of contact for Berlioz was rather the possibility of establishing
within the scope of an imaginative music a feeling for the atmosphere of a
landscape. He thought he had found a composer who knew how to speak
to the heart, mind, and memory of a sensitive and intelligent audience by

means of a theatrical composition, a symphony in descriptive, programmatic style.

For the French intelligentsia, exoticism had become a consuming passion, superseding the classical and medieval revivals as well as all other aspects of romanticism. While their English fellows were no closer to the Orient than a reading of eighteenth-century travel books, the enactment on a Parisian stage of an authentic Islamic caravan journey, seen and heard by a French musician, removed cataracts from their eyes, as the Goncourt brothers were to say of the whole nineteenth century. They knew no other music or oriental locale in which the music itself contained so much certified exotic reference.

It was to be expected that imitations would soon synthesize David's clichés to satisfy the latest vogue. Even Beethoven was brought into the act with a revival of his incidental music to *Ruins of Athens,* now expanded by spoken narration. Maurice Bourges threw up his hands at the effrontery and bad taste that presumed to connect fragments of the music with declaimed passages from Kotzebue's original play.

> Perform the play with music as originally written or perform the music alone in the normal order. Supply, if you must, an introductory program for the listener to consult at will. But why this arbitrary translation superimposed on great and original music only to render it inaudible? This endless recitation serves only the fads of fashion.[47]

Having made his public declaration of social vocation, David returned to the protective arms of his coreligionists. He had taken no legal advice in the drawing up of agreements. He was again penniless. His publishers promised festivals in London with orchestras of 140 and choruses of 80, exceeding those mustered for Handel, idol of the English. In fact, they announced for publication a quadrille on the *Danse des almées,* and they instituted proceedings against the inventor of the harmonium, one Delain, to prevent performance of *The Desert* on that instrument. Not to be outdone, Auguste Colin, fancying that his role in the project had not been sufficiently publicized, appealed to the newspapers of Lyons, Marseilles and Paris to qualify his contribution to the great new success as a full collaboration, a notion common enough in squabbles between composers and their librettists in the preceding century.

With his weak chest, his inborn melancholy, and a cherished intention of musical fame debilitated by a sense of doom in the attainment,

David—total innocent that he was—simply detached himself from the situation. Enfantin, as so often, called in his astute friend Jean-Barthélemy Arlès-Dufour (1805–72) for consultation, and in the Colin affair the friendly offices of the lawyer A. Lecour brought matters to a reasonable conclusion.[48]

Berlioz reported in the *Journal des debats*, 4 March 1845, that David had gone on tour with *The Desert*. After Lyons and Marseilles he would visit Germany, which could be counted on to "take a great interest in a composer whose revelation to France has been so brilliant and so prompt. . . . To Germany then! Our wishes precede him and will follow him."[49] On the scale of Berlioz's waxing and waning enthusiasm for matters Saint-Simonian, this declaration registers the highest mark.[50]

8

Moses on Sinai

\mathcal{A}S AN INFLUENTIAL MOVEMENT, Saint-Simonism ran its course well within the limits of the exciting 1830s. As a system of thought assembled in the pages of the *Doctrine* and the *Producteur,* it has continued to command interest up to the present day.[1] One of its adepts, Pierre Leroux, used the term socialism for the first time in his *Cour d'économie politique* of 1833. In leading a dissident group away from Enfantin at that time, Leroux indicated a need to reassess the notions of liberty and equality and to restore parliamentary debate among opposition groups. The Saint-Simonians had moved towards authoritarianism and pursued their singleminded goal of peaceful association. By 1840 it was clear, in any case, that Enfantin's interests had coalesced behind his industrial projects and their pantheistic expression. In this respect he is now better understood by technocrats than by socialists.[2]

In an attempt to base an ethics, an aesthetic, and a politics on the economic principle of productivity, Enfantin set out to encompass no less than all the problems of human behavior, a sweeping gesture which required the donning of a prophet's mantle. In the end he achieved only the directorship of a railroad corporation. The project of the Suez canal, his great apostolic offering to humanity, was to be consummated by his more worldly rival Ferdinand de Lesseps (1805–94).

To the end of his life, Félicien David, musician-apostle, addressed Enfantin always as Le Père of his severe religion. Le Pére himself defined religion as a living politics. It is this political mythology that we now address. David's oratorio *Moses on Sinai* was the result of one of Enfantin's absurd maneuvers to win support and esteem for his industrial schemes. Since human beings are not noted for their willingness to put social before

individualistic interests, he fashioned a convenient and compelling myth which would implement Saint-Simonian social morality and at the same time support his economic demands. The model, of course, was the saga of Moses leading the children of Israel into the promised land.

Lewis Feuer, in his *Ideology and the Ideologists,* points to the fact that the Saint-Simonians alone among the ideological schools eschewed anti-Semitism.[3] Indeed, their scientific version of the Mosaic myth had such signal appeal to the Jewish intellectual and industrial elite in their ranks that the Saint-Simonians became known as the "new Jews."[4] Shortly before his death, Saint-Simon himself had shown a strong disposition to identify his vision with the universalist nature of the Hebrew prophecy and its messianic expectation.[5] Enfantin's continuing consciousness of this vision, particularly as it merged with the ideology of industrialism which Saint-Simon had founded, could now be seen to glorify the virtues and achievements in which Jews had been known to excel. As leader, Enfantin chose to see himself in a class with a long line of socially conscious geniuses, Moses at their head. And, like Moses, he presumed to ascend Mount Sinai to received the law and the privilege of enlightening humanity and improving its lot. Eventually he made this symbolic ascent without his new Jews. Most of them had defected, partly due to the celibacy rule and the peculiar sexual theory which he had designed for the cult, and partly because they were now pursuing highly successful careers in government and business.

In 1845 Enfantin's leadership maneuvers came to involve Félicien David and his oratorio. Not only did he fashion a scenario for the work, he also maintained with David, whom he had dispatched as priestly ambassador to Germany, a correspondence aimed at raising the composer's consciousness of his religious role in the movement and the world. At Enfantin's request, a tiny but effective network of faithful adherents and sympathizers undertook to watch over the health, welfare, and tangled business affairs of Enfantin's artistic coreligionist. The resulting musical work was exactly as David's friend and biographer Sylvain Saint-Étienne later described it — his work of predilection "and to which he gave himself with faith and love, for he was persuaded that Le Père Enfantin had symbolized himself in the person of Moses."[6]

It is appropriate to consider what Enfantin's state of mind must have been at this time. High government office consistently eluded his grasp. Appointments, first as a member, then as secretary of a scientific commission in Algeria, ended in what he considered a personal and a national failure. His report took the form of a large book packed with Saint-Simonian explanations and suggestions for the future.[7] Since nothing less than Eu-

ropean peace was at stake, the failure to organize a harmonious grouping of nations for cooperation in Algerian colonization was the threat to peace itself. In his view the initiative toward communal progress in the troubled Eastern world now lay with France and with organized companies and workshops directed by geniuses from the École Polytechnique equipped with Saint-Simonian plans for the building of peaceable cities. Enfantin made indirect approaches to King Louis Philippe (normal procedure for what Enfantin called his princely apostolate). But although Louis Philippe purported to be interested in peaceful solutions to colonial problems, he continued to allow the military operations in North Africa which resulted in devastation of the land and decimation of its population. His advisers were little inclined to imagine Saint-Simonian Gardens of Eden, and the French Mediterranean continued to be governed by France's least able administrators according to the least serviceable of her institutions—bourgeois ownership of land among tribes which were three parts nomad.[8]

On his return from Algeria, Enfantin found himself essentially isolated. As he said himself, "Having left Paris with forty apostles, I return alone." A few young people who had not known the enthusiastic commitment experienced in the Rue Monsigny and at Ménilmontant clustered around him, but only one good and faithful friend, Arlès-Dufour, a successful Lyons silk manufacturer, shared his indefatigable intellectual and industrial activities.[9] It was their plan now to direct their apostolate to important people in government relative to their old dreams of merging railroad companies and building a Suez canal. Thus the intelligent atmosphere which Karl Marx found in Paris in the early 1840s was shared on the one hand by Michael Bakunin and Pierre-Joseph Proudhon, at war with one another on philosophical issues, and on the other by Prosper Enfantin, chief ideologue of a new religion focussed on railroads and canals, those "regulators of civilization, transporters of new ideas, and principal agents of exchange between peoples."[10]

Saint-Simonian positivism required, especially in view of such world-shaking inventions, an ultimate plan involving the training of specialists in three separate departments. These had as their objects sympathy (the source of the fine arts), the rational faculty (the instrument of science), and material activity (the agent of industry). So far as state ownership of the railroads was concerned, the outlook was optimistic, for the failure of private ventures by small companies was increasing. National developments among France's neighbors, Germany for one, indicated to Enfantin that the time had come to propagandize the larger vision among them. And since persuasion belonged to the artist's province of sympathy,

David fell heir to the mission. Business prevented Enfantin from accompanying him, but he wrote a letter to Felix Mendelssohn in Frankfurt explaining that of all those who had given him filial affection Félicien David was the favorite son and truly the Benjamin of that family, "several of whose members you knew and loved."[11] Although Saint-Simonian ideas affronted his own religious convictions, the generous welcome Mendelssohn gave David is a measure of his own deep personal response.[12] One may well conjecture that a mutually shared sentimental imagination drew them together.

The tour of Germany proved fairly successful particularly in the performances of the Desert Symphony.[13] David gained popularity with the general public and a more distant nod from the official artistic world, as the *RGM* reported. The outcome was entirely pleasing to Le Pére. The great Meyerbeer himself conducted, rehearsed, and acted as troubleshooter for David in Potsdam, and Arlès-Dufour enlisted the aid of his wife's nephew, the banker Dufour-Féronce, in introducing David to the notables of Leipzig. On his side, shy, retiring David much preferred the delights of a walking trip in Switzerland with the pianist-composer Ferdinand Hiller (1811–85), during which they shared reminiscences about the old Saint-Simonian days in the Rue Monsigny.[14]

All this David relayed dutifully to Le Père in correspondence that gives details on the composition of *Moses*. In addition to shedding further light on their relationship, the letters to and from Germany confirm that Enfantin indeed saw himself as the Moses of French industry.[15] He also made sure that David considered his own activity socially relevant. With *Le Désert*, David had made his stand against all that was corrupt and artificial in the musical life of Louis Philippe's July Monarchy. He had set an example of music rich in humanity, public and accessible to all men in all countries. He was now ready for the next and higher step. His *Moses* oratorio was to further Enfantin's industrial plans and ambitious world view. Accordingly, in June 1845, Enfantin counsels David as follows: "It is necessary that you leave this great musical foyer that is Germany entirely overcome by the [moral] flames that you carry within you. Consult with Dufour in the matter of a German who could furnish adequate translations of the words I have provided to inspire you."[16]

The same letter rejects Dufour's proposal for David to extend his tour to northern cities: "It is all very well for a touring performer, but not in the least suitable for an artist who has received the plaudits of Berlin, Leipzig and Vienna." As for Baden, where David was anticipated like a Liszt or the famous actress Rachel, "do not cast your pearls before swine." Success had done wonders for David's self-confidence, but his celebrity,

continued his mentor, will swell the audience for the message of Saint-Simonian moral concerns. "Your Sinai work, to which I attach so much importance [is a] religious prelude to our Mass of Suez." Earlier he had argued even more vehemently:

> I am recommending to Dufour that in making his judgment he examine your affair from the very capital point of view that you are working for the Suez affair just as he is. Consequently, your journeys, your presence, your music, all actions must be combined in the single aim of your religious life. Yes, dear friend, think well on David carrying Moses within him who bears Israel to the promised land. Show this letter to Dufour and walk strong in the direction that leads the world to Suez.[17]

Thus uplifted, David proceeds to his music, and his first suggestion Enfantin accepts gladly, for it is directed toward a large increase in the pomp and circumstance that he craved. Conservation of the ritual and ceremonial displays of the depleted Saint-Simonian order is always on Enfantin's mind. Accordingly, David includes part of Le Père's favorite Ménilmontant opener "The Father's Return" (*Le retour du Père*) in his last scene, altering easily "Salut, Père, salut" to "Salut, terre, salut" for the march of the Hebrews to the promised land. Similarly, another old chorus "All is dead" (*Tout est mort*) is retexted as "Israel, Israel." The composer takes care to set the opening section monophonically in an approximation of the Dorian mode. Generally he vacillates between the major and the minor second, possibly to suggest one of the Moslem modes. Finally, his decision to include women's voices might be traced back to one of Barrault's old sermons, "Glory to you, Jewish women," which David knew by heart.

Tributes to the Saint-Simonian cult accomplished, David's spirits continued to rise. His suggested ending moves into "a song of enthusiasm, of thanks to God, of hope for the future, something grandiose and strong."[18] The optimistic outcome is celebrated throughout the last scenes of the oratorio, and both the old and the new Moses are vindicated in an upward marching movement where David expresses the enthusiasm with a conventional piling up of octaves, tremolos, unison cries, rapid scales, and widely spaced common chords. The *March of the Hebrews* concluding the work was universally approved on first hearing (see Musical Example No. 4). On his side, Le Père did not fail to hear the truths that had once before inspired listeners in the coda of David's "sublime oriental comet"—a reference to the Desert Symphony.

For the rest, Moses addresses his God in unaccompanied mono-

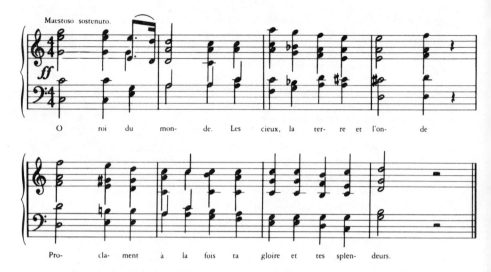

Musical Example No. 4. "Marche des Hébreux" (*Moïse au Sinaï*, fi-
nale), choral part only.

logue. When emotion mounts, the orchestra enters in hushed tremolo af-
ter the manner of Beethoven's "Now tremble nature" in the *Mount of Ol-
ives.* When the scene shifts to the uneasy Hebrews, they long for the
abundance of Egypt and complain of their privations and the gloom of the
cult of Jehovah that Moses has imposed on them. A young girl expresses
these sentiments in a nostalgic romance which then leads to an intoxicated
"Dance of the Golden Calf" shared by orchestra, choruses of men and
women, separately and together cursing the old God and welcoming a
new God of joy and prosperity.

When Yahweh comes to the aid of Moses, he manifests his presence
in a chromatic symphony which ends, after the fashion of the moment,
with piccolo shrieks and drum rolls depicting lightning and thunder. It is
possible, remarked the *Illustration* critic when the piece reached Paris, that
God's chromatic scales signified the wind, at the least a gross material im-
itation, at the most a trivial revelation of the Eternal.[19] To make matters
worse, it was considered improper for Moses to reprove his subjects in a
light air, the only one to penetrate his long series of gloomy recitatives. In
the end, only the *March,* the *Romance* of the young Israelite and the spir-
ited *Dance* received full approval.

With the dance, David's Egyptian manner was in full flower. This "Ronde" exploits the harmonic-minor scale which was to serve composers for some time to come in dealing with the augmented second, characteristic of the near East; it is full of joyous skipping, slides, drones, unison singing over octave tremolos and trills, orchestrated with all manner of striking, drumming and piping suggestive of Near-Eastern tambourines, drums and flutes.

Considering the text needed for this allegory, Enfantin fancied that "nothing could be easier than to put words to your music. You phrase so well that the words should fall of their own accord in the musical feeling."[20] It was, after all, common practice to compose music in advance, the words falling where they could, as Meyerbeer and Scribe well understood. In this case, translation into German was an added complication met by Enfantin with his airy optimism. Given the natural affinities between poetry and music in German; given the possibility of choosing a German translator who would understand the "poetry" of David's music; given all that, David could not but make "an apostolic conquest of the greatest importance." Above all, "the further I advance here in business matters, the more I see how much both of us must make Germany dance the dance of God."[21] The religious task was, of course, not limited to David's music. Plans for the canal made by Linant de Bellegonds were carried by David to Dufour. The latter, solid banker and diplomatist, was to approach Prince Metternich on Enfantin's behalf, while at the same time protecting the cosmopolitan industrial color of the enterprise from Enfantin's mysticism.

At home, the indefatigable mystic continued his pressures on bankers, engineers, polytechnicians, and senior ministry officials, and one of his dreams finally came true. He had brought off a deal equal, as he writes David, to the latter's *coup d' éclat,* the highly successful Desert Symphony. He had also been working on a plan to send David to Russia, but this had to wait until 1860 to materialize. The business deal, for once, succeeded.

> I don't know if I can come to terms with Escudier concerning Russia. Doing business with these fellows is more difficult than dealing in the world of finance. With the latter, my friend, your Father has, in 1845, made a deal involving a matter of 200 millions where his signature may be found between those of Rothschild and Lafitte: this is my desert symphony. You can well imagine that in spite of my great desire to join you, I must absolutely remain in the post that God has marvelously given me this year.[22]

This stands cheek by jowl with a crescendo of directives for the "Salut" chorus from *Moses* mentioned earlier. It is an excellent example of Enfantin's Messianic style, undiminished after almost twenty years of discouragement in his administrative and scientific projects.

> I still insist on the *Salut,* but ending with an instrumental crescendo, then vocal, such as has never been heard before—apocalyptic, but an apocalypse of joy. Your entry into the desert reversed; that is to say, the contrary of immensity and eternity: the point, the moment, the fact, the present, the instantaneous, the religious excitement, the dance of David before the Ark, on the altar, in the presence of the God of grace and power, the God of beautiful, good and frisky flesh. While the masons build the temple, the engineers dig the canal, the blacksmiths form the rails, the children peal with laughter, the women sing, and all nature, sun, earth, and sky together are in a state of joy.[23]

Enfantin as Moses stands here fully revealed. His nineteenth-century task is to inspire his people with the moral evaluations necessary to a productive life; a life of love, play, pleasure, ease, order and, above all, self-realizing work. In his research for *Moses,* Enfantin may in fact have lighted on Exodus, XXXV:

> Them hath he filled with wisdom of heart, to work all manner of work, of the engraver, and of the cunning workman, and of the embroiderer, in blue, and in purple, in scarlet, and in fine linen, and of the weaver, even of them that do any work, and of those that devise cunning work.

The image of the beautiful naked David dancing before the ark has no role in the oratorio. He is summoned to the correspondence as an adjunct to Enfantin's role-playing. The role of Le Père was, as Barrault had written to him in 1837, his nature, his mission, his capacity. Enfantin's son, with his lassitudes and depressions, was in need of just such an example as the Old Testament could provide—a David high-spirited, beautiful, talented, and capable of entering a mission on behalf of humanity at full tilt. Example 4 demonstrates David's full-blooded musical response.

The joy of communal work that Enfantin conjured up for David's benefit is a late version of hundreds of messages exchanged by the Saint-Simonians in earlier days. More importantly, that the senses should be

gratified through the flowering of art, sciences, and material prosperity was a Saint-Simonian theological postulate of long standing. The ode to joy which Enfantin was pressing on his David encompassed every facet of the Saint-Simonian notion of the rehabilitation of the flesh and matter, a new morality which, by mitigating the priority of the spirit over the flesh, would prepare a universal future of peace, happiness, work, and joy. Here Enfantin's messages bear specifically on the sensuous means of music; on playful sex as the origin not of evil but of good; on Saint-Simonian brotherhood—described elsewhere as "that love that ties members of the same sex . . . that sweetness . . . that unites, for the good of all, two beings of the same sex"[24]—all these uniting and contributing to the ultimate goal of universal association toward precise technological ends and projects.

Enfantin may have recalled how Félicien David visited every day with his portable piano to play and sing to him when he languished on the ship that had brought him to join the others in Egypt. Was it Saul he was thinking of then ("Send me David thy son, who is with the sheep")? The musicianship of David in the Bible, we may remember, also had social significance akin to that with which the Saint-Simonians endowed their musician. He held the rank of leading spirit, and his activity, it was hoped, was to become decisive for the religion and the intellectual history of the Hebrews.[25]

Very little of this lore still occupied the small group of Saint-Simonian survivors. The cult no longer touched their lives closely, and their composer, despite his recent success, made no great stir in their present universe of concerns, whether in the corridors of government and business or, as in the case of Duveyrier, their poet of God, in the librettos of the opéra-comique. David was now among the very few survivors of the original group of disturbed young men who cleaved passionately to the magnetic, narcissistic Enfantin.[26] A religion Saint-Simonism undoubtedly was, but a more mundane cluster of concerns now occupied Enfantin's favorite apostle. Identity, ego, achievement of status, money were much on David's mind. Enfantin answered to these too, but always as we have seen, with the hyperbolic exegesis of the dying cult.

Behind the run-on sentences and headlong images of Le Père's messages stands the immense range of human experience that the Saint-Simonians claimed for their divinity. David's gentle disposition, his normal restraint, and simplicity of expression are stretched to the limit in an effort to meet such challenges. Le Père undertook his education no less attentively than that of his own son—he does so with a will.

Still, sleeves rolled up, David was left waiting for the full text of his

oratorio. As for writing the music in advance of the words, impossible! "I absolutely must have a text. You would greatly please your son and collaborator if you could spare a moment from your task to think about this."[27] But Enfantin was now thoroughly engrossed in his developing industrial projects, and David thought seriously of yielding to his old friend Sylvain Saint-Étienne's long-standing ambition to become his manager, librettist and publisher. Loath as Enfantin must have been to surrender his long-distance "passional attraction," he had great things to do. An amusing correspondence ensues among the three, in which the point at issue is Saint-Étienne's role as an outsider in the Saint-Simonian scheme of things. To David, Enfantin counseled:

> You are not there [in Germany] for exploitation, but for reputation, and above all for propagation. You are an apostle, and Sylvain knows less about this profession than the other, although apparently he has more of a natural leaning in this direction, since he loves you and you love him.[28]

But Enfantin would carefully circumscribe the role Saint-Étienne might play:

> . . . to keep me informed of your health, your itinerary, your works, and also, dear child, of your large and small chagrins; to spare you the annoyances and fatigue of relations with theaters, musicians, copyists, offerers of librettos and nuisances of all kinds; to cut, alter, and arrange any verses that do not fit your music; who will forge them for you whenever inspiration strikes; who will seize your musical thoughts in flight when you might otherwise forget them; [in short] an intelligent register and friend of your thinking. But for God's sake, let him stop there and not meddle with *affairs*; he understands absolutely nothing there and stands to do more harm than good.[29]

David responded as follows:

> As for the position you would like him to establish with me, I'd think it impracticable. Sylvain cannot separate from his family, and he must support them. I am not wealthy enough to assure him a sum [adequate to his needs]. I should hate to withdraw my promise [to let Sylvain publish *Moses* and other things] after all the sacrifices he has

made for me. I needn't remind you how old our friendship is, and I should like in this way to prove my affection. I hope you will not blame me for my insistence.[30]

The fact is that Enfantin and Arlès-Dufour were at this time keeping David in funds on condition that his works be played or acquired only with their consent—primarily to prevent further disasters like his private deal with the Parisian publishers, the Escudier brothers. Not only had he sold his rights to the *Desert Symphony* but to all future works, and the sum of money involved, 1200 francs, was less than he was to earn later for a single concert. Eventually Enfantin and Duveyrier were able to break this contract and to help him through other entanglements that plagued his celebrity. The burden was perhaps too heavy for David's provincial friend Sylvain.

David definitely needed a manager, since he absent-mindedly departed Leipzig for a Berlin performance leaving the score and parts of *The Desert* behind in an unlocked office.[31] Saint-Étienne stood his ground volubly, and by default he became David's occasional travelling companion and impresario, and his Parisian publisher as well. Enfantin seems quite effectively to have prevented him from obtaining David's more successful scores *Christopher Columbus* and *The Pearl of Brazil*. He did take up the works for which there was little or no demand: *Moses* and *Eden*; and in his zeal to please David's coreligionists, he retexted (with Charles Chaubet) and published the Ménilmontant choruses (*La Ruche harmonieuse*). He even resuscitated the six motets that David had written at Aix before he came to Paris as well as the symphonies of David's gestation period. Needless to say, his efforts were not repaid with sales, and eventually he closed up shop. For the time being Enfantin seemed reconciled to the arrangement, provided that David's place in the hierarchy was respected absolutely. "You are one of [our] great glories," he told David, "you are harmony itself."[32] This was normal language for Le Père, and it had especial utility in dealing with this most shy and retiring of his adepts.

With Saint-Étienne in Germany, the French text for *Moses* materialized. In the meantime, David had been prodded into showing himself at the splendid Beethoven commemoration organized at Bonn and carried out with the aid of a devoted Berlioz. Both Liszt and Berlioz, like Heine, George Sand, Hugo and Sainte-Beuve, had in the past maintained friendly relations with the Saint-Simonians, but more than the others, Liszt probably provoked jealousy with his fascinating personality, his dynamic musical energy, and his ability to convert others to his personal beliefs. Nevertheless, Arles-Dufour, one of the few remaining custodians of

the true Saint-Simonian sacred fire, confessed to such exaltation in the face of just such a grand communion among men as to begin to detest family life, business, and city. Were he a musician like David, the transport and musical delirium would never leave him should his life be completely transformed twenty years hence. Why, Dufour wondered, had the French failed to organize such festivals from which a new system of pacific values could arise. Our festivals "always call to mind gunpowder, blood, destruction—Christian dogs that we are!"[33] David had finally decided to go to Bonn, he added, but the honors went to that "charlatan" Liszt. David did go, but had little to say—Le Père frequently accused him of being afraid to burn up paper. A more or less accurate account could be found in the newspapers, he reported to his chief. As for himself, he found the observances somewhat less than reverential.[34]

Moses never achieved its projected debut in Vienna. Nothing came of the approach to Metternich and the proposed joint enterprises which were to bind their countries in commerce and rapid communication systems, bringing riches and well-being to all. In France, on the other hand, things were going very well for Enfantin. As we have seen, some of the richest bankers in Europe were prepared to invest enormous sums of money in his technocratic dreams, although Enfantin omitted none of his doctrinal points in persuading them. "Believe me," he told them, "if anything has still to be protected in France, it is the manufacture of locomotives, for there is no more powerful means of education for the French working class." Finally, he was put in charge of consolidating the three railroad lines that had been serving the run from Paris to Marseilles; he was named secretary-general of the Paris-Lyons stretch; and his participation in an international research council on the Suez canal seemed assured.

A final comment on the ideological connections with Vienna is appropriate here, for it explains Enfantin's fixation on that city for the first performance of Moses. Heinrich Heine had presented Enfantin with a copy of De l'Allemagne, which he dedicated to Le Père together with the acknowledgment that he was the most considerable mind of their time. Enfantin repaid the compliment with a long lecture on, among other things, Heine's misconception of pantheism. The points of divergence appear to have been what Enfantin called the political character of religion, the practical nature of pantheism, and the leadership role of Austria in European affairs. He defined religion as a living politics, for its essence resides in its binding quality, its capacity to unite men in the solving of problems political, moral, artistic, and industrial. By Saint-Simonian proof he judged the pantheism of the philosophers (Spinoza, Goethe) non-religious, for religion rests on politics and underlying social and economic conditions. In

its political and social implications, therefore, Saint-Simonian pantheism separated itself from indifferentism, most especially in the concern for the well-being of matter. Since material wretchedness destroys the image of God, it is in its political and social implications that Saint-Simonism understands the law of progress in nature.[35]

Just as Saint-Simonian leadership in capitalistic enterprises could be readily justified, so Austria could become the exemplar of primary Saint-Simonian norms: authoritarian order and hierarchy, a sense of duty, and, above all, of peace. Contrary to liberal opinion, Austria had earned its priestly role of leadership in Germany "precisely because she had resisted the blandishments of French revolutionary ideas with which the other German states were intoxicated."[36] As described to Metternich by Enfantin's diplomatic messengers, this support of Austria's leadership role, based on Saint-Simonian analysis of its moral basis, was expected to win the Prince over to the projects: immediately to the railroads, eventually to the canal. Thus, David's projected oratorio, the joint creation of Saint-Simonian prophet and high priest, was expected to emerge triumphant in a joyous statement embodying the same generous social sentiments, religious, political, pacific, and harmonic that had nurtured the genius of Gluck, Haydn, Mozart, and Beethoven.

Enfantin's plan for "propagating " *Moses* in Vienna foundered not through neglect and mismanagement alone. Like Le Père's princely apostolate, the Vienna production died of ideological overkill. The wonder is that the composer himself survived. The lengthy exegesis of materialistic pantheism to Heinrich Heine cost Enfantin a friend: Heine quietly withdrew his dedication and transferred his respect to Karl Marx. But apocalyptic humanism in large doses seems to have kept the musician at his awesome mission, that of being the charming, moralist composer not merely for France but for all humanity.

Eventually even Sylvain Saint-Étienne's turn of phrase responded to Enfantin's style. Through devotion to his friend, he reported, he had abandoned country, family, wife, children, everything. David had been held too long to composition without words. "There are rhythms without regular cadences, and it is necessary to be more a musician than a poet to put words to them."[37] Between them, David and Saint-Étienne had at last managed to put first things first. Accordingly, the oratorio had its premiere on 24 March 1846 at the Paris Opéra. Maurice Bourges in the *Revue et gazette musicale* took the lead in a line of criticism which marked the work for early oblivion. Referring to David's use of "bits and pieces of old material dating back to the days when the Saint-Simonians pitched their tents at Ménilmontant and David wrote songs for them," he implied

that what was good for the party was not necessarily good for music.[38] Renaissance parody techniques had long since passed out of mind. The self-quotation which was once an impetus to invention was now viewed as a sign of failing creativity.

The appeal to popular feeling through choral declamations in the rhythms of religious processions and pilgrim marches fell short of its mark. The promised land yet remained a Saint-Simonian abstraction, while the Arab fantasy in *The Desert* continued to mesmerize a public already sick, as Gautier and Heine were telling them, with exoticism.

Further, it was considered imprudent on David's part to challenge two powerful renditions of the subject, one in marble (Michelangelo) and one in gold (Rossini's *Mosè*). The latter, particularly with the dramatic final chorus of its French version, had thoroughly captivated Paris. And by reducing scripture to dialogues and monologues in prolonged recitative David had taken the risk of boring a public with no perspective in the conduct of religious music other than what Italian opera gave them. They required, as Heine put it, rouge on the cheeks of religion.

David had foreseen the necessity for a contrasting *affettuoso* component to "attenuate a bit the monotony of so grave a subject," and this component was supplied, according to doctrine, with the seductiveness of *La Femme*. To this end, David informed Le Père, "We have added a plaintive romance sung by a woman at the end of the cries of revolt of the Hebrews. This will go very well."[39] It did, and critics agreed that it was the saving grace of the work.

The Romance is in the exquisite taste of David's best songs, making an almost Bellinian effect in its touching nostalgia. At the same time, the amplitude of the melody goes far beyond anything known to the national genre. Although the strophic form of the melody is retained, choral intervention heightens the expression by pitting its mood of unhappy exile in the desert against the dreaming young woman's voluptuous yearning for the milk and honey of the promised land. David was to make further good use of this kind of piece. With Berlioz, he shares credit for emancipating the romance by imposing on it the vocal style of the lyric theatre and the expressive instrumental usage that came so easily to David in his symphonic odes. Every opportunity offered by the text is attended to: a slight waving of the accompaniment at "Je gémis et je pleure (I groan and I weep)," a livelier rhythmic motive and an octave rise in the melody at "L'espérance," the light tapping of the near-Eastern drum punctuating indolent strings and alluding to the locale—all these are carried through without affectation. Altogether, the piece points to the qualities that will distinguish the future composer of lyric opera.

Above all, the opening pages of the oratorio should be cited for the

touching portrayal of Moses, fourscore and four, rising laboriously to the top of the mountain. He is definitely not Michelangelo's colossus. Weary and pained by his protesting people, suffering tormenting doubts about which he speaks directly to God, Moses receives, along with his answer, the instrumental play of early morning light on his face. Ensuing declamatory portions disclose the message received, straight out of one of Enfantin's moral lectures. Moses, like Orpheus, Jesus, Mohammed, Charlemagne, Gregory VII, Luther, Napoleon, and Saint-Simon (Enfantin classed himself with all of them), was a loving Father raised above the multitude by his gift, a moral passion with which he persuades his people to mutual affection, the joys of paternity, and the blessings of filial obedience. Mankind had lost its way in rebellion and revolution. There are no enemies. There is simply work to be done.

One after the other, reviewers were only too happy to report that *Moses* had been received at the Opéra by "a sad and silent assembly."[40] Henri Blaze de Bury, more thoughtfully than his colleagues, tempered his criticisms with a prophetic guess. Had not ill-advised friends derailed him, David would long since have been on his way "with his melodious tourism" to the opéra-comique of his true inclination. "To reach Favart by way of the Orient may seem like the long way round, but who knows, it may turn out to be the shortest route of all."[41] In any case, a Biblical epic was "impossible in our times, when religious feeling no longer serves the masses, so that the austere unity of style indispensable to works of this order must necessarily appear monotonous."[42] And since David was known to share Berlioz's enthusiasm for Carl Maria von Weber, Blaze allowed himself a final amusement not entirely inconsistent with the evidence. Having reproached the librettist for his "heavy and rebellious alexandrines" and the composer for "the obscure and declamatory character which unfortunately runs from end to end of the score," Blaze turns to the orchestra:

> The program takes care to announce that Jehovah manifests himself to Moses amidst lightning and thunder. This is a necessary precaution, for without it nothing in the music indicates the solemnity of such a scene. We have here a storm like many another, with the piccolos imitating the flashes of lightning. Caspar invoking Samiel at the crossroads of the Wolf's Glen went about it no differently. At any moment I fully expected the singer in the role of the Prophet to break into the sacramental formula: *Erschein, Samiel, erschein!*"[43]

The passage openly appropriates one of Heine's bons mots, and is followed by a note on the opening night's performance: "They say at the

first performance of Méhul's *Jeune Henri* the parterre, dissatisfied with the work, made them lower the curtain and repeat the overture. So moved was the present audience to reassure an interesting personality from the unhappy consequences of failure that I fancied they would demand a replaying of *The Desert*."[44]

Moses did fare somewhat better in its second performance, but the projected blend of Mosiac myth and industrial management seems to have had little effect on the outcome. According to Blaze de Bury, David's oratorio managed to set off "a sacred delirium out of which we may expect to see morality plays succeed our operas in five acts."[45] Berlioz's *Fuite en Egypte* was such a piece, published in advance of *l'Enfance du Christ*. And one of the earliest of these biblical "auditions," as they were also called, was the young César Franck's Biblical eclogue *Ruth,* introduced at the Paris Conservatory on 4 January 1846. It is noteworthy that, although a number of critics spoke of a fall from Handelian high style in these works (the Reaper's Chorus in *Ruth* is a scherzo, and the temptation of Saint Anthony in Josse's oratorio of that name is conveyed in a saltarello), no credit accrued to *Moses* for the intentionally large role David gave to choral declamation, to the Israelites' reiterated cries of distress and hope, to the deeply felt *Romance,* to the symbolic Egyptian dance—all responding to the single purpose and verisimilitude which the elite critics called for and, in Biblical parlance, heard not.[46] No wonder David was persuaded to introduce the mystical Christopher Columbus of his next work in a barcarolle!

9

Christopher Columbus

*I*F THE PIOUS ARDOR that sustained David throughout the composition of *Moses* failed to impress Paris, it was abundantly clear that his seductive Desert Symphony would continue to appeal to consumers jaded by the usual musical fare, which he called "cold and colorless, like the century itself."[1] The time had come to capitalize on that success with another ode-symphony that would invoke nature and the social good. Thus a third exotic pilgrimage was invented for David, predicated as usual on the underlying Saint-Simonian religious message. Doctrinal single-mindedness and opportunism now combined to set David a subject worthy of the functional epic as proposed by Barrault. The latter had proclaimed the epic as a popular form of an exemplary organic period, one with universal sentimental appeal. Now the symphonic ode became its analogue, adding to drama's power to unite people in a community of thought music's power to inspire in them a community of feeling.

The scenario for *Christopher Columbus, or the Discovery of the New World,* concerned with departure, sea voyage, and discovery, answered to purposes of a practical kind. First, the pantheistic intimacy of nature which Beethoven had brought to symphonic music and Weber to German opera would again be experienced in a French music representing life's great solar forces and the cycles of nature. Obvious symbolic intent lay behind the choice of subject, for the Saint-Simonians thought of themselves as discoverers comparable not only to Newton and Galileo in their divers ways, but to the inspired Columbus as well. The initial recitative makes this plain.

> Ocean unknown, stormy Atlantic,
> You are about to divest yourself of your mystery.

103

> Courageous navigator excited by glory,
> Columbus has divined the fortunate primitive shore,
> The rivers, the deserts, and the islands.
> Ocean, the hero is about to leave Iberia
> For what will henceforth be another country.
> And to frighten him is in vain,
> For he already contemplates in the new promised land
> The magnificent world he sees in a dream.

Prosper Enfantin, father of corporate railways and other public enterprises, was obsessed throughout his life with a mystical universalism which came to him in dreams and visions. One was the unification of Europe and Asia that he symbolized by means of images conveyed not only to his apostles, but to more worldly people who could be inspired to promote his projects in the proper high places. Thus, it was Ferdinand de Lesseps who invented the great financial plan for the Suez Canal which pleased both Mohammed Sahih and Napoleon III. But the rainbow de Lesseps is reported to have seen near Suez, which he interpreted as a divine revelation, must have originated with Enfantin, for de Lesseps was not a contemplative type.

David was such a type, but this time he did not travel. The delights of taking down indigenous tunes had to yield to those imaginary harmonies of nature at the center of the continents and the seas where, according to one of Barrault's legends, the nuptial couch of the Orient and Occident was to be located. One met Indians there, and they, together with the wind, the ocean, and some recalcitrant sailors (not to speak of a large orchestra) were more than enough pretext for an exotic and symbolic net to be cast.

In the text, David was assisted by a triumvirate of authors, each with a different capacity. Presumably Charles Chaubet, later to provide new texts for David's Saint-Simonian hymns as well as poems for his most conspicuously tendentious songs, pondered dogmatic matters. Joseph Méry, whose understanding of the exigencies of French opera was to bring him to Verdi's notice for his French *Don Carlos,* was a glib versifier who would take care of the modish poem. Devoted friend and protector of Gérard de Nerval, confrère of Baudelaire, Gautier, and Champfleury, he was no stranger to the intellectual currents of the time. And lastly, as usual, David's faithful friend Saint-Étienne took as his special task to reconcile his colleagues' artistic responses with Le Pére's doctrinal priorities.

For the composer, the conditioning of artistic actions to the ritual framework of the cult was no problem. He had faith and years of practice.

The Saint-Simonian movement had been in decline for a dozen years, but its attribution to the artist of an unprecedented motive power in human relations flourished among France's mid-century intelligentsia. This belief appealed to their idealism and encouraged artistic egos long damaged by such profound isolation as that described by David in his early letters. Like Heinrich Heine's commitment to Saint-Simonism, the inspiration came less from Saint-Simon's original socialist theory than from the singular intellectual elite, the poets and philosophers, whose conversation artists were now invited to share.

If no great romantic poets, artists and musicians converted formally to the cult, it is not accurate to say that the Saint-Simonians produced only "religious ditties."[2] They had in Félicien David a talented composer, albeit one who responded naively and wholeheartedly to the surrogate religion and its myths. The religious ditties of his youth were now behind him and, as we have seen, he had produced two substantial concert works relevant to Enfantin's industrial-pantheistic inspirations. He had learned to pray to God in a manner very different from that of Christian piety. And he had been persuaded to enchant the multitude and lead them to pacific change with love and hyperbolic paeans to industry:

> . . . by a rapid succession of seductive tableaux to make visible the richness, the fecundity of nature; to sing of God in his infinite beauty; to celebrate the power of man who fashions the exterior world to his own uses and subjugates it like a horse going into battle; to raise noble trophies to industry; to exalt love and her pacific conquests; and to make all eyes turn to the blinding image of that glory that crowns the victors to the applause of the enchanted crowd.[3]

Barrault's spectacular teaching methods had included the use of so-called interventions, in the course of which he customarily summoned such notables as Shakespeare and Racine from their niches in order to confront them with oppositions of form and content, the internal and external worlds of man, classicism and romanticism, spirit and wisdom, and expressions of "force, matter, and beauty." A lofty summation then informed the artists that it was their destiny to associate in progress and to unite in a new art inspired by the utmost love. "Hark! for our poetics is indeed a religion, for the regeneration of art is that of society."[4]

Further, Barrault gave the musician special permission to proselytize for the new religion with two voices, "one soft, pure, pliant, restrained in its instrumentation and melody, the other clamoring with more sono-

rous instruments interpreting joy, combat, and all manner of active ardor."[5] Is it just here that Berlioz, who read *Le Globe* attentively, found his idea of contrasting tableaux inspired by a diverse phenomenal world?[6] In *Christopher Columbus,* David's field is even more plainly circumscribed by Barrault's ocean, lapping the shores of two worlds to be united in hope, love, and peace.[7] So much for the preordained social character of David's new composition.

Columbus was introduced on 7 March 1847 at the Paris Conservatory for the benefit of the Association of Artist-Musicians. Critical opinion was mixed. On the one side, Gustave Héquet, writing in *Revue et gazette musicale de Paris,* found the new ode-symphony appropriate to the narrative subject but wondered whether the repetitive orchestral formulas—drum rolls, string tremolos, busy scale passages, growling cellos, whistling piccolos, crashing cymbals—could reasonably go on bearing their descriptive burdens.[8] On the other, Émile Deschamps, Berlioz's temporary replacement on the *JD* and perhaps intimidated by the effusive review of *The Desert* which the absent "king of criticism" had left in his wake, obliged with poetic pictures for each scene and reported continuous applause from the audience.[9]

Héquet, noticing a few important Saint-Simonians in the crowd, mocked their edifying zeal. "We must help one another; it's nature's law."[10] One way or another, the Saint-Simonians were attracting attention to ideas whose time had come. First, they taught that conditions could be shaped so that man might live his true human life. Second, they lost no opportunity to assert that pleasure was a positive value in this shaping. Universal harmony could be induced by pursuading men to do for pleasure's sake what civilized society gets him to do by threat and coercion.[11] That this had to do with music was recognized in a thoughtful review of *Columbus* by Edouard Fétis, son of François. "The spirit of the time in France is against simply writing music," he wrote. "It must be philosophical, historical, legendary."[12] And Heinrich Heine had long since declared that music is interesting when it represents.[13]

The première audience included Saint-Simonian friends, but they were friends like George Sand, who held to an idea of music similar to theirs. Music could indeed represent, but what it represented was an ideal harmony of nature and human nature in a manner "more exquisite and vast than the most beautiful landscape in painting."[14] Travelling in the Engadine, she was instantly reminded of Beethoven's colorful Pastoral Symphony. Landscape and music activated her imagination with the same spiritual horizons. Not surprisingly, Émile Deschamps, listening to *Columbus* in the concert hall, was able to say the illusion of rising and falling

LE DÉPART.

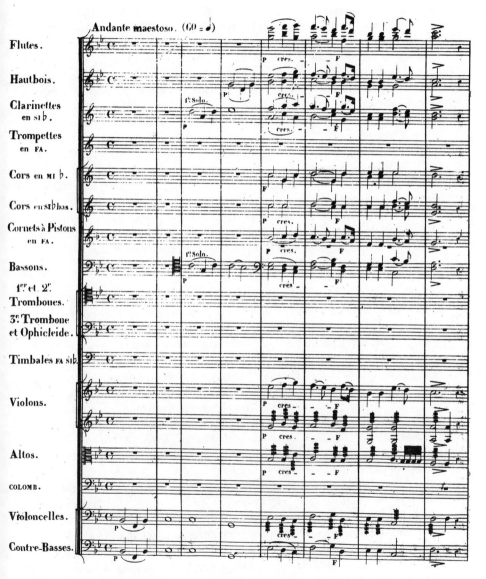

Musical Example No. 5. "Le Départ," opening (*Christophe Colomb*, Part I).

waves was worth far more than any operatic staging, "in my opinion the worst of falsifiers."[15]

At the same time, the qualification "characteristic" borrowed from Germany had taken hold in the French press.[16] When, as a young student, Félicien David confided to his friend Sylvain that he was not a romantic like Auber and Rossini (God keep me from it), but a romantic like Beethoven and Weber—"that is to say, new, original, *caractérisé* like them"[17]—he was under instruction to divorce himself from the devitalized condition of contemporary music. As time went on, the specific areas of feeling that were thus assigned to Beethoven's symphonies and Weber's fantastic operas expanded to include Berlioz and Meyerbeer as well as David and his imitators.

In his long essay "The Spirit of the Time in Regard to Music" (1859), Blaze de Bury made the *caractéristique* a central point in his discussion of the high principles embraced by Meyerbeer's eclectic style. Preeminent among these was German "truth of expression." For Blaze and others, it was in terms of this profound representation, ultimately German, that David had failed. In place of broad human affective states, Blaze could find only a number of colorful clichés imitated from Beethoven and inevitably trivialized in the transmission.[18]

The titles of *Columbus'* four parts indicate the illustrative intent of the music: "Le départ," "Une nuit des tropiques," "La révolte," "Le nouveau monde." "Departure" sets the stage with a reminiscence of the cloudy opening of the Adagio of Beethoven's Ninth Symphony and, indeed, of the cumulative effect of that same symphony's wondrous initial page. Entrances are staggered on color levels. Cellos and basses announce the key of B-flat. Bassoon and clarinet then set forth in C, blurring the sense of key briefly. Flutes, oboes, horns, and violins proceed in sunny crescendos over cello and bass tremolos (Musical Example No. 5). Then the famous Davidian pedalpoint is planted in violas and violins while cellos and basses resume the original figure.

After the invocation to the Atlantic, Columbus sings a barcarolle. Not that he neglects the weighty things on his mind ("Let us depart, heaven disposes, subjugate the deep, we merit the crown of immortality"), but a barcarolle was an appropriate attention-getting device. It recalled the hero's Italian origins and, in general, the notion of singing on the water, whether by Venetian gondolier or Genoese seafarer. The uniform movement of waves and ship executed in a pretty orchestra of clarinets, horns, bassoons and strings put the audience in an excellent humor.

The air and chorus "Faithful friends" (*Amis fidèles*) expresses the first of two lengthy quotations from David's early Saint-Simonian music.[19] A duet of lovers follows: they will be parted by the voyage and, we are to understand, by its apostolic purpose; the tone, therefore, is not lugubrious. The barcarolle endures and, according to Deschamps, the audience continues to applaud. Part I ends with a plaintive folkish prayer for chorus and full complement of winds and strings.

A Night in the Tropics enchanted the audience. David's pedals, which served earlier for morning awakening of the sea, now contemplate its profound slumber. Wisps of melody floating and sighing in the woodwinds over muted strings create the much admired mist that frequently enveloped David's orchestra. It is, wrote Deschamps, one more proof of music's ability to borrow from painting and to surpass it. Once again David had his critics groping in the imitation of nature question.

If Beethoven's notation at the head of his Pastoral Symphony could be taken as a guide to the balancing of emotion and tone-painting, then Beethoven clearly meant to persuade us more to one side (the first) than the other. David's process was perhaps heading in the other direction. Taking advantage of the melodrama which permitted him to make his contingencies precise, he was free to draw on the seductive powers of the modern orchestra. That he succeeded is plain from accounts of the audience's reaction.

Counterweight came from another direction—from the old high and low style controversies of the ancients and moderns. David's Atlantic is anything but the "Mighty Ocean" of Weber's *Oberon*. It is dappled with melodic shapes floating in and out of the texture while pretty shades of instrumental color integrate them with the static basses. The result is as pleasing to the ear as a decorative painting to the eye. But what would this mincing grace and protracted reverie do to the heroic proportions and dramatic weight of the classical symphonic ideal?

Paul Scudo, writing in *RGM*, hastened to join the argument after David's *Columbus* and Berlioz's *Damnation of Faust* had reached the concert hall within a few months of each other. His adjudication of the topic "The Symphony and Imitative Music in France" involves both composers.[20] Music, says Scudo, is indeed playing an important part in the maturing of the intellectual movement initiated by Rousseau, Chateaubriand, and Mme. de Staël, a movement raising a curtain on nature while at the same time restraining the winds of fantasy rampaging across the Rhine. The time was ripe for a new symphonic departure (France had completed her education and formed her taste under Habeneck), but Scudo doubted that the confusion of genres in the ode-symphony would lead to a definitive so-

lution. The future, he suggested, might well lie with Mendelssohn, with a coupling of the romantic response to pictorial impressions and a renewed mining of the resources of sonata form. The paths, in fact, remained separate. Mendelssohn's "Fingals's Cave" led to Wagner's *Flying Dutchman, Rheingold,* and *Tristan,* while sonata form and the "internal landscape" became Brahms' province.

Curiously, Scudo speaks to Berlioz in the language of Barrault, leaving the impression that Berlioz had perhaps gone to the right school but had misunderstood "the movement of modern society."

> A vast tableau must be invented to paint the river of life, now swollen by storms, now reflecting in its limpid waters the enchanted shores that it touches; reproducing with instrumental color the infinite harmonies of the outside world. In short, man has learned to invest nature with the breath of his inner life . . . With our ears we refine her sonority and fashion out of her thousand scattered noises a harmonious concert. She lives and breathes only through us, changing her form, moreover, according to the moral disposition in which we find ourselves.

To Scudo, the Pastoral Symphony symbolizes for all time "the nuptials of the human mind and nature, so long separated by the austerity of Christian spirituality." This is patently Saint-Simonian talk. Where, asks Scudo, has Berlioz gone wrong? And he answers: by pursuing puerile detail, by violating the notion of *caractère* as to nature, the peasant, and the plenitude of communal joy. The last two Scudo could not reasonably have held against David, as we shall see.

But where had David gone wrong? For Scudo, the new piece lacked that ingenious unifying tool of *The Desert,* the caravan march. An acute observation, but Scudo stopped short of adding that the latter made superb use of a musical tool in the service of the Saint-Simonian social message. Never exact in the repetition, but modified contrapuntally, sonorously, and dynamically according to events of the voyage, it tempered in interesting musical ways the constantly reiterated motif of the march toward the general good.

In the second symphonic ode, the composer and his writers seemed to be seeking means of enlarging both the pictorial and the musical scope. The score is much longer, and the organization suggests greater emphasis on narration and opportunities to display the composer's as yet untested talent for operatic composition—recitative, solo, duet, mixed chorus, ballet. But even here Scudo put his finger on a defect. David's inability to

Figure 5. Honoré Daumier, "Battle of the Schools: Idealism and Realism." In *Le Charivari*, 24 April 1855.

"paint the energy of dramatic passions," so marked in *Moses*, still handicapped him in dealing with his new hero.

Again, Scudo might have added to his case with the observation that David's portrayal of Columbus attracted but little attention to his persona. He sings a barcarolle in the beginning, and a chorus is addressed to him in the end. The revolt of the sailors is subdued quickly and quietly. This is not the hero of a Spontini opera, such as *Fernand Cortès,* so much admired in Paris, but Enfantin, father of a new religion. Just as in real life Enfantin preferred the role of benevolent authority to an active political career, so Enfantin-Columbus walks over the waters in this ode as he had done in David's song "l'Océan." He is, as ever, the great voice of Saint-Simon, the great seeker of the world invented by him.

As 1848 loomed, the subject of the true characteristic symphony was surely not the most pressing topic of the day. Nevertheless, reviewers continued to buzz about the destruction of the symphony for the sake of description, and the introduction of popular song, ballades and romances

in place of the old development section. With respect to both popular song and the fantasy "rampaging across the Rhine," David was now at the center of France's newest combat of the styles, a musical controversy paralleling the artistic (see Figure 5). Ironically, David was being accused of neglecting the very idealism that he espoused. His ballads (there are three in *Columbus*) point not only to questions of social justice but to the importance of popular expression in music. The "Chanson du Mousse" and "Le Quart," both in Part II, and "La Mère Indienne" in Part IV are paradigms of romantic humanism: the child (mirror of nature, source of all wisdom), the folk (embodiment of the nation), and the mother (legendary symbol of social regeneration). All convey their melancholy moods in simple, unelaborated expressions.

The cabin-boy is an orphan. He is society's responsibility, no less than "women and people." Left alone to brood over the terrors of life before experience, the orphan rocks on the gentle sea that is now his only home and mother. Félicien David was himself an orphan, but, unlike Childe Harold who would always be alone, the Saint-Simonian orphan is safe on the ocean that binds the world behind him to the world ahead. He is a point in the immensity, a moment in eternity, a sigh in universal life, and blessed by God.[21]

No word-painting intrudes in the text of the second verse: "Life is bitter for the forsaken child, never caressed with a mother's love." The orchestra rocks confidently on bass strings, while higher strings occupy middle ground between sky and ocean. An interlude offers interplay among English horn, flute, oboe and bassoon, and the same charming material recurs at greater length for the coda. As if awakened by this melancholy small voice crying in the midst of nature's opulence, bucolic genies of the ocean begin to vocalise over arpeggios in muted lower strings, another of David's mannerisms cherished by audiences and colleagues alike. The critics occupied themselves with painterly analogies, some supportive, some pejorative. Years later Paul Scudo was still talking about David's *gris*, perhaps to show off what he knew, through Baudelaire, about Delacroix's special color.[22]

While the "Chorus of the Genies of the Ocean" (see Musical Example No. 6) shows every sign of having been inspired by Weber's "Spirits of air and earth and sea" (*Oberon*, Act II), David's seascape displays a variety of instrumental color that could only have been buttressed by Berlioz's practice. Weber's texture, refined and economical, exudes the nocturnal warmth of an exotic air, its distance defined by the opening horn melody. In David's genre piece, the action is close at hand, crowded, and less evocative. Splashing harp, calm and level sea trembling on muted strings, per-

Musical Example No. 6. "Choeur des génies de l'océan" (*Christophe Colomb*, Part II).

vasive repeated notes in voices and instruments, flutes and clarinets softly
doubling the vocalise, English horn solos, double basses *divisi,* violas dou-
bling winds in unison and octaves, a banal chorale—all work not so much
toward Weber's primary image, the fall of fairy feet, but to Weber's evo-
cation of the joy of floating on the sparkling water ("O, 'tis pleasant to
float on the sea." A rare touch is the patch of vocalization on the vowel *O,*
which may remind a twentieth-century listener of Debussy's *Sirènes;* Da-
vid himself may have been aware of Spontini's use of the device in his
1822 opera *Nurmahal.* Even when men's voices add words, there is no
emotional rise. And it is perhaps too early for a musician to be thinking of
the blurring of harmonies and timbres with which impressionism would
evade banality. On the contrary, for a Saint-Simonian, vulgarisation was
the prescribed goal. The listener was supposed to collect a pleasurable sen-
sation rapidly. At least one biographer of Columbus, the Baron Bonne-
foux, congratulated David on enhancing a well-known story with a new
descriptive style.[23] It may be noted that Lamartine, in reworking Wash-
ington Irving's biography of Columbus, added equivalent literary flour-
ish: "The Ocean with its freshly levelled surface; the sun without cloud or
limit reflected as in a second sky; the caressing waves crowning the prow
with light foam; the harmonizing dolphins bounding in their wake; the
fish flying, rising and coming to rest on the decks—the entire sea seemed
inhabited [and] all of nature seemed to concert with Columbus to inspire
his thoughtless sailors with renewed hope."[24]

Near the close of this chorus, David assumes the 6/8 meter of the be-
ginning of Weber's pastoral, and the summing up is accompanied by "di-
vine lutes" (harp pedals) and magical woodwinds, including two English
horns. The final Saint-Simonian command repeats the burden: "Be unified
in this moment, this sweet moment."

Both scores then turn to simple song. Weber's Fatima dreams of Ar-
aby. David's "Le Quart" emerges naturally out of his preceding moonlit
fantasy. The melody set to Fernando's first words, "O sea, in which night
weeps," (*O mer où la nuit pleure*) had been announced by the clarinet (Ber-
lioz's "heroic voice of love"). Preparing for the folk song that is to follow,
Fernando's melody alludes to the Arabic *Mezmoum* mode of popular Span-
ish love song, an E scale with the second degree usually omitted: E (F) G
A B C D E;[25] only David's tune ("The Spanish song will soothe my
grief") pitches this mode on C (see Musical Example No. 7).

Fernando's Baudelarian reverie speaks to the marvelous clouds and
the intoxicating night. He implores his companions to calm his sense of
loss in the missing loved one. A sailor responds, and the other sailors take
up the refrains. The song is charming in itself and entirely in accord with

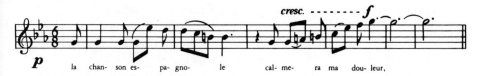

Musical Example No. 7. Fernando's "Rêverie," ending (*Christophe Colomb*, Part II), voice part only.

those Rousseauesque touchstones of the 1840s, the natural and the naive of which George Sand and Franz Liszt spoke on their walks in the country. They were not alone. The writing of Chateaubriand, Dumas, Musset, Balzac, Baudelaire and Nerval abound in high-flown phrases about the classical and solemn singing of the people and the importance of the modalities of popular music in the musical culture of a nation.[26] Joseph Méry's collaborations with Gérard had given him a fair amount of insight into these characters exiled on the pavements of Paris with oriental dust on their wings. He met and encouraged David's natural spontaneity and simple touch which was not make-believe. The prodigality with which David spread his upper and lower pedals to support images ranging all the way from the immense Atlantic to the veiled night, the silence surrounding ships at sea, and the distance between sky and land, may seem simple-minded to a post-impressionist critic. But the pantheistic reverie and the management of the archaic ballad together correspond to personal traits and sincere preoccupations of the composer, and their reunion in this place is both original and characteristic.

David's sailor and Berlioz's King of Thule (Marguerite's song in *The Damnation of Faust*) have a great deal in common, much as the landscape of their pieces differs. Berlioz's characters gallop about in different locales and pandemoniums, while David is necessarily limited to his symbolic sea voyage and its optimistic destination. But their idyllic folksongs share the simple and ingenuous "small style," and both are ballads of requited love. Both also cadence with holds on the dominant of the dominant. Since each of David's lines is repeated *tutti,* a communal touch that Berlioz's piece lacks, the tune is repeated eight times, always cadencing in the same way and never resolving.

It is no accident that David's sailor sings not of a king, but of a man of the people "without doublet and jewelled collar" who will win the hand of the beauty "without beads and mantilla." Berlioz's liking for unison and octave in the orchestral fabric was generally regarded as barbarism,

one of many in his handling of melody and harmony. But David makes in-
genious use of it in his real *barbarie*. Since the individual lines are distinct
in tone color, the doublings, while adding nothing substantive to the fab-
ric, create a kind of harmonious sonority that David might have carried in
his ears from the East. Berlioz's attraction to the device seems to have been
intuitive. We have no reason to think that he knew anything about an-
cient or medieval means of improvising music in parts. He did write in
his treatise on orchestration that the means of which we are speaking had
"singular charm" for him, possessed as it were of "a vague and secret
harmony."[27]

On the other hand, some things clearly go back to Beethoven. Da-
vid's experience of the slow movement of the Pastoral Symphony stands
suggestively behind his quiet folk melody carried through the orchestra in
unison and octave couplings.

The "Bacchic Chorus" following in Part II profited, according to "E.
Ds.," from resemblance to the chorus of dervishes in Beethoven's *Ruins of
Athens,* but the critic shuddered at its Saint-Simonian claim that wine re-
doubles religious enthusiasm, which guides the craft through the throes of
achieving a brave new world better than any compass. The message was
readily received and just as readily subjected to ridicule, as were other rev-
elations of the time-spirit. Charles Baudelaire wrote a wine cycle in 1843,
later published in *Les Fleurs du Mal.* It is addressed to the same "divine
liquor," and it exudes the same sentimental religiosity as George Sand's
"generous grape."[28] These sentimental façades functioned in exactly the
same way as those of Jean Millet and Félicien David when they portrayed
poor reapers and despondent sailors in the throes of their labors and in the
enjoyment of their sentimental consolations. There is, of course, the dif-
ference that David uses a Berlioz-size orchestra to project his shipboard ca-
pers, introduced humorously in unison bassoons and strings (see Musical
Example No. 8).

Inevitably, the storm and its calming fall due. Romantic critical ef-
fusions can fly no higher than Émile Deschamps' paragraph on David's
storm.

> We shall not analyze in detail the instrumental procedures which
> make this storm one of the masterpieces of descriptive music, but we
> do not believe that the imitation of nature can be pushed any further.
> It is not only the noise and the fracas. It is, in a grandiose and terri-
> ble ensemble, the reunion of the million accidents that accompany
> the great commotions of the globe. Another tempest arose in the
> hall. The most frenetic applause, the most Italian that we have heard

Musical Example No. 8. "Choeur Bachique," orchestral introduction (*Christophe Colomb*, Part II).

since the day that the Pastoral Symphony and the Allegro of the
Symphony in C minor were truly understood by the public.[29]

The calming goes unmentioned, but it recalls the melodic cast of the
"happy and thankful feelings after a storm" in Beethoven's Pastoral Sym-
phony and adheres, complete with drone and 6/8 meter, to the *Ranz des
Vaches* stereotype.

More useful than the revival of the classical imitation of nature ques-
tion is a sense for the historical moment to which the critic speaks. Hab-
eneck had indeed been presenting with his conservatory orchestra excel-
lent performances of Beethoven's symphonies. It is worth noting that,
although the Pastoral is exceptional within Beethoven's symphonic cor-
pus, the time-spirit in France had singled it out for particular sympathy.
Thus David imitating Beethoven was acting not only on one of the oldest
directives for the imitation of nature (imitate Vergil!), but on one of the
most recent, the Saint-Simonian concern for the communal nature of art.
In that light, composer, orchestra, and educated audience acted together
as coauthors.

Operationally, whether or not programmatic devices are original is
less important than the thought embedded in the clichés effecting a storm
and its resolution, ostensibly in nature, actually in the human heart. A
critical society, subject to constant accidents of injustice, "saves the child
who suffers and calms the one who is distraught."[30] In the new, loving
society, such stresses would be exceptional.

Part III, "The Revolt," is actually a recasting of the preceding, and
the Paris audience was understandably restive. Quite simply, the uneasy
feelings of the long, trying voyage ("Where are the fortunate shores?")
provoke rebellion. The Saint-Simonians were socialists, not republicans or
communists. Since the promised land could appear only with pacification,
the prophet Columbus-Enfantin must reestablish a fraternal ambience
before dreaming nature can open wide for the Saint-Simonian march to-
ward general good. In the end, the praise Enfantin had hoped to garner for
the sermon on the mount in *Moses* came instead for "one of the prettiest
tempests ever to agitate the hundred voices of an orchestra."[31]

With Part IV, "The New World" and the opportunity to picture a
spring dawn, David was again in his element. The folk idiom reappears
— not merely the land, but the singer who lives on the land, the peasant
with naiveté and freshness untarnished, the stuff of George Sand's real and
true in nature. The melody of the Indian mother's lullaby hardly exceeds
the span of a tetrachord. The constant, even rhythm of a pastoral drone
regulates the flow of the song, at the same time providing a far-away osti-

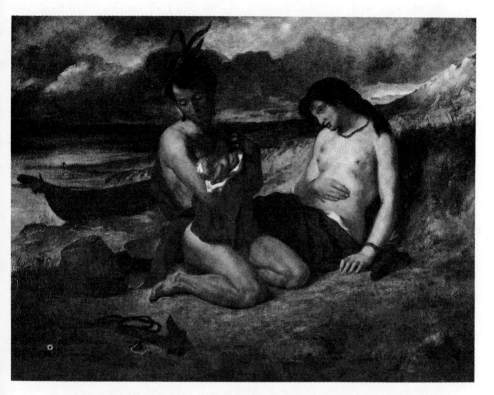

Figure 6. Eugène Delacroix, *Les Natchez* (1824–1835). The Lord and Lady Walston Collection, Royston, Herfordshire.

nato bass, as in Chopin's *Berceuse,* op. 57, published in 1845. David's melody is more primitive than Chopin's: perhaps he was thinking here of songs heard in the East, where the four-note capability of the three-holed flute enabled it to double the singer throughout. But the accompaniment is enriched in the second and third couplets with English horn and cello counterpointing elegantly with the voice.

The desolate young mother, like the young Israelite in *Moses,* is Woman, if not the longed-for Mother of Saint-Simonian theology. One listener at a performance conducted by the composer many years later found this touching elegy reminded him of Chateaubriand's *Natchez.* He must surely have been thinking of the lines: "One hardly knew if one had been present at the beginning or the end of the world: a little bird, like

the one that sings in our woods at night, let us hear a plaintive warbling
. . ."[32] for they are matched by the music. No wonder critics suggested
that David's talent lay not merely with portraying nature in the abstract
but particularly the countryside of his native Provence.[33] Chateaubriand
portrays a people whose pastoral paradise and instinctive rectitude, espe-
cially that of the women who lived by the values of life and love, the
Saint-Simonians would have hoped to succor. Nevertheless, it is not out of
the question that his melancholy little masterpiece may have been sug-
gested by vision of the dying Indian tribes, *Les Natchez 1824–1835* (see
Figure 6). In any case, the audience demanded an encore of "The Lone In-
dian Mother 'Neath the Tree." Héquet in the *Revue et gazette musicale de
Paris* spoke admiringly of its exquisite simplicity, a romance cast in "only
three couplets of five small verses in which not a single word is repeated."
No composer, he added, would be sorry to have written it.[34]

The opening nature-piece of Part IV demonstrates David's success
with sparse orchestration that conveys the exotic simply by tracing a
primitive phrase through the fabric. This time the familiar pedals and os-
tinato figures are called in to harmonize the fresh perfume of water and
birdsong in the clear, filtered light of dawn. Having portrayed his solitary
noble savage in song, David remembers to please the audience with a
dance of savages that offers a fair substitute for the conventional *air de bal-
let*.[35] David's *sauvagerie* is beautifully orchestrated, not without some of
Berlioz's favorite devices—muted strings, violas divisi, tapping *tambour-
de-basque*, high woodwinds duetting "like shepherds in a Vergil eclogue"
(Scudo). Of all of David's exotic dances, it is the most advanced with re-
spect to form.[36] David is now far removed from the great experience of
his life, his expedition to the East. Like the other orphan, he is not yet in a
new and better world, but still at sea. A vestigial exoticism still exists,
chiefly in the primitive drumming, rhythmic-motivic repetitions, and
birdtrilling endemic in the folk idiom of so many regions. But talk of
embracing the Saint-Simonian altar of reconciliation lovingly had, after
all, landed him on the far Western side, and he was likely to stay there.

In sum, David's second ode-symphony, like the first, demands con-
sideration not only in the abstract perspective of its technical components
but in factors from the surrounding cultural world. The lyrical pieces as-
sociating the peasants of both old and new worlds present them as lonely
and isolated in an inhumane solitude. The point of the morality, for that
is what we have here, is the associative element of the hoped-for new soci-
ety. That element is the sea. The composer's great concern seems to have
been the achievement of water music worthy of *Oberon*, which he had
known and admired since his student days. But the basic water piece for

romantics was E.T.A. Hoffmann's *Undine,* held in high esteem by Weber and doubtless also by Wagner. Could it have reflected so far as David's *Columbus?* If so, it was by accident rather than, as in Weber's case, by natural national inheritance.

An undated letter from the unpublished collection of David's letters in the Bibliothèque Nationale, Paris, written to Charles Pillet, shows that he was indeed concerned about ways of acquiring and controlling a suitable orchestra for his unusual work.

> You were right to insist on a bigger orchestra: five violas at the least, better six, and I absolutely must have five double-basses. Please pay attention to the choruses, especially the attacks and the nuances in the chorus of the genies. It is necessary to arrive at a mysterious half-light that we have never attained in Paris, especially at *la voix, la douce voix des génies.* Attention to the attack of the tempest *leffah!*

David writes about a forthcoming performance at Baden in 1869. An earlier letter written to Saint-Étienne in Aix during the actual composition of *Columbus* yields information of a personal nature. He continues to suffer from a typical combination of bronchial troubles and overwork, and has been advised to try the thermal baths. Naively, he fancies this taking the waters will do him a world of good for the hurricane in *Columbus.* "I leave tomorrow for the baths at Dieppe at the doctor's recommendation—also a good study for the hurricane I have to do. The symphony is going slowly because I was sick, but I have finished Part One; Part Two, all but the hurricane; and Part Three, all but the final chorus. At Dieppe I will start to write the score."[37]

Thus, with the help of the baths at Dieppe, David achieved his double aim: a suitable vehicle for a Columbus myth congruent with Saint-Simonism, and an orchestral sea capable of holding the action to the nostalgic suspense of a voyage in the direction of a calm and beautiful world.

The two large-scale works by Berlioz and David introduced to Paris during the 1846–47 winter season had sharply diverging fortunes. For his *Damnation of Faust* Berlioz hired the Opéra-Comique, assembled a full orchestra, and organized a vast campaign of publicity, all to no avail. David's path to triumph in *Christopher Columbus* was relatively easy. He had a crowded hall; Berlioz had a half-empty one. A second performance of the *Damnation* fared no better. Berlioz's "concert opera" was not to reappear in France during the composer's lifetime.

Christopher Columbus had performances well into the 1860s. Initially, David's self-esteem got a tremendous boost from a request for performance

at court, at the conclusion of which Louis Philippe bestowed on the composer the cross of the Legion of Honor.[38] David's musico-descriptive style and the moral-social connections of his output continued to sustain public interest. Exotic research, as the intense preoccupations with the wellsprings of folk music came to be called in the 1860s, resulted in publications like the *Chansons populaires des provinces de la France* by Champfleury and Weckerlin. These two practitioners of literature and music respectively belonged to the new breed of realists who envisaged the expression of moral ideals cherished by mankind in every age. On first performance in 1861, Weckerlin's ode-symphony *Les Poèmes de la Mer* was welcomed as a picturesque essay recalling Haydn's *Seasons,* Beethoven's Pastoral Symphony, Mendelssohn's *Midsummer Night's Dream* and, most important, David's *Christopher Columbus.* Weckerlin's imitation did not fail to include a graceful romance sung by a "mousse" cabinboy.[39]

The parlous state of the Opéra in the 1860s forced on young composers of the new school a battle for recognition similar to that of the realist painters. A musical *salon des refusés* was an absolute necessity. It was located at the hall of the Societé Nationale des Beaux Arts. The room was opened to music by a M. Martinet, who should have been commended, Berlioz observed, for extending a welcome to musicians "who had the bad luck not to be dead."[40] It was here that Berlioz found David conducting his *Columbus* in a matinée performance on 21 December 1862. In spite of the defective acoustics of the room, Berlioz wrote, the piece had been produced with good effect under the composer's firm conducting hand. The *RGM* reviewer Adolphe Botte agreed with him and enlarged on the advantage of the "nuances, caprices, finesses of the orchestra" in the clear and precise directions to an elite group. Botte also tells us that the *Danse de Sauvages* was encored, as was the touching elegy of the young Indian mother, which activated memories of Chateaubriand's *Natchez.*[41]

In the meantime, David had become the father of descriptive music. Younger composers saw an opportunity in David's invention, the ode-symphony, to draw attention to themselves while they waited for acceptance at the lyric theater. It had been a long journey for David, but he had won acceptance three times at the Paris Opéra. This appearance in M. Martinet's hall lent an air of respectability to a school of which he was now a leader.

Columbus was performed for the last time in the composer's lifetime at Baden in 1869. This performance turned into exactly the kind of fête against which Enfantin had cautioned David twenty-odd years earlier. But Enfantin was dead, and David was a celebrated composer, travelling from Paris to direct final rehearsals and performance. According to the German

critic Richard Pohl, the piece had never been performed anywhere with more care. It was a real *solennité musicale*. A large platform had been constructed in the hall and banked with flowers. The whole room glittered with the light of five hundred gas bulbs. The Queen of Prussia honored the occasion with her presence, and the whole thing recalled the great musical festivals conducted by Berlioz.[42]

At this point in his career, a quarter century after his Parisian debut, David, wrote Pohl, "takes his place among the greatest and most celebrated composers of the modern French school. He is one of the happiest representatives of the music called descriptive. He cultivates the poetic element of music with conviction, and—a sign of originality—he is constantly searching for new forms." If *Christopher Columbus* no longer sounds new, Pohl concluded, "it is only because it has so often been copied and imitated. In the *Desert* he had the attraction of novelty, and there he had only one rival—Hector Berlioz."[43]

10

Garden of Eden

THE CONSTITUTIONAL MONARCHY of Louis Philippe, which had been established by the romantic July revolution of 1830, began to unravel in the 1840s. Prosperity by that time had ended for France, and the lowest point was reached in the severe economic crisis of 1846–47. On the eve of the revolutionary upheaval of February 1848, disturbed voices were heard on all sides. In a speech to the Chamber of Deputies Alexis de Tocqueville warned of the danger of social as well as political revolution.[1] Lamartine noted that "a muffled restlessness pervaded society," while Louis Blanc declared that "the phantom of revolution was at every feast." Heinrich Heine, who well knew the social theories of Karl Marx, "had the poet's intuitive sense of the troubles to come."[2]

Meanwhile, on a more positive note, David was writing a new symphonic ode, *Eden*. Enfantin, for his part, was organizing an expedition to Suez. It was accompanied by a vast campaign in the press of all Europe in favor of the breakthrough of the isthmus. Chiefs of state and ministers were alerted. Prince Metternich still refused to support Enfantin, but in France the Duc de Montpensier not only aided but contributed capital.[3] "The Revolution? . . . One more reason to persevere; the canal will be the first great work of the Republic," proclaimed Enfantin.[4] Fundamental social problems were still without answer. The primary battle was to relieve tension between nature and man. No amount of revolutionary destruction would achieve this. Although *Eden* was commissioned as a recreational park piece, the composer had, as always, a special version of the story in mind, a story turning on enlightenment versus superstition. The time was to be perpetual spring, the scene always idyllic.

The Desert and *Christopher Columbus* had been designated as ode-sym-

phonies, while *Moses on Sinai* was called an oratorio. The new *Eden,* however, was termed "a mystery in two parts." It was conceived as a morality play in concert form with a theatrical variety of songs, recitatives, orchestral interludes, dances, choruses—all within a short time span. The tumult of the February Revolution accompanied its composition. But, as seen through Saint-Simonian eyes, revolution suited the myth of creation admirably. Saint-Simon himself had taught that revolution was not merely an event, but an advent, the augury of a new religious and social commitment.[5]

Félicien David was again in his element, maintaining the faith and discipline of his religion through an allegory on the perfectly balanced Saint-Simonian moral and material universe. The manner established in *Moses,* deriving not so much from Handelian oratorio as from an earlier contemplative type, prevails in this second oratorio as well. One critic mentioned the *Ludi scenici spirituali* of "the time of barbary and ignorance," and fancied that David's imitation would have profited from an accompanying "grossly naive" scenic acting-out which would at least have furthered some archeological interest.[6]

Even so, on the face of it, *Eden* should have answered perfectly to the revolutionary zeal of the lyric theaters to persuade their publics that all was best in the best of all possible worlds. Yet the piece was not received well, in spite of innovations incorporated from *The Desert* and *Christopher Columbus. L'Illustration* catalogued David's assets: a certain distinction in the turn of phrases, some finesse of detail in the orchestration, and a nuance of "sweet reverie" entirely original to the composer. The fault seemed to lie not with the music but with the subject and its manner of presentation. The *mystère* belonged to another time and place. A frivolous public now demanded amusing opéra-comique and ballet music with abundant pretexts for pirouettes, entrechats, pointes, ronds-de-jambes and countless other fascinating gyrations.

David undoubtedly had advice like this even closer at hand, for success in the marketplace was considered by his coreligionists a natural consequence of the complete exercise of one's capacity. David had not yet been honored with an operatic libretto. The next best thing was an effort to invest his oratorio with elements from contemporary lyric opera, including scenery, costumes, ballet, and the well-turned French phrase tinged with Italianate feeling.

The librettist Joseph Méry was able to interest a certain M. Bouhain in mounting the piece in a Parisian inner-city public garden (Le Château des Fleurs), welcome as a place to escape the man-made environment. The original plan was to incorporate flowers, trees, costumes, and tab-

leaux elaborately suggestive of a bright and radiant Eden. Unfortunately, bankruptcy necessitated removal to the Opéra where, stripped of its decorations, the *mystère* finally received an austere stationary concert performance on 25 August 1848, six months after the February Revolution. It had only five performances.

A notice appeared two days later in the *Revue et gazette musicale,* signed "R." It indicated that although the composer was "an artist of incontestable worth," he was subject to strange illusions about the reach of his art and work.[7] If this was an oblique reference to the composer's religion, so also was the critic's concern with the representation of Genesis, which he attributed to influence from the 18th-century French naturalist Georges Leclerc de Buffon. By implication, this was to be associated with the evolutionary paleobiology achieving strength toward mid-century. Not a bad guess, since this line of thinking permitted the Saint-Simonians to see in the evolution of societies a life force similar to that of organic nature, a permanent imperative which could not be stayed.

David's versifier had been handed a set of symbols which strayed very little from the pantheistic view of salvation. Contrary to Christian doctrine, a vision of the just and harmonious society is implied at the end of the six days of creation. Inevitable also is the motif of the rehabilitation of the flesh. In David's Eden, the morbidity of Christianity gives way to a new religion of joy and springtime. Before him Adam sees the golden age. Saint-Simon had written in 1814 that "the golden age of mankind is not behind us; it is ahead. It is in the perfection of the social order. Our fathers have not seen it. Our children will get there one day. And it is for us to open the way for them."[8] Enfantin, writing to Duveyrier in 1829, supplied an addendum which read that, according to Saint-Simon, Adam had "received the fruit of the tree of science from Eve because it was through her that he was conducted to the very God from which the Christians believed she had alienated him."[9]

The Christian story of the Fall is disturbed as little as possible in the recounting, since the composer could be counted on to summon the lyrical overtones for an affirmation of the earth and its positive future. Eve is to be taken as *La Mère* of old, symbol of earthly technological development. It is understood that man is to be liberated from an unchanging Eden and his hope restored when he becomes an instrument of the new Saint-Simonian religion of progress. Raised up by God to heights of love, he will be capable of the utmost persuasion to new moral-social tasks.

To this harmonious view of the Garden and of the world as it should be David responded in his own way. With a well-made trio he was even able to make Adam, Eve, and Lucifer communicate according to the deep

structures of universality which, according to Barrault, were inherent in music. To Genesis he brought his well practiced "picturesque" baggage. To the double commitment to the original topos of paradise and the "forward not behind" ideology, he took elements from the musical style of the eighteenth-century pastorale. Charming and appropriate as this may have seemed to the authors, the critics were quick to recall and defend a more classical frame of reference based on Milton and Haydn, and to accuse David of neorococo mannerism unsuited to the grandiose and elevated subject. It was perhaps to be expected that, in a time of panic and confusion, such an approach appeared to be no more suitable than what Byron had called the eighteenth-century "touch of sugar candy." While in public and in private Heinrich Heine and Alexis de Tocqueville shuddered with a sense of impending doom for the Western world and indeed for all of mankind, Tocqueville might well have been considering David's *Eden* following on *Christopher Columbus* when he wrote: "I do not know when this long voyage will be ended. I am weary of seeing the shore in each successive mirage, and I often ask myself whether the *terra firma* we are seeking does really exist, and whether we are not doomed to rove upon the sea forever!"[10]

Tocqueville escaped, like Saint-Simon before him, to a review of the origins of the first French revolution. It was felt that the intellectual bases of 1789 held the key to or "secret" of the social exigencies of new political structures. But it was not change that was feared; it was violence itself.

Enfantin had for some time been predicting this violence as a fall imputed not to Louis Philippe, the so-called peace and work king, wise and generous, but to the disintegrating parliamentary regime. He hoped to become the spokesman of a public who would not wish to follow "those revolutionary socialists and plunderers," the anarchists and communists of the February Revolution with whom his friend Lamartine carelessly classed the Saint-Simonians. Lamartine apologized for a liberal error, but not before Enfantin lectured him on the fact that a large number of his original "family" were already playing a role of considerable importance in the orderly organization of the new republic, preempting positions on the Constituent Assembly, the Ministry of Education, the Committee for Higher Scientific Studies, and the chair of economics at the Collège de France.[11] "Do not confuse the accomplishments of such people with your revolutionary despoilers," begs Enfantin, singling out the "twelve brave men who died in Egypt in the cause of preparing the greatest industrial and political work of the century," and the one who is "my Benjamin, my good and gentle Félicien David, whom everyone admires, and who is loved by all those who know him."[12]

When Enfantin made a point, he made it thoroughly, and what could be more fitting than to introduce the name of his favorite son, the musician disciple who more than any other accepted on faith the allegory of La Mère, the female messiah behind whom stood the bold conception of the preponderant role that industry would be called on to play in the modern world?

It is also not without interest that, as *L'Illustration* announced on 15 April 1848, "F. Halévy and F. David have just been named members of a commission charged by the minister of the interior to examine reforms to be made in the organization of L'École Française de Rome and L'École des Beaux Arts." This must have given satisfaction to David's friends, especially as, in the words of the same dispatch, it was learned that Franz Liszt had been called from Berlin to his native Hungary at the moment of the Revolution and named vice-president of one of the legislative assemblies, a complement to the sword of honor that his countrymen had presented to him in 1846.

Still without the offer of a worthy post (his Suez mission had failed), Enfantin returned to journalism. *Le Crédit,* his own journal of practical politics, supported financially by the the faithful Arlès-Dufour, lasted two years, 1848–50, rather a long run for a socialist magazine at the time. During this period Enfantin propounded two of the most durable of the themes of the good society: a moral and political commitment to disarmament as the salvation of nations, and the creation of a national development fund. Disarmament went no better in 1848 than it does at the present time, but the national land bank became and has remained an essential cog in the French economy. Enfantin also proposed nationalization of the railways, again in the belief that from a whole series of progressive administrative acts would come the organic and religious socialism of the future. Neither left nor right, this was to be a humane, intelligent, liberal, and magnanimous socialism. The proletarians would defend it; the bankers would give credit; the women and priests would give their blessing; and the poets would sing.[13] *Eden* falls into place in this context as a metaphor for the cult of the material world to which Enfantin vowed filial devotion. David had learned to perform the ritual in his early choruses for the Ménilmontant services according to proclamation that "Our Saint-Simonian songs repeated by a large number [form] our language of action."[14]

In *Eden* the entire object of religious effort is again transferred from Heaven to Earth, and choral presentations of demons and angels reiterate the old Saint-Simonian antimonies: the region of moral-social commitment, and the region of the individual, wild, lawless, revolutionary. These are resolved in the final chorus of the "mystery." Not surprisingly,

David included choruses from *Eden* in his hymnbook published in 1854 under the title *The Harmonious Beehive* (*La Ruche Harmonieuse*), in the company of such affirmations as "Les Statues de Promethée," words by Chaubet ("No more gloom or misery, but light for the world!").

What amounts to David's second oratorio is thus an expression of the persevering Saint-Simonian vocation for great works, and the rebel angel's curse blends with the realization on the part of Adam and Eve that banishment from the divine abode is nothing other than a welcome, in Lucifer's words, "to the unknown land where the sky has no light, where the naked shore of the desert will be nourished with their sweat."

Eve, a thinly disguised *La Mére,* is the protagonist. Both Adam and Lucifer are incorporated into her industrial plans to fructify the deserts. They repent and they suffer, but they survive like the fallen in Baudelaire's most socialistic poem, "The Litanies of Satan," with no thanks to the God of false justice, who favors the rich over the poor, the strong over the weak. Baudelaire's poem ends, appropriately, with a quasi Saint-Simonian anthem, "Grant that one day my soul find rest by your side under the tree of knowledge" (*Fais que mon âme un jour, sous l'arbre de Science près de toi se repose*). [15]

Ironically, after two decades of dreams and effort, Enfantin lost the canal to the astute diplomatic maneuvers of Ferdinand de Lesseps. There is no reason to disparage Enfantin's engineering abilities,[16] but the merging of logic with mysticism proved his undoing in the world of politics. For his artistic priests and priestesses, on the other hand, its effect was to accelerate ecstatic response. In the old days, Enfantin was accustomed to remind his orator Émile Barrault that he had perhaps the need "to understand and to feel that industry is the real call to *La Femme,* and that it is the basis of the cult that God demands. *Le Globe* is our fiancée, our mother for the moment. Let us embrace and caress the earth."[17] These erotic canticles were still being dispensed as late as 1858, when Enfantin wrote, "O earth, I shall give you more than my corpse! You are my mother! You will be glorified, embellished by your child. You will be blessed in the fruit of your entrails, for I shall make you even better for everyone than you have been for me."[18]

Eden bears a dedication to Isaac Pereire, the rich banker who, like Arlès-Dufour, had pledged considerable material aid to David. In 1848, Pereire testified publicly, in face of yet another schism in Saint-Simonian ranks, to his enduring faith in the principles of the doctrine: "the association of all producers, retribution according to works, and the abolition of all privileges of birth."[19]

A letter from David in Paris to Saint-Étienne dated 1 April 1848 not

only confirms an obligation to Pereire and the intention to make him in person a gift of the parts of *Eden* that had been published, but it mentions a visit from Dufour to talk about "the affair in question. In order not to separate myself from my *confrères*," wrote David with characteristic loyalty, "I have signed the agreement."[20]

Eden received a cool reception from both critics and audiences. Didacticism was not cited directly as a contributing factor to the failure. David's underlying themes, if they were not studiously ignored, were certainly not discerned with anything like the popular force of, for example, the anti-clericalism expressed in the novels of the time.

While one critic confined himself to mention of numbers like the romance, cavatina, and flower pieces simply because they graced the opera house, another was intent on measuring the artistic weight of the work as a whole. He was only to conclude, as Berlioz was then declaring about the entire contemporary output, that "these days one would think Gluck and Beethoven had never come."[21]

In the opinion of the *Revue et gazette musicale* critic, David's manner dated not from the beginning of the world, but from the beginning of the eighteenth century. "His Adam wears powder, his Eve patches and petticoats." The piece is rightly called a mystery, "for without the aid of the program, we defy even Oedipus to guess what it is all about." The complaint is double-edged—against program music and against the quality identified pejoratively as rococo.[22] In fact, *Eden* bears a distinctive mark of its time, a contentment with simplicity familiar to English utilitarianism and German pastoral romanticism. It is precisely in this respect that it is a representative Saint-Simonian enterprise. It is not, as the critic implies, affected, but natural, picturesque, and lyrical—factors to be reckoned with in mid-nineteenth-century romanticism. They exist in Saint-Simonian rhetoric and in what Charléty has called its underlying state of mind. They account for what Henry James sensed, with pleasure, as "the sentimental fragrance" of Alfred de Musset's poetry. And David found these things in the music of Schubert and Mendelssohn as well. Even his principal demon conveys his urgent message in smooth lyricism, and the younger composers seeking preference at the ballet now had another accomplished example of the appropriate style set before them (see Musical Example No. 9).

Except for taking Genesis as its text, the oratorio is designed with conventional numbers derived from lyric opera, culminating with the Trio of Adam, Eve and Lucifer, which superficially recalls Meyerbeer's Trio of Alice, Bertram and Robert in *Robert le diable* (1831). But even allowing for difference in scale, musical and dramatic, and full use of vocal

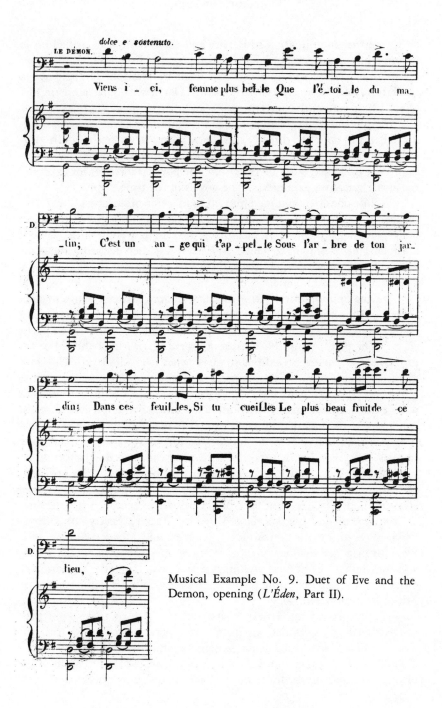

Musical Example No. 9. Duet of Eve and the Demon, opening (*L'Éden*, Part II).

effects (slides, vibrato, upper-octave leaps) abundant crescendos, diminu-
endos and thunderclaps, there can be little further comparison. The critic
"R" in the *Revue et gazette musicale* found the exodus ordinary; no doubt he
would have preferred Masaccio's expressionism, or Milton's. This was a
matter of taste, for the preordained styles set out to conserve the paradis-
iacal calm of Milton's poetry while sacrificing the tumult and, with it, the
grandeur. Withal, the music which accompanies the figure of the desert
watered with human sweat reveals an affective vocabulary inflected with
more than a little Gluckian pathos. No doubt the initiates were moved,
for a retreat to the desert had once been a promising moral option to the
Saint-Simonians, and they had lost some of their faithful in the attempt.

David's innate tenderness and naiveté, the qualities Enfantin so of-

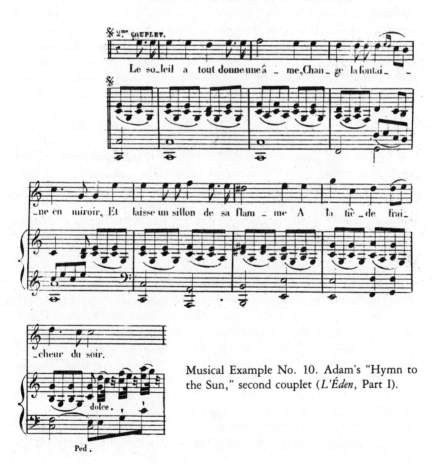

Musical Example No. 10. Adam's "Hymn to the Sun," second couplet (*L'Éden*, Part I).

ten imputed to him, guide him even more in the soliloquy at the moment of creation when Adam experiences the simple sensations of a newly animated creature; the air is an excellent example of the composer's "inimitable reverie" (see Musical Example No. 10).

The geological narrative, all five million years worth, in eleven stanzas of six lines each, stands apart from the rest. David's time-scale, like God's, is rapid, and it is managed with the orchestral pedals, fermatas, tremolos, contrary-motion scales, and slowly resolving appoggiaturas of his symphonic-ode introductions. The symphonic portion that precedes the declamation is a good example of the composer's ability to describe and suggest with simple coloristic variants of a single motif.

Can Haydn's *Creation* of fifty years earlier have been David's model? A comparison of the introductions alone discloses different moral and aesthetic conditions. Haydn's "Representation of Chaos," the shifting harmonies of which Donald F. Tovey called Tristanesque, awaits supernatural intervention. David's "Before Mankind" paints the orderly insistence of the ocean tides and nature's opportune time, ably setting the stage for Méry's lines "The atmosphere is veiled with mist, and the ocean floods the volcanic planet on which the world must spring forth." And the world flowers, adjectives multiply, and the verses begin to stand up in fluffy peaks of their own. At this point David draws back into his characteristic melodramatic orchestral punctuation, supporting rather than imitating the words. God breathes on the fiery ball. Fern and moss spring to the sweet dew raining from the iridescent clouds. The ocean subsides, a fresh sun beams behind the craters, and as the capsule cosmic history proceeds, a tree grows, unfurling its curtain of verdure against the distant horizons. No human voice resounds. Only the ocean echoes in the valleys while trees answer to the wind. Suddenly from the verdant depths, a first bellow is heard: earth curses the giant monster whom she has birthed. The long evolutionary travail has begun.

For the rest, it is quite possible to see Haydn's work as a model for *Eden*. Berlioz heard the *Creation* in 1844 and was quick to seize the childlike innocence of the music—its cheerful ideas, its charming freshness—pointing back to Enlightenment aspirations lost to his own age. He wondered how it was possible to avoid monotony when repeating the space of three hours: "It is beautiful! It is great! God is powerful! The day is pure! I am happy! We are happy! They are happy! The air is fresh! The flowers bloom! What sweet perfume! What sweet murmurs! Let us worship God!" unless one owned "a simple heart and touching naiveté, hope without limit, and a faith capable of moving mountains."[23]

Thus man arrives, and soon at his side rises among the flowers the

Musical Example No. 11. "Choeur des fleurs," opening (*L'Éden*, end of Part I).

living flower of Eve. *La Femme* has been born to give love to the universe. "All that my heart desires," sings Adam in lovely Bellinian phrases, "God has put in your smile. All that my heart desires is love and happiness." Eve responds in kind. A ballet of the flowers ensues. "Why flowers dance is indeed a mystery," concludes "R," recasting superficially Blaze de Bury's question in the review of *Moses*: "Is it fitting that an oratorio, a work of feeling and erudition brought to the highest power, should succeed by the same qualities as a ballet?"[24]

Hindsight suggests a somewhat different address to David's pastoral style. David's critics were reporting on what they regarded as unauthenticity; that is to say, put a couple of shepherds in place of Adam and Eve, and there is no need to change anything. However, it may also be argued that plentiful testimony exists in Renaissance literature as to the authenticity of a fusion of pastoral form and already well-developed complex notions of harmony and moral organization in the Garden of Eden.[25] Likewise, the sincerity of David's musical-moral actions need not be doubted if they are regarded within this double context. For example, among his directives concerning the composition of *Moses*, Enfantin had implied that he and David should continue to be inspired by the "sublime oriental comet" of the Desert Symphony.[26] The element in question was none other than the moral exoticism, as we have been calling it, of David's optimum style.

Ralph Locke has made a survey of segments from selected works of David which supports the claim that David's pastoral-picturesque style is an amalgam of his own oriental recollections and idyllic pastoralisms imbibed from current French music.[27] The effect may be judged from the ballet of the flowers and the humming chorus (see Musical Example No. 11), a veritable utopian vision out of Fourier, where the hypnotic rocking rhythm assumes an oriental gravity from the underlying, slowly moving pedals.

Another beautiful example occurs in the *Andantino grazioso* close to the beginning, where the pedal extends to embrace a fifth and an octave. The music is thus a counterpart of what is to emerge as the new Eden, the mythical desert which had long held for the Saint-Simonians the promising moral option of the Suez Canal.

As for the second part, which begins with the chorus of the demons, it is time, according to "R," "to inject a few wolves into this eternal *bergerie*." David's Part II is at least pleasantly demonic. Even a successful representation is necessarily limited by its assumptions, and here the principal demon must counsel Eve to leave Heaven to the angels, and taste of

the tree of Science, just as Baudelaire had said. "You shall know all, and you shall be queen of the earth," sings David's demon.

In this idyllic Saint-Simonian place one did not engage in revolution. Had Enfantin been writing one of his letters of state, he would have added that revolution is destructive because it elevates the mob to political life, and the mob are poor administrators. From *Eden* he expected what David had supplied—an agreeable lyricism; a well-crafted music falling easily on the ear; an allusive orientalism; and a perception of what people secretly long for in art—a bit of Victorian tinsel with the gold. "I myself admire tinsel as much as gold," wrote Flaubert. "The poetry of tinsel is even superior in that it is sad."[28]

11

The Pearl of Brazil

\mathcal{T}HE UNKNOWN COMPOSER who waits for a libretto, as David had explained carefully to his eager friend Saint-Étienne in Aix, waits for a gift not from the gods but from the management. And while one waited, one wrote symphonies and oratorios. Then, if they reached production—David was luckier than most, they received considerable attention, some admiration, few monetary rewards, and barely a ray of hope that the requisite talent would be discerned, that a suitable libretto would come to hand, that success would ensue.

By the time the door opened, the marketplace and its demands had become as much the concern of David's mentors, Enfantin and Duveyrier, as of the composer himself. There was less talk of divorcing oneself from contemporary musical currents. In time, the gay and charming Auber, whom David had disparaged in his youthful Saint-Simonian years, became a sympathetic and influential friend.[1] And Azevedo, the critic with strong Saint-Simonian sympathies who wrote the most substantial biography of David published in the composer's lifetime, divided his unflagging enthusiasm between two heroes, David and Rossini. It was a coupling that belied David's youthful parroting of the ideological armature of the 1830s. Auber and the Italian Rossini strongly influenced David's operas: despite the noisy literary quarrels over the fact, French composers have always been delighted with Italian styles, especially when, like Couperin with Corelli and Lully, the discovery is their own.

Enfantin's friend Térence Hadot, who had assisted Méry with the *Eden* libretto, was asked to approach the great librettist Eugène Scribe (1791–1861) in the hope that the composer could start off for once in a well-defined situation.[2] In the end, David did not achieve the honor of

collaborating with the grand master. Instead, the usual route prevailed: Enfantin was consulted. The other grey eminence Duveyrier was about to refashion Verdi's *Sicilian Vespers* into a Meyerbeerian "nights of carnage" (Wagner) of the sort on which the declining fortunes of the Paris Opéra now depended for survival. One thing must have been clear to everyone concerned. The opera houses were not then the place for redemptive Saint-Simonian histories, as Duveyrier well knew, having also dispensed an abundance of mediocre opéra-comique texts on his own. He was seldom out of work.

With a libretto jointly fashioned by Joseph Gabriel and the faithful Saint-Étienne, David went to work, much as he disliked some of the dialogue. The usual anxieties, dissatisfactions and harassments followed, with the piece eventually being turned back at the Opéra-Comique after David had gone to great trouble to compose music especially suited to their singers.

Gabriel's claim to fame rested chiefly on his collaborating on the enormously popular ballet-farce *Jocko, the Brazilian Monkey*. It would have been difficult to sink lower! Clearly, no literary masterpiece was to be expected, and none resulted. Nonetheless, the Opéra-Comique, located between (and a long way from) Offenbach's delightful confections and the bloodshed and mayhem onstage at the Opéra, could have been a fortunate haven for David. While not exactly a temple of religion, David's Saint-Simonian signpost under the cover of an exotic love story would have gone well there. But as it turned out, providence sent him to an even better place. With his gentle optimism, so curiously misplaced in the world of 1848, David launched his first opera into the new world of President Louis Bonaparte. *The Pearl* had the honor of raising the curtain not at the Comique but at the new Théâtre de l'Opéra National on 22 November 1851. Not many days later came the coup d'état which raised the curtain on the new empire of Napoleon III, whom Victor Hugo dubbed Napoleon *le petit*.

The time of the opera (1530) marked events in Portuguese colonization associated with the institution of slavery. Revolts were common. In one of them the noble Portuguese native, father of the opera's heroine, had been killed. A brouhaha between the Portuguese and the Indian chiefs furnishes the operatic pretext for a compliment to the modern Brazilian entrepreneurs who had come to see that slavery should be abolished, if for no other reason than that it was holding back economic development.[3]

Enfantin's writings on the colonization of Algeria were no secret to the press, but, so far as the musical critics were concerned, no connections were deemed necessary, possibly to avoid embarrassment to the rising

composer whose association with Le Père's megalomania was of doubtful value in the opera house. It was safer for them to allude to the enduring effects of the romance of the desert on David's imagination. Nevertheless, *The Pearl of Brazil* represents plainly enough another Voyage, as fundamental as it ever was to the dream that once sent David and his coreligionists to bring life and fecundity via dams and canals to the ancient land of the pharaohs. The moral may also have complimented the young humanitarians on the literary scene (Leconte de Lisle for one) who had succeeeded around 1848 in effecting the emancipation of the slaves in French settlements overseas.[4]

The plot rests, as usual, on another advent, another crossing, another storm and shipwreck, and another seductive female messiah who speaks discretely of a universal sense of human brotherhood. As usual, criticism of the libretto tended to ignore the internal consistency, suitability to David's purpose, and the natural Saint-Simonian theatricality which did operatic behavior no harm. Evidently David was reasonably happy with the libretto, dialogue excepted. It gave appropriate opportunities for music which he thought of later as his operatic best.

His pecuniary situation at this time was deplorable, and so was his health. "We now have liberty to starve to death," Balzac had written in 1848. David, who had hardly ever done anything else, was again reduced to begging. Enfantin received a note addressed to "Cher Père" which read: "Again I ask you for money, 500 francs. I have my rent to pay and my provision of wood to lay in. But I hope quite soon for the receipts from the concerts in Holland and Paris, and then this great opera on which I am working with love."[5]

The Pearl, with spoken dialogue, went into rehearsal in 1850 at the Comique. Almost immediately differences arose between Perrin's management and the librettists. It was at this point that Eugène Scribe was called in—he had considerable reputation in old age as a libretto doctor—but his services came high, and fortunately the new Théâtre de l' Opéra National (soon to be renamed Théâtre-Lyrique) accepted the piece. Initially the spoken dialogue remained. The 1858 performance retained the spoken dialogue and added the title "lyric opera." But in 1862 the work went into rehearsal at Bordeaux with recitatives requested from the composer by the director. It is the Heugel edition of 1873 incorporating the recitatives that serves us for study here.[6] The term "lyric drama" appears on the title page, and footnotes locate places in the score where recitatives replace the original spoken material. It is interesting to note that Gounod's *Faust* followed the same route in 1869, but *The Pearl*, when it was revived in 1883 at the Opéra-Comique, was performed with some of

its original dialogue, with alterations by Jules Barbier, one of the librettists of Gounod's *Faust*. The other *Faust* librettist, Michel Carré, was to serve David later on.

Not only was a French semi-serious opera type congenial to David's lyrical talent, but it paved the way over which younger composers like Massenet and Saint-Saëns could escape the persiflage of one musical theater and the pomposity of the other. The *opéra mixte*, as lyric opera has been called, appealed to both composers and audiences, and it is this temperate genre which gave rise to the most durable of the works selected for the French stage in the second half of the century.[7] Among these was David's own *Lalla-Roukh* (1862), preceded by Gounod's *Faust* (1859) and followed by operas with various appellations which succeeded by means of the qualities to be noted in David's *Pearl*. With the exception of Bizet's *Carmen* (1875), which is genuinely dramatic, all of them—Thomas' *Mignon* (1866), Saint-Saëns's *Samson and Dalila* (1877), Delibes' *Lakmé* (1883), Massenet's *Manon* (1884)—are relatively non-dramatic works making their appeal through sentimental melody, effective choral writing, and delicate orchestration. Some of them partake of the exoticism—here Meyerbeer's *L'Africaine* comes to mind—which perhaps represents the superficial issue of David's earlier successes. It may even be, as one writer maintained, that *L'Africaine*, discarded in 1847, would never have been thought of again but for Meyerbeer's intense and frankly acknowledged admiration of Félicien David's genius.[8]

Soubies and Malherbe's adjective "temperate" is especially apt for David's characters. Their principal traits are those of the well-intentioned middle-class audience: rectitude, sincerity, courage, and devotional feelings. Salvador, the Portuguese admiral (bass), is a man of honor and a Christian (as Octave Feuillet's novel *M. de Camors* declared, "morals divorced from religion are nothing at all").[9] Lorenz (tenor), a nobleman in sailor's disguise, triumphs through a noble love which he shares with Zora (soprano), a Brazilian tribal princess who has been rescued by Salvador and taken back to Portugal to be educated. Her baptism at Lisbon opens the opera, enhanced with a stylish processional and male chorus onstage, followed by a conventional prayer scene with female chorus accompanied by organ backstage. In Mendelssohnian boat-song fashion, it fittingly prefaces the love song of the seafaring heroes. Local dancing follows to introduce Zora's servant Naouna in a "Ballad of the Great Spirit" which returns in the dénouement of the opera.[10] For the moment it permits the authors to demonstrate (in waltz time) that Saint-Simonian pantheism is as emphatically devotional as Christian prayer and twice as enjoyable.

The second act, at sea, features a sailors' chorus, the first of two

duets for Zora and Lorenz, and the tempest scene which David's audiences had learned to expect. Rio (tenor), the young sailor who is in the unenviable position of having to obey his master while promoting the interests of his rival, sings a duet with Salvador. There is an extended ballet, and Act II closes, as did Act I, imploring God's protection.

In Act III, Zora is discovered asleep in a hammock as the curtain rises on a Brazilian jungle set. Her dream song is heavily appliquéd with accompanying birdsong in the orchestra. Lorenz enters, she awakens, and they assert their love in a passionate duet. A magnificent male quartet with Salvador's bass solo—which David was to reprint, together with the Act II sailors' chorus, in his *Ruche Harmonieuse*—leads to a finale that completes the action. Zora (taken now as La Mère of old) placates the four Indian chiefs by means of her radiant calm in the returning ancestral hymn, voice of the Gods. Providence is given full-throated thanks.

The sentimental-serious tone constant in David's expression, whether in lyric opera or any other of his orderly formulations, is perfectly in tune with the outlook of his time. So, too, was a set of models carefully chosen from among masterpieces still on public view. Choral intervention in the modestly proportioned Desert Symphony undoubtedly took as its grandiose model Beethoven's Ninth. *Christopher Columbus* looked to Beethoven's *Pastoral*, the loose form of Weber's *Oberon*, and Berlioz's coloristic orchestration. *Moses on Sinai* experimented with a category (oratorio) not then familiar in Paris, but, although originally intended for Germany, it was probably patterned after Méhul's *Joseph*, itself more an oratorio than an opera. *Eden* was planned to transform a pretty city park into paradise with its flower music. The oblique moral which cast Lucifer as the father of irresponsible radicalism suited Saint-Simonian principles, and the extremely literary librettist must have been pleased to find it also in Milton. The melding of pretty melody and pictorial words suggested Haydn's harmonious *Creation* as well.

As some of the critics had anticipated, the emerging composite style considered thus far destined David for success in the lyric theater. Well-established habits of study and an acquisitive and retentive ear had led him to adopt an eclectic practice which was still drawing defenders as well as detractors among Parisian intellectuals. Defenders dominated, arguing that Meyerbeer's "hits" set an example of pliant Italian melody which gave Meyerbeer no greater handicap than the balanced form of the Italian phrase had given Mozart. For others, like George Sand, eclecticism was not worth the sacrifice of originality. This became a recurring theme in the criticism of David's works, but as time went on, reassurances were also forthcoming. David's was a distinguished talent, Italian in the facility of

melody, French by clarity and attention to prosody, and German by descriptive detail in the service of character expression, which was presumed to belong to Germany. Prominent too in this opera about the Portuguese in Brazil is an appropriate Iberian color marking the mid-century revival of ideas about nationhood. The reach of David's aspirations seemed at first destined for grand developments, but with each new work it became increasingly apparent that his art would remain one of fine arrangement, delicate details and exotic rhythms. His temperament and his new religion both contributed to this end result.

David's letters testify to his attentiveness to the musical theaters over a period of twenty years. Now that he had his chance, it is interesting that his chief formal decision should include the scene complex as a means of musico-theatrical organization, thus setting the work apart from the sequences of unrelated numbers that still passed for opera in the 1850s. Early models in this respect existed in the practice of Gluck, Mozart and the Italians, as Morton Achter suggests.[11] But Rey Longyear quite rightly attributes the nineteenth-century scene complex type—defined as "many individual numbers linked together by conversational singing over a light-textured accompaniment, rather than separated by spoken dialogue"—to Auber's *Crown Diamonds* of 1841.[12] We know from the account of the anonymous Englishman quoted earlier that David was frequently in Auber's company in these years; that Auber was a great talker; and that he seldom talked about anything but music. David listened.

The eventual replacement of spoken dialogue with Rossinian "external" recitative, as Achter calls it, was undoubtedly advantageous to David's lyric expression. More important to the overall organization was his grasp of the order and unity to be gained from extended "internal" recitatives. These, according to Achter, "may involve choral participation, are provided with more ambitious and attractive accompaniment, and often have their own formal organization."[13] In his treatment of recitative alone, David rose well above the agreeableness of the mid-century French standard.

Achter's thoroughgoing analyses of David's scene complexes indicate that they became more confident as the opera progressed. The method, he concludes, tends to unification by single key or through large tripartite design whose outer tonalities are the same. Naturally, this was considered old fashioned and simplistic by the time *The Pearl* was revived in 1883. After 19 performances it then sank permanently into oblivion. As Auber used to say, David simply had no luck. Eventually the algebraists of Bayreuth had to be reckoned with, cried the *RDM*: "an opéra-comique that

includes airs, duos, quartets, romances, choral couplets . . . what a scandal!"[14]

Berlioz's first-night review, with its bantering account of the plot, probably contributed to a loss of reputation for the work. Berlioz the composer suffered from almost complete misunderstanding on the part of the French public, but Berlioz, king of musical criticism, had great influence. He assailed the quality of performance given the opera: "At every turn the ear is wounded by instruments or voices that commit unpardonable errors. Here a discordant harp, there a damned piccolo with bad pitch hurries the tempo and is unable to mark the weak beats of the measure with precision. On stage all the minor roles are sung in execrable fashion, and the women of the chorus have cruelly treacherous voices."[15]

It should be remembered, however, that Berlioz scorned most of the operas of his day as unnecessary evils. In David's case, some of Berlioz's remarks reveal sympathetic understanding of the Saint-Simonian *idée fixe*. This differentiated his review from others, but to no particular advantage, since he tended to include Saint-Simonism among David's infantile simplicities. On the other hand, it cannot be denied that Berlioz's moments of truth, when it came to the outlook of his era and its music, are illuminating. The following alludes to continuing elements in David's new work, but he exaggerates excessively and chooses to ignore areas in which David showed marked growth in technique and expressive power.

> There are two composers in Félicien David: the melodious dreamer singing the charms of solitude, starry nights, the fresh oasis, the mysterious calm of the virgin forest, the sweet song of the young mother rocking her first born, or the grandiose hymn of the majestic sovereigns of the desert and the ocean which inspire him to authentic accents, an elegant style, a vibrant harmony and a fine picturesque orchestration. Then, there is the composer whom I will call lazy, who seems to be content with forms of an almost infantile simplicity, unison choruses accompanied with unison orchestras, primitive rhythms, harmony a bit lax, melody a bit immature, and in some instances just plain unmotivated commotion.[16]

To be fair, Berlioz does approve the overture after the Weberian model, anticipating four tunes from the stage music that is to follow. The first is from the Festive Chorus of the first act finale, its double-dotted rhythms neatly recalling the baroque overture. The second is from Zora's "Couplets de Mysoli" (see Musical Example No. 12). The third is from the Act II duet of Salvador and Rio. Here Berlioz exclaims, "Why in this opera

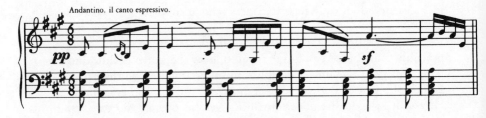

Musical Example No. 12. "Ouverture," excerpt (*La perle du Brésil*).

written for a small orchestra and a small hall accentuate the fortes by a
drum added to the bass drum? What motivates this drum?" Judging from
the number of times that Berlioz had to remonstrate with his colleagues
on this unmotivated drum, the answer is not far to seek. French audiences
took pleasure in reminders of Rossini, the Italian wit who was still in their
midst, who enjoyed French life but worried very little in his comic operas
about French proprieties. The debt to Rossini is even more prominent in
the fourth and last overture segment, drawn from the important Act II
duet of Zora and Lorenz, "At last we are alone" (*Enfin l'on nous laisse*). The
mounting excitement in the second part of the duet prompts its use for
the coda-crescendo of the curtain raiser. For a person of David's languid
temperament, intimacy of expression is apt to be the rule and energetic
movement the exception. This duet, however, is a striking expression of
passion in which David achieves a rare sustained excitement by means of
direct imitation of Rossini. Berlioz commented only on the high A "at-
tacked by the tenor in chest voice to very good effect."

David was not poking fun here at the tried-and-true Italian method
of stirring up applause. On the contrary, he must have been desperately
anxious to evoke demonstrations of approval like those accorded Auber
and Meyerbeer. Berlioz continued to argue that eclecticism precluded the
freedom and innovation that he demanded from himself and, in his re-
views, from his contemporaries. He subjected Gounod and Massenet to
the same criticism, but their admiration for him remained boundless, al-
though they knew what they were about and continued to ride their own
horses. With less innate confidence, David tended to be more competi-
tive. There is no reason to think that he had changed his mind about
Berlioz's music since his attendance at the second performance of *Benvenuto
Cellini* (1838):

The journals have spoken of it in different ways. Several have attributed the failure to the libretto. True, it is very bad. However, Berlioz could have turned it to better account. Instead of setting it to an infernal music, as is his wont, he should have given his work an Italian color. This man is wanting in inspiration and melody. There is in his work incontestable talent, but all this is forced, dragged about by the hair. In order not to follow the ordinary route, he has taken one so bizarre that it renders him unintelligible. Clarity should come before all else. A display of learning is all very well, but not at the expense of inspiration. In sum, this music did not affect me forcibly at all; I experienced on hearing it nothing but great fatigue.[17]

The fatigue was reciprocal. Berlioz attended the 1858 production of *The Pearl* and wrote to his sister as follows:

I am in a complete stupor this morning. We returned at one last night in the midst of atrocious snow and mud, after having suffered through the revival of the *Perle du Brésil* at the Théâtre Lyrique, the opera by that poor Félicien David, in which he has given a curious specimen of stupid music which he takes to be simple music. All the ex-Saint-Simonians were there. They made for him a grotesque success. The plot is as flat as the score.[18]

Both composers shared a concept of the descriptive orchestra, but when it came to opera, there is no denying places in the scores where David's enduring naiveté falls in too complacently with the banalities of the hour. For example, Salvador's Act II address to the sailors attempts to assert his benign, encouraging presence in the face of an oncoming storm whipped up in the orchestra. In such a context, the tiny bolero with four-square phrases in 6/8 meter, with a tune of limited range, the barest harmony, and a few appoggiaturas that David provides must have tried Berlioz's patience. The tempest scene is mercifully passed over in his 1851 review, except for the remark that nothing had been added to the memory of the original Simoun in *The Desert*. Nothing had, except for the intention to fashion out of old materials a sort of Donizetti finale-stretto for Act II. Once the chorus has returned the compliment of the admiral's bolero, the storm music develops harmonically throughout the dialogue between the embittered Salvador and the noble Lorenz. A tragic flaw is revealed. Salvador had some time ago killed Lorenz's father in Rome. The storm then builds with the usual means—diminished sevenths and chromatic

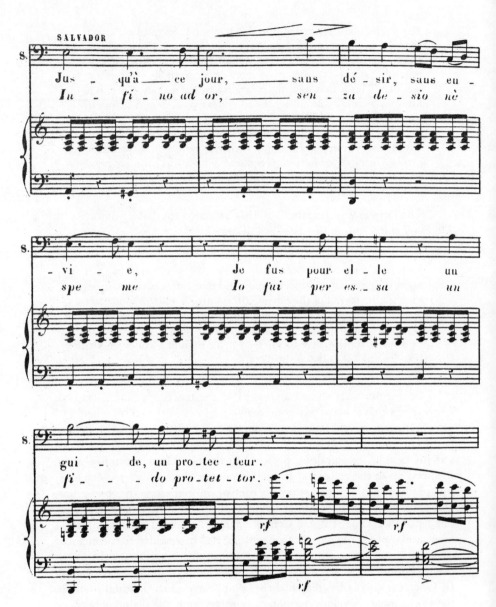

Musical Example No. 13. Salvador's Air "Jusqu'à ce jour," excerpt 1
(*La perle du Brésil*, Act I).

runs. Finally, with accompaniment at full force, the chorus belts out its mounting fright in the unisons and octaves to which Berlioz had already objected in Act I.

The representation of stress by these means may not suggest psychological depth to a present-day listener, but it seems to have made its point at the time. It is even possible that more, not less, of these commonplaces would have reassured the audience, which Berlioz took to be in agreement with him! There is no mention in the first night reports of an audience rising in volcanic explosions of enthusiasm, but Berlioz mentions their sympathetic attention, and his own; a few critics kindly reserved judgment for a second hearing. All of them, however, Berlioz included, responded to the dazzling idyllic exoticism of the last act. Elsewhere, uncertainty could have had to do with the so-called *caractère*, seen, as yet, to be joining awkwardly with the challenges of David's more dramatic situations.

As a case in point, Berlioz found Salvador's Act I aria "Jusqu'à ce jour" too reminiscent of Benjamin's Romance in Méhul's *Joseph* and advised cutting it. But this is anything but a simple romance. It shows David grappling in his own way with the Mozartian aria concept of a decisive spiritual turning-point in the emotional life of a character. A courtly introduction provides for the exit of the ladies who have just planned an elegant ball. Salvador's spacious three-part aria deals first with his role as Zora's protector. Delicate and intimate, incredibly sweet, this section represents David at his best (See Musical Example No. 13). As Salvador recognizes the deepening effect of Zora's charms, the charming trills of the introduction appear in the orchestra. Finally, as his intoxication mounts, a bit of word painting is admitted on the word "enivre" (inebriate) (see Musical Example No. 14).

The second section changes key and meter for a cantabile love song, this time with accompanying rhythm combining the steady rise and fall of the barcarolle bass with the livelier beat of bolero castanets. Salvador's emotion drives the music to a repeated curse of the as-yet-unknown rival, but then he returns to avowal of love. In the last part, an agitated accompaniment figure stands for the voyages, reefs, and tempests which Salvador hopes to give up when he and Zora, rather like Adam and Eve in their original innocence, settle down to their calm conjugal happiness. The song recedes in a multiplication of short sing-song phrases, hardly rising before they fall, and the first sweet strain is never repeated. Mozartian simplicity and ingenuous harmony moving over a melodic bass, rather than in David's customary picturesque ostinati, remain with Salvador's first state of mind.

Formulated as it is in three sharply differentiated parts, the aria suc-

Musical Example No. 14. Salvador's Air, excerpt 2 (*La perle du Brésil*, Act I), voice part only.

ceeds on the psychological plane, for it takes Salvador from his situation as it has been to his present anxieties and aggressions, and finally to a condition of hope for the future—a Saint-Simonian catharsis. The motivation is consistent.

In the more conventional forms, David allowed himself an amount of repetition heavenly in Mozart and Schubert but admittedly shallow in the romantic composers of his own generation. His melodies are far better than "hardly green," as Berlioz called them, and in *The Pearl* he took full advantage of the elastic possibilities of the French air, from the A B A of Zora's Ballade, to the stringing together of waltz tunes in the first scene-complex of Act II, to Zora's ample A A B "These lively, joyful refrains" (*Ces refrains vifs*)—which may have inspired Bizet's famous Toreador Song—to strophic songs like "Charmant oiseau." All these bear the mark of a well-practiced song writer.

If there were indeed two composers inside David, as Berlioz claimed, among the last achievements of the first are the ensembles in this opera: the Act I trio, Act III quartet, the choruses of Acts II and III, and Zora's final scenes would alone justify the revival that has lately been accorded some of the lyric operas of Gounod and Massenet. David's skill at choral writing had been "cooking over a slow stove" since the motets of his schooldays and the introduction to society-as-it-should-be at Ménilmontant. Placed without accompaniment in his *Harmonious Beehive*, these *Pearl* choruses not only take their place with similar selections from *Moses* and *Eden* in the programmatic Saint-Simonian collection, but they were doubtless welcome additions to the repertoire of Parisian orpheonic societies. One wonders whether Gounod performed them when he conducted the *Orphéon de Paris* during the years 1852–60. It is impossible not to keep time to David's clear rhythms, an advantage to the untutored as well as to the notoriously undisciplined and under-rehearsed choral groups in the opera houses of those years.

Of particular interest is the festive air with chorus in Act II in

which Zora sings while Naouna dances "Quand sur notre beau navire." It would be more than ten years before Manet shocked Paris with the singular vitality of his reaction to a Spanish ballet presented for the first time at the Hippodrome. It would be twenty-five years before Bizet challenged the same kind of public with his sensual *Carmen*. Yet a striking example lies buried in *The Pearl*. Berlioz fails to notice it, although its equivocal tonality, augmented sixths, and dominant superimpositions over tonic pedals would belie the charge of lazy harmony. Indeed, this music testifies to a sophisticated manipulation of modern harmony and instrumentation to convey a Spanish sound propelled by imported rhythms. An elaborate fioritura, rare in the opera as a whole, invests the melodic phraseology here for exotic purpose. Sometimes, the melismas take off on enthusiastic words *chanter, fêter, amour, allegresse, harmonie, transport*. The responding chorus resolves finally into a humming harmonic support over a dominant pedal for Zora's effloration on "everything stirs up, everything excites." The piece is, at the least, a triumph for a melancholy Frenchman who had never been to Spain. If it caught Bizet's eye, the example and the imitation were worthy of each other.

The Act III chorus *Song of War* ("La Patrie") for tenors, baritones, basses with bass solo, is without question David's best. Berlioz singled it out for good reason, for it is melodically fresh, harmonically and rhythmically vigorous and functionally moving within a scene complex devoted to patriotic fervor. The noble savages have appeared in the trees, bows and arrows in hand and, as Berlioz did not fail to remark, quite naked. The sailors present arms. Salvador holds aloft a large cross and announces *maestoso religioso* the magnanimity of his defensive action. It is understood that the savages, lacking the Saint-Simonian concept of country, must be persuaded that the supreme fraternal attachment makes men heroic in the process of social liberation.

Musical Example No. 15. Entr'acte "Le Rêve" (*La perle du Brésil*, Act III).

One of the best moments of the last act occurs when Zora awakens with her *charmant oiseau* strophes. Birdsong insures a smooth connection with the introduction to the song, and it returns at the end of each stanza expanded into full cascades for solo flute which Zora tosses off in turn (see Musical Example No. 15). This is the sort of bravura aria that an opera audience waits for, and it is the only David composition to survive in the modern singer's repertoire (See Musical Example No. 16).[19]

The finale of Act III is a long scene complex that ties up loose ends. The true identity of Lorenz, the disguised sailor-savior, must be established. The Brazilian chiefs must make their case. Salvador must make his declaration of fraternity to the Brazilians, and they must reject his offer in revenge for the never forgotten abduction of Princess Zora years before. Salvador must accede to the wishes of the lovers, and most important, Zora must arrive in time to avert violence with a repetition of the Ballad of the Great Spirit. The importance of placing the ballad at the beginning and the end is obvious. It is the point of focus for the Saint-Simonian pantheism. The Great Spirit is that which provides fertility to the forest, diamonds and gold to industry, beauty to women, science to sages, majesty to deserts. Behind the vocal flourishes, cadenzas, trills, and ad-lib improvisation, Berlioz sensed the pagan sound of a native chant when he called the piece "a national tune of the savages, their Robin Adair, their *Ranz des vaches*, their *Bamboula*." But the details of David's moral-exotic method have perhaps ceased to interest him. They came into play here as usual, with a light accompaniment over a persistent tonic pedal, major-minor alternations, and long humming passages for sailors and Brazilians.

Properly read, Berlioz's letter to his sister, cited earlier, ridicules the bourgeois involvement of Saint-Simonism along with its artistic manifestations. It holds up a mirror to the Philistine mixture of softness and triviality in mid-nineteenth-century France that infected composers, architects, decorators, and poets alike. A thorough search would disclose traces even in Heine, Baudelaire and Berlioz himself. On the other hand, Berlioz did recognize a fair number of elements in the score which returned to the countryside of David's more distant inspirations. Paramount among these is the clear, confident chordal sound of the choruses, standing like facts of life among the make believe. David's religion—his religious vocation if you will—and the sense of fraternity which the Saint-Simonians gave him achieve a rare sincerity of statement here. Longyear's unequivocal judgment that "David's operatic choruses are probably the best between those of Rameau and Saint-Saëns" is tribute enough.[20]

It remains only to point again to the elusive myth, the Promised Land, that threads its way through David's work. While his Saint-Simon-

Musical Example No. 16. Zora's "Couplets du Mysoli," cadenza interlude (*La perle du Brésil*, Act III).

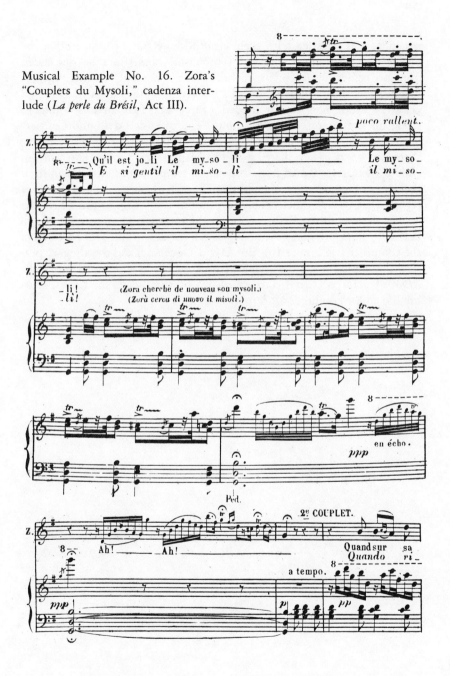

ian colleagues wrestled with their sociotheology and with each other, he practiced his simplistic musical symbolism. Sometimes he descended from his camel, as Auber urged him to do,[21] but only to exchange his Bedouins for naked Indians. Auber's *bon mot* certainly antedated Zola's on Gautier's exotic novels: "He needed a camel and four dirty Bedouins to tickle his brains into creative action." The cases of David and Gautier, however, seem to have been similar; it is a pity that they should not have shared an opera. They shared a child-like nostalgia for the East, and in each of them style issued from a romantic temperament rather than from the aesthetic convictions of their realist contemporaries. Albert Vandam reports that David's "melancholy vanished as if by magic when he related his wanderings in the East."[22] In time the romantic physiognomy was to fade with ill health and privation—as can be seen in the later portraits of the composer (see Figure 10). But David's souvenirs and the allegory persisted, together with the characteristic innocence which prompted the *RDM*'s fanciful obituary: "Little birds my brothers, roses my sisters, ideas my life and my light: *omnis beatitudo nostra!*"[23]

12

Herculaneum

\mathcal{D}AVID'S ONLY four-act opera, *Herculaneum*, grew out of an earlier
work, a *Last Judgment* composed about 1849 to a text by Joseph
Gabriel and Eugéne de Mirecourt, with incidental music for chorus and
orchestra.[1] As the piece underwent revisions, the title changed first to *The
End of the World* and then to *The Last Love*. When the latter was rejected by
Perrin at the Théâtre-Lyrique, Joseph Méry was asked to construct a full-
scale opera, the early acts of which lead to the grand judgment scene. At
this moment (1852), Halévy's *Wandering Jew* took the stage with a Last
Judgment of its own, and David felt obliged to date his pages as legal
proof that they antedated Halévy's.[2] Under its final title *Herculaneum*, the
work received its première 4 March 1859 at the Académie Nationale de
Musique. According to David's close friend Saint-Étienne, the original
last scene was in the end suppressed to avoid tedium.[3] The new design of
the opera led naturally to an ending of its own well in tune with Saint-Si-
monian theology.

Under Méry's ministrations, the ancient legend of Herculaneum's
disaster took on echoes of moral and religious attitudes current in the lit-
erate French society and well explored by Meyerbeer in his grand operas.
Not least of Meyerbeer's fascinations for the Saint-Simonian composer was
the satanic fable presented in *Robert le diable*, the opera which had assem-
bled Enfantin's original band in full regalia, front center, for Meyerbeer's
first night, 21 November 1831.

The orchestral parts and conductor's score of *Herculaneum*, now in
the Bibliothèque de l'Opéra, Paris, show that the piece was heavily cut,
arias transposed, and so on. In the process, pages were stitched together,
others glued over. Not all of this came after the première, as one might at

155

first think. Berlioz wrote to Auguste Morel on 13 February 1859: "At present they are still rewriting certain scenes of David's *Herculaneum*."[4] Hadot may have helped with some of these last-minute changes. The original score of *Herculaneum* was dedicated to the two Pereire brothers, Isaac and Émile. It was bought after David's death by Isaac Pereire, and is now in the Stiftelsen Musikkulturens Främjande, Stockholm.[5]

The action takes place in A.D. 79, when the handsome and prosperous town dedicated to the legendary strongman Hercules was destroyed by volcanic eruption. According to legend, the destruction of Herculaneum was an act of divine vengeance against the Romans for their sacking of Jerusalem and their continued persecution of Christians in the Eastern provinces, Corinth, and the Greek colonies of southern Italy. If ulterior motives of class struggle further attracted the Saint-Simonians to Herculaneum's history, evidence could be found in the social life of the town itself. Buried for fifteen centuries under the curse, it had once been a center of wealthy suburban Romans pursuing a life of ease and pleasure at the expense of its more industrious citizens. The balance of nature had been upset by the sins and passions of men. At such times, sacrificial offerings to the gods were made in order to restore proper balance. The time for this had come in A.D. 79, and Vesuvius was the agent. An added advantage from history was the ancient story of Spartacus, which recounted a full-scale revolt in the area, an event that contributes to the peroration of the opera. Having resorted to the revolutionary act which violated Saint-Simonian doctrine, the slaves had to go under with Satan and the Roman profligates, while the Christians rose in symbolic flight. The ancient miracle of Christian faith was reborn in loving Saint-Simonism.[6]

The story concerns a queen, named appropriately Olympia, who is devoted to the religion of Olympus and receives her investiture at Naples. Her mission is to arrest the progress of Christianity, making martyrs by violence and apostles by seduction. Her brother Nicanor (alias Satan) seconds her nefarious plans.

After a short introduction, we are in the palace of Olympia at Herculaneum. Satraps, princes, and tributary kings come in great pomp to prostrate themselves before the queen. Their chorus is unmistakably in the style of the old Saint-Simonian salutes, albeit with more ornate accompaniment. It can easily be read as an address to *La Mère* in the person of the pagan queen:

> Glory to thee, great queen, ruler of peoples and kings!
> The world is conquered by thy charm:
> Thy strength is thy beauty,

Love is thy sole weapon;
Thy minister is pleasure.

Clamors from the crowd are heard outside demanding blood and justice.
Two Christians are dragged in, neophytes of high birth, Helios and his fi-
ancée Lilia. They confess their faith and Nicanor recommends their death.
But Olympia is taken with the beautiful prince, to whom she offers her
hand, her gods, and her kingdom. The queen sends for wine, under the
influence of which Helios forgets his chaste love, ignores the fierce warn-
ings of his prophet, and disappears into the queen's banqueting room,
where the obligatory drinking song is heard.

Act II finds Nicanor falling in love with the saintly Lilia, but she
stands fast both in religion and love. While praying at the tomb of the
martyrs (shades of Meyerbeer's "Alice at the Cross"), she is surrounded by
a crowd of Christians. Nicanor and his guards disperse them brutally. Left
alone with the Christian virgin, he attempts to seduce her. A clap of thun-
der strikes Nicanor down. Lilia vanishes, and the scene is plunged into
darkness. Satan comes forth to show Lilia visions of Helios in all his de-
pravity. The vision is conveyed in the kind of humming chorus (tenors in
the wings) which David used so effectively in *Christopher Columbus*.

Act III reverts to Olympia's enchantments. Helios traverses the deli-
cious gardens with his queen. They are entertained with voluptuous bac-
chanalia.[7] Enter the despairing Lilia. Her touching "Credo" alternates
with threats of death from the chorus, but Satan counsels Olympia to let
Lilia live, a far greater punishment than the death that all Christians are
taught to welcome.

Act IV opens in the richly ornamented Etruscan atrium of Olympia's
palace (Figure 7). A theme first heard in the introduction to Act I now
takes on significance with Satan's words: "My power will overtake this
land with ruin, and eternal night will replace day. Support my wrath!
Come, proscribed peoples, so often victims to pride! Vultures, pounce
upon the cursed city! Children of Spartacus, heed my voice!" The reversal
is at hand. Satan reveals himself to the slaves as the proconsul Nicanor, a
fellow conscript. The set enlarges to reveal the entire villa and the avenue
to the temple of Isis, long associated with mysteries of death and resurrec-
tion. At back is an aqueduct with two rows of arches linking the heights
of Herculaneum with the arid rocks at the beginning of the slopes. Satan
in the guise of Nicanor continues to instruct the slaves as masters. "King
of the earth, the hour has come": with a clap of thunder, Helios appears,
crying for Lilia. Although resentful of her unfaithful lover, she ends by
pardoning and blessing him.[8] A prophet appears to announce death and

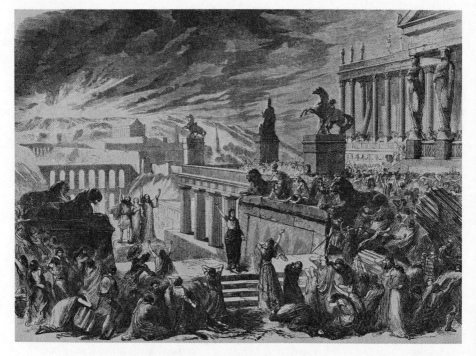

Figure 7. *Herculaneum*, opening of Act IV, from the premier perfor-
mance, 1859. *L'Illustration*, 12 March 1859.

resurrection to the Christians and a sea of fire for the Romans. All is en-
gulfed in a magnificent final tableau.

Berlioz's review of the première[9] dates from a time of intense per-
sonal stress. It issues from the reluctant pen of a man sick to death not
only of an appalling physical ailment but of a critic's corner he had grown
to hate and, in his words, "always the need to find something good to say
about a French musical theater crawling with fleas." In the case of *Hercula-
neum*, Berlioz was anxious to support the work of his friend Méry.

Partisans of rhymed prose and inelegant, nonsensical verse, which
they take as the sole satisfactory nourishment for music, will be a bit
embarrassed this time to uphold their system. Be assured that a
poem (it is one) written by M. Méry can bear no resemblance to an
ordinary libretto. Besides, the imagination of one of the foremost lat-

inists of our time, one of the most learned in the field of Roman an-
tiquity, can certainly be counted on to treat such a subject profes-
sionally, while at the same time ornamenting it with splendid
figures of speech and the most harmonious of verses. The reader of
Herculaneum will see that M. Méry has not failed in this task.[10]

Berlioz had just completed the task of versifying his own *Les Troyens*. As
an expert in such matters, he offers the opinion that Méry's brilliant poem
written in French, and in verse, had not trammeled the inspiration of the
composer. To this he adds that David benefitted from the poem with "a
multitude of charming things," a compliment he then dilutes with the
observation that innovative situations are as little to be expected from Da-
vid, as they are from any other composer of the time.

 Berlioz singles out for favorable mention the fateful introduction to
Act I underlined by David's habitual veiled cellos; the brilliant effect of
the coronation march; Helios' charming Romance with Lilia's correspond-
ing couplets; and the beautiful "Noble Helios" at the beginning of Scene
4. The drinking song he considers original and perfectly written for Mme.
Borghi-Mano's pliant coloratura. The chromatic figure in the muted vio-
lins at the moment when Helios feels the influence of the love potion
Berlioz finds worthy, but Olympia's "Open the abyss",suffers from Da-
vid's habitual misapplication of the piccolos.

 Olympia's elegant coloratura air, "Let us love, free of longing"
(*Aimons, libre d'envie*) was the great hit of Act III, and Berlioz tells us that
the audience demanded an encore. Most of the act is given over to ballet
which he finds "a bit on the dull side." What this judgment implies may
be guessed from his own ballets for *Les Troyens*, written in the same year.
Berlioz can only point to a few pleasing touches in the orchestra and, in
the Bacchanale, the persistent "intoxicating" choral interpolations,
"Evoe!"[11] Finally he acknowledges that Lilia's Credo is infinitely superior
to the Credo from Donizetti's *The Martyrs* and that Lilia's Bellinian call to
Helios is extremely touching.

 In Act IV, the chorus of the slaves prompts Berlioz to think "in-
voluntarily of the minuets of old symphonies—irreconcilable with the ex-
pression of such violent passions." He reproaches David here for a "color-
less orchestra," too often confined to the lowest range, and the use of
accompaniment too simple for the proprieties of epic style. Although
Berlioz does not state the fact, Satan is the principal ideological spokes-
man of the opera. Not only does he activate the underdog; he brings to fo-
cus the major conflicts of the human condition. The message must have
been obvious to Berlioz, but his concern was, as it should have been, with

the effect on the music, and here his pen falters. To review the music is to uncover the stereotypes without which such an opera was unacceptable to its Parisian public. At fifty, David was well beyond those innovative years when he broke from the symphonic mold in the *Desert*, the work that had excited Berlioz's early interest. So far as Berlioz could tell, David was making no new address to the lyric drama. In the final decade of his life, Berlioz seemed more than ever to be travelling in a troika flanked by Gluck and Beethoven. He had no heart for David's remarkable achievement: a romantic lyric scene within which David managed to unite, as in the last scene and duet of Helios and Lilia, Saint-Simonian ecstasy with Italianate expression.

Herculaneum was revived during the 1860s and managed to gain a certain reclame in the process. In 1867 it won its composer the 20,000-franc prize established by Napoleon III for the work or discovery most fit to honor the country. When it was given in the summer of 1868, Berlioz was no longer in the critical circle, but several reviews ranked *Herculaneum* with the very best operas of the decade.[12] The *Revue et gazette musicale* commended Perrin, now in his new sinecure at the Opéra, for his good taste in reviving the work, at the same time paying David back for the vicissitudes that had arrested the success of the opera from the very beginning. David was placed in the tradition of Meyerbeer and Halévy, without losing his own individuality: "charm and color emerge unceasingly from the fecund palette of this Léopold Robert of music."[13] All in all, the critic continues, "an honorable work lacking only that single page and the inspirations which make history and place a work among the masterpieces of the modern school." Generally speaking, critical demurrals all took this form, on the theory that high style, not Italianate charm, was appropriate to the subject. Scudo attributed David's pervasive "nostalgic complaints" not only to his place of origin (Méry also came from the Midi) but to Saint-Simonian pantheism, which he undertook to explain to his readers again in 1859.

A man of the Midi, with colorful imagination, a sweet and simple soul, better fitted to contemplation than to spiritual battles and emotional turmoil, Félicien David was persuaded by the Saint-Simonians, whom he joined and who directed his first steps, that man and nature intermix and embrace in a most intimate manner. This idea is called pantheism in philosophy and, in the arts, the picturesque. Goethe explained it in German poetry. Hegel gave it the philosophical formula. Beethoven, and above all Weber, reproduced it in the symphony and in the fantastic and legendary drama. This

same idea, reduced to lesser proportions, inspired Félicien David's *Desert*, the delightful creation which made his reputation and which he reproduced as well in a kind of oratorio entitled *Moses*, and then in *Christopher Columbus*, and even in his three-act opera *The Pearl of Brazil*. I am certain that if Félicien were to consult his own musicianly and poetic instinct he would say from the bottom of his heart, "the critic is right." Very well! The fable of Herculaneum is nothing but a coarse canvas with the same familiar trappings beneath.[14]

13

Lalla-Roukh

O N 12 JULY 1862, readers of *L'Illustration* opened their paper to two cartoons chronicling the national and international musical scene. In one, a Daumier crowd out of *Les bons bourgeois* is seen pushing its way into a performance of David's comic opera *Lalla-Roukh*; caption: "It must be that thankless Félicien David! To owe his fortune to the *Desert* and now to produce the mob!" (see Figure 8). In the same issue Auber and Meyerbeer are pictured steeplechasing their way to the opening of the International Exposition in London (see Figure 9). Music is admitted to the festival, and these two are invited to represent their countries with a march each. Rossini has declined the honor on the grounds that he is no longer among the living. Auber, on the other hand, just short of 80, falls to with the juvenile verve for which he is justly famous. As for Meyerbeer, he feels sufficiently young to contribute an overture with three marches, not forgetting a lengthy allusion to *Rule Brittania*. On behalf of his own country, Sterndale Bennett presents a Mendelssohnian choral piece, and Verdi misses his deadline.

The first cartoon indicates general knowledge that the taciturn, reclusive David still bore the scars of early rejection by a cynical environment, although *Lalla-Roukh* was beginning to call forth an amount of applause seldom heard in the opera houses of those years. Daumier's art hardly needed captions. His graphic language is direct and quickly understood.[1] His differences with the Saint-Simonians are enshrined in the well fed, top-hatted crowd pressing to enter and to enjoy David's latest. The cartoon binds David to the petty bourgeoisie whom Daumier abhorred. Daumier distanced himself from the "apostles" in every possible way. The catchwords of Saint-Simonian socialism raised all his hackles. Instead, the

Figure 8. Cartoon from *L'Illustration*, 12 July 1862.

somber mystery of the human condition occupied his thoughts. David's dream is entirely missing from his calculations; it no longer had anything to do with the poor people in second and third-class carriages.

Nevertheless, recognition and financial support had come slowly to David. Since 1858, his coreligionists the bankers Pereire had been responsible for an annual pension which assured him 1200 francs. But in May 1862, two days following the first performance of *Lalla-Roukh*, Napoleon III named him an officer of the Legion of Honor, and in the same year he received 30,000 francs from the Academy in compensation for the expenses of mounting his symphonic odes.[2]

David, unlike his audience, was still far from well-fed. It rankled that, in Alexander Dumas's words, "that fine opera *La Perle du Brésil*" was still "a pearl hid in a dung-hill for a decade or more." "Napoleon is worse than the fish with the ring of Polycrates," added Auber. It took him

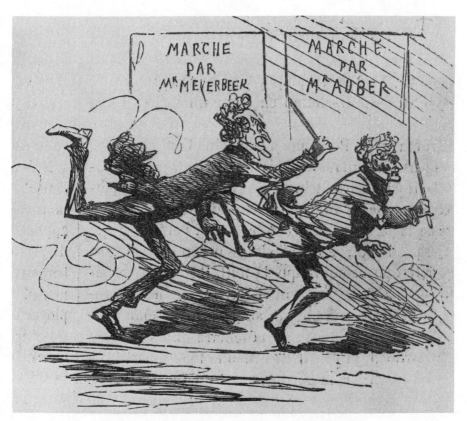

Figure 9. Cartoon from *L'Illustration*, 12 July 1862.

eleven years to find David and bring him back. Auber cited several causes in his assessment of David's disasters. He was too great an artist to be popular. He wrote oratorios when a taste for them did not exist in France. He composed slowly. Performance of *La Perle*, his principal opera, was interrupted by the coup d'état of 1852. He had had serious differences with Émile Perrin, later director of the Opéra.[3]

This history of hard luck attached itself to David's international reputation. *Dwight's Journal of Music* reported to American readers in 1861 the stellar program that had launched the new Union Artistique series in Paris. It included the slow movement and finale of Beethoven's Seventh Symphony and the Benedictus of his *Missa Solemnis*; the D minor keyboard concerto of J. S. Bach, and Mendelssohn's "Calm Sea" Concert Overture.

Three compositions by living composers balance the program: an "Ave verum corpus" by Gounod, an air from Edmond Membrée's opera *Fingal*, and the "sublime descriptive composition of Félicien David, *The Last Judgment*, which formed the leading feature of the program." Dwight then appends an interesting dispatch from the Paris correspondent of the *New York Evening Post*, dated 24 May 1861, entitled "David the Composer," which describes David's predicament in his own country and provides a rare verbal portrait of the composer as romantic—the lyrical poet, as Gautier once remarked, who weighed barely 99 pounds (Figure 10):

> The author of the *Desert*, the *Pearl of Brazil*, the *Last Judgment*, though he has now fully conquered the reluctant suffrages of Paris, was long the object of the bitterest and most persistent hostility. The boldness of his conceptions and the originality of the means which he employs in working them out, though now lauded to the skies, were formerly denounced as monstrous, heretical and absurd. Gentle, refined and exceedingly sensitive, the feelings of the man suffered intensely under the persecution to which the artist was subjected; and it would be difficult to imagine a more touching protest against the cruel virulence of party passion than the expression of patient, weary suffering worn into the features of the man of genius, whom long persecution has rendered prematurely old.
>
> Tall, slightly bent, thin as a shadow; a high forehead, already bald; black elf locks streaked with silver falling backwards from a pale, long face; large, lustrous black eyes, deep, earnest and sorrowful; a mouth placid but as sad in expression as the eyes; and an air of almost feminine gentleness and timidity make up a personality equally striking and pathetic. There is no sign of weakness about the man. He is evidently one to hold on his way, as he has done, gently but firmly; never flinching under opposition but feeling it so acutely that no amount of success can ever obliterate the traces of the suffering through which he has won his way to his present eminence.[4]

Lalla-Roukh is the culminating work of David's career. He was never to surpass it in the ten years that remained to him. It became his last orientale (*The Captive* was never performed),[5] just as the *Desert* was the first. Although they diverge in important respects, each is essentially a set of miniatures, a narrative mode common to the aesthetic experience which David made his own. *Lalla-Roukh* is one of only two of his pieces to be directly derived from an already existing literary work. His experienced writers Hippolyte Lucas and Michel Carré had a firm command of libretto conventions. The particularities of plot were carefully selected from the

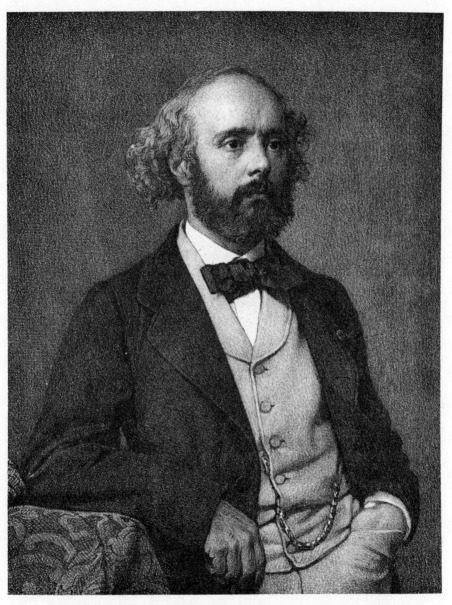

Figure 10. Félicien David from a lithograph by Auguste Lemoine, printed by Bertauts, Paris. From Alexis Azevedo, *F. David: coup d'oeil sur sa vie et son œuvre*. Paris, Heugel, 1863.

recurring frame for Thomas Moore's poetical stories, but the operatic text suffers from none of the English poet's accumulation of metaphors and learned footnotes, useful as these may have been to the scene designers. It fits with the simple ballads, romances, serenades—roses by any other name—of David's previous experience. The forms never exceed his natural reticence, sureness of measure and refinement of melody, harmony, and orchestration—an example of a librettist's sense of music in a story, and his grasp of a particular composer's talent for carrying his impulse into the lyric theater. Although Berlioz seldom failed to remark on the inadequacies of operatic librettos, he let this one go by.

Briefly, it is the moral tale of a king who passes himself off as his own rival in order to assure himself of the love of his fiancée and thus to owe his happiness to himself alone. Even today Indian folk plays and their theaters still thrive on stories about disguised kings like the ambulant singer of *Lalla-Roukh*, and the growth of pure and truthful love between young people who have been pledged by their families to other, more suitable partners. A rapt audience is always on hand for these repetitive stories, and apparently David found one in Paris.

Lalla-Roukh, first performed at the Opéra-Comique on 12 May 1862, was clearly the great event of the season. It earned 6,000 francs a performance for the first eleven, and that figure was exceeded over the next three months. People came up from Provence in droves.[6] A special train brought 800 Angevins to the theater for a performance in July. In their honor the director devised a curtain with a panorama of Angers and a view of its old chateau, rimmed with emblematic subjects and the date of this memorable visit to the opera. Between the years 1862 and 1884 performances at the Salle Favart alone totalled 279.[7]

At a time when composers were being reproached for extreme poverty of musical ideas, David seemed to be strewing his about with full hands.[8] Critics now felt it necessary to caution him that an opéra-comique audience needed to draw its breath occasionally; that it was perhaps a mistake to abandon the animated moments of spoken dialogue that sparkled in the old *comique*. Since the new work continued to draw audiences like flies, this proved to be an unnecessary admonition. Even Berlioz succumbed to the enjoyment of David's efflorescent lyricism. David was moving with ease in a decisively French alternative to the Italian recitative-aria convention. There is no trace of the patchwork visible in *The Pearl* in result of David's overstriving to approximate the highly successful Scribe-Meyerbeer musical moral tone. *Lalla Roukh* has been reduced to one type and one expression, that of ideal love.

The exotic sets had cost a lot of money, but the appeal of the opera

went beyond the Second Empire nouveau-riche taste. This time the crowd came from both the provinces and the metropolitan enclaves. These were the innocent bystanders to revolution and change. No aesthetic gulf separated them from David's beautiful lovers, their sweet melancholy, the bucolic effluence, and—above all—the consoling, sentimental narrative with the happy vision at the end of the road. Then, too, there were reminders of David's first journey. The *Desert* was still on the boards. Everybody understood it. Now David had achieved another popular work, but in place of a religious enactment there is simply the vague excursion that Indians still call "eating the air." The enchantment vanishes only with the end, when the opera moves indoors into the forever-after of a Taj Mahal.

As the reader may gather, the charming music suffers none of the inconveniences of a commanding libretto, since the writers did little more than encourage the composer in his virtues. The overture works with seven themes, three of which are from the opera proper, including Noureddin's barcarolle in Act II, and the duet from the finale of Act I, the most voluptuous melody in the opera. A male chorus accompanies the rise of the curtain on a lovely valley. In due course, Noureddin, no other than the disguised King of Samarkand (first tenor), is asked by Lalla-Roukh's self-important chamberlain (baritone) to disappear on the threat of hanging. Noureddin withdraws, and the tripartite scene complex[9] closes with a developed version of the opening chorus, female voices added.

Lalla-Roukh (first soprano) makes her entrance expressing unease with her new surroundings and the fear that, like her youthful dreams, the banished young man will never be seen again. On first hearing, the critic Léon Durocher reported that her Romance had all the charms and fantasy of Arab poetry: "it was an oriental dream."[10] It is not easy to say where the orientalism lies. Flowery triplets, syncopations, floating cadential elongations in natural minor perhaps contribute more than the wistful wail of the clarinet and the play of muted strings. But altogether, they express nothing so much as the first sadness on "youth's smooth current," as Thomas Moore had it. The music, in any case, is infinitely more touching than the metaphor. As Durocher said, it yielded the Duchess of Lonqueville's favorite pleasure: "a fine melancholy in a lovely meadow."[11]

Baskir's entrance shifts attention from the prevailing bucolic sentimentality with his comic couplets on the difficulties of playing sentinel to a romantic young lady. Baskir has only two pieces in the opera, and although David is remarkably successful with the light comic touch, his critics felt that the opera would have profited from a few more examples. On the other hand, given the modest dimensions of the opera, David erred only on the side of good taste and a consummate sense of balance

when he confined the comic element to four additional numbers, including the coupletts allotted to Mirza, Lalla Roukh's companion (second soprano), the comic duet of Nourredin and Baskir, and the drinking song of the guards, which David turned into "The dark mantle of night" (*La nuit au manteau*), a masterly men's chorus full of humor and carried through with melodic fragments migrating contrapuntally among voices and accompaniment.

Among his remarks on *Lalla-Roukh* in *Musiciens d'aujourd'hui*, Adolphe Jullien observes that at first it was the roles of Baskir and Mirza, rather than the prevailing sentimental exotic, that assured David's success.[12] It seems, however, that David's comic schemes barely outlived the moment. To Berlioz fourteen years later, the comic duet seemed far less striking when compared with David's "outpourings of tender orientalism." But Berlioz was in tune with the first audience when he wrote that the duet "All will go well tomorrow (*Tout ira bien*)" was a "lively, crackling dialogue of a clever dramatic intention. At times the vocal phrase rushes toward a prolonged trill in the winds with perfectly motivated raillery complementing the singers' bursts of laughter. In short, this duo, a true, masterfully developed opéra-comique duo, seems to me the most meritorious piece of the score."[13]

This was not to deny the oriental softness and languor of the ravishing love duet by hero and heroine in the last scene complex of Act I. "Night spreads her wings" (*La nuit en déployant*) begins with the kind of dialogue scene that David always wrote well. The clarinets follow Lalla Roukh like love birds, and the lovers are enveloped in an atmosphere of dormant nature which seems to share their emotions. Lalla Roukh's ecstasy mounts in counterpoint to Noureddin's words. In the second episode, nature awakens to a distant exotic dance (clarinets doubling triplet figures in octaves over, as usual, a tonic pedal), while slow-moving harmonies are sustained in muted strings, horns, and bassoons. Descending natural-minor scales govern the twin soliloquies of the lovers while the orchestra responds softly with archaic harmonies rising from the mysterious valley. Finally, Lalla Roukh's tears overflow to a counterpointing orchestra, and minor is replaced by clear major. A tiny recitative forms a transition to a final *cabaletta*—featured at length in the overture—that particularly pleased Berlioz.

Their first wave of passion exhausted, Lalla Roukh begs Noureddin to hide and to flee. Their recitative is interrupted by the chorus, buoyant with consolations of the grape, singing their Night's Round. By adding Mirza's siren-song to the texture, David accomplished a tour-de-force of combinative writing. Of Mirza's elegant couplets wafting from the wings

Berlioz wrote: "Their butterfly-like allure offers the happiest contrast to the clumsy song and disorderly appearance of the crowd." Humorlessly he adds: "I must reproach the composer for making an arpeggiated vocalise on the last syllable of the word *amour*, which necessarily produces a prolongation of the vowels *ou* . . . abutting on the isolated consonant *r*."[14] David so seldom made a gaucherie that the passage must surely have been conceived tongue in cheek. Mirza apes the aristocracy. She preens with all the superficial decorations which are withheld from her mistress' expressions of pure love. Baskir, the self important buffoon, is the object of her attentions, and this moment fulfills whatever need for a lower-class subplot after opéra-comique convention. As Act I ends, the assembly subsides in stupor so that the lovers can make their escape.

The large scene complex Number 4 in Act I (Achter cites it as the longest in all three of David's lyric operas) deserves special comment. It includes the opera's major ballet, introduced ostensibly to offer entertainment to the languishing princess: the group of pieces bears the heading *Choeur et Airs de Danse*. The opening chorus is perhaps a distant cousin to the Chorus of Countrymen and Women at the end of Act I of Mozart's *Figaro*, or to the merry meeting of country folk in Beethoven's Pastoral Symphony. The second is the ballet proper: an introduction, an *Allegretto*, and an *Andante*. Then a brief instrumental interlude (*Allegro*) ushers in a danced chorale, "Indian dancing girls more nimble than lightning," which gives distant reflection to one of Barrault's East-West homilies.[15]

Berlioz recognized the originality of various rhythmic patterns in this section but was inclined to question the assumption of the public that they were listening to importations from the Orient. "So go," he tells them, "hear these melodic turns that the Orientals perform on their instruments, and you can give me news of them." Berlioz was attracted to compelling rhythms wherever he found them, in David no more or less than in Strauss waltzes; their possible ethnology—this showed already in his first review of *The Desert*—he seems to have excluded from his major concerns, although this does not, for him, rule out the charm of oriental decorative effects, no matter how the European composer achieves them.

A second glance at the beginning of the scene reinforces the earlier impression of an East-West homily. The drone and dominant upper-pedals could be classed with the oriental clichés to which David turns when it is a question of the familiar golden dream. But the opening section with chorus sounds more like "salonized" Polish dance, as Pushkin called the mazurka in *Eugene Onegin*. David occasionally bowed to clichés from admired contemporaries, and a few measures here invoke Chopin by accenting second beats à la mazurka (although common time is indicated)

and making cadential breaks like a polonaise. David aimed at a rustic atmosphere, but a rustic Indian atmosphere was not within his experience. On the other hand, the use of Polish dance rhythms for folkish situations was well within the experience of the operatic audience, and Chopin's experiments with the characteristic dances of his country were close at hand. Why Poland? Among the risen nations, Poland had long been the paramount object of messianic theory, a means of justifying national particularity in the cause of the universal ideal.

The ballet is charming but utterly conventional; the one place, as Berlioz said, "they could have given us a bit of local color and true oriental character suggesting the poses of the *bayadères* rather than those eternal *enjambées* that make the dancers reappear in pairs of great open scissors, ready to cut in two everything on the neighboring scene."[16]

The essential note of the composer's "naturism" is to be found in the choral addition to the dance, and it depends on his orientation to a particular pantheist-oriented religion. Here the composer's state of mind comes unusually clear in the music. The impassive, syllabic chanting of "Night falls upon the earth" (*La nuit tombe sur la terre*) conveys a feeling of being so harmoniously a part of nature that movement diminishes to near immobility. An exquisite melody painting the fall of night (horn and cello in octaves) repeats with slight variations and, as the stars appear, assumes a soft upward curve. Foreshadowing the line "already the stars are gleaming," the chanting gives way regularly to innocent tone-painting in the shimmering orchestra (see Musical Example No. 17).

The style is both schematic and consistent with the expression of form by means of color which one sociologist has equated with the typical value-orientation of religions tending toward a sensuous, harmonious image of the universe.[17] Be that as it may, the limitations of David's style have had other explanations. Its uniformity and repetitiveness have been variously attributed to an inadequate education, to temperamental languor brought on by chronic illness, to the tendency toward reverie characteristic of the reclusive personality, to the lingering weariness that afflicts permanently the energy levels of those formed in climates balanced by the heat of the day and the blessed release of nightfall. Finally, that ill-tempered and ill-considered accusation of intellectual and emotional infantilism to which Berlioz gave vent privately in 1858 may perhaps be attributed to pressure from his own lonely torment of the moment.

The want of "proper" education is no more valid for David than for other composers, including Berlioz. Scorereading was David's principal leisure-time activity throughout life: a deeper education was not likely to be found in conservatories. Undoubtedly temperament prevented his de-

Musical Example No. 17. "Choeur et airs de danse" (*Lalla-Roukh*, Act I).

veloping the vigorous or harsh dimension of orientalism, as he was himself aware at the height of his seductive experience with the East. His exploration of its first dimension, however, was so on-target as to be defined by one of his early critics as "musical beatitude."[18] David's originality is best expressed in the persistent mannerisms themselves. The humming chorus interpolated in the *Lalla-Roukh* ballet, for example, is only a matter of rising chromatic harmony over a dominant pedal, with "shining stars" in the orchestra and an accompanying rising chromatic bass line. David's audi-

ences were evidently highly susceptible to the attraction of these mo-
ments, no matter how repetitive. Simple Simonian as these words may be,
they point to an emotional current that connected one of the restrained,
intimate romanticisms of the middle nineteenth century to its largely
middle-class public. [19]

The grand scene complex to which we have turned our attention re-
solves itself in the final fairy-tale romance-waltz of the ambulant singer,
who is now fully aware of his mistress's devotion. "My mistress has left the
tent" (*Ma maîtresse a quitté*) is cast in the customary three stanzas with in-
troduction. Unerringly, Berlioz pointed to the originality of the tiny or-
chestral refrains and the accompaniment throughout. The brush strokes
he mentions are not unlike those found in his own "Queen Mab." The al-
ternating minor-major of stanza and refrain suggested to Azevedo "the
opening of a rose." [20] The piece may even be heard as another evocation of
Weber's *Invitation to the Dance*. It has that absolute unity of atmosphere
that characterizes David's moods at their most innocent.

Lalla-Roukh received praise from all quarters, at times with some
cavilling about Act II's inability to awaken from Act I's dream. [21] The
complaint, however, held no weight with Berlioz, the most reliable and
sorrowful witness to his time and place. He was perceptive enough to rec-
ognize in this instance what David supplied to its vacuum—undimin-
ished lyricism and lovely instrumental detail. The Act II entr'acte adds
bird calls to its night music. Dreamy, slowly resolving delicate chords
hang from upper held tones. A solo horn melts into six measures of recita-
tive. Lalla-Roukh's beautiful aria, "O Night of Love" (*O Nuit d'amour*), in
the opera's main key of E major is a highly developed account of her pres-
ent despairs and girlish dreams of a happy past. Cadences move effortlessly
into memory of the horn calls. Operatic agitation overcomes the melody
only briefly. In the central episode Lalla-Roukh's insecurity demands reso-
lution. She prepares to face "without fear, as without love," the great king
to whom she is promised. The interludes retain chromatic agitation; by
contrast, the stanzas have the movement of an old French pastoral, with
touching little descending melodies. This is one of David's most naive re-
ligious moments. Lalla-Roukh has grown to the stature of the liberating
woman of Saint-Simonian myth. Her moral vigor is subject to a certain
vulnerability because of her sufferings. Her expression is akin to that of
the Indian fantasy-mother in *Christopher Columbus*. "From what points on
the horizon and by which roads does she come?" Barrault once asked.
"Does she live in a palace? Daughter of a king, is she, by these unlooked-
for beneficences to reconcile with the throne the popular masses who
grumble?" [22]

Jean-Baptiste Weckerlin (1821–1910) raised a minor hullabaloo[23] over the resemblance shared by David's scalar melody, another in Legrenzi's *Eteocle e Polinice* (1675), and the principal theme of the finale of Mendelssohn's *Trio in C minor*, Opus 66 of 1845 (see Musical Example No. 18). Since David assumed his accustomed cloak of innocence in the matter, one may only note that Legrenzi's arietta belongs to the jaunty Eurillo whose concerns are clearly not those of David's heroine. Mendelssohn's theme, with its initial leap of a minor ninth, invokes an affect of deeper import, but what one has to do with the other two is probably no great matter: David was given to such things. They are not petty thefts; rather, they emanate unselfconsciously from a retentive aural memory. We are better advised to notice, after the interlude that separates the stanzas of "Night of Love," the unaccompanied four-measure recitative, ex-

Musical Example No. 18. Melodic similarities: David and Mendelssohn.

actly at mid-point in the section in which Lalla Roukh reaches her highest resolve (see Musical Example No. 19).

For the remainder of the opera, Berlioz commented judiciously on the duet of Mirza and her mistress "accompanied by an ingenious little orchestra," and the original texture resulting from the addition of the concerns of Lalla Roukh, Mirza, and Baskir to the chorus of women bearing gifts and baubles from the king. Bertrand compared this passage to "the graceful ingenuity of Gluck's smaller choruses."[24] David's reluctance to emerge from his enchanted valley shows in the final march, which is respectable in a neo-Louis XV way, but a little tired. A politically astute compliment to the director M. Perrin winds up Berlioz's commentary. "Everything contributed to consolidate and increase David's success—the performance, the sets, the decorations, and the incomparable richness of the costumes. The director of the Opéra-Comique is an artist."[25]

It was also M. Perrin's good idea to couple David's two-acter with the single-act Rose et Colas by Monsigny and Sedaine (1764). If Lalla Roukh should be revived today in this coupling, Rose et Colas should give at least as much pleasure as it did in 1862. We would now have little difficulty in reproducing Berlioz's favorite piece from it, a well-wrought three-voice fugue. It was cut, said Berlioz, because in spite of all their efforts the singers never succeeded in learning it by heart, and a cacophonic accident occurred every two out of three times in rehearsal. "Maybe we should conclude that 88 years ago Monsigny was writing for the future and that the future has not yet arrived." So far as the education of singers was concerned, it had not, as Berlioz well knew. But a more serious difficulty existed in retuning nineteenth-century ears to accommodate Monsigny's village soothsayers. Rousseau's idealized nature was by this time as remote as David's Indians soon would be. The difference was that, standing philosophically behind Lalla-Roukh, Rousseau's ideal found its romantic equivalent in David's lyrical grace, his unhurried pace, and his pretty orchestrations. This the audience grasped without difficulty.

David and his fellow orientalist, the painter and writer Eugène Fromentin (they died within a few days of each other), derived their separate subjective impressions of starry nights and desert silences, one as a result of his presence in an archeological expedition to Algeria, the other in the midst of an ongoing industrial expedition to Egypt. Both brought an acute sense of hearing to their exotic landscapes—prose the medium of one, music of the other. Each was aware of the other. "We have hummed Félicien David's Desert to the measured step of our camels," wrote Fromentin to a friend in 1848.[26] Neither wished to descend from his camel, although the reproach of a monotonous character-type did drive David, in

Musical Example No. 19. "Lalla-Roukh's Air "O nuit d'amour,"
transitional recitative (*Lalla-Roukh*, Act II).

his anxiety to please, to the unfortunate attempt for change of atmosphere
in his last lyric opera *Le Saphir*. *Lalla-Roukh* remains his greatest achieve-
ment in landscape painting within the lyric opera scheme, introduced
with an almost eighteenth-century grace, together with its "gallantries,
masquerades, festivals, so-called rural or amusing mythologies."[27]

At the end of his review of *Lalla-Roukh's* first night, Paul Scudo
brought back his favorite excursion into the work of France's first literary
landscape masters—Jean-Jacques Rousseau, Bernardin de Saint-Pierre
and Chateaubriand—without having looked closely enough at the music
of David's opera to realize the essential point of comparison.[28] These
writers expressed their artistic vision of things observed and felt in a mul-
tiplication of rhetorical formulas as brief and variously shaded in their rep-
etitions as those of Félicien David. And David's formulas were not in
themselves original or exclusively oriental or specifically symbolic. The
drones, the humming, the birdcalls, the curvilinear melodies, the rhyth-
mic ostinatos, the melodic doublings in unison or octave in one instru-
ment or another, the exotic-sounding scale patterns—all are a repertory
of objective facts for which David himself made no claims in terms of
spiritualizing the material world. It is the persistence of the exotic stance
that draws one to the inner state of the man. Even his remission from sad-
ness and ill health came at the times when he was in closest touch with na-
ture's qualities.

So marked was the success of *Lalla-Roukh* that performances contin-
ued in France until 1897. There were also French-language productions in
Brussels and Antwerp during the 1862 season and in Geneva in 1864.
Translated into German it played in Coburg, Mainz, and Munich in
1862, in Vienna the following year, and two seasons later in Berlin. As
the opera gained international fame, there were performances in Hungar-
ian in Budapest, in Polish in Warsaw, and in Swedish in Stockholm. In
the three decades following its première, *Lalla-Roukh* also received Italian
and Russian productions in Milan, and in Saint Petersburg and Mos-
cow.[29]

Enfantin and his intellectual family considered no corner of social life be-
yond the ministrations of the highest human science they called politics.
Since 1829 they had been dreaming of an implementation of the theorem
according to which they would ordain the artist as the word of the priest,
the high estate which proved to be a binding factor at various times with
such different artistic personalities as Berlioz, Sainte-Beuve, Franz Liszt,
and above all Heinrich Heine. Enfantin's most important insight, how-
ever, had to do with the utility of offering with one hand the security of
ideology, with the other the security of planning agencies bent on
battling misery. He acted on an intuition that fantasies can energize art-
ists, move them to creative action. In 1862, the year of *Lalla-Roukh*, he
spread about the idea of a fund for intellectual workers, thus to assert the
moral value of money by founding an intellectual credit on the pattern of
his land grants. He also proposed the compiling of a new encyclopedia in
which material on the social and formal sciences, industrial arts, literature
and fine arts (including religion), and philosophy (including moral) would
be so arranged as to begin with what was accessible to the greatest num-
ber. A double format (bourgeois and popular) was to include a résumé of a
few pages for each volume to serve as a guide for the journalism which
would propagate the work.[30] Despite the energy and enthusiasm of their
proponent, both projects came to naught.

14

The Sapphire

The Sapphire was one of only two new works introduced at the Salle Favart in 1865. The other, François Bazin's *Voyage to China*, supplied to the opéra-comique audience a pidgin orientalism cheerfully accepted along with David's genuine exoticism. In some respects, *The Sapphire* may have been an attempt on Michel Carré's part to improve on his book for Gounod's 1864 pastoral opera *Mireille*, based on a poem by Fréderic Mistral, David's younger neighbor at Arles. An educated peasant who kept his Provençal heritage alive in a vibrant poetry, Mistral should by all odds have been the one to inspire David to a last lyric opera of distinction. But the humiliating necessity that Gounod faced, that of literally "decomposing"[1] a serious idyllic pastoral down to the taste of impresarios and singers, afflicted David as well. *The Sapphire* fared no better than *Mireille*, but the decisive winner of the year was an operetta by Edmond Audran of Lyons, thirty years younger than David and smart enough to rework the expected popular ingredients into his *Gillette de Narbonne*. It was rewarded with hundreds of performances and thousands of francs that were never forthcoming to David or Berlioz.

In *The Sapphire* David issued no challenge to Berlioz in the territory of Shakespearean adaptation, nor was there even comparable interest in the English poet on the part of the two composers. Berlioz's devotion to Shakespeare was deeply felt and longlasting. His transformation of *Much Ado About Nothing* into *Beatrice and Benedict* (1862) was, in respect to both poetry and music, witty and genuinely inspired. With *The Sapphire*, on the other hand, David was being asked to board an operatic bandwagon which his librettists hoped would take him on as a regular passenger. The operatic book that took three authors to achieve was no tribute even to

179

this perhaps least of Shakespeare's plays—*All's Well That Ends Well*. The intention, as Jean Gustave Bertrand remarked in his *Ménestrel* review, was to refit Shakespeare with the French zest of Planard and Scribe.[2] As it turned out, David's opera was neither comic enough to please the middle-class audience conquered so easily in 1862 nor picturesque enough to please the elite who had come to recognize the fresh inspirations of his musical address to the sun, the moon, and the stars. Nevertheless, the same critics continued to acknowledge his elegant and orderly forms.

The first performance of *The Sapphire* took place at the Théâtre Imperial de l'Opéra-Comique on 8 March 1865. It was noted immediately that the composer had left his clear landscapes behind in favor of a murky plot, freely adapted from Shakespeare and carefully cleansed of the bard's poetry. It was destined fatally to disinspire the composer. Writing in *Le ménestrel*, now under the editorship of Joseph d'Ortigue with Blaze de Bury and others, Bertrand camouflaged his reaction, probably for old times' sake, with some kind words about ingenious amusing scenes.

The heroine Hermine (first soprano) remains a paragon of virtue throughout a daunting series of events that emphasize very few of the womanly qualities celebrated by Shakespeare or Saint-Simon. An allusion to Shakespeare's notion of healing as in some way related to the virtue of the healer does, however, initiate the action. Hermine, daughter of the Queen of Navarre's doctor, has saved the life of the infant heir-presumptive with precious prescriptions inherited from her distinguished father. She has secretly been in love with the young Count Gaston (tenor), who becomes her reluctant husband by edict of the grateful queen. The queen's role is just long enough to corroborate Hermine's assertion that pride of birth is only prejudice, a distant reverberation, perhaps, of Enfantin's stand on inheritance.

Gaston leaves promptly for the wars in Spain and Italy. This takes Gaston and David to the Pyrenees for some useful local color. David was familiar with the region, as he often took the waters there. Meanwhile, Gaston has sworn that a de-facto marriage with Hermine will not be valid until he places a sapphire ring on her finger, as is customary among the counts of Lusignan. Shakespeare's second requirement, proof of pregnancy, goes by the board. If Gaston travels to Naples rather than to Shakespeare's Florence, the decision was probably owing to the popularity of Neapolitan music. Since an encounter with the Spanish was expected, Act II was taken to be an imbroglio after the Spanish genre.[3]

Gaston now pays court to Fiammetta, a soubrette like Zerlina in *Don Giovanni*. He goes from bad to worse in a dissolute life, aided and abetted by the devious Parole and by Olivier, a Cherubino-like character (mezzo-

soprano). In Shakespeare, Parole's equivalent stands out as a stage villain with considerable dramatic motivation. He is, in fact, morally related to Iago; in the opera, he is only a minor Leporello, inveighing against an unwanted marriage.

Hermine arrives unexpectedly, tells her story to the experienced duenna Lucrezia (contralto), who organizes a series of disguises, mistaken identities, entrances and exits reminiscent of the intrigue atmosphere of Mozart's *Figaro*. Parole eventually surrenders the sapphire to Fiammetta—actually Hermine in disguise. Hermine then returns to France. In Act III, Gaston's company returns to France as well. At his chateau he finds the widowed Hermine surrounded by fawning courtiers. Having incited his jealousy, she demands the ring, which neither Gaston nor Fiammetta can produce. Hermine then shows it on her finger, paving the way for the denouement.

With *The Sapphire* David ended his public career on a note far from his normal expression, defined here in terms of a delicate and sensuous romantic conception of nature. Up until this point, one could easily relate his musical actions to Saint-Simonian principles. As his career developed, he frequently met the taste of his concert and opera audiences—that is to say, both elite and popular interests. In this last work, David is at least still in tune with Saint-Simonian conviction that individual talent should be nurtured within a consensus society, that the artist could make his way like any other producer, with reward commensurate to capacity.

David's spontaneous ties had always been with Saint-Simonian fraternalism and its high ideal of a peaceful social-religious movement directed toward the general good. In his music, the sensuous tone of the romantic religion, passively absorbed under Enfantin's tutelage, came to best expression in his symbolic-exotic style. The forcible turning away from high romantic optimism in *The Sapphire* was bound to be inhibiting, but much of the score was acknowledged by the critics to contain some of his most attractive music. At the same time, David's enduring melancholy was noticed and judged inappropriate to frivolous comic opera. With Enfantin's death in August 1864, David's melancholy frame of mind may well have expressed his last identification with his mentor's world view. Its psychic aftermath was David's withdrawal from the community he had ardently supported in the past with a gentle idealism now at odds with the operatic courting of Louis Napoleon's favor.

When the *Revue et gazette musicale* announced that Félicien David had lost his father, he had indeed been orphaned a second time. More than ever there was the desperate need to live upon the generosity of others. There is some reason to think that David was somewhat disillusioned with

the quantity and quality of Saint-Simonian nurturing of his person and art. Albert Vandam reports that he chided him one day with "after all, M. David, they did you good. They inspired you with the themes of your most beautiful works."[4] Whereupon the catalogue of bitter memories unrolled. But for Azevedo's generosity, he would have gone supperless to bed on the eve of *The Desert*'s fabulous success. Were it not for the Escudiers' backing, he would not have had a series of performances of the work. David continues:

> Those good Saint-Simonians the Pereires, Enfantin, Michel Chevalier had not lifted a finger to help me in my need; nevertheless I was not going to condemn good principles on account of the men who represented them not very worthily. Do you know what was the result of this determination not to be unjust if others were? I embarked my little savings on a concern presided over by one of them. I lost every penny of it; since then I have never been able to save a penny.[5]

The savings he speaks of were probably the proceeds from *Lalla-Roukh*. The failed project was perhaps that of Enfantin's encyclopedia. Despite all this *The Sapphire* bears a dedication to Isaac Pereire.[6] If, in addition, David had submitted to a marketplace libretto, he was at 55 already a tired old man not far advanced from the fifth-floor attic of his Parisian beginnings. Perhaps he hoped that, having attained considerable skill in the production of French lyric opera, he could move closer to his audience on their terms as well as on his.

The comments of reviewers that, with *The Sapphire*, David had completely altered his accustomed style was certainly not true. As one of them put it, there was no resemblance in its melodic conception and harmony to any of the other works.[7] The concentration on rondo and three-part forms, the attention to recitative in place of spoken dialogue, the concepts of balance, the modal contrast, the layering by key levels, and the closed circles of tonality noted in the other two lyric operas are, if anything, more noticeable here. And they reveal another model in David's storehouse—the Mozartian operatic process. Above all, they represent a move toward the goal of the unbroken flow of music in the service of drama.

David's melodies flowed as naturally as before, although critics insisted they were not impeded by Italian flourishes. Increasingly, singers had to be given brilliant passages which otherwise they would invent for themselves. Accompaniments also suffered. In Bertrand's words, they were often no fuller, motifs no more developed, than would be the case in salon music. What could the composer of *The Desert* do, he added, with

such frivolous material as clashing burlesque rhymes, superannuated soldiers, babbling chambermaids, and the artificial give-and-take of vaudeville halls?[8]

It was, moreover, not unreasonable that David should have been offered a French subject at this time. He was a reputable composer whose background assured strong affinities with French popular culture, now stylish among well-to-do city dwellers. He did not deserve the absurdities and banalities of his libretto, but his growing passivity and morbidity simply prevented effective resistance. Nothing short of the old idealization of popular music—the spirit of George Sand and Liszt in the country—would have been sufficient to reinspire him with the beautiful valleys of the Vaucluse. Those vistas, Bertrand suspected, were always behind the pedal points and orchestral tremolos that registered his dreams of the Orient. The devices so eagerly mined from Beethoven and Cherubini were now memories to be carried back to the country, together with the roses of *Lalla-Roukh*.

The overture to *The Sapphire* is a standard opéra-comique medley of tunes from the opera. The opening chorus of Act I utilizes David's repetitive formula for the happy peasant in an ideal state—a wide-ranging melody in 6/8 meter over a tonic pedal; it was immediately encored at the première. It is doubtful that the lesson, even with constant repetition of its musical realizations, was ever fully grasped by David's audiences, but Rousseau's paradise—the idyllic life of the natural man—stands there in its Saint-Simonian penumbra for the last time in a David opera.

Parole's only solo in the opera is a comic tour-de-force that comes just before the end of the act. It is exactly the length of Leporello's catalogue aria, of which it is a reasonable parody: "Seduction is marvelous, but do not get married." Many of Mozart's effects are imitated: a fast, casual singing in patter style with raucous wind interruptions and comic retards for stage business—everything except Mozart's witty inventory of Don Giovanni's conquests.

The complications of Act II are cleverly organized so that key levels move through a cycle of fifths. The opening male drinking chorus of the conventional type is used here to locate the French soldier on foreign soil. Meanwhile Parole has been flirting with Fiammetta. When she is persuaded to sing, it is to assure her listeners that, should Naples open its doors to Spain, she herself would not be "taken." The song, very attractive in itself, is of the tra-la-la sort that David used so cleverly in the *Pearl*—solo with choral responses. The guitar-like accompaniment in the orchestra, the ambiguous scalar formations, and Fiammetta's vocal flourishes, all evoke the traditional flamenco style.

Having assumed a principal role in the complication, Fiammetta is now in the position of having to resist the dishonorable advances of Olivier, Gaston, and Parole. An energetic orchestra negotiates many shifts of key while she conducts a three-way conversation during which Gaston and Olivier declare their particular concerns in counterpoint. Fiammetta manages to retain her folk integrity while dealing diplomatically among them. Finally, all four characters unite in song, each fully confident of holding the upper hand. Here David's singers are, musically speaking, as much at home on the bridge at Avignon as they are in Italy, and David shows himeslf in command of skillful ensemble writing in a spirited and witty situation all but unknown in his other work.

In the aria, "I would surrender, poor and foolish" (*Je me livrais pauvre*), Hermine draws her own portrait. She is a lady serene and wise whose fate it is to love a man weak, immature, and devious. If one can but wonder why a good woman goes to great lengths and distant parts to recover him, her example has already been set before us, not just in Shakespeare but in Mozart, too. Hermine shares her predicament with the Countess in *Figaro* in that she still hopes for a happier life with her faithless husband. Her problems drive David's harmony to unaccustomed chromaticism at the outset, but the dominant mood is that of the Countess' elegiac soliloquy at the opening of *Figaro*, Act II. The comparison is reinforced by elegant imitations of Mozart's twining thirds and tender appoggiaturas. As in Mozart, an unsettled state of mind is suggested by rich harmonies in the orchestra (see Musical Example No. 20). A second section expresses Hermine's intense concern to resolve the conflicts, reflected in brilliant coloratura and in a tendency—boldly offcourse for David—to elide phrase endings.

The finale of Act II is a long scene complex during which a great deal of Mozartian intrigue advances in recitative while the accompanying orchestra alludes patiently to sentiments hidden in the silly stratagems and deceptions taking place on stage. It remains for Hermine, disguised as Fiammetta, to retrieve the ring from Gaston, and in typical opéra-comique style the act ends in a march toward battle with a few hastily summoned Spaniards.

David's chorus of the Neapolitan fishermen, enthusiastically applauded, reminded several critics of the highly praised choruses of Auber's *Muette*. One reviewer saw it as not merely picturesque but rather as color understood as the human material of history.[9] Clearly, the words of the chorus had been designed to evoke David's famous picturesque style, achieved as often as not without the aid of instrumental tonecolors. The idea of the receding boatmen is presented simply by means of holding the

Musical Example No. 20. Hermine's Air "Je me livrais pauvre," orchestral interlude (*Le Saphir*, Act II).

pianissimo through a repetition of their initial response. David's chorus belongs with those imitations of nature that Berlioz had suggested almost thirty years earlier in his *Revue et gazette musicale* articles. His example from Rossini's *William Tell* depicted a movement the reverse of David's; that is, the arrival rather than the departure of the boatmen. Such imitations, wrote Berlioz, "in no way overstep the vast circle, within which our art is circumscribed by its very nature. For these imitations are not in fact offered us as pictures of objects but only as images or analogues. They help to reawaken comparable sensations by means which music undoubtedly possesses."[10]

Achter suggests that Gaston's serenade was sung offstage but probably danced to onstage.[11] Since Carré was principal librettist for *The Sapphire*, the critics were inevitably of a mind to trace such a piece to Gounod's popular moonlight scene in *Faust*; that libretto was derived, they said, from Carré's play *Faust et Marguerite*. But, in fact, David's individual expression is at its most authentic here and, as the *Illustration* critic said, it was unfortunate that the remainder of the work was not up to the level of the second act.[12] On the dramatic side there were the usual reservations. The same critic found David's seduction scene too sincere, given the fact that his libertine relates to Fiammetta as Don Giovanni does to Zerlina—"insinuating, caressing, voluptuous, pressing—anything but tender."

The orchestral introduction to the short third act is a waltz that continues as the curtain-raiser accompaniment to a festive chorus in progress at Gaston's chateau. From here to the end, Mozart hovers over David's shoulder. The ball scene, although lacking in dramatic content comparable to Leporello's banquet preparations, successfully combines a four-

square chorus and whirling waltz. The local mountain people then inter-
rupt the aristrocracy with a *fête champêtre* in honor of the queen, thus
giving the third act an important ballet.

A comic trio on the frustrations of love, sung by those fake peasants
Gaston, Olivier, and Parole, leads Hermine to rap them on the knuckles
with couplets for which David summons a few vocal tritones and a good
measure of excited coloratura. Lacking the picturesque staging opportuni-
ties of his exotic operas, David's final act resorts instead to a procession
that conveniently frames sections in prolonged recitative. Since no reason-
able psychology can justify Hermine's desire to regain her dreadful hus-
band, Gaston is at first recalled by means of the music which accompanied
the reading of his farewell letter in the Act I finale. Then Hermine pro-
duces the sapphire. Like the Countess in *Figaro*, she remains passionate in
her resignation. The queen, ever charming with the mellow wisdom of
age, gives her blessing to all three marriages: Hermine to Gaston, Fiam-
metta to Olivier, and Lucrezia to that pseudo-Shakespearean weakling,
braggart, and rogue—Parole. A chorus with the attractive music from
the beginning of the overture ends the opera. As usual, choruses have
taken first place in David's work, and according to all accounts of *The Sap-
phire*'s first night, they were unusually well performed.

Critical response to David's last opera was, on the whole, generous,
but it achieved only twenty performances and was never revived. During
its last performance, a small fire broke out backstage. Given the compos-
er's well-known bad luck, this was enough to prevent a reopening.

Once David's personal expression had been assigned by his contem-
poraries to the mezzotints of his orchestra and the short, naive, tonally
vacillating melodies of his odes, it was inevitable that he should be per-
petually blamed for his first success, the Desert Symphony. *The Sapphire* is
not likely to emerge from the obscurity which it shares with hundreds of
other agreeable light operas from the same epoch. It would be a mistake,
however, to overlook the seriousness and fastidiousness with which David
went about raising the tone of the genre at great cost to his career. The
sentimentalization of his airs according to the melodic, harmonic and
rhythmic formulae imbibed from Mendelssohn over the years, far from
trivializing his music, added a distinction to his writing conspicuously
absent from the general output of the 1860s. Gaston's "Yes it is you
alone, Hermine" (*Oui, c'est vous seule*), his final plea for forgiveness and
redemption, represents the most sincere of David's temperamental ties
with a fellow composer, so strongly does it suggest Mendelssohn's much
admired and imitated character pieces.

As regards the vogue then in progress for the French folk idiom,

Bertrand saw signs that David could still be repatriated, so to speak, as a troubadour of Provence.[13] David's contributions to the new cause of promoting the native art were too slight really to accomplish this—piano accompaniments for Pascal Lamazou's *Songs from the Pyrenees* of 1869 and the *French Noels* of 1873. But Bertrand realized that David had long since attained an idealization of popular music, whether it be the reverie of an Arab maiden, the lullaby of an Indian mother, or the ritual dance of a New World savage.[14] This was, after all, the sense of earlier intimations of Rousseau.

Afterword

*T*HE DEATH of Félicien David on 29 August 1876 at Saint-Germain-en-Laye prompted the issue of extravagant eulogies in the Parisian papers for the by-then distinguished composer, successor to Berlioz at the Institute of France, member of the Académie des Beaux Arts, and officer of the Legion of Honor. The year 1876, however, was a time of keen political and religious strife when the Monarchists were within a few votes of bringing down the Third Republic, and tempers were perilously short at both ends of the political spectrum. David's funeral arrangements seemed destined to ignite fresh disputes. The spark was furnished by the fact that his funeral, by traditional observance for members of the Legion of Honor, was entitled to a marching military guard. On the other hand, David's final testament declared: "I die in the Saint-Simonian faith, which has been my life since my 22nd year. In consequence, I direct that my interment be without any intervention of the Catholic religion."[1] On learning that the ceremony was to be civil only, not religious, the cavalry officer in charge, on orders from above, halted his soldiers short of the tomb in Du Pecq Cemetery. Many judged this an affront to the deceased and to the Legion, and both Monarchist and Republican journals took up cudgels to deal telling blows on both sides. Parliamentary debates ensued, and the Minister of War was called to task for effacing the memory of a great man. Before the smoke lifted, Prime Minister Jules Dufaure felt it necessary to resign. Thus our dreamer of peace and progress for all humankind made his final departure amidst volleys of protest and acrimony.[2]

At the end of his journey, David indeed had come a long way: from naive and impecunious conservatory student out of the provinces to internationally renowned composer. The neophyte who early on crafted modest

189

Mendelssohnian piano pieces (*Breezes from the East*) later became a concert hall name for his ode-symphony *The Desert*, which Hector Berlioz immediately pronounced a masterwork by a great composer. The delicate craftsman of simple salon songs rose to command the stages of lyric opera. That itinerant musician diverting curious passersby from a balcony above a dusty Smyrna street later drew such throngs to Parisian theaters as to invite caricature. Quite clearly David's talents put at the service of Saint-Simonian doctrine provided an irresistible lure to a Parisian public eager for picturesque music. That sure descriptive style of his, coupled with strong sensuous appeal to the ear, eye and imagination, steadily contributed to his remarkable conquest of the musical marketplace.

The Revolution of 1789, which David accepted as his inheritance, and the Commune of 1870, which he lived to see, were neither of them the desired ends of his religious faith. "For me it is a certainty," he wrote of the Commune, "that France is in childbirth being delivered of the world's destiny."[3] This could well provide the occasion (the letter is to a Mme. Magnus) for one of those quotable sentences in which the thoughtful summarize human nature and settle man's fate. The tradition for doing this sort of thing seems strong especially in France. The savant D'Alembert (1717–83), for example, long before either of these historic agonies, noted: "Letters certainly contribute to making society more pleasing; it would be difficult to prove that, because of them, men are better and virtue is more common."[4] As for acts of violence: "Barbarism lasts for centuries. It seems that it is our natural element. Reason and good taste are only passing."[5]

The Commune of 1870, a continuation of 1789 and like it an event obedient, in David's faith, to "the law of progress", brought him no happiness and no occasion for the phrase-balancing of the disenchanted. He said his piece simply. "But it is deplorable that this moment proceeds by violence. Brute force can never be the foundation for what is durable." The collective mind had not yet been transformed. "It is necessary that the ideas of association, of solidarity, infiltrate bit by bit into one's thinking. We must resign ourselves and try to console ourselves by turning our eyes towards the future. My consolation and my glory will be for me to have prepared the peaceful ways and in being part of the Saint-Simonian school."[6] This comes at the close of David's life, but he had never been of the Church Militant. In his work there is always a turning away from the world that is, and in its best moments a touch of authentic magic in evoking a world that might be.

The pursuit of the peaceful ways was surely a decent, indeed a noble, way to cultivate a self-effacing but utterly genuine talent for music making. All said and done, some difficult years notwithstanding, David was

one of the happier romantics, for he was indeed Baudelaire's marvelous traveller returning with eyes as deep as the seas and dispensing stars from the caskets of his memory.[7] Baudelaire, who so obviously and eloquently understood, nevertheless complained of such flights from Paris. "The life of our city is rich in poetic and marvelous subjects. We are enveloped and steeped as though in an atmosphere of the marvelous, but we do not notice it."[8] David noticed the marvelous in Paris no more than did Delacroix before him. Both were successful travellers, the painter returning with the images of classical nobility he found among the Arabs and Jews of North Africa, the composer from the Near East with the scent of the marvelous, which, according to Baudelaire, he could have sniffed at his front door.

In another respect David was one of the fortunate. At all times he seems to have been using his musical and intellectual abilities on a level within his competence and in ways that gave pleasure to others as well as to himself. David is the sort of artist who locates the merit of his life and work within the larger cause to which both are dedicated. What is special in his case is the formal nature of the Saint-Simonian religion and of his affiliation with it. The more common romantic instance would be his contemporary Shelley whose enthusiasms are without formal religious or political affiliation and whose intensities tend to be relieved in memorable exclamations about mankind. Despite obvious differences in intellect, temperament, and genius, David and Shelley share in much that each would have considered vital. Both, for example, hoped for "the bloodless dethronement of oppressors";[9] both were "excited by the misery with which the world is burning."[10] Both wanted most passionately "to create a brotherhood of property and service."[11]

David was also fortunate in his relationship with Berlioz. While some music histories write off David as an apostle of Berlioz, this is hardly supported by the facts. After the success of *The Desert*, Berlioz welcomed David into his pantheon of great composers. That welcome, based on artistic factors meticulously set forth in his review, was soon to wear out. It would seem that artistic apostleship was never in question. That term, however, suggests a generational bond which Berlioz shared also with Liszt, Joseph d'Ortigue and Heine. In a limited sense, they were all apostles in Saint-Simonism, or rather in that aspect of the ideology concerned with the artist's high place in the social hierarchy. It was, after all, Berlioz and not Barrault who said of Beethoven: "he floats in the ether like an eagle of the Andes soaring at a height below which other creatures have already found death. His gaze cleaves the spaces. He flies toward all the suns, singing infinite nature."[13]

But the approach to David's last opera and a lapse of almost twenty

years since the première of the Desert Symphony remind us of divisions and differences. Had Berlioz lived to write David's obituary in the *Journal des débats*—it was in fact written by Ernest Reyer, Berlioz's close friend and disciple[14]—sentiments from his eulogy of Bellini in 1836 might have been repeated: "it is not then to his pretended progress that one must attribute his reputation in Paris but only to the time which has permitted us little by little to enter into the conditions outside which it was impossible for us to appreciate his real merit, expression."[15] In fact, Berlioz's appreciation of *Lalla-Roukh* cited earlier presents a similar view of David. Again, apostleship is not in question. Privately, each denigrated the other, and competition cannot be excluded from David's ambivalence toward his older contemporary. On Berlioz's side, the *Lalla-Roukh* review may even have been an effort to identify with a work that Perrin had accepted, thus advancing the cause of his own *Beatrice and Benedict*. Yet his appreciation of David's opera honestly and ably defines David's individual expression at its best. Resignation from his post on the *Journal des débats* saved Berlioz from many unpleasant tasks, among them having to notice the falling off in that last David opera of "the vague sonority" that made one dream of the "mysterious murmurs of nature."[16] It may well be that with Enfantin's death the demands of a modish libretto could at last override the need for a life long apostleship in a religion dominated by Le Père's rule.

Bearing in mind the extraordinary success of such works as *The Desert* and *Lalla-Roukh*, one wonders why David's fame did not outlast his own century. This ungrateful fate the composer shares with myriad colleagues of high contemporary reputation whose works now silently gather dust on library shelves. To speculate as to causes may be useless, but surely first one would point to the shifting sands of public fancy and differing standards of expectation. Prior to our museum-oriented twentieth-century situation, music for the theater, for example, was dominated by living composers and librettists who wrote on commission for both routine and special performances at the various theaters. Their subjects and scenarios were geared to popular taste, and their aim was immediate topical success. After as many performances as the public demanded through the box office, the works would be summarily packed off the boards to make way for new productions. Of the hundreds of operas so produced, very few were revived in subsequent years.

In France, the native composer also had to compete with his successful German and Italian counterparts. In addition to Gluck and Mozart, the main German contenders were Weber, E. T. A. Hoffmann, and Meyerbeer. Even Wagner entered the Parisian lists with an ill fated produc-

tion of *Tannhaüser*. The Italian competition was even stiffer. Paris had a veritable cult of Italian opera and a Théâtre Italien to produce it. Cherubini was writing for Paris from 1788 to 1823. Bellini's *Norma* and *I Puritani* came along in 1831 and 1835. Rossini produced four operas for Paris from 1826 to 1829, including his *Moses* and *William Tell*. Lack of sustained popular success brought on his premature retirement. Donizetti was active in the French capital in the 1830s and 1840s, producing seven works, among them his comic operas *Daughter of the Regiment* and *Don Pasquale*. Verdi loved Paris and produced his *Sicilian Vespers*, *Macbeth*, and *Don Carlos* there.

Such was the formidable competition then for native composers of opera in nineteenth-century France. Even today the only French operas with secure foothold in the standard international repertory can be numbered on five fingers of one hand—Gounod's *Faust* (occasionally his *Romeo and Juliet*), Bizet's *Carmen*, Saint-Saëns' *Samson and Delilah*, Offenbach's *Tales of Hoffmann* and Massenet's *Manon* (with infrequent performances of *Werther*). Debussy's masterpiece *Pelleas and Melisande*, revived periodically on the international scene, is something of a special case, but it scarcely ranks as a popular favorite. But the once great names of France's operatic past—Lully, Rameau, Grétry, Adam, Auber, Meyerbeer—are now only entries in the history books, where their works can be read about, but not witnessed. Even the greatest French romantic composer has fared unhappily in his stage works. Berlioz's *Benvenuto Cellini* and *Beatrice and Benedict* are almost never performed, and his acknowledged masterpiece *The Trojans* had to wait for its first integral performance until 1957 and then not even in his native country. Staged subsequently at New York's Metropolitan Opera (1973 and 1983), *The Trojans* excited critical enthusiasm, but doubtless the complexities and expense of mounting the work will effectively work against its entering the standard repertory.

In David's case, one might suspect that his current obscurity may be owing at least partly to the idealistic and moral message that burdens many of his works. This theory hardly seems tenable, since it would ultimately bring into question not only all religious music from medieval plainsong to Stravinsky's *Symphony of Psalms*; but also Utopian literature from Augustine to Thomas More; social satire from Petronius to Swift; and political exposés from Fielding to Zola, all continuing to command their audiences. Similarly burdened, after all, is Beethoven's dramatic music—*Egmont*, *Ruins of Athens*, *King Stephan*, and his only opera *Fidelio*. All of them have to do with the struggle of the weak against the strong, the freedom of humanity, and the ideals of liberty, equality, and fraternity. Indeed, the choral setting of Schiller's *Ode to Joy* in Beethoven's

Ninth Symphony exalts the brotherhood of man and obviously furnished the cornerstone to David's own ode-symphonies.

The notion that music and its allied arts have power to shape social attitudes is as old as Western civilization itself. When the modes of music change, wrote Plato in the *Republic*, the fundamental laws of the state always change with them.[17] Aristotle takes up the same theme in his *Politics*,[18] affirming that music forms character and that, in educating youth, the mode inducing Bacchic frenzy should be avoided in favor of a more ethical mode. Even today Aristotle's words ring true: musical rhythms and melodies provide us with images of states of character which come closer to their actual nature than anything else can do. This is confirmed by our experience: to listen to these images is to undergo a real change of the soul.[19]

In the nineteenth century the notion of socially conscious music and poetry was still a matter of philosophical argument. John Stuart Mill, for instance, found the arts to be "a sympathetic and imaginative pleasure which could be shared in by all human beings; which had no connection with struggle or imperfection, but would be made richer by every improvement in the physical and social condition of mankind."[20] The poet Shelley also declared that it is not only Prometheus but the poet hero himself who is "the highest perfection of moral and intellectual nature, impelled by the purest and truest motives to the best and noblest end."[21]

Tolstoy was grappling with similar problems at the close of the century. In his *What is Art?* (1898) he questioned the purpose of art in society; the responsibility of the artist for moral uplift; and the ethical basis of the principle of harmony, supported by the concept of universal life and the mutual dependency of all human beings.[22]

On ideological grounds, David's music can hardly be considered a failure. But with the intimate knowledge of the strifes, conflicts and tensions that rack our post-colonial global village, perhaps twentieth-century audiences can no longer contemplate distant lands and peoples with the same sense of nostalgia and mystery that was possible to the romantic movement. Perhaps, too, it is posterity's failure to recognize David's work for what it is—charming, imaginative, a delightful evocation of the romantic exotic, a glinting fragile bubble that burst with the age of social realism.

At present, unfortunately, one finds little opportunity to hear Félicien David's music. A few solo songs and operatic arias appear now and again on concert programs. In recent years some of his choruses have been performed on French radio and television as illustrations of the socialist tradition. The Desert Symphony was revived in France during his cente-

nary year and was also heard in a Romantic festival at Butler University in 1969.

David was certainly a child of his own times whose music struck a responsive chord among mid-nineteenth-century listeners. It had, of course, its immediate audience, a Parisian public inclined to mercurial shifts of favor. David's works must first be recognized as historical period pieces that responded to fluctuating tastes. Their literary parallels would be the novels of Rousseau, Mme. de Staël, George Sand, and even Proust, which often project values missed in present-day experience. Such works of art invite the sophisticated to relocate frames of reference special to the audience for which they were originally conceived.

In an era when the grand gesture was taken for granted, David, like Berlioz and Liszt, wrote outside the normal genres of symphonic music. Today concert performances with choirs and soloists are exceptions rather than the rule. Orchestral conductors shy away from ambitious works for large, varied ensembles, discouraged by the need of costly extra rehearsals and other expenses of production. Even so, works such as Berlioz's *Romeo and Juliet*, Liszt's *Faust* Symphony, and the choral symphonies of Mahler are no strangers to the concert halls: David's Desert Symphony and *Christopher Columbus* might well win a place in their company, given the opportunity for revival.

David's mark on subsequent musical developments guarantees his place in music history. His expansion of the idea of the ode-symphony was one of the more fruitful reactions to Beethoven's choral symphony, and his works in this form in some ways parallel Berlioz's similar conceptions for *Romeo and Juliet* and *Damnation of Faust*. David's introduction and exploration of the picturesque and romantic-exotic vocabularies had direct influence on such works as Bizet's *Carmen*, Saint-Saëns' *Samson and Delilah*, Delibes' *Lakmé*, perhaps even Verdi's *Aida*. Numerous composers drew profit from the example of his oriental fantasies. After the resounding success of the *Desert*, France's concert halls were flooded with orchestral, balletic and operatic scores capitalizing on the new exotic vogue—Saint-Saëns' *Suite Algérienne* is representative of the type.[23]

Perhaps most important of all were David's pioneering efforts in the development of that special French form of lyric opera, as opposed to grand opera, comic opera and operetta. In lyric opera David truly found his niche. In its unfolding, dramatic power and truth can take second place to charm, grace and seductive melodic ideas. On those grounds, at least, his *Pearl of Brazil* and *Lalla-Roukh* should find new welcome in any opera house willing to risk unfamiliar scores. Similarly, in David's solo songs and choral pieces lies a potentially rewarding source yet to be

tapped.[24] The existing dance music in most of David's large-scale works could also easily be rescued by enterprising choreographers. Lastly, the early symphonies, the second brass nonet, and the short string quintets contain much fresh, interesting material awaiting rediscovery and revival.

In our post-modern world, historical allusions are fast becoming commonplace in architecture, literature, and music. The readily discernible object and human figure are reentering post-abstract art. Writers are rediscovering the basic value of telling a good story and drawing believable characters. All artists are learning anew the power of emotion and passion. So it is quite possible that other fascinations of an earlier era —beauty and goodness, the picturesque, the magical and mystical—may also make a return visit. If so, the art of Félicien David stands ready to recreate for the new age the color, fantasy, charm, and sincerity that so enchanted audiences of his own time.

Notes

ABBREVIATIONS

FM	*La France musicale*
JAMS	*Journal of the American Musicological Society*
JD	*Journal des débats*
MSS	Ralph Locke, "Music and the Saint-Simonians"
OSSE	*Œuvres de Saint-Simon et d'Enfantin*
RDM	*Revue des deux mondes*
RGM	*Revue et gazette musicale de Paris*

CHAPTER 1—FRANCE IN SOCIAL UPHEAVAL

1. William H. Sewell, *Work and Revolution in France* (Cambridge, 1980), p. 216.

2. See Christopher H. Johnson, *Utopian Communism in France* (Ithaca, 1974), p. 214.

3. *Ibid.*, p. 148.

4. David S. Landes, *The Unbound Prometheus* (Cambridge, 1972), p. 187.

5. Edward P. Thompson, *The Making of the English Working Class* (New York, 1966), p. 803.

6. The source of these and the following quotations is Karl Marx and Friedrich Engels, *The Communist Manifesto* (Middlesex, 1967), pp. 115–17.

7. Sébastien Charléty, *Histoire du Saint-Simonisme, 1825–1864* (Paris, 1931), pp. 88–91.

8. *Ibid.*, pp. 314–15.

CHAPTER 2—THE SAINT-SIMONIANS

1. Johann Wolfgang von Goethe, *Truth and Poetry: From My Own Life*, Engl. tr. J. Oxenford (London, 1874), p. vii.

2. A view sustained in Henry d'Allemagne's *Prosper Enfantin et les grandes entreprises du XIX^e siècle* (Paris, 1935).

3. The many faces of Enfantin are studied in Jean-Pierre Callot's *Enfantin, le prophète aux sept visages* (Paris, 1963).

4. From Fyodor Dostoyevsky's *The Brothers Karamazov*, Engl. tr. C. Garnett (London, 1912), Pt. 2, Bk. 5, Ch. 5 (The Grand Inquisitor), p. 267: "We shall have an answer for all. And they will be glad to believe our answer, for it will save them from the great anxiety and terrible agony they endure at present in making a free decision for themselves. And all will be happy."

5. This motto appeared on the title page of *Le Globe* on 18 January 1831 when Enfantin purchased the paper for propaganda purposes, and it remained there throughout the period of Saint-Simonian ownership. Karl Marx altered the second clause to read "to each according to his need," thereby putting considerable distance between the two concepts.

6. Frank E. Manuel, *The Prophets of Paris* (Cambridge, Ma., 1962), p. 165.

7. See Hippolyte Carnot, *Sur le Saint-Simonisme* (Paris, 1887), pp. 25–6. Further on the contacts of Berlioz, Liszt, and other musicians with the Saint-Simonians in Locke, *MSS*, Ch. III; see also Locke's "Liszt's Saint-Simonian Adventure," *19th Century Music* 4, no. 3 (Spring 1981): 209–27.

8. An English translation of the work, which has been called the Old Testament of socialism, has been made by Georg G. Iggers in *The Doctrine of Saint-Simon* (Boston, 1958). Frank Manuel supplies a serviceable bibliography of scholarly work on the Saint-Simonians in his *Prophets of Paris*, pp. 331–3, n. 1. Charléty's classic *Histoire*, which heads the list, has not yet been translated. Manuel's *The New World of Henri Saint-Simon* (Cambridge, Ma., 1956) is comprehensive and imaginatively done.

9. Edmund Wilson, *To the Finland Station* (New York, 1940), p. 111.

10. For an extended examination of this subject, see my Ph.D. diss., "French Musical Criticism Between the Revolutions, 1830–1848" (University of Illinois, 1965).

11. See Basil Willey, *More Nineteenth-Century Studies* (London, 1956), p. 270.

12. Emile Barrault, "Aux artistes," *Religion Saint-Simonienne: Enseignement central* (Paris, 1831), pp. 11 and 15. Further on Barault's views about the proper role of the arts in Locke, *MSS*, pp. 59–70; Jane Fulcher, "Music and the Communal Order: The Vision of Utopian Socialism in France," *Current Musicology* 27 (1979): 27–35; and the same author's "The Popular Chanson of the Second Empire: 'Music of the Peasants' in France," *Acta musicologica* 52 (1980): 29–30.

13. Barrault, "Aux artistes," p. 19.

14. *Ibid.*, 22.

15. *Ibid.*, p. 34. The Saint-Simonians never formulated a structure for their ideal society. Consequently, "social character" goes undefined except through such examples as Barrault offers: they include Michelangelo's Moses; see *ibid.*, p. 35.

16. *Ibid.*, p. 59.

17. *Ibid.*, p. 65.

18. *Ibid.*, p. 70; also cited in Locke, *MSS*, p. 69.

19. Barrault, "Aux artistes," pp. 77–78; cited in Locke, *MSS*, p. 64.

20. Barrault, "Aux artistes," p. 76.

21. See Emile Barrault, "Prédication: L'Art," *Le Globe* 7, no. 122 (2 May 1831): 491–92; repr. in *OSSE* (Paris, 1865–78) 44: 160–89 (*Religion Saint-Simonienne: Recueil de prédications* 2, no. 26).

22. For a re-examination of Enfantin's idea of pantheism, see Georg Iggers "Heine and the Saint-Simonians," *Comparative Literature* 10 (1958): 303–304.

23. See Martin Green, *The von Richthofen Sisters: The Triumphant and the Tragic Modes of Love* (New York, 1974), p. 81.

24. On D. H. Lawrence and the erotic *Zeitgeist*, see Green, *von Righthofen Sisters*, Pt. III and Epilogue. On the social psychological basis of matriarchy, see Erich Fromm, *The Crisis of Psychology* (New York, 1970), Ch. VII.

25. "Poète de Dieu," politician, playwright, and man of business, Duveyrier included among his accomplishments a warm reception at court, but in 1864 he published a criticism of the Napoleonic dynasty called *Testament d'un voyant*. He was a lifelong Saint-Simonian and, like Enfantin and David, expressed the wish to be buried without church ceremony.

26. Callot, *Enfantin*, p. 200; on the "moi-non moi" formulations, see p. 206.

27. "Un vent qui vient de la tombe/Moissone aussi les vivants./Ils tombent alors par mille,/ Comme la plume inutile/Que l'aigle abandonne aux airs/Lorsque des plumes nouvelles/Viennent rechauffer ses ailes/A l'approche des hivers." From "Le jour des morts (Méditation)," no. 25 in Félicien David's *Recueil des cinquante mélodies* for voice and piano (Paris: Meissonnier, n.d.), pp. 163–72.

28. See Stefan Morawski, "The Aesthetic Views of Marx and Engels," *The Journal of Aesthetics and Art Criticism* 28, no. 3 (Spring 1970): 311.

29. *Le Globe* 10 March 1831, p. 276: "Littérature: Des beaux-arts à l'epoque actuelle," col. 2.

30. See Jacques-Gabriel Prod'homme, "Félicien David d'après sa correspondance inédite et celle de ses amis, 1832–1864," *Mecure musical et bulletin français de la société internationale de musique* 3 (1907): 120.

31. Quoted by Jacob L. Talmon, *Political Messianism: The Romantic Phase* (London and New York, 1960), p. 110.

CHAPTER 3—FROM THE PROVINCES TO PARIS

1. A. Denian-Treppo, Jacques Kryn, and Ralph Locke collaborated on a genealogy for the 1976 David centenary celebration.

2. See Ralph Locke, "Notice biographique sur Félicien David" in *Célébration du centenaire de la mort de Félicien David* (Cadenet, 1976).

3. There are four biographical studies of David, none of them comprehensive. The first *biographie* (Marseilles, 1845) is a memoir by his childhood friend Sylvain Saint-Étienne; two installments appeared in *FM* 8, no. 2 and 3 (12 and 19 January 1845): 9–12 and 17–19. This was followed by Eugène de Mirecourt's biography, no. 14 in the series

Les contemporaines (Paris, 1854; with subsequent editions in 1858 and 1869). Alexis Azevedo's monograph (Paris, 1863) offers the most detail and is the main source for my account of David's early years: a Saint-Simonian of the boulevards, Azevedo had two admirations—Rossini and David, and he rode both with blind zeal. René Brancour's study (Paris, 1911) in the series *Collection des musiciens célèbres* pays more attention to David's music than his earlier biographers do.

4. Alexis Azevedo, *Félicien David: coup d'oeil sur sa vie et son œuvre* (Paris, 1863), p. 14.

5. *Ibid.*, pp. 16 and 19.

6. Joseph François Porte, *Des moyens de propager le goût de la musique en France*, 2nd ed. rev. (Aix, 1838), pp. 74–75.

7. Joseph Marie, comte de Maistre, *Oeuvres complètes, II: Du Pape* (Lyons, 1892), p. 512.

8. Charles de Montrevel, "Félicien David, 1810–1876," *Biographies du XIXᵉ siècle* (Paris, n.d.), p. 113.

9. On the Saint-Simonian associations of Reber, see Locke, *MSS*, pp. 308–12.

10. Ralph Locke very kindly shared with me his microfilm of these autograph letters from the 1830s and 1840s, now preserved in the Bibliothèque National (Paris), Music Division, file 8001; they will be cited hereafter as "autograph letters."

11. Autograph letter 66 (15 April 1831); cited in Locke, *MSS*, pp. 77 and 115.

12. See Rose R. Subotnick, "Adorno's Diagnosis of Beethoven's Late Style," *JAMS* 29 (1976): 272.

13. John Warrack, *Carl Maria von Weber* (New York, 1968), p. 273.

14. Autograph letters 65 and 67; cited in Locke, *MSS*, p. 112.

15. Autograph letter 66.

16. "O que nos coeurs étaient contents!/ les voix chantaient Dieu dans l'église, les oiseaux chantaient le printemps/ le vrai bonheur pour le connoître, il faurait amoureux toujours/ toujours voir le beau printemps naître et se marier tous les jours."

17. Autograph letter 67 (12 August 1831).

18. *Ibid.* See also Autograph letter 73 (24 July 1836), and Locke, *MSS*, p. 348.

19. Heinrich Heine, *Werke, III: Schriften über Frankreich*, ed. E. Galley (Frankfurt: Insel-Verlag, 1968), p. 597.

20. Autograph letter 67; cited in Locke, *MSS*, p. 112.

CHAPTER 4—MUSIC AS SOCIAL MESSAGE

1. This is the assessment of Charles de Montrevel, "Félicien David . . . ," p. 105.

2. Louis Blanc, *The History of Ten Years, 1830–1840*, Engl. tr. (London, 1844–45), 1: 558–59.

3. Voilquin, *Souvenirs d'une fille du peuple, ou La Saint-Simonienne en Egypte, 1834 à 1836* (Paris, 1866), p. 81.

4. *Ibid.*, p. 111.

5. See Erik H. Erikson, *Gandhi's Truth* (New York, 1969), pp. 408–409.

6. Contemporary accounts of the Ménilmontant ceremonials strikingly resemble Erikson's account of Gandhi's meetings:

> A crowd of thousands would wait for hours, then make way for Gandhi and his party. Perfect silence reigned while the day's leaflet was read aloud and while Gandhi discoursed on it. Day by day, more and more outsiders would come to witness the strange ceremonial, with its concluding mass reaffirmation of the original pledge, followed by a friendly contest among various groups who had made up new songs for the occasion. Some of these were doggerel and loudly appreciated; others indicated clearly that a transfer of traditional religious feeling to this new kind of social experience was underway. . . . At the end of the meeting, as he withdrew his retinue, the workmen would form small processions to march through town singing the newly improvised songs. The texts of these songs, stripped of the gaiety, the improvisation, and the rhythm of musical intonation, now appear banal (Erikson, p. 342).

For further on David's role at Ménilmontant, see Marguerite Thibert, *Le rôle social de l'art d'apres les Saint-Simoniens* (Paris, 1926), pp. 42–45.

7. Voilquin, *Souvenirs*, p. 91.

8. David's "Hymne à Saint-Simon" is included in Appendix 5, no. 2, of Locke, *MSS*; description on pp. 116–19.

9. See Du Camp, *Souvenirs littéraires, 1822–1850*, 3rd ed. (Paris, 1906), 2: 90–91.

10. *RDM* 58 (July 1883): 443–44; signed F. de Lagenevais, pseudonym of Blaze de Bury.

11. Auguste Chevalier, "Exposé sommaire de mes fonctions à Ménil-Montant," *Le cabinet de lecture* 129 (4 January 1833): 9–10.

12. See Azevedo, *Félicien David*, pp. 44–45; and Locke, *MSS*, p. 231.

13. For the article of faith at the head of his first publication and a list of the contents, see Prod'homme, "Félicien David," pp. 121–22.

14. Autograph letter 71, Marseilles, 3 July 1835; quoted by Locke, *MSS*, p. 347.

15. David to Enfantin, Lyons, 9 January 1833, in Prod'homme, "Félicien David," p. 120.

16. *Ibid.*

17. Quoted by d'Allemagne, *Les Saint-Simoniens*, p. 316. In addition to proclaiming the final emancipation of women, Enfantin asserted that the wife must be the husband's equal, and that she must be the husband's associate in the functions of the church, the state and the family; so that the social individual who up to then was man alone would in future be man and woman. Voilquin identified George Sand as the epitome of *la femme nouvelle* (see her *Souvenirs*, pp. 96–97); indeed, Enfantin is said to have offered her a share of his mantle. She declined with a show of sympathy and appreciation.

18. *The Prophets of Paris*, p. 309.

19. *Ibid.*, p. 342, n. 22.

20. Stendhal's novel was begun in 1834 but was never completed.

21. Further particulars of the Ménilmontant phase in Locke, *MSS*, Ch. 4: "Music at the Ménilmontant Retreat (1832)."

CHAPTER 5—EXOTIC VOYAGE

1. See *The Plays of Arthur Murphy*, ed. R. Schwartz (New York and London, 1979), I, vi.

2. Brancour, *Félicien David*, p. 24, n. 1.

3. Further on Tajan-Rogé in Locke, *MSS*, especially Chapters 2, 7 and 8.

4. Described by d'Allemagne in *Les Saint-Simoniens*, p. 312. On Vinçard and the Saint-Simonian chansonniers, see Locke, *MSS*, Chapters 6 and 8.

5. Locke, *MSS*, p. 309.

6. Rogé to Enfantin, 25 September 1834; quoted in Locke, *MSS*, p. 310.

7. For a description of Reber's March, see Locke, *MSS*, pp. 311–12; the melody of its refrain is given in *MSS*, Appendix 5, no. 34.

8. See Brancour, *Félicien David*, p. 28; and Azevedo, pp. 55–56.

9. Quoted in d'Allemagne, *Les Saint-Simoniens*, p. 326.

10. For examples, see Carel De Liefde, *Le Saint-Simonisme dans la poésie française entre 1825 et 1865* (Haarlem, 1927), especially Chapter 6: "La femme et la morale Saint-Simonienne."

11. Reboul, not to be confused with the poet Jean Reboul (1796–1864), is not identified by first name in any reference known to me. His account is reproduced in part by G. D. Zioutos in "Le Saint-Simonisme hors de France: Quelques cahiers inédits sur l'expédition d'Egypte," *Revue d'histoire économique et sociale* 31 (1953): 23–49.

12. Zioutos, "Le Saint-Simonisme hors de France," p. 38.

13. *Ibid.*, p. 39.

14. *Ibid.*, p. 39, n. II.

15. *Ibid.*, p. 41.

16. Enfantin to David, 3 July 1845; in Prod'homme, "Correspondance inédite de Félicien David et du Père Enfantin, 1845," *Mercure de France* (1 May 1910): 74.

17. Zioutos, "Les Saint-Simonisme hors de France," p. 32, n. 5.

18. *Ibid.*, p. 40.

19. *Ibid.*, p. 42.

20. See his *Esquisse historique de la musique arabe aux temps anciens* (Cologne, 1863), p. 1.

21. See William P. Malm, *Music Cultures of the Pacific, the Near East, and Asia* (Englewood Cliffs, N.J., 1967), p. 64.

22. See Henry G. Farmer, "Egyptian Music," *Grove's Dictionary of Music and Musicians*, 5th ed. ed. E. Blom (New York, 1954) 2: 895.

23. See Talmon, *Political Messianism*, pp. 122–23.

24. See Albert Vandam, *An Englishman in Paris*, 2nd rev. ed. (London, 1892), I, 229.

25. Voilquin, *Souvenirs*, p. 302.

26. *Ibid.*, pp. 268–69.

27. *Ibid.*, p. 267.

28. Autograph letter 69 (11 May 1835), written aboard the *Madonna di grazia* bound for Marseilles; quoted in Locke, *MSS*, p. 345.

29. Voilquin, *Souvenirs*, p. 298.

30. *Ibid.*, p. 266.

31. Autograph letter 69 (11 May 1835); cited in Locke, *MSS*, p. 345.

32. Autograph letter 71 (3 July 1835); *ibid.*, pp. 346–47. On the proposed collaboration with Duveyrier, see *ibid.*, pp. 347–50.

33. Unsigned article, "Beaux-Arts/Théâtre-Italien/Tancredi," *Le Globe* 269 (26 September 1831): 1075.

34. Locke, *MSS*, p. 346.

CHAPTER 6—BREEZES FROM THE EAST

1. Joseph-Arthur comte de Gobineau, *Tales of Asia*, Engl. tr. J. L. May (London, 1847, rpt. London, 1947), p. 257.

2. Prod'homme reproduces the entire announcement in "Félicien David . . . ," pp. 123–24. Further on the *Mélodies orientales* in Locke, *MSS*, pp. 312–18 and Appendix 5, no. 33.

3. ". . . quelques cris nationaux," Brancour, *Félicien David*, p. 32.

4. See Favre's "La musique de clavecin en France de 1760 à 1850," *Histoire de la musique*, ed. Roland-Manuel (Paris, 1960–63), 2: 290.

5. For a perceptive account of Schumann's view, see Leon Plantinga, *Schumann as Critic* (New Haven, 1967), pp. 107–10.

6. "Sur le dernier modèle de pianos executé par M. Érard," *FM* 1, no. 8 (18 February 1838): 2.

7. David later reused the Arab "air" from *Promenade* in the "Evening Reverie" of the Desert Symphony. In his Master's thesis, "Exotic Techniques and their Meaning in the Music of Félicien David" (University of Chicago, 1974), Ralph Locke discusses David's borrowings of Arab melodies for *The Desert* and matches this "air" with a melody transcribed by Dom Jean Parisot in Lebanon about 1896. Possibly other melodies in this collection may also one day be linked to authentic Arab tunes.

8. Voilquin, *Souvenirs*, pp. 375–76.

9. Unsigned article, "Thalberg," *FM* 1, no. 12 (18 March 1838): 1. See also Castil-Blaze's "Concert de M. Thalberg," *FM* 8, no. 15 (13 April 1845): 113–14.

10. See Edward Lockspeiser, *Debussy*, 4th rev. ed. (London, 1963), pp. 143–45.

11. Qualities that Berlioz's friends found for him when the bizarre individuality of his style as portrayed in the press, together with his absorption in the mechanical marvels of musical instruments, threatened his "sincerity."

12. "Referential" in the sense imparted to the word by Jean-Jacques Nattiez, *Fondements d'une sémiologie de la musique* (Paris, 1975), pp. 27–28; and by Rose Subotnick, "The Cultural Message of Musical Semiology: Some Thoughts on Music, Language and Criticism Since the Enlightenment," *Critical Inquiry* 4, no. 4 (Summer 1978): 743.

CHAPTER 7—THE DESERT SYMPHONY

1. "Et sa main te tresse un laurier," goes one line from *Compagnage de la femme* (Lyons, 1830); words by Barrault, music by David.

2. See Brian Juden, *Traditions orphiques et tendances mystiques dans le romantisme français, 1800–1855* (Paris, 1971), pp. 523–24. Juden cites Gautier's review of David's *Desert* as the "fil conducteur" of one of the heretical strains—symbolism, imagination, idealism, and spiritualism were among the others—which engaged Lamartine, Hugo, and Pierre Leroux in embattled debate during the 1830s.

3. Voilquin writes in *Souvenirs* (p. 267) that she and her comrades had gone to the Orient to search out an ancient spirit, "the great oriental light" to which modern cultures owe everything, and to revive it with the strength of Saint-Simonian ideas.

4. See Solomon A. Rhodes, *Gérard de Nerval, 1808–1855* (New York, 1951), p. 198.

5. Writing from the Sahara about 1848, Eugène Fromentin describes the typical desert village as "an arid, burned out place where Providence has, by exception, put a bit of water and man's industry is directed to creating a bit of shade. The fountain is where the women are, the patch of shade in the street is where the men sleep away the days." The children, he adds, nod sleepily on the doorsteps, and the young men are off to the wars: from *Un été dans le Sahara*, 11th ed. (Paris, 1896), p. 155.

6. Voilquin, *Souvenirs*, pp. 467–68.

7. Théophile Gautier, *Histoire de l'art dramatique en France depuis vingt-cinq ans* (Paris and Leipzig, 1858–59; rpt. Geneva, 1968), 4: 5–13: source for this and the following quotations. An extended passage from Gautier's review of *The Desert*'s second performance was printed in *FM* 8, no. 4 (26 January 1845): 29.

8. Even Edgar Quinet, liberal historian, was invited to the concert of "your glorious disciple," but he declined with thanks: see Locke, *MSS*, p. 358. Enfantin, however, had his own circle of like-minded intellectual-political writers who contributed to *L'Artiste* in the 1840s. Over and over, Gautier, Enfantin and Théophile Thoré urged the artists to turn their passions away from their godless preoccupation with art for art's sake and with the self and its instinctive depressions; see Malcolm Easton, *Artists and Writers in Paris: The Bohemian Idea, 1803–1867* (London, 1964), pp. 85–87.

9. Evidently Gautier separated Saint-Simonian pantheism from its pragmatic basis, for the last sentence betrays common knowledge that Enfantin was now currying favor in bureaucratic circles.

10. Neither was Gautier himself a prize-winner. As for David's "Arab" appearance, he had the handsome, almost Spanish look of his native Midi (see Frontispiece). The dark face and eyes, with their habitual serious gaze, must have been especially pleasing to Enfantin, whose strong belief in the moral force of physical beauty was undoubtedly an element in his early choice of David for the role of his "Benjamin."

11. Letter of 8 January 1833 from Enfantin to David (directed to the Maison des Saint-Simoniens, Place de la liberté) in Lyons; reproduced in Prod'homme, "Félicien David," p. 118.

12. The simple, repetitive quality of David's style, coupled with the achievement of his ode-symphony in three months' time, are indications that he experienced no difficulty in moving straight to the point of turning his natural musical impulses to the high ideals of his mentors. The Saint-Simonian theory that in elevating intuition and instinct

over intellect we penetrate to the "real truth" encouraged David to believe his artistic ordering process was correct not in and for itself, but for the communication of enjoyment, the ultimate pragmatic test.

13. "Ineffables accords de l'éternel silence/Chaque grain de sable a sa voix/ Dans l'ether onduleux, le concert se balance;/Je le sens, je le vois!" Colin's fine lines and Gautier's appreciation of them bring to mind Baudelaire's wonderful sonnet *Les correspondances*, published in 1855 but written ten years earlier, and devoted to a theme that occupied many of his contemporaries: see Charles Baudelaire, *Les fleurs du mal*, ed. J. Crépet and G. Blin (Paris, 1942); text, pp. 9–11; commentary, pp. 294–303. In *The Symbolist Movement: A Critical Appraisal* (New York, 1967), pp. 30–31, Anna Balakian notes that whenever Baudelaire evoked the concept of correspondences, it was in the context of an existing repertory of romantic analogues and metaphors linking the divine and natural worlds.

14. See Prod'homme, "Félicien David," p. 120.

15. Iggers, *The Doctrine of Saint-Simon*, p. xxv.

16. See Frank and Fritzie Manuel, eds., *French Utopias: An Anthology of Ideal Societies* (New York, 1966), p. 5.

17. Henry Farmer, in his memoir of Francesco Salvador-Daniel, says that on Daniel's mantelpiece around 1869 "stood together, by a strange choice, a skull, a statue of the Republic, and a tambour de basque"; see Salvador-Daniel, *The Music and Musical Instruments of the Arab*, rev. ed., Engl. tr. H. Farmer (London, 1914), p. 24.

18. See, for example, Maurice Bourges review of *The Desert* in *RGM* 11, no. 50 (15 December 1844): 414.

19. *Ibid.*

20. The Fantasy as prelude to the dance may possibly relate to the Arab *bechéraf*, as described in Salvador-Daniel, *Music and Musical Instruments*, pp. 81–84.

21. See, for example, Enfantin's *Correspondance politique, 1835–1840* (Paris, 1849), p. 153.

22. *Un été dans le Sahara*, pp. 31–34. Fromentin's lengthy and detailed account seems to owe more than a little to Delacroix' description of a Jewish wedding in Tangier, 1832, which inspired the painting of that title exhibited in the Salon of 1841 (Catalogue Robaut, 867); it now hangs in the Louvre: see *The Journal of Eugène Delacroix*, Engl. tr. W. Pach (New York, 1937; repr. 1961), pp. 106–8.

23. *RGM* 13, no. 8 (22 February 1846): 56. Several months later the same journal ("Chronique étrangère," 24 May 1846, p. 167) reported that a performance of *The Desert* under Louis Spohr, music director to the Elector of Hesse-Kassel, had "enchanted listeners despite its simplicity."

24. Quoted by René Guise, "Le roman-feuilleton et la vulgarisation des idées politiques et sociales sous la monarchie de juillet," *Romantisme et politique, 1815–1851* (Paris, 1969), p. 324.

25. See *The Works of Joseph de Maistre*, selected, tr. and introduced by Jack Lively (New York, 1965), p. 289.

26. Autograph letter 69 (11 May 1835); quoted by Locke, *MSS*, p. 345.

27. See Gradenwitz, "Félicien David (1810–1876) and French Romantic Orientalism,"*The Musical Quarterly* 62, no. 4 (October 1976): 472.

28. Fromentin, *Un été*, p. 8.

29. See Salvador-Daniel, *The Music of the Arab*, pp. 259–60.

30. Gradenwitz, "Félicien David," p. 491.

31. For an example of Escudier's eagerly promoting notices of *The Desert*, see *FM* 8, no. 1 (5 January 1845): 1–2.

32. J. Maurel, "Correspondance particulière," *FM* 8, no. 7 (16 February 1845): 52–53.

33. See Gail's *Réflexions sur le goût musical en France* (Paris, 1832). A noted Hellenist, Gail was also an amateur poet and composer. His mother, Edmée-Sophie Garre, was a singer and composer of substantial repute. Further on Gail's aesthetic in my dissertation, pp. 164–66.

34. *JD*, 15 December 1844. On Berlioz and Lacépède, see my dissertation, Ch. 3 especially pp. 115–35.

35. *Ibid.*

36. Undated (1844?) letter from David to Emma Tourneux, quoted by Marguerite Thibert, *Le rôle social de l'art d'après les Saint-Simoniens* (Paris, 1926), pp. 48–49, n. 20; and by Locke, *MSS*, p. 361.

37. Quoted by Thibert, *Le rôle . . . après les Saint-Simoniens*, p. 48, n. 19.

38. Berlioz, *JD* 15 December 1844.

39. *RGM*, 11, no. 50 (15 December 1844): 413.

40. *FM*, 8, no. 3 (19 January 1845): 19; also Saint-Étienne, *Biographie*, pp. 29–30.

41. Berlioz, *JD* 15 December 1844.

42. *Ibid.*

43. See, for example, Paul Scudo, "La symphonie et la musique imitative en France," *RDM* 18 (14 May 1847): 755.

44. Berlioz, *JD* 15 December 1844.

45. See Berlioz, *Traité d'instrumentation et d'orchestration* (Paris, 1855; repr. London, 1970), p. 297; rev. ed. R. Strauss, in Engl. tr. as *Treatise on Instrumentation* (New York, 1948), p. 409.

46. Quoted in d'Allemagne, *Les Saint-Simoniens*, p. 415.

47. *RGM* 15, no. 6 (6 February 1848): 42.

48. Prod'homme, "Félicien David . . . ," pp. 229–43, reproduces the series of letters pertaining to the problematic aftermath of *The Desert*'s success.

49. Berlioz, *JD*, 4 March 1845.

50. On Berlioz's inconstant attraction to the Saint-Simonians, see Ralph Locke, "Autour de la lettre à Duveyrier: Berlioz et les Saint-Simoniens," *Revue de musicologie* 63, no. 1–2 (1977): 55–77. For additional commentary on David's Desert Symphony, see Saint-Étienne, *Biographie*, pp. 27–32; Mirecourt, *Félicien David*, pp. 69–80; Azevedo, *Félicien David*, pp. 72–79; Brancour, *Félicien David*, pp. 40–68; my dissertation, pp. 292–308; Gradenwitz, "Félicien David," pp. 488–98; Locke, *MSS*, pp. 354–62; and Jean Pierre Bartoli, "La musique française et l'Orient: A propos du *Désert* de Félicien David," *Revue internationale de musique française* 2, no. 6 (November 1981): 29–36.

CHAPTER 8—MOSES ON SINAI

1. The very titles of studies about Saint-Simonism reflect the wide range of interpretations applied: Talmon's *Political Messianism, The Romantic Phase*; Iggers' *The Cult of*

Authority; Manuel's *Prophets of Paris*. The list continues to present-day sociologists again seeking to cross technology and ideology.

2. A twentieth-century comprehensivist, R. Buckminster Fuller, insists that "people everywhere will be rich in power when integrated worldwide industrial networks are established," and that technocracy fails if it makes no allowances for the feelings, intuitions and the mysticism of harmony: see B. Fuller, J. Agel, and Q. Fiore, *I Seem to Be a Verb* (New York, 1970), p. 82.

3. Feuer, *Ideology and the Ideologists* (New York, 1975), pp. 145–46.

4. *Ibid.*, p. 146. Talmon (*Political Messianism*, p. 77) erroneously attributes Jewish origins to David; in fact, David had neither Jewish blood nor, as has occasionally been claimed (see Gradenwitz, "Félicien David," p. 481), Creole descent on his mother's side.

5. See Talmon, *Political Messianism*, p. 81.

6. Saint-Étienne in *La chanson française*, 24 September 1876.

7. Namely, *La colonisation d'Algérie* (Paris, 1843).

8. See Charles Morazé, *The Triumph of the Middle Classes*, Engl. tr. G. Weidenfeld (Cleveland and New York, 1966), p. 186; originally publ. as *Les bourgeois conquérants* (Paris, 1957).

9. Named in Enfantin's will to carry on Saint-Simonian propaganda, Arlès-Dufour subscribed to the social and political aims of the group and their pacifism, but not to the theory of the hierarchical community. He was a generous benefactor to members of the group, including Félicien David.

10. See d'Allemagne, *Les Saint-Simoniens*, p. 442.

11. Enfantin to Mendelssohn (7 May 1845), Mendelssohn correspondence in Oxford, Bodleian Library, "Green Books," 21: 168; quoted by Locke, *MSS*, p. 361.

12. On 19 February 1832, Mendelssohn instructed *Le Globe* "not to continue to send me a journal the only aim of which is to propagate your religion and which has contributed only to alienate me irrevocably"; quoted in d'Allemagne, *Les Saint-Simoniens*, p. 182. Further on Mendelssohn and the Saint-Simonians in Locke, *MSS*, pp. 156–65.

13. For further details on the German tour of 1845, see Gradenwitz, "David and Orientalism," pp. 495–500; and Locke, *MSS*, pp. 359–62.

14. See Prod'homme, "Correspondance . . . ," p. 76. The German Hiller fraternized with the Saint-Simonians during student days in Paris: see Locke, *MSS*, pp. 154–56. Hiller's performance of Beethoven's "Emperor" Concerto was the first in France. Further on Hiller in Reinhold Sietz's entry in *The New Grove Dictionary* 8: 562–64.

15. See Prod'homme, "Correspondance," pp. 67–86.

16. *Ibid.*, p. 70.

17. *Ibid.*, p. 71. As for David's carrying Moses within him, similar phrases reecho through letters to Duveyrier in which Le Père speaks of "feeling you in me, me in you." He even describes Saint-Simonian love of humanity as "a love coitus (the word is too beautiful to be avoided) of intellect and matter with all that is"; quoted by Manuel, *Prophets of Paris*, p. 342, n. 21.

18. David to Enfantin (26 June 1845), in Prod'homme, "Correspondance . . . ," p. 73.

19. *L'Illustration* 7, no. 161 (28 March 1846): 50–51: unsigned "Chronique musicale."

20. Enfantin to David (3 July 1845), in Prod'homme, "Correspondance . . . ," p. 75.

21. *Ibid.*, pp. 74–75.

22. Enfantin to David (8 August 1845), *ibid.*, p. 78.

23. *Ibid.*, p. 79; corrected reading in Locke, *MSS*, p. 364.

24. Quoted in d'Allemagne, *Les Saint-Simoniens*, p. 346.

25. See Alfred Sendrey, *Music in Ancient Israel* (New York, 1969), p. 530.

26. Talmon remarks in *Political Messianism* (p. 120) that almost every one of Enfantin's ardent disciples had a background of personal unhappiness to which some stigma was attached, particularly one associated with the father: "Perhaps as a result of that, their pathetic yearning for affection and their ivy-like mentality was exceptional even in an age of Romanticism, with its cult of feeling.

27. David to Enfantin (25 July 1845), in Prod'homme, "Correspondance . . . ," p. 77.

28. Enfantin to David (28 August 1845), *ibid.*, p. 84.

29. *Ibid.*

30. David to Enfantin (early September 1845), *ibid.*, p. 86.

31. See Prod'homme, "Félicien David," p. 240.

32. Enfantin to David (28 August 1845), in Prod'homme, "Correspondance," p. 85.

33. Arlès-Dufour in Zurich to Enfantin (17 August 1845), in Prod'homme, "Félicien David," p. 251.

34. See Prod'homme, "Correspondance," p. 80.

35. See Iggers, "Heine and the Saint-Simonians," especially pp. 303–305; and Charléty, *Histoire du Saint-Simonisme*, Bk. III, Ch. 3.

36. Iggers, "Heine and the Saint-Simonians," pp. 303–305.

37. Saint-Étienne in Baden to Enfantin (1 September 1845), in Prod'homme, "Félicien David . . . ," p. 253. In this letter, Saint-Étienne goes to some pains to show that he fully understands his role in terms of Saint-Simonian fraternity, hierarchy, moral activism, and is besides not handicapped in respect to success in business by his provincial background. A graduate of the École Polytechnique he was not, nor was he a good poet; but neither was he the muddlehead that Enfantin and Dufour thought him to be, and there is no question that, for a time, he did a great deal to ease the stresses of David's life.

38. "Moïse au Sinaï," *RGM* 13, no. 13 (29 March 1846): 98.

39. David to Enfantin, in Prod'homme, "Correspondance . . . ," p. 86.

40. See, for example, Scudo in *RDM* 18 (14 May 1847): 753.

41. "Revue musicale," signed H[ans] W[erner], Blaze de Bury's pseudonym, in *RDM* 14 (1 April 1846): 144.

42. *Ibid.*, p. 145.

43. *Ibid.*

44. *Ibid.*, p. 146. David eventually came to regret the popularity of his first ode-symphony. In the summer of 1847, he wrote from Marseilles to Enfantin that his honorable countrymen continued to demand camels in the desert or (their equivalent in *Christopher Columbus*) "fish, tritons and who knows what else. They adore this *Desert*. They yelled for it. And I, reluctant as I am to refuse, am going to give it to them next Monday." See Prod'homme, "Félicien David," p. 260; and Brancour, *Félicien David*, p. 71.

45. *RDM* 14 (1 April 1846): 147.

46. For further commentary on *Moses*, see Brancour, *Félicien David*, pp. 68–69; and Locke, *MSS*, pp. 362–66. David presented a revised version of the work at the Paris Conservatory on 12 December 1847 to somewhat warmer, if hardly enthusiastic, reviews; see *Le ménestrel* 15, no. 3 (19 December 1847); and *RGM* 15, no. 51 (19 December 1847): 412.

CHAPTER 9—CHRISTOPHER COLUMBUS

1. David in Paris to Saint-Étienne, autograph letter 87 (8 December 1839); quoted in Locke, *MSS*, pp. 353–54.

2. Manuel, *Prophets of Paris*, p. 308.

3. Barrault, "Prédication: L'Art," *Le Globe* 7, no. 122 (2 May 1831): 492.

4. *Ibid.*, p. 491. Regarding the uniting of artists toward progress, one sees first the enthusiastic response and then gradually the disenchantment of certain artistic radicals with the Saint-Simonian message. Among those to turn away was Charles Baudelaire, and in his poem *Le voyage* he is able to deliver the old images with a gentle raillery (see *Les fleurs du mal*, ed. Crépet and Blin, pp. 159–65). Baudelaire dedicated the poem to Maxime du Camp, author of the famous phrase "Je suis né voyageur," inviting him to be shocked "de mes plaisanteries contre le progrès, ou bien de ce que le voyageur avoue n'avoir vu que la banalité": *Les fleurs du mal*, p. 523.

5. Barrault, "Predication: L'Art," *Le Globe* 7, no. 122 (2 May 1831) p. 492.

6. Compare Berlioz's "De l'imitation musicale," *RGM* (1 January 1837): 9–11; (7 January 1837): 15–17; Engl. tr. with notes in *Pleasures of Music*, ed. J. Barzun (New York, 1951), pp. 243–51; and in Berlioz, *Fantastic Symphony*, ed. Edward T. Cone (New York, 1971), pp. 36–46.

7. Barrault, "Prédication: L'Art," p. 492.

8. "Christophe Colomb," *RGM* 14, no. 11 (14 March 1847): 87.

9. *JD*, 10 March 1847, signed "E. Ds."

10. A jibe at the Saint-Simonian costume; since it buttoned in the back, one could only dress with the help of a brother.

11. See Talmon, *Political Messianism*, p. 139.

12. "Quelques réflexions sur la saison musicale de 1847," *RGM*, 14, no. 20 (16 May 1847): 166. An earlier anonymous profile of Ferdinand Hiller places a Saint-Simonian stamp on this concept (I am indebted to Ralph Locke for providing the quotation): "Here is a man ready to do great things if an inspiring idea should one day fructify the caprices of his imagination. This idea should spring not from Beethoven's somber misanthropy and the frenzied revolt which were his glory and misfortune. Nor should it come from the satiric and careless verve that inspired Rossini's *Barber*. This idea to which men of talent should appeal, which gives each of them his place, his role and his name, this idea is for artists to search for. If they seek, they will find.": "Concert donné par M. F. Hiller," *Le Globe* (7 December 1831): 1364.

13. See Heine, *Zeitungsberichte über Musik und Malerei*, ed. Michael Mann (Frankfurt, 1964), pp. 13–14.

14. George Sand to Meyerbeer, "Lettres d'un voyageur, 8," *RDM* 8 (15 November 1836): 461.

15. "E. Ds.," in *JD*, 10 March 1847.

16. See Frank E. Kirby, "Beethoven's Pastoral Symphony as a *Sinfonia caratteristica*," *The Musical Quarterly* 56, no. 4 (October 1970): 605–23, for a valuable consideration of the German precedents for Beethoven's conception.

17. Autograph letter 67 (12 August 1831).

18. *RDM* 29, no. 2 (September 1859): 666.

19. The chorus appeared originally as "Chant de l'overture des travaux du temple." Its music was borrowed in 1833 for a cantata celebrating the Saint-Simonian sailing for the East. In its *Columbus* format, it has full orchestral accompaniment of course; Ralph Locke informs me that the "Choeur des génies de l'ocean," to which David attached such significance, is also an arrangement of an earlier piece written by David in Smyrna and dedicated to La Mère: see Locke, *MSS*, pp. 205, 319–21 and 367.

20. "La symphonie et la musique imitative en France," *RDM* 18 (14 May 1847): 743–55; source for the quotations that follow.

21. In writing his verses, perhaps Méry had Balzac's *L'enfant maudit* in mind. In any case, the cabin boy's song brings to mind these words from Enfantin's text for David's "Father's Prayer," written in 1832 at Ménilmontant: "Grand Dieu, source inépuisable de vie, que suis-je en ce monde qui m'environne un point dans l'immensité, un moment dans l'eternité, un soupir de l'universelle vie. Mais toi, tu es l'immensité, l'eternité, la vie, monde des mondes. Gloire à toi! Père, tu m'aimes. . . . Je t'aime aussi. Père, c'est Dieu qui nous unit à vous. Peuple, c'est lui qui nous dévoue à toi." For the complete text and music of David's "Prière du Père," see Locke, *MSS*, Appendix V, no. 18, pp. 612–23.

22. *RDM* 20 (15 March 1859): 511.

23. See Monique Lebreton-Savigny, "La fortune littéraire de Christophe Colomb au XIX^e siècle en France," *Nineteenth-Century French Studies* 6, no. 3–4 (Spring-Summer 1978): 157.

24. *Ibid.*, p. 156; from Lamartine's *Histoire de l'humanité par la vie des grands hommes* (Paris, 1856), II, 312.

25. See Salvador-Daniel, *The Music . . . of the Arab*, p. 207.

26. Further on this in Thérèse Marix, "George Sand, la musique naturelle et la musique populaire," *Revue musicale* 7, no. 9 (July 1926): 33–45.

27. Quoted by Léon Vallas in "Berlioz," *Grove's Dictionary*, 5th ed., 1: 665.

28. In the socialist circles which Baudelaire frequented at the time of writing his wine pieces, a tradition celebrated in wine the insignia of a God kind to workers, consoling to the poor, and comforting to the unhappy; see *Les fleurs du mal*, pp. 485–86.

29. *JD*, 10 March 1847.

30. Enfantin to his natural mother, speaking about La Mère, his moral mother; quoted at length in Manuel, *Prophets of Paris*, p. 342, n. 22.

31. *JD*, 10 March 1847.

32. See Adolphe Botte, "Matinée musicale," *RGM* 29, no. 51 (21 December 1862): 410; and François, comte de Chateaubriand, *Les Natchez*, ed. G. Chinard (Baltimore, Paris and London, 1932), Bk. VIII, p. 241. Although written by 1800, Chateaubriand's work was not published until 1826.

33. See, for example, Gustave Bertrand's *Les nationalités musicales étudiées dans le drame lyrique* (Paris, 1872), Chapter XI, pp. 307–309.

34. *RGM* (14 March 1847): 86.

35. Surely this is the sort of piece Glinka had in mind when he wrote, "I am determined to compose some orchestral concert pieces, for I think it would be possible to unite the requirements of art and the demands of the public and, profitting by the present perfect of instrumentation and execution, to compose works which should satisfy both the connoisseur and the ordinary hearer": quoted by Rosa Newmarch, "Glinka," *Grove's Dictionary*, 5th ed., 3: 668. An immediate result was his *Jota aragonesa* of 1845; perhaps David knew the piece. Through Berlioz, Glinka may also have known about David's "oriental" music. Commissioned by Franconi early in 1845 to conduct a series of concerts at the Cirque Olympique, Berlioz introduced works by David and Glinka in addition to his own music: see Berlioz, *A Selection From His Letters*, tr. and ed. H. Searle (New York, 1966), p. 88; and Maurice Bourges in *RGM* 12, no. 12 (23 March 1845): 90–91.

36. In "Exotic Techniques . . . ," Ralph Locke analyzes the dance according to sonata-allegro procedure.

37. Autograph letter 113 (18 August 1846); cited in Locke, *MSS*, p. 366.

38. See Brancour, *Félicien David*, p. 71.

39. See Paul Scudo, "Revue musicale: Les concerts de la dernière saison," *RDM* 31 (1 June 1861): 743.

40. *JD*, 23 December 1862.

41. See Adolphe Botte in *RGM* (21 December 1861), as above.

42. See Richard Pohl, "Le *Christophe Colomb* de Félicien David à Bade," *Le ménestrel* (19 September 1869): 333. Pohl (1826–96) was a dissident whose political activities cost him a professorship at Graz. Around 1850 he moved to Dresden and then to Weimar, where he began his life-long defense of the music and innovative ideas of Berlioz, Liszt and Wagner. See John Warrack's entry on Pohl, *The New Grove Dictionary* 15: 20–21.

43. Pohl, "Le *Christophe Colomb*," p. 333.

CHAPTER 10—GARDEN OF EDEN

1. See William L. Langer, *The Rise of Modern Europe: Political and Social Upheaval, 1832–1852* (New York, 1969), p. 319.

2. *Ibid.*, p. 237.

3. *Christopher Columbus* was dedicated to the Duchesse de Montpensier.

4. Quoted in Callot, *Enfantin*, p. 179.

5. See Henri Gouhier, *Études d'histoire de la philosophie française* (Hildesheim, 1976), p. 199.

6. "Chronique musicale," signed G.B., *L'Illustration* 12, no. 288 (2 September 1848): 14.

7. *RGM* 15, no. 35 (27 August 1848): 265–66.

8. Quoted in Harry Levin, *The Myth of the Golden Age in the Renaissance* (Bloomington, 1969), p. 159.

9. Quoted in d'Allemagne, *Les Saint-Simoniens*, p. 213.

10. *The Recollections of Alexis de Tocqueville*, Engl. tr. A. de Mattos, ed. J. Mayer (New York, 1949), p. 69.

11. Callot, *Enfantin*, p. 185, supplies an impressive list of the appointees.

12. Enfantin to Lamartine (15 September 1849), quoted in d'Allemagne, *Prosper Enfantin*, p. 145; the entire letter is reproduced in Charléty, *Enfantin*, pp. 89–94.

13. Charléty, *Histoire du Saint-Simonisme*, p. 297; Duveyrier's phraseology evokes the imagery of Enfantin's prescriptions for David's *Moses* cited in Chapter 8; see Prod'homme, "Correspondance," p. 79. Further on the policies propounded in *Le Crédit* in Charléty, *Histoire*, Bk. IV, Chapter 2.

14. Quoted by Charléty, *Histoire*, p. 198.

15. See Baudelaire, *Les fleurs du mal*, p. 142.

16. As Charles Morazé, for one, is careful to point out; see his *Triumph of the Middle Classes*, p. 275.

17. Quoted by Charléty, *Histoire*, p. 213.

18. Callot, *Enfantin*, p. 204, quoting from Enfantin's *La science de l'homme*.

19. *Ibid.*, p. 184.

20. Autograph letter 37; cited in Locke, *MSS*, p. 370.

21. "R," writing in the *RGM* 15 (1848): 265.

22. *Ibid.*

23. *JD*, 5 November 1844.

24. "Revue musicale," *RDM* 14 (1 April 1846): 148.

25. See Edward W. Tayler, *Nature and Art in Renaissance Literature* (New York, 1964), p. 6.

26. Enfantin to David (3 July 1845); in Prod'homme, "Correspondance," p. 74.

27. See Locke, "Exotic Techniques," Chapter V, "The Drone Bass: The Pastoral Connection."

28. Flaubert to Louis Colet (6 or 7 August 1846); quoted in Engl. tr. in Charles Rosen, "Romantic Documents," *The New York Review of Books* 22, no. 8 (15 May 1975): 15.

CHAPTER 11—THE PEARL OF BRAZIL

1. See Vandam, *An Englishman in Paris* 1: 224. Vandam was too young to witness some of the earlier events he accounts for, but he seems to have had direct contact with Auber and David in their later years or with others who knew the two composers intimately.

2. Hadot to Enfantin (25 June 1848); in Prod'homme, "Félicien David . . . ," p. 262.

3. The celebrated Viscount Mauá furnishes a case in point. Saint-Simonian doctrine may or may not have influenced his industrial initiative, but unarguably he became the political symbol for his country that Enfantin wished to become for France. See Henri

Hauser, "Un problème d'influences: Le Saint-Simonisme au Brésil," *Annales d'histoire économique et sociale* 9 (1937): 1–7.

4. See Frederick W. Hemmings, *Culture and Society in France, 1848–1898* (London, 1971), p. 33.

5. Autograph letter 23; in it David indicates that his chief health problem was rheumatism. On David's financial troubles, see Locke, *MSS*, pp. 370–71.

6. Veuve Launer published the first version, but Saint-Étienne soon took over its distribution. A series of urgent notes from David imply that his old friend was becoming a liability, not just as librettist but as manager and publisher as well. David (autograph letter 162; cited in Locke, *MSS*, p. 370) asks Gabriel to deal with—among other things—Saint-Étienne's excessive self-esteem: "He fancies himself a great genius, but you must not yield." Offers for performance outside France were coming in, and Heugel was offering to buy *The Pearl*. Sylvain fussed over his royalties, and David finally raised his normally mild voice: "Go and negotiate. In Heugel's hands, the work will certainly be pushed in Paris and even abroad."

7. This sentiment closes the first volume of Albert Soubies and Charles Malherbe's *Histoire de l'Opéra-Comique* (Paris, 1892) 1: 323.

8. See Vandam, *Englishman*, 1: 225–26.

9. Hemmings, *Culture and Society*, p. 156.

10. Mute Naouna is not the heroine of David's opera, nor is she required to leap a distance of some eight miles from her balcony into Mount Vesuvius after the manner of Auber's *Muette*; but the idea of an important character who, being mute, is represented by the equivalent of a prima ballerina, may have come to David from knowing Auber's famous opera of 1828.

11. See Morton J. Achter, "Félicien David, Ambroise Thomas, and French Opéra-Lyrique, 1850–1870," Ph.D. dissertation, University of Michigan, 1972, p. 74.

12. See Rey M. Longyear, "Daniel-François-Esprit Auber (1782–1871): A Chapter in French Opéra Comique, 1800–1870," Ph. D. dissertation, Cornell University, 1957, p. 79.

13. Achter, "Félicien David," p. 82.

14. "Revue musicale," *RDM* 58 (1 July 1883): 448–49; signed F. de Lagenevais, pseudonym of Blaze de Bury.

15. *JD*, 27 November 1851.

16. *Ibid.* Further on Berlioz's critical response to David's music in Locke, *MSS*, 176–77; also see n. 18 below.

17. Autograph letter 82. The tone of criticism echoes the anti-Berlioz stance of Blaze de Bury and others who bemoaned the individualistic malady of the age as represented in Berlioz's wayward musical style: see my dissertation, Chapter III: "Berlioz."

18. Berlioz to his sister Adèle (11 March 1858); reproduced in Berlioz, "Lettres sur 'Les Troyens,'" *Revue de Paris* 28, no. 4 (15 August 1921): 768–69.

19. Achter, "Félicien David," pp. 173–77, gives an analysis of this aria.

20. See Longyear, "Auber," p. 197.

21. See Brancour, *Félicien David*, p. 99.

22. Vandam, *Englishman* 1: 226.

23. *RDM* 58 (1883): 443.

CHAPTER 12—HERCULANEUM

1. On the transformation from *Last Judgment* to *Herculaneum*, see Brancour, *Félicien David*, pp. 78–85. *Le jugement dernier*, however, received at least one noteworthy performance at the inaugural concert of the Union Artistique at the Théâtre Italien, Paris, in May 1861; a distinguished audience turned out for it, but the work was not well received: see reviews in *L'Illustration* 37, no. 952 (25 May 1861): 323; *RDM* 33 (1 June 1861): 745–46; and *RGM* 28, no. 20 (19 May 1861): 154–55.

2. Referring to the vexing circumstances attending the production of David's work, Paul Scudo commented in the *RDM* 20 (15 March 1859): 506, "Si l'on pouvait raconter tout ce qui rattache à la collaboration du scenario d'*Herculanum*, on écrirait une page piquante des moeurs littéraires et politiques de ce temps-ci." Among other things, Scudo knew that Gabriel and Mirecourt were slowly edged out of responsibility for the libretto in favor of Hadot, a friend of Enfantin and David. In fact Hadot contributed very little. The first edition of Mirecourt's biography of David (1854) concludes with the assurance that the score of *La fin du monde* is ready to be distributed to the orchestra (p. 91); in the third edition (Paris, 1869) Mirecourt attempts to settle accounts in the matter, quoting from the exchange of letters (pp. 48–63). A brief account also appears in Brancour, *Félicien David*, p. 79, and Azevedo, *Félicien David*, pp. 88–89.

3. See *La chanson française*, 24 September 1876.

4. Berlioz, *Correspondance inédite*, ed. D. Bernard (Paris, 1879), p. 263.

5. At least one excerpt from *Herculaneum* also crossed the channel to Victorian England: "Je crois en Dieu" exists in a British Library copy as "Trust in Heaven," translated by John Oxenford, 1874. I am indebted to Ralph Locke for the information.

6. François Fétis, in the entry for Félicien David in his *Biographie universelle des musiciens*, 2nd ed. (Paris, 1860–65) 2: 441–43, refers to the Saint-Simonians as Anabaptists. Responding to Fétis in "Les Anabaptistes et Félicien David," *Fausses Notes* (Paris, 1862), Dominique Tajan-Rogé left no doubt that the Christian heaven of *Herculaneum*'s young lovers was easily translatable to a universalist kingdom of Saint-Simonian imagination.

7. Following the precedent of Meyerbeer's *Robert le diable*, David confines dance to a single act. An unsigned article in *FM* 8, no. 3 (30 March 1845): 101, notes the discovery in London of an unfinished opera by Weber (*L'enfer sur terre*) that has some structural resemblance to Meyerbeer's *Robert*: one act is almost entirely ballet.

8. Thereby calling to mind events from the final act of *La favorite*, produced by Donizetti with Royer and Vaëz for Paris in 1840.

9. *JD*, 12 March 1859; source also for the following quotations.

10. *Ibid.* As usual, Berlioz's opponents took a divergent view. After the revival of *Herculaneum* in 1868, Blaze de Bury dismissed Méry as a facile versifier: "Aussi les plus graves torts de cette partition doivent être imputés au librettiste. M. Méry ne fut jamais qu'un faux poète": "Revue musicale," *RDM* 63 (1 August 1868): 755–56.

11. In a letter to Humbert Ferrand (28 April 1859), Berlioz's reservations about the score seem to have increased: "Que la musique d'*Herculanum* est d'une faiblesse et d'un *incoloris* (pardon du néologisme!) désespérants!" See Berlioz, *Lettres intimes* (Paris, 1882), no. 84, p. 220. In the ballet of *Herculanum*, Emma Livry (1841–63) was *première danseuse*. In the tradition of Taglioni, she possessed the lightness and grace that led her to great suc-

cess in various "butterfly" roles; see Théophile Gautier, *The Romantic Ballet*, Engl. tr. C. Beaumont, rev. ed. (London, 1947), pp. 86–87.

12. See M. Savigny, "Les Théâtres," *L'Illustration* 52, no. 1323 (4 July 1868): 11; and Paul Bernard, "Herculanum," *RGM* 35, no. 27 (5 July 1868): 209–10.

13. Léopold Robert (1794–1835) is credited with founding the classicizing Italian genre-painting of the first half of the nineteenth century. His best known work is "The Return of the Harvesters from the Pontine Marshes" from 1830, now in the Louvre: see Fritz Novotny, *Painting and Sculpture in Europe, 1780 to 1880*, 2nd ed. (London, 1970), pp. 49–50.

14. *RDM* 20 (15 March 1859): 507.

CHAPTER 13—LALLA-ROUKH

1. As Baudelaire put it: Daumier "carefully avoids anything that would not be perceived immediately and clearly by the French public." See his *Œuvres complètes, II: Curiosités esthétiques*, ed. J. Crépet (Paris, 1923), p. 418.

2. See Montrevel, "Félicien David," p. 130; Azevedo, *Félicien David*, p. 89; Brancour, *Félicien David*, p. 96; and Gradenwitz, "Félicien David," p. 501.

3. See Vandam, *An Englishman in Paris*, I, 231.

4. *Dwight's Journal of Music* 19, no. 3 (29 June 1861): 101. John Sullivan Dwight (1813–93) founded his journal in 1852 after returning to Boston from several years of teaching music and the classics at the collectivist Brook Farm community; he also contributed to the Fourierist *Harbinger*. Further on Dwight in Walter L. Fertig's "John Sullivan Dwight, Transcendentalist and Literary Amateur of Music," Ph. D. dissertation, University of Maryland, 1952.

5. *Editor's note*: Not included in Dorothy Hagan's study of David's music is the opéra-comique *La Captive*, also to a libretto by Carré, composed before *Le Saphir*, between 1860 and 1864. Destined for the Théâtre-Lyrique, it went into rehearsal but was withdrawn before the scheduled first performance and, so far as can be determined, still remains unperformed. A vocal score was published in 1883. See Brancour, *Félicien David*, pp. 99–100.

6. As reported by Camille Le Senne in his sketch of David: "Période contemporaine," *Histoire de la musique, 1/3: France, Belgique, Angleterre*, ed. Albert Lavignac (Paris, 1914), p. 1709.

7. According to Soubies and Malherbe, *Histoire de l'Opéra-Comique* 2: 39–42.

8. See Gustave Héquet, "Chronique musicale," *L'Illustration* 39, no. 1004 (24 May 1862): 334.

9. Achter, "Félicien David," pp. 179–80 and *passim*, describes David's three-part schemes for songs and dramatic scene complexes, noting the care given to the thematic and tonal plan.

10. *RGM* 29, no. 20 (18 May 1862), p. 162.

11. *Ibid.*

12. See Jullien, *Musiciens d'aujourd'hui* (Paris, 1892–94) 2: 121.

13. *JD*, 23 May 1862.

14. *Ibid.*

15. Namely, his "L'orient et l'occident," published in *OSSE* 45: *Religion Saint-Simonienne: Recueil de prédications* 3, no. 50.

16. Berlioz, *op. cit.*

17. Vytautas Kavolis, *Artistic Expression: A Sociological Analysis* (Ithaca, 1968), Chapter IX and p. 119.

18. Jean-Gustave Bertrand, *Les nationalités musicales étudiées dans le drame lyrique* (Paris, 1872), Chapter XI, "Félicien David, l'orientalisme en musique," p. 302.

19. Kavolis, *Artistic Expression*, pp. 72–73.

20. See Azevedo, *Félicien David*, p. 95.

21. For Paul Scudo's review, see "Revue musicale," *RDM* 38 (1862): 756–61, repr. in Scudo's *La musique en l'année 1862* (Paris, 1863), pp. 26–38. Other extended commentary on *Lalla-Roukh* in Achter, "Félicien David," Chapter 4; Bertrand, *Les nationalités*, pp. 300–304; Brancour, *Félicien David*, Chapter VI; and Hellmuth Christian Woff, "Der Orient in der französischen Oper des 19. Jahrhunderts," *Die "Couleur locale" in der Oper des 19. Jahrhunderts*, ed. Heinz Becker (Regensburg, 1976), pp. 374–79.

22. Quoted in Talmon, *Political Messianism*, p. 123.

23. See Weckerlin, *Nouveau musiciana* (Paris, 1890), pp. 293–96; Brancour, *Félicien David*, p. 95, n. 1; and Achter, "Félicien David," p. 124.

24. *Les nationalités musicales*, p. 304.

25. Berlioz, *op. cit.*

26. From a letter to Armand du Ménil, quoted by Brancour, p. 110.

27. These appropriate phrases are from Fromentin, but in the context of identifying the influence of the Dutch on the French in landscape painting: see *Les maîtres d'autrefois*, ed. P. Moisy (Paris, 1972), pp. 173–74.

28. See Scudo, *La Musique*, p. 761.

29. For the list of performances, see Alfred Loewenberg, *Annals of Opera*, 3rd rev. ed. (Totowa, N.J., 1978), pp. 956–57. In regard to the Russian performances, one wonders whether Leo Tolstoy happened to attend a St. Petersburg performance of *Lalla-Roukh*. Many of his disapproving remarks about opera in *What is Art?* (1898) seem to apply closely to situations in David's opera. The passages are given in Aylmer Maude's translation as "An Opera Is Rehearsed," in *The Pleasures of Music*, ed. J. Barzun (New York, 1951), pp. 413–18.

30. See d'Allemagne, *Prosper Enfantin*, Chapter VII.

CHAPTER 14—THE SAPPHIRE

1. See James Harding, *Gounod* (New York, 1973), p. 139, for Gounod's complaint on being asked for changes in *Mireille*.

2. See Bertrand, "Semaine théâtrale," *Le ménestrel* 32, no. 15 (12 March 1865): 115.

3. See Armand Gouzien's review in *RGM* 32, no. 11 (12 March 1865): 81–82.

4. See Vandam, *An Englishman in Paris* 1: 229.

5. *Ibid.*, 230–31.

6. Frank Manuel in *The Prophets of Paris*, p. 191, writes: "In all their multifarious activities the Pereires clung to the allusion that their temple of Mammon had been sanctified by the [Saint-Simonian] commandment to improve the lot of the most numerous and poorest classes." Their philanthropy, however, started at the top and contributed substantially to the relative ease and security of Enfantin's life. Félicien David seems to have warranted less of their attention. For details on the composer's relationships with wealthy Saint-Simonians and the benefits he derived, see Locke, *MSS*, pp. 372–75.

7. See Gouzien's review in *RGM* 32, no. 11 (12 March 1865).

8. *Les nationalités musicales*, p. 306.

9. See Gustave Héquet, "Chronique musicale," *L'Illustration* 45, no. 1151 (18 March 1865): 164–66.

10. "De l'imitation musicale," *RGM* 4, no. 2 (8 January 1837); Engl. tr. in Berlioz, *Fantastic Symphony*, ed. E. Cone (New York, 1971), p. 44.

11. See Achter, "Félicien David," p. 160.

12. Héquet, "Chronique musicale," p. 166.

13. See Bertrand, *Les nationalités*, p. 296.

14. Bertrand in *Le ménestrel* (12 March 1865): 116.

AFTERWORD

1. Quoted in Locke, *MSS*, p. 378.

2. On David's last days and the political repercussions of his funeral, see *Le ménestrel* 42, no. 40 (3 September 1876): 314–15; Brancour, *Félicien David*, pp. 107–109; *Grande Larousse encyclopédique* (Paris, 1960) 3: 806; Gradenwitz, "Félicien David," pp. 501–2; and Locke, *MSS*, 378–79.

3. For the text of this letter, see Locke, *MSS*, p. 377.

4. Jean Le Rond d'Alembert, *Oeuvres complètes* (Paris, 1821–22) 1: 82: "Discours préliminaire de l'encyclopédie."

5. *Ibid.*

6. Locke, *MSS*.

7. Imagery from "Le voyage": see Baudelaire, *Les fleurs du mal*, ed. J. Crépet and G. Blin (Paris, 1942), pp. 159–65.

8. Baudelaire, *The Mirror of Art: Critical Studies*, Engl. tr. J. Mayne (Garden City, 1956), p. 130.

9. Percy Bysshe Shelley, *The Complete Poetical Works*, ed. N. Rogers (Oxford, 1972–1975) 2: 100: Preface to "Laon and Cythna."

10. *Ibid.*, 1: 340: Mary Shelley's "Note on Queen Mab."

11. *Ibid.*

12. For example, Donald Grout's *A Short History of Opera*, 2nd ed. (New York, 1965) 1: 328.

13. Quoted in Jacques Barzun, *Berlioz and the Romantic Century*, 3rd rev. ed. (New York, 1969) 2: 104.

14. *JD*, 3 September 1876; reprinted in Brancour, *Félicien David*, pp. 109–11.

15. Berlioz, "Bellini," *JD*, 16 July 1836.

16. Gustave Bertrand, *Les nationalités*, p. 296.

17. See Plato, *The Dialogues*, Engl. tr. B. Jowett (London, 1892; repr. New York, 1937): "The Republic" 4: 424.

18. Aristotle, *The Politics*, Engl. tr. E. Barker (Oxford, 1946) 8: "The Training of Youth," esp. Chapters V through VII: "The Aims and Methods of Education in Music."

19. *Ibid.*, pp. 343–44.

20. Mill, *Autobiography* (New York, 1924), p. 104.

21. Shelley, *"Prometheus Unbound": The Texts and the Drafts*, ed. L. Zillman (New Haven and London, 1968), p. 37: Preface.

22. See Aylmer Maude's Engl. tr. (London, 1930).

23. See Brancour, *Félicien David*, p. 120.

24. For an intelligent appraisal of David's solo songs, an important category of David's output not considered in this study, see Frits Noske, *French Song from Berlioz to Duparc*, 2nd rev. ed. by R. Benton and F. Noske (New York, 1970), pp. 140–49, including 12 musical examples. The same source, pp. 343–47, lists sixty songs by David that appeared separately or in three collections of 1845, 1846, and 1866. Noske notes the natural simplicity of David's song writing, his genuine sympathy for poetry, his essential intimacy of expression, and judges him preeminently suited to song composition. He reserves special praise for David's settings of Lamartine's *Le jour des morts* (1837) and Gautier's *Tristesse de l'odalisque* (1845).

Bibliography

Abrams, Meyer H. *The Mirror and the Lamp: Romantic Theory and the Critical Tradition*. New York, 1953.

Achter, Morton J. "Félicien David, Ambroise Thomas and French Opéra Lyrique, 1850–1870." Ph.D. dissertation, University of Michigan, 1972.

d'Alembert, Jean Le Rond. *Oeuvres complètes*. 5 vols. Paris: Belin, 1821–22.

d'Allemagne, Henry-René. *Les Saint-Simoniens, 1827–1837*. Paris, 1930.

————. *Prosper Enfantin et les grandes entreprises du XIXᵉ siècle*. Paris, 1935.

Aristotle. *The Politics*. Engl. tr. Ernest Barker. Oxford, 1946.

Arnal, Pierre, Jacques Kryn, and Ralph Locke. *Célébration centenaire de la mort de Félicien David*. Cadenet, 1976.

Azevedo, Alexis. *Félicien David: coup d'oeil sur sa vie et son œuvre*. Paris, 1863.

Balakian, Anna. *The Symbolist Movement: A Critical Appraisal*. New York, 1967.

Baldensperger, Fernand. *La sensibilité musicale et romantisme*. Paris, 1925.

Barrault, Émile. "Aux artistes," *Religion Saint-Simonienne: Enseignement central* (Paris, 1831); orig. publ. as *Aux artistes: Du passé et de l'avenir des beaux-arts*. Paris, 1830.

————. "L'Art," *Le Globe* 7, no. 122 (2 May 1831): 491–92; also publ. in *OSSE* 44: *Religion Saint-Simonienne, Recueil de prédications* 2, 26 (1876): 160–89.

Bartoli, Jean Pierre. "La musique française et l'Orient: A propos du *Désert de Félicien David*," *Revue internationale de musique française* 2/6 (November 1981): 29–36.

Barzun, Jacques. *Berlioz and the Romantic Century*. 3rd rev. ed. 2 vols. New York, 1969.

————. *Pleasures of Music*. New York, 1951.

Baudelaire, Charles. *Les fleurs du mal*. Ed. J. Crépet and G. Blin. Paris, 1942.

————. *Oeuvres complètes, II: Curiosités esthétiques*. Ed. J. Crepet. Paris, 1923.

————. *The Mirror of Art: Critical Studies by Charles Baudelaire*. Engl. tr. J. Mayne. Garden City, 1956.

Baudet, Henri. *Paradise on Earth: Some Thoughts on European Images of Non-European Man*. Engl. tr. E. Wentholt. New Haven, 1965.

Becker, Heinz, ed. *Die "Couleur locale" in der Oper des 19. Jahrhunderts*. Regensburg, 1976.

Bellaigue, Camille. *Études musicales et nouvelles silhouettes de musiciens*. Paris, 1898.

Berlioz, Hector. *Fantastic Symphony*. Ed. E. Cone. New York, 1971.

————. *Grand Traité d'instrumentation et d'orchestration modernes, Opus 10*. Paris, 1843; 1855; rpt. London, 1970; rev. by R. Strauss as *Treatise on Instrumentation*. Engl. tr. T. Front. New York, 1948.

————. *Lettres intimes*. Paris: Calmann-Lévy, 1882.

————. "Lettres sur 'Les Troyens,'" *Revue de Paris* 28, no. 4 (15 August 1921): 749–70.

Bertrand, Jean Gustave. *Les nationalitiés musicales étudiées dans le drame lyrique*. Paris, 1872.

Beyle (=Stendhal), Marie Henri. *Mémoires d'un touriste*. Rev. ed. 2 vols. Paris: Calmann-Lévy, 1891.

Bishop, Morris. "The Incomparable Enfantin: A Moral Tale," *Horizon* 10, no. 4 (Autumn 1968): 48–51.

Blanc, Louis. *The History of Ten Years, 1830–1840*. 2 vols. London, 1844–45; orig. publ. as *Histoire de dix ans*. Paris, 1841–44.

Brancour, René. *Félicien David (Collection des musiciens célèbres)*. Paris, 1911.

Brandes, Georg. *Naturalism in Nineteenth-Century Literature*. New York, 1957.

————. *Revolution and Reaction in Nineteenth-Century French Literature*. New York, 1957.

Callot, Jean Pierre. *Enfantin, le prophète aux sept visages*. Paris, 1963.

Camp, Maxime du. *Souvenirs littéraires, 1822–1850*. 3rd ed. Paris, 1906.

Carnot, Lazare Hippolyte. *Sur le Saint-Simonisme. Lecture faite à l'Académie des sciences et politiques*. Paris: Picard, 1887.

Castille, Hippolyte. *Le Père Enfantin*. Paris, 1859.

La chanson française, 24 September 1876.

Chantavoine, Jean. *Musiciens et poètes*. Paris, 1912.

Chantavoine, Jean with Gaudefroy-Demombynes, J. *Le romantisme dans la musique européene*. Paris, 1955.

Charléty, Sébastien. *Enfantin*. Paris, 1930.

————. *Histoire du Saint-Simonisme, 1825–1864*. 2nd ed. Paris, 1931.

Chateaubriand, François vicomte de. *Les Natchez*. Ed. G. Chinard. Baltimore, Paris, and London, 1932.

Chevalier, Auguste. "Exposé sommaire de mes fonctions à Ménil-Montant," *Le cabinet de lecture* 129 (4 January 1833).

Chouquet, Gustave. *Histoire de la musique dramatique en France.* Paris, 1873.

Christianowitsch, Alexandre. *Esquisse historique de la musique arabe aux temps anciens.* Cologne, 1863.

Clément, Félix. *Les musiciens célèbres depuis le seizieme siècle jusqu'à nos jours.* 3rd ed. Paris, 1878.

Crum, Margaret. *Catalogue of the Mendelssohn Papers in the Bodleian Library, Oxford, I: Correspondence of Felix Mendelssohn-Bartholdy and Others.* Tutzing, 1980.

David, Félicien. Autograph letters, 1830–41. Paris, Bibliothèque Nationale, Music Division, letter file 8001.

Dean, Winton. *Georges Bizet, His Life and Work.* London, 1965.

Delacroix, Eugène. *The Journal of Eugène Delacroix.* Engl. tr. W. Pach. New York, 1937; repr. 1961.

Donakowski, Conrad L. *A Muse for the Masses: Ritual and Music in an Age of Democratic Revolution, 1770–1870.* Chicago, 1972.

Dostoyevsky, Fyodor. *The Brothers Karamazov.* Engl. tr. C. Garnett. London, 1912.

Dumesnil, René. *La musique romantique française.* Paris, 1945.

Dwight's Journal of Music. 41 vols. Boston, 1852–81; rpt. New York, 1968.

Easton, Malcolm. *Artists and Writers in Paris: The Bohemian Idea, 1803–1867.* London, 1964.

Egbert, Donald D. *Social Radicalism and the Arts in Western Europe: A Cultural History from the French Revolution to 1968.* New York, 1970.

Encyclopédie de la musique et dictionnaire du conservatoire. Ed. A. Lavignac and L. de la Laurencie. 2 pts. in 11 vols. Paris, 1913–31.

Enfantin, Barthélémy-Prosper. "Correspondance politique, 1835–1840," extract from *Le crédit* (Paris, 1849).

———. *La colonisation d'Algérie.* Paris, 1843. Also see *Œuvres.*

Erikson, Erik H. *Gandhi's Truth.* New York, 1969.

Escudier, Léon. *Mes souvenirs.* 2nd ed. Paris, 1863.

Evans, David O. *Social Romanticism in France, 1830–1848.* New York, 1951; rpt. 1969.

Farmer, Henry G. "Egyptian Music," *Grove's Dictionary.* 5th ed., 2: 891–97. *Also see* Salvador-Daniel.

Favre, Georges. "La musique de clavecin en France de 1760 à 1850." *Histoire de la musique,* ed. Roland-Manuel (Paris, 1960–63), 2: 277–92.

Fétis, François Joseph. *Biographie universelle des musiciens et bibliographie générale de la musique.* 2nd rev. ed. 8 vols. in 4. Paris, 1866–70.

Feuer, Lewis S. *Ideology and the Ideologists.* New York, 1975.

La France musicale. Paris, 1837–70.

Fromentin, Eugène. *Les maîtres d'autrefois*. Ed. P. Moisy. Paris, 1972.

———. *Un été dans le Sahara*. 11th ed. Paris, 1896.

Fromm, Erich. *The Crisis of Psychoanalysis*. New York, 1970.

Fulcher, Jane. "Music and the Communal Order: The Vision of Utopian Socialism in France," *Current Musicology* 27 (1979): 27–35.

———. "The Popular Chanson of the Second Empire: 'Music of the Peasants' in France." *Acta musicologica* 52 (1980): 27–37.

Fuller, R. Buckminster, with J. Agel and Q. Fiore. *I Seem to Be a Verb*. New York, 1970.

Gail, Jean François. *Réflexions sur le goût musical en France*. Paris: Paulin, 1832.

Gautier, Théophile. *Histoire de l'art dramatique en France depuis vingt-cinq ans*. 6 vols. Paris and Leipzig, 1858–59; rpt. Geneva, 1968.

———. *The Romantic Ballet*. Rev. ed. Engl. tr. C. Beaumont. London, 1947.

Le Globe, journal de la doctrine de Saint-Simon (also described as *journal de la religion Saint-Simonienne*). Paris, 1830–32.

Gobineau, Joseph-Arthur comte de. *Tales of Asia*. Engl. tr. J. L. May. London, 1847; rpt. 1947.

Goethe, Johann Wolfgang von. *Truth and Poetry: From My Own Life*. Engl. tr. J. Oxenford. London, 1874.

Gouhier, Henri. *Études d'histoire de la philosophie française*. Hildesheim, 1976.

Gouin, T. "Félicien David, le père de l'exotisme musical." *Musica Disques* no. 99 (June 1962): 50–55.

Gradenwitz, Peter. "Félicien David (1810–1876) and French Romantic Orientalism." *The Musical Quarterly* 62/4 (October 1976): 471–506.

Green, Martin. *The Von Richthofen Sisters: The Triumphant and the Tragic Modes of Love*. New York, 1974.

Grout, Donald Jay. *A Short History of Opera*. 2nd ed. 2 vols. New York, 1965.

Grove's Dictionary of Music and Musicians. 5th ed. rev. E. Blom. 9 vols. London, 1954.

Guichard, Léon. *La musique et les lettres au temps du romantisme*. Paris, 1955.

Le guide musical, revue internationale de la musique et de théâtres lyriques. 61 vols. Paris and Brussels, 1855–1918.

Guise, René. "Le roman-feuilleton et la vulgarisation des idées politiques et sociales sous la monarchie de juillet." *Romantisme et politique* (*Colloque de l'école normale supérieure de Saint-Cloud, 1966*) (Paris, 1969), pp. 316–28.

Hagan, Dorothy V. "French Musical Criticism Between the Revolutions, 1830–1848." Ph.D. diss., University of Illinois, 1965.

———. "Musical Notes in French Mémoires of the 18th Century." M.A. thesis. Cornell University, 1933.

Harding, James. *Gounod*. New York, 1973.

Hauser, Henri. "Un problème d'influences: Le Saint-Simonisme au Brésil." *Annales d'histoire économique et sociale* 9/43 (31 January 1937): 1–7.

Heine, Heinrich. *Werke*. 4 vols. Frankfurt: Insel, 1968.

———. *Zeitungsberichte über Musik und Malerei*. Ed. M. Mann. Frankfurt, 1964.

Hemmings, Frederick W. *Culture and Society in France, 1848–1898*. London, 1971.

Iggers, Georg G. "Heine and the Saint-Simonians." *Comparative Literature* 10 (1958): 289–308.

———. *The Cult of Authority: The Political Philosophy of the Saint-Simonians*. The Hague, 1958.

———. *The Doctrine of Saint-Simon: An Exposition, First Year, 1828–1829*. Boston, 1958.

L'Illustration, journal universel hebdomadaire. Paris, 1843–1944.

Johnson, Christopher H. *Utopian Communism in France: Cabet and the Icarians, 1839–1851*. Ithaca, 1974.

Journal des débats (title continued variously, but for longest period as *politiques et littéraires*). Paris, 1789–1944.

Juden, Brian. *Traditions orphiques et tendances mystiques dans le romantisme français, 1800–1855*. Paris, 1971.

Jullien, Adolphe. *Musiciens d'aujourd'hui*. 2 vols. Paris, 1892–94.

Kavolis, Vytautas. *Artistic Expression: A Sociological Analysis*. Ithaca, 1968.

Kirby, Frank E. "Beethoven's Pastoral Symphony as a *Sinfonia caratteristica*." *The Musical Quarterly* 56/4 (October 1970): 605–23.

Lamartine, Alphonse de. *Vies des grands hommes* II. Paris, 1856.

Landes, David S. *The Unbound Prometheus: Technological Change and Industrial Development in Western Europe from 1750 to the Present*. Cambridge, 1972.

Langer, William L. *The Rise of Modern Europe: Political and Social Upheaval, 1832–1852*. New York, 1969.

Lasky, Melvin J. *Utopia and Revolution*. Chicago, 1976.

Lavoix, Henri. *La musique française*. Rev. ed. F. Robineau. Paris, 1910.

Lebeau, Elisabeth. "Félicien David." *Die Musik in Geschichte und Gegenwart* 3 (1954), cols. 47–51.

Lebreton-Savigny, Monique. "La fortune littéraire de Christophe Colomb au dix-neuvieme siècle en France." *Nineteenth-Century French Studies* 6/3–4 (Spring–Summer 1978): 149–65.

Le Senne, Camille. "Félicien David, 1810–1876." *Encyclopédie de la musique et dictionnaire du conservatoire, I/3: Histoire de la musique: France, Belgique, Angleterre*. Ed. A. Lavignac (Paris, 1914), pp. 1707–10.

Levin, Harry. *The Myth of the Golden Age in the Renaissance*. Bloomington, In., 1969.

Liefde, Carel L. de. *Le Saint-Simonisme dans la poésie française entre 1825 et 1865*. Haarlem, 1927.

Locke, Ralph P. "Autour de la lettre à Duveyrier: Berlioz et les Saint-Simoniens." *Revue de musicologie* 63/1–2 (1977): 55–77.

———. "Exotic Techniques and Their Meaning in the Music of Félicien David." M.A. thesis, University of Chicago, 1974.

———. "Liszt's Saint-Simonian Adventure." *Nineteenth-Century Music* 4/3 (Spring 1981): 209–27.

———. "Music and the Saint-Simonians: The Involvement of Félicien David and Other Musicians in a Utopian Socialist Movement." Ph. D. diss., University of Chicago, 1980.

———. "Notice biographique sur Félicien David." *Célébration du centenaire de la mort de Félicien David*. Cadenet, 1976. *Also see* Macdonald.

Lockspeiser, Edward. *Debussy*. 4th rev. ed. London, 1963.

Loewenberg, Alfred. *Annals of Opera, 1597–1940*. 3rd rev. ed. Totowa, N.J., 1978.

Longyear, Rey M. "Daniel-François-Esprit Auber (1782–1871): A Chapter in French Opéra-Comique, 1800–1870." Ph.D. diss., Cornell, 1957.

Macdonald, Hugh, and Ralph Locke. "Félicien David." *The New Grove Dictionary* 5: 263–65.

Maestre, André Espiau de la. "Berlioz, Metternich et le Saint-Simonisme." *Revue musicale* no. 233 (1956): 65–78.

Maistre, Joseph-Marie comte de. *Œuvres complètes*. 14 vols. Lyon, 1885–1924.

———. *The Works of Joseph de Maistre*. Selected, tr., and intro. by Jack Lively. New York, 1965.

Malm, William P. *Music Cultures of the Pacific, the Near East, and Asia*. Englewood Cliffs, N.J., 1967.

Manuel, Frank E. *The New World of Henri Saint-Simon*. Cambridge, Ma., 1956.

———. *The Prophets of Paris*. Cambridge, Ma. 1962.

Manuel, Frank E., and Fritzie P. Manuel, eds. *French Utopias: An Anthology of Ideal Societies*. New York, 1966.

Marix, Thérèse. "George Sand, la musique naturelle et la musique populaire." *Revue musicale* 7 (July 1926): 33–45.

Le ménestrel. Paris, 1833–1940.

Mill, John Stuart. *Autobiography*. New York: Columbia University Press, 1924.

Mirecourt, Eugène de. *Félicien David (Les contemporaines, 14)*. Paris, 1854; 3rd rev. ed., 1869.

Montrevel, Charles de. "Félicien David, 1810–1876." *Biographies du XIX^e siècle*. Paris: Bloud et Barral, n.d., pp. 99–132.

Morawski, Stefan. "The Aesthetic Views of Marx and Engels," *The Journal of Aesthetics and Art Criticism* 28/3 (Spring 1970): 301–14.

Morazé, Charles. *Les bourgeois conquérants (XIXᵉ siècle)*. Paris, 1957; Engl. tr. G. Weidenfeld: *The Triumph of the Middle Classes*. Cleveland and New York, 1966.

Nattiez, Jean Jacques. *Fondements d'une sémiologie de la musique*. Paris, 1975.

The New Grove Dictionary of Music and Musicians. Ed. S. Sadie. 20 vols. London and New York, 1980.

Newmarch, Rosa. "Glinka." *Grove's Dictionary*. 5th ed., 3: 666–71.

Noske, Frits. *French Song from Berlioz to Duparc*. 2nd ed. rev. by R. Benton and F. Noske. New York, 1970.

Œuvres de Saint-Simon et d'Enfantin. 47 vols. Paris, 1865–78; rpt. Aalen, 1963–64.

Pellet, Alphonse. *Essai sur l'opéra en France depuis Lully jusqu'à nos jours*. Nimes, 1875.

Picard, Roger. *Le romantisme social*. New York, 1944.

Plamenatz, John P. *The Revolutionary Movement in France, 1815–1871*. London, 1952; rpt. New York, 1965.

Plantinga, Leon. *Schumann as Critic*. New Haven, 1967.

Plato. *The Dialogues*. Engl. tr. Benjamin Jowett. London, 1892; rpt. New York, 1937.

Porte, Joseph François. *Des moyens de propager le goût de la musique en France*. 2nd ed. Aix, 1838.

Prod'homme, Jacques Gabriel. "Correspondance inédite de Félicien David et du Père Enfantin, 1845." *Mercure de France* (1 May 1910): 67–86.

———. "Félicien David d'après sa correspondance inédite et celle de ses amis, 1832–1864." *Mercure musical et bulletin français de la société internationale de musique* 3 (1907): 105–25 and 229–75.

Revue des deux mondes. Paris, 1829–1947.

Revue et gazette musicale de Paris. Paris, 1834–80.

Rhodes, Solomon A. *Gérard de Nerval, 1808–1855*. New York, 1951.

Ringer, Alexander. "J.-J. Barthélemy and Musical Utopia in Revolutionary France." *Journal of the History of Ideas* 22 (1961): 355–68.

———. "On the Question of 'Exoticism' in 19th-Century Music." *Studia musicologica* 7 (1965): 115–23.

Rosen, Charles. "Romantic Documents." *The New York Review of Books* 22/8 (15 May 1975): 15–20.

Saint-Étienne, Sylvain. *Biographie de Félicien David*. Marseilles, 1845.

Saint-Saëns, Camille. *Harmonie et mélodie*. Paris, 1885.

Saint-Simon, Claude-Henri de Rouvroy comte de. See *Œuvres*.

Salvador-Daniel, Francesco. *The Music and Musical Instruments of the Arab.* Rev. ed. and Engl. tr. by H. G. Farmer. London, 1914.

Schmidt-Garre, Helmut. "Exotismus in der Musik," *Neue Zeitschrift für Musik* 129 (1 January 1968): 27–33.

Schrade, Leo. *Beethoven in France: The Growth of an Idea.* New Haven and London, 1942; rpt. 1978.

Scudo, Paul. *La musique en l'année 1862.* Paris, 1863.

Sendrey, Alfred. *Music in Ancient Israel.* New York, 1969.

Sewell, William H. *Work and Revolution in France: The Language of Labor from the Old Regime to 1848.* Cambridge, 1980.

Shelley, Percy Bysshe. *Prometheus Unbound: The Texts and the Drafts.* Ed. L. Zillman. New Haven and London, 1968.

———. *The Complete Poetical Works.* Vols. I and II. Ed. N. Rogers. Oxford, 1972–75.

Soubies, Albert, and Charles Malherbe. *Histoire de l'Opéra-comique, 1840–1887.* 2 vols. Paris, 1892–93; rpt. Geneva, 1978.

Subotnick, Rose R. "Adorno's Diagnosis of Beethoven's Late Style: Early Symptom of a Fatal Condition." *JAMS* 29 (1976): 242–75.

———. "The Cultural Message of Musical Semiology: Some Thoughts on Music, Language and Criticism Since the Enlightenment." *Critical Inquiry* 4 (Summer 1978): 741–68.

Tajan-Rogé, Dominique. "Les Anabaptistes et Félicien David: Le Saint-Simonisme et la musique." *Fausses notes* (Paris, 1862).

Talmon, Jacob L. *Political Messianism: The Romantic Phase.* London and New York, 1960.

Tayler, Edward W. *Nature and Art in Renaissance Literature.* New York, 1964.

Thibert, Marguerite. *Le rôle social de l'art d'après les Saint-Simoniens.* Paris, 1926.

Thompson, Edward Palmer. *The Making of the English Working Class.* New York, 1966.

Tocqueville, Alexis de. *Recollections.* Engl. tr. A. T. de Mattos., ed. J. P. Mayer. New York, 1949.

Tolstoy, Leo. *What Is Art? and Essays on Art.* Engl. tr. Aylmer Maude. London, 1930; rpt. 1962.

Vallas, Léon. "Berlioz." *Grove's Dictionary.* 5th ed., 1: 653–73.

Vandam, Albert D. *An Englishman in Paris.* 2nd rev. ed. 2 vols. London, 1892.

Vinçard, Jules. *Mémoires épisodiques d'un vieux chansonnier Saint-Simonien.* Paris, 1878.

Voilquin, Suzanne. *Souvenirs d'une fille du peuple, ou La Saint-Simonienne en Egypte, 1834 à 1836.* Paris, 1866; abridged ed. with intro. by Lydia Elhadad, Paris, 1978.

Walch, Jean. *Bibliographie saint-simonienne.* Paris, 1967.

Walsh, T. J. *Second Empire Opera: The Théâtre Lyrique, Paris (1851–1870).* London, 1981.

Warrack, John. *Carl Maria von Weber.* New York, 1968.

Weber, William. *Music and the Middle Class: The Social Structure of Concert Life in London, Paris and Vienna.* London, 1975.

Weckerlin, Jean-Baptiste. *Nouveau musiciana.* Paris, 1890.

Weill, Georges. *L'école Saint-Simonienne, son histoire, son influence jusqu'à nos jours.* Paris, 1896.

Weinberg, Bernard. *French Realism: The Critical Reaction, 1830–1870.* New York, 1937.

Willey, Basil. *More Nineteenth-Century Studies.* London, 1956.

Wilson, Edmund. *To the Finland Station: A Study in the Writing and Acting of History.* New York, 1940.

Wolff, Hellmuth C. "Der Orient in der französischen Oper des 19. Jahrhunderts." *Die "Couleur locale" in der Oper des 19. Jahrhunderts*, ed. H. Becker (Regensburg, 1976), pp. 371–85.

Zioutos, G. D. "Le Saint-Simonisme hors de France: Quelques cahiers inédits sur l'expédition d'Egypte." *Revue d'histoire économique et sociale* 31 (1953): 23–49.

Principal Works of Félicien David

The most comprehensive work list published to date is Ralph Locke's contribution to the Félicien David entry in *The New Grove Dictionary* V: 264–65; also see Frits Noske's list of David's solo songs in his *French Song from Berlioz to Duparc* (New York, 1970), pp. 343–47.

WORKS FOR THE STAGE

Le jugement dernier, ou La fin du monde. Incidental music for vocal soloists, chorus, and orchestra. Text by J. Gabriel and E. de Mirecourt. *Ca.* 1849. Concert performance, 1861.

La perle du Brésil. Opéra comique in three acts. Text by J. Gabriel and S. Saint-Étienne. Paris, Opéra National, 22 November 1851. Rev. 1859–61.

Le fermier de Franconville. Opéra comique in one act. *Ca.* 1857. Unperformed.

Herculanum. Opera in four acts. Text by J. Méry and T. Hadot. Paris, Opéra, 4 March 1859.

Lalla-Roukh. Opéra-comique in two acts. Text after T. Moore by H. Lucas and M. Carré. Paris, Opéra-Comique, 12 May 1862.

La captive. Opéra comique in three acts. Text by M. Carré. *Ca.* 1860–64. Withdrawn after rehearsal. Vocal score published 1883.

Le saphir. Opera comique in three acts. Text after Shakespeare's *All's Well That Ends Well*, by Carré, Hadot, and de Leuven. Paris, Opéra-Comique, 8 March 1865.

229

ODE-SYMPHONIES AND ORATORIOS

Le désert. Ode-symphony in three parts for tenor soloist, male and female choruses, speaking voice, [dancers] and orchestra. Text by A. Colin. Paris, Conservatory, 8 December 1844.

Moïse au Sinaï. Oratorio in two parts for vocal soloists, chorus, [dancers] and orchestra. Text by S. Saint-Étienne on suggestions from Prosper Enfantin. Paris, Opéra, 24 March 1846. Rev. 1847.

Christophe Colomb, ou La découverte du nouveau monde. Ode-symphony in four parts for vocal soloists, chorus, [dancers] and orchestra. Text by J. Méry, C. Chaubet, and S. Saint-Étienne. Paris, Conservatory, 7 March 1847.

L'Eden. *Mystère* (oratorio) in two parts for vocal soloists, choruses, [dancers] and orchestra. Text by J. Méry. Paris, Opéra, 25 August 1848.

ORCHESTRAL WORKS

Symphony No. 1 in F major, 1837.
Symphony No. 2 in E major, 1838.
Symphony No. 3 in E flat major, 1846.
Symphony No. 4 in C minor, 1849.

WORKS FOR CHAMBER ENSEMBLES

String Quartet in F minor, 1868.

Les quatre saisons, twenty-four short quintets for strings and bass or second cello, 1845–46.

Three Trios in E flat major, D minor, and C minor for violin, violoncello, and piano, 1857.

Two Nonets in F major (lost) and C minor for brass instruments, 1839.

PIANO PIECES

Mélodies orientales, 1836. Two pieces in seven books. Listed in Prod'homme, "Félicien David," pp. 123–24; and Locke, *MSS*, pp. 689–90.

 I. 1. Une promenade sur le Nil
 2. Smyrne
 3. Fantasia Harabi

II. 4. Fantasia Harabi
5. Prière
6. Adieu au vieux Caire
7. A Jenny Montgolfier
III. 8. L'Egyptienne
9. Le harem
IV. 10. Aux filles d'Egypte
11. Rêverie
12. A une Smyrniote
V. 13. A "H."
14. Souvenir d'Occident
15. Anaïs
16. Une plainte
VI. 17. Une larme de douleur
18. Rêverie
19. Un moment de bonheur
VII. 20. Souvenir d'Egypte
21. A Henri Granal
22. Adieux à l'Orient

Brises d'Orient, 1845. Books I to VI of the *Mélodies orientales*, some with new titles.

Les minarets, 1845. Book VII of the *Mélodies orientales*.

Three *Mélodie-valses*, 1851.

Six *Esquisses symphoniques*, 1856.

Numerous other *valses, pensées, rêveries, romances, méditations*, 1833–73.

CHORAL WORKS

Ménilmontant, 1832–33. Saint-Simonian songs usually for male chorus, all with piano accompaniment. See Prod'homme, "Félicien David," pp. 121–22; and Locke, *MSS*, Appendices 1, 2, 3, and 5.

La ruche harmonieuse, Ca. 1854. Thirty pieces for unaccompanied male chorus, some from the *Ménilmontant* series, others from *Moses, Eden,* and *The Pearl.*

Six *Motets religieux,* publ. *ca.* 1853, most with organ accompaniment.

Te Deum for unaccompanied men's voices (text by E. de Lonlay), 1861.

COLLECTIONS OF SONGS FOR SOLO VOICE AND PIANO

Les perles d'Orient, 1845–46. Six songs to texts by Brazier, Cognat, Gautier, and Marc-Constantin.

Album de 10 mélodies et 3 valses expressives pour le piano, 1846–47. Ten songs to texts by Barateau, Chaubet, Deschamps, Plouvier, and Séjour.

Cinquante mélodies, scènes, romances pour chant et piano, 1866. Fifty songs to texts by Bouscatel, Escudier, Fonteille, Jourdain, Musset, Lamartine, Saint-Etienne, Tourneux, and others; includes reprints from the two earlier collections. Separate listings in Noske, *French Song*, and Locke, *New Grove* V: 265.

Index of Names and Titles

233

FÉLICIEN DAVID

was composed in 11-point Merganthaler Linotron 202 Garamond #3 and leaded two points
by Eastern Graphics;
with display type in Elizabeth by J. M. Bundscho, Inc.;
printed by sheet-fed offset on 55-pound, acid-free Glatfelter Antique Cream,
Smythe-sewn, and bound over binder's boards in Joanna Arrestox
by Maple-Vail Book Manufacturing Group, Inc.;
and published by

SYRACUSE UNIVERSITY PRESS
SYRACUSE, NEW YORK 13210